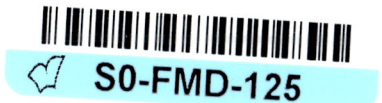

The Art Of The Italian Renaissance

You are holding a reproduction of an original work that is in the public domain in the United States of America, and possibly other countries.You may freely copy and distribute this work as no entity (individual or corporate) has a copyright on the body of the work.This book may contain prior copyright references, and library stamps (as most of these works were scanned from library copies).These have been scanned and retained as part of the historical artifact.

This book may have occasional imperfections such as missing or blurred pages, poor pictures, errant marks, etc. that were either part of the original artifact, or were introduced by the scanning process. We believe this work is culturally important, and despite the imperfections, have elected to bring it back into print as part of our continuing commitment to the preservation of printed works worldwide. We appreciate your understanding of the imperfections in the preservation process, and hope you enjoy this valuable book.

THE ART OF THE
ITALIAN RENAISSANCE

DEDICATED
TO THE MEMORY OF
JAKOB BURCKHARDT

Portrait of Count Castiglione, by Raphael.

THE ART OF THE
ITALIAN RENAISSANCE

A HANDBOOK FOR
STUDENTS AND TRAVELLERS

FROM THE GERMAN OF
HEINRICH WÖLFFLIN

WITH A PREFATORY NOTE BY
SIR WALTER ARMSTRONG

ILLUSTRATED

LONDON: WILLIAM HEINEMANN
MCMIII

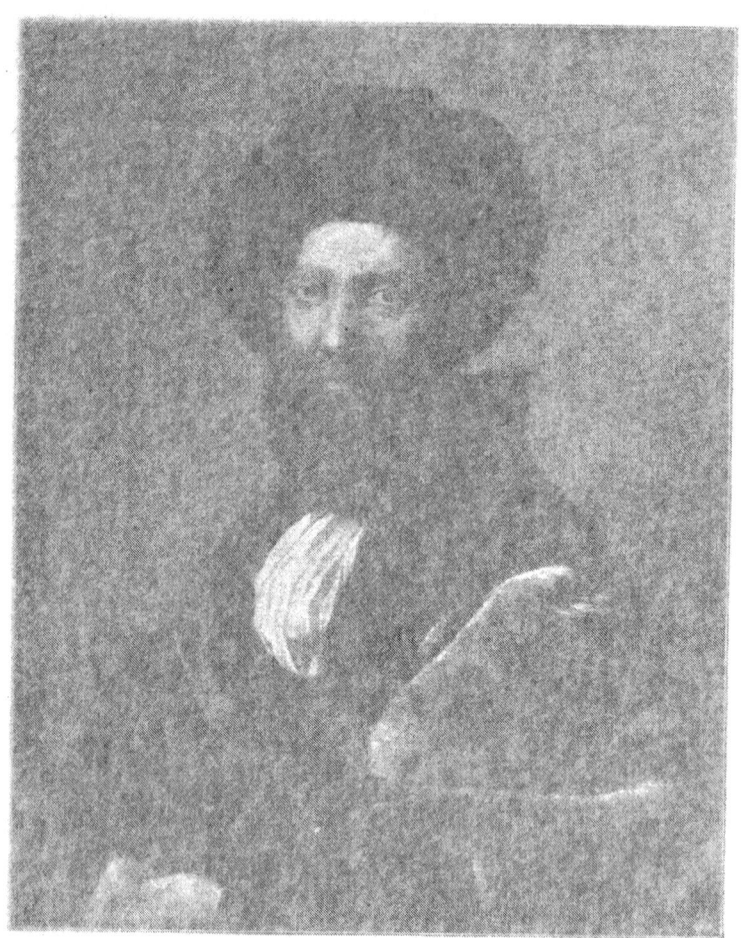

Portrait of Count Castiglione, by Raphael.

THE ART OF THE
ITALIAN RENAISSANCE

A HANDBOOK FOR STUDENTS AND TRAVELLERS

FROM THE GERMAN OF
HEINRICH WÖLFFLIN
Professor of Art-History at Berlin University

WITH A PREFATORY NOTE BY
SIR WALTER ARMSTRONG
Director of the National Gallery, Dublin

ILLUSTRATED

NEW YORK : G. P. PUTNAM'S SONS
LONDON : WILLIAM HEINEMANN
MCMIII

All rights reserved

PREFATORY NOTE

In this interesting treatise a German writer has made an attempt, and a curiously successful one, to deal with the great period of the High Renaissance in Italy from a somewhat novel point of view—that, in fact, of the craftsman himself, rather than that of the interpreter. Passing over the anecdotic and historical aspects of schools and periods, he has made a synthetic study of that completed form of art which has been described—mistakenly, he contends—as a return to classic ideals brought about by the discovery of antique models. He has confined himself for purposes of demonstration to the works of the great masters of Central Italy. The book is of modest dimensions, and its author does not claim to have dealt exhaustively with his vast theme, but rather to be one of the pioneers in a field that has been strangely neglected by art-historians and the newest school of art-critics—the field of pure aesthetics. Insisting strongly on the necessity of systematic work on this fruitful ground, Herr Wölfflin does not wander haphazard among the artistic phenomena of the period. The whole question of colour, for instance, has been left for future consideration. He deals here with problems of form alone. From this point of view he has given us an excellent treatise

on composition, or design, to use that word in its widest sense, dealing chiefly with the character and action of figures, and the pattern made by them. The result is a trustworthy guide to the minds of those painters who belonged to the Schools of Florence and Rome—the schools of pure design, as distinguished from those which placed their chief dependence on colour and chiaroscuro. Speaking broadly, his reasoning is the unconscious reasoning of the painter put into words, so that he conveys to the reader the whys and wherefores of things from the artist's own standpoint. Anyone reading Herr Wölfflin carefully may fairly assume that he is following the workings of Raphael's mind as he built up things like the *Disputa,* the *School of Athens* and the *Madonna di San Sisto.*

WALTER ARMSTRONG.

CONTENTS

PAGE

INTRODUCTION

CLASSIC ART 1

PART I

I. PRELIMINARY SURVEY 7

II. LEONARDO 25
 1. The Last Supper 29
 2. The Monna Lisa 35
 3. St. Anne with the Virgin and the Infant Christ 40
 4. The Battle of Anghiari 42

III. MICHELANGELO (to 1520) 46
 1. Early Works 47
 2. The Ceiling of the Sistine Chapel 58
 3. The Prophets and Sibyls 64
 4. The Slaves 67
 5. The Tomb of Julius 72

IV. RAPHAEL 78
 1. The Marriage of the Virgin and the Entombment 80
 2. The Florentine Madonnas 85
 3. The Camera della Segnatura 90
 The Disputa 92
 The School of Athens 96
 Parnassus 99
 Jurisprudence 102

CONTENTS

	PAGE
IV. RAPHAEL (*continued*)	
4. The Camera d'Eliodoro	103
The Chastisement of Heliodorus	104
The Deliverance of Peter	106
The Mass of Bolsena	108
5. The Cartoons for Tapestries	111
6. The Roman Portraits	120
7. Roman Altar-pictures	131
V. FRA BARTOLOMMEO	143
VI. ANDREA DEL SARTO	157
1. The Frescoes of the Annunziata	158
2. The Frescoes of the Scalzo	162
3. Madonnas and Saints	169
4. A Portrait of Andrea	177
VII. MICHELANGELO (after 1520)	185
1. The Chapel of the Medici	185
2. The Last Judgment and the Pauline Chapel	194
3. The Decadence	195

PART II

I. THE NEW FEELING	201
II. THE NEW BEAUTY	225
III. THE NEW PICTORIAL FORM	247
1. Repose, Space, Mass and Size	248
2. Simplification and Lucidity	251
3. Enrichment	263
4. Unity and Inevitability	275
CONCLUSION	284

LIST OF ILLUSTRATIONS

	PAGE
Portrait of Count Castiglione, by Raphael *Frontispiece*	
David, by Donatello	12
David, by Verrocchio	13
Madonna. Relief by Rossellino	14
Angel bearing Candelabrum, by Luca della Robbia	15
Angel bearing Candelabrum, by Benedetto da Majano	16
Allegory of Spring, by Botticelli	17
Raphael's Madonna di Foligno. From Marc Antonio's engraving	23
Study of a Girl's Head, by Leonardo da Vinci	27
The Last Supper, by Ghirlandajo	30
The Last Supper, from an engraving by Marc Antonio	33
Bust of a Florentine Girl, by Desiderio	35
Portrait of Monna Lisa, by Leonardo da Vinci	37
St. Anne with the Virgin and Infant Christ, by Leonardo da Vinci	41
Abundantia, by Gianpietrino	45
Pietà, by Michelangelo	47
The Madonna of Bruges, by Michelangelo	48
Madonna and Child, by Benedetto da Majano	49

LIST OF ILLUSTRATIONS

	PAGE
Madonna with the Book. Relief by Michelangelo	50
Holy Family, by Michelangelo	51
David, by Michelangelo	54
Apollo, by Michelangelo	55
Fragment from the Cartoon of the Bathing Soldiers, by Michelangelo	57
The Erythræan Sibyl, by Michelangelo	66
Figures of Slaves, by Michelangelo. (From the first group)	68
Figures of Slaves, by Michelangelo. (From the third group)	69
Figure of a Slave, by Michelangelo	70
Tomb of the Cardinal of Portugal, by Antonio Rossellino	73
Tomb of a Prelate, by Andrea Sansovino	75
The Virgin with SS. Sebastian and John the Baptist, by Perugino	79
The Entombment, by Perugino	82
The Entombment, by Raphael	83
The Madonna del Granduca, by Raphael	86
The Madonna della Sedia, by Raphael	87
The Madonna del Cardellino, by Raphael	88
The Madonna della Casa Alba, by Raphael	89
The Deliverance of St. Peter, by Domenichino	107
The Miraculous Draught of Fishes	113
"Feed my Lambs"	115
The Death of Ananias	117
Portrait of Francesco dell' Opere, by Perugino	123
Portrait of a Cardinal, by Raphael	125
The Violin-Player, by Sebastiano del Piombo	127
Dorothea (Portrait), by Sebastiano del Piombo	129

	PAGE
La Donna Velata, by Raphael	131
Madonna with two kneeling Saints, by Albertinelli	135
The Transfiguration, by Giovanni Bellini	138
Fragment from the Transfiguration, by Raphael	139
The Transfiguration, by L. Carracci	141
Vintage. From the Engraving by Marc Antonio	142
The Virgin appearing to St. Bernard, by Fra Bartolommeo	147
Madonna with Saints, by Fra Bartolommeo	149
The Risen Christ with the Four Evangelists, by Fra Bartolommeo	152
Pietà, by Fra Bartolommeo	153
The Holy Trinity, by Albertinelli.	154
The Annunciation, by Albertinelli	155
The Birth of the Virgin, by Andrea del Sarto	159
The Preaching of John the Baptist, by Andrea del Sarto	164
The Preaching of John the Baptist, by Ghirlandajo	165
Salome Dancing before Herod, by Andrea del Sarto	167
Justice, by A. Sansovino	169
The Annunciation, by Andrea del Sarto	170
The Madonna delle Arpie, by Andrea del Sarto	171
Disputa, by Andrea del Sarto	172
The Madonna with six Saints (1524), by Andrea del Sarto	174
The Madonna del Sacco, by Andrea del Sarto	175
St. John the Baptist, by Andrea del Sarto	177
Supposed Portrait of Himself, by Andrea del Sarto	179
Portrait of a Youth, by Franciabigio	183
The Tomb of Lorenzo de' Medici, with the figures of Morning and Evening, by Michelangelo	187

LIST OF ILLUSTRATIONS

	PAGE
The Medici Madonna, by Michelangelo	190
Crouching Boy, by Michelangelo	191
Christ, by Michelangelo	192
An Allegory, by Bronzino	193
Venus and Amor (*Il Giorno*), by Vasari	197
The Adoration of the Shepherds, by P. Tibaldi	198
Baptism of Christ, by Verrocchio	202
Baptism of Christ, by A. Sansovino	203
Pietà. (From Marc Antonio's engraving after Raphael)	205
The Visitation, by Sebastiano del Piombo	207
Madonna and Child with Angels, by Filippino Lippi	216
The youthful St. John Preaching, by Raphael	224
The Birth of John the Baptist, by Ghirlandajo	226
Tobias with the Angel, by Verrocchio (?) (or perhaps Botticini)	227
Attendant carrying Fruit, by Ghirlandajo	228
Woman carrying Water, by Raphael	229
Venus, by Lorenzo di Credi	230
Venus, by Franciabigio (?)	231
La bella Simonetta, by Piero di Cosimo	232
Vittoria Colonna (so-called), by Michelangelo	233
Allegory, by Filippino Lippi	240
Venus. (Copy from Marc Antonio's engraving)	246
Three Female Saints (fragment), by Sebastiano del Piombo	253
Prudence, by Pollaiuolo	256
Reclining Venus (fragment), by Piero di Cosimo	260
Reclining Venus, by Titian	261
Perseus (cast), by Benvenuto Cellini	264

		PAGE
Giovannino, in the Berlin Museum		265
St. Cosmo, by Montorsoli		266
St. John the Baptist, by J. Sansovino		267
Madonna with eight Saints, by Andrea del Sarto		268
Madonna with Angels and six Saints, by Botticelli		269
Madonna with the two SS. John, by Botticelli		274
The Death of Peter Martyr, by Gentile Bellini (?)		278
The Death of Peter Martyr, by Titian		279
St. Jerome, by Basaiti		280
St. Jerome, by Titian		281
Holy Family, by Bronzino		285

INTRODUCTION

CLASSIC ART[1]

The word "classic" has a somewhat chilly sound. It seems to thrust us out of the brilliant, living world into an airless space, the abode of shadows, not of human beings with warm red blood. Classic Art represents for us eternal death, eternal age, the fruit of the academies, a product of teaching rather than of life. And our thirst for the living, the actual, the tangible is so insatiable! The art the modern man demands is an art that savours of earth. The Quattrocento, and not the Cinquecento, is the darling age of our generation; we love its frank sense of reality, its *naïveté* of vision and emotion. We readily take a few archaisms of expressions into the bargain, so pleasant is it to admire and to smile at the same time. The traveller at Florence pores with unquenchable delight over the pictures of the old masters, who tell their story so artlessly and sincerely that he feels himself transported into the cheerful Florentine room where a woman receives her visitors after child-birth, or into the streets and squares of the mediæval city where the people stand about, and whence one or the other of the actors in the scene looks out of the picture at us with a vitality positively startling. Everyone knows Ghirlandajo's paintings in Santa Maria Novella. How gaily the artist sets forth the legends of the Virgin and of St. John, telling the story in a homely, but not a sordid fashion, showing life under its holiday aspect, with a healthy delight in colour and profusion, costly raiment and ornaments, rich architecture and plenishings. What could be daintier than Filippino's picture in the Badia,

[1] It will, of course, be understood that throughout this work, the author uses the term "Classic Art" in a special sense, applying it to the Art of the High Renaissance in Italy.—Tr.

of the *Madonna appearing to St. Bernard*, and laying her slender hand on his book? And what an aroma of Nature breathes from the lovely girl-angels who attend the Virgin, and press forward, timid yet inquisitive, behind her mantle, their hands mechanically folded in the attitude of prayer, as they look wonderingly at the strange man. Before Botticelli's charm even Raphael himself must yield, and he who has once fallen under the spell of his sensuous melancholy will be apt to find a *Madonna della Sedia* uninteresting.

The early Renaissance calls up a vision of slender-limbed, virginal figures in variegated robes, blooming meadows, floating veils, spacious halls with wide arches on graceful pillars. It means all the fresh vigour of youth, shining eyes, all that is bright, transparent, lively, cheerful, natural and varied. Pure nature, yet nature with a touch of fairy splendour.

We pass unwillingly and distrustfully from this gay and many-coloured world into the still and stately halls of classic art. What manner of men are these? Their gestures seem strange to us. We miss the child-like unconscious charm of a more intimate art. Here there is no one who looks at us like an old friend. Here are no cosy rooms with homely utensils scattered about, but colourless walls and massive architecture.

Indeed, the modern Northerner approaches works of art such as the *School of Athens* so wholly unprepared for their enjoyment, that his embarrassment at a first sight of them is not unnatural. We can hardly blame him, if he secretly asks himself why Raphael did not rather choose to paint a Roman flower-market, or some such animated scene as that of the peasants coming to be shaved on Sunday mornings in the Piazza Montanara. The artistic problems solved in those other works have no points of contact with modern dilettantism, and we, with our archaic predilections, are fundamentally incapable of appreciating these masterpieces of form. We delight in primitive simplicity. We enjoy the hard, childishly clumsy construction, the jerky, breathless style of the precursors, and neither understand nor value the artistically rounded, sonorous periods of their successors.

But even when the thesis is more familiar, as when the Cinquecentists treat the old simple themes of the Gospel cycle, the indifference of the public is still comprehensible. It feels itself on insecure ground, and cannot tell whether it should accept the gestures and ideas of classic art as genuine. It has had to swallow so much false classicism, that it turns with

zest to coarser but purer fare. We have lost faith in the grandiose. We have become weak and distrustful, and everywhere we detect theatrical sentiment and empty declamation.

And the factor that counts for most in our distrust is the perpetual suggestion that this art is not original, that it derives from the antique, that the marble world of the buried past laid a deathly hand on the blooming life of the Renaissance.

Yet classic art is but the natural sequence of the Quattrocento, a perfectly spontaneous manifestation of the Italian genius. It was not the outcome of imitation of a foreign exemplar—the antique—it was no product of schools, but a hardy growth, springing up at a period of most vigorous life.

This correlation has been obscured for us, because—and herein perhaps lies the real ground of the prejudice against Italian classicism—a purely national movement has been taken for universal, and forms which have life and meaning only under certain skies and on certain soil have been reproduced under wholly different conditions. The art of the High Renaissance in Italy is Italian art, and its idealisation of reality was after all, but an idealisation of Italian realities.

Vasari himself so divided his work as to open a new section with the sixteenth century, that period in relation to which the earlier stages were to appear but as preliminary and preparatory. He begins the third division of his art-history with Leonardo. Leonardo's *Last Supper* was painted in the last decade of the fifteenth century. It was the first great work of the new art. Michelangelo made his *début* at the same time. Nearly twenty-five years younger than the Milanese, he too had new things to say in his very first works. Fra Bartolommeo was his contemporary. Raphael followed at an interval of about ten years, and Andrea del Sarto came close upon him. Broadly speaking, the first twenty-five years of the sixteenth century are taken as representative of the classic evolution in Romano-Florentine art.

It is not altogether easy to take a general survey of this epoch. Familiar as its masterpieces have been made to us from our youth up by means of engravings and reproductions of all kinds, it is only by slow degrees that we can form a coherent and lively idea of the world that bore these fruits. It is otherwise with the Quattrocento. The fifteenth century still lives before our eyes in Florence. Much has disappeared,

much has been removed from its natural setting to the prisons of the museums, but still, there are many places left in which one seems to breathe the very air of the period. The Cinquecento is represented in more fragmentary fashion; in fact, it never achieved complete expression. In Florence one feels that the vast substructure of the Cinquecento lacks its crown. The final development is not clearly apparent. I am not alluding to the early removal of easel pictures, in consequence of which there is very little of Leonardo's left in Italy, but to the dissipation of forces that took place in the very beginning. Leonardo's *Last Supper*, which belongs incontrovertibly to Florence, was painted for Milan. Michelangelo became half-Roman, Raphael wholly so. But among their Roman achievements are the Sistine ceiling, an absurdity, a penance to the artist and the spectator, and those paintings Raphael was obliged to execute on walls in the Vatican, where no one can see them properly. Of the rest, how much was actually finished, how much of the short period of perfection went further than the initial project, and how much escaped immediate destruction? Leonardo's *Last Supper* itself is a wreck. His great battle-piece, destined for Florence, was never completed, and even the cartoon is lost. Michelangelo's *Bathing Soldiers* shared the same fate. Of the tomb of Julius II., only two figures were executed, and the façade of San Lorenzo, which was to have been a mirror reflecting the soul of Tuscan architecture and sculpture, was never carried out. The Medici Chapel is only a partial compensation; already it verges on the *baroque*. Classic art has left us no monument in the great style, in which architecture and sculpture are welded together for perfect expression; and the great achievement of architecture, in which all the artistic forces of the age combined, St. Peter's at Rome, was destined after all to be no true monument of the High Renaissance.

Classic art then may be likened to the ruins of an unfinished building, the original form of which must be reconstructed from fragments widely scattered and from imperfect tradition, and there is perhaps much justice in the assertion that in all the history of Italian art there is no more obscure epoch than that of its golden age.

PART I

I

PRELIMINARY SURVEY

ITALIAN Painting begins with GIOTTO. It was he who loosened the tongue of art. What he painted has a voice, and what he relates becomes an experience. He explored the wide circle of human emotion, he discoursed of sacred history and the legends of the saints, and everywhere of actual, living things. The heart of the incident is always plucked out, the scene, with its effect upon the beholders, is always brought before us, just as it must have taken place. Giotto, like the preachers and poets of the school of St. Francis of Assisi, undertook to expound the sacred story, and to elucidate it by intimate details; but the essence of his achievement is to be found, not in poetic invention, but in pictorial presentment, in the rendering of things that no one had hitherto been able to give in painting. He had an eye for the speaking elements of a scene, and perhaps painting never made such a sudden advance in expressive power as in his time. Giotto must not be looked upon as a kind of Christian Romantic, who bore about in his pocket the outpourings of a Franciscan brother, and whose art had blossomed under the inspiration of that infinite love by which the Saint of Assisi drew heaven down to earth, and made the world an Eden. He was no enthusiast, but a man of realities; no poet, but an observer; an artist who is never carried away by the ardour of his eloquence, but whose speech is always limpid and expressive.

Others surpassed him in fervour of emotion and in force of passion. Giovanni Pisano, the sculptor, shows more soul in his more inflexible material than the painter Giotto. The story of the Annunciation could not have been more tenderly told in the spirit of that age than by Giovanni in his relief on the pulpit at Pistoja, and in his more passionate scenes

there is something of Dante's fiery spirit. But this very quality was his undoing. He forced expression too far. The desire to express emotion destroyed the sense of form, and the master's art ran riot.

Giotto is calmer, cooler, more equable. His popularity will never wane, for all can understand him. The rough traits of national life appealed to him more strongly than its refinements, and he sought his effects in clarity rather than in beauty of line. His works are curiously lacking in that harmonious sweep of draperies, those rhythmic movements and attitudes which constituted style in his generation. Compared with those of Giovanni Pisano, they are clumsy, and with those of Andrea Pisano, the master of the brazen gates of the Baptistery at Florence, absolutely ugly. The grouping of the two women who embrace and the servant attending them in Andrea's *Visitation*, is a sculptured melody. Giotto's rendering is hard, but extraordinarily expressive. One does not easily forget the line of his Elizabeth bending down to look into the Virgin's face (Chapel of the Arena, Padua); whereas of Andrea's group one retains but a vague impression of harmonious curves.

Giotto's art reached its highest expression in the frescoes of Santa Croce. In clarity of representation he here went beyond all his earlier works, and in composition he essayed effects which entitle him, in intention at least, to rank beside the masters of the sixteenth century. His own immediate successors could not understand this aspect of his art. Simplicity and concentration were again abandoned; painters desired above all things to be rich and varied; in the effort to be profound, they produced pictures that were confused and ambiguous. Then, at the beginning of the fifteenth century, a painter appeared who set things right by his vigorous initiative, and determined the pictorial aspects of the visible world. This master was MASACCIO.

The student at Florence should not fail to see Masaccio immediately after Giotto, in order to note the difference in all its intensity. The contrast is amazing.

Vasari makes a remark about Masaccio, which has a somewhat trivial and obvious sound. "He recognised that painting is but the imitation of things as they are."[1] One might ask why the same should not have been said of Giotto. The sentence has probably a meaning deeper than the superficial one. What now seems to us a commonplace—that painting

[1] Vasari, *Le Vite* (ed. Milanesi), II. 288.

should give an impression of reality—was not always an axiom. There was a time when this requirement was quite unknown, and for the sufficient reason, that it was believed to be essentially impossible to suggest the tactile quality of material objects on a flat surface. This was the received opinion of the whole mediæval period. Men were content with a representation that merely suggested objects and their relation to one another in space, without any idea of inviting a comparison with Nature. It is a mistake to suppose that a mediæval picture was ever approached with our preconceptions of illusory effect. It was undoubtedly one of the greatest advances achieved by humanity, when this limitation was recognised as prejudicial, and when men began to believe that it might be possible to achieve something which should come near to the actual impression made by Nature, though the effects might be produced by very different means. No one man could have brought about such a re-adjustment of ideas. A single generation indeed could not suffice. Giotto did something towards it; but Masaccio added so much, that he was very justly described as the first artist who attained to " the imitation of things as they are."

First of all, he amazes us by his thorough mastery of the problems of space. In his hands for the first time a picture became a stage, in the construction of which a certain fixed point of sight was kept steadily in view, a space in which persons, trees and houses had their duly and geometrically determined places. In Giotto's works everything was still massed together; he superimposed head above head, without asking himself how their respective bodies were to find places, and the architecture of the background has the appearance of unsubstantial stage scenery, bearing no sort of actual proportion to the figures. Masaccio not only portrays possible, habitable houses, but gives a sense of space that extends to the last line of his landscapes. His point of sight is taken on a level with the heads, and the crowns of the heads of figures on the equal surfaces are therefore all of a height. This gives an extraordinary appearance of solidity to a row of three heads in profile, one behind the other, terminating perhaps with a fourth head, seen full-face. Step by step we are led into the depths of the given space; everything is ranged in clearly defined strata, one behind the other. The student who wishes to see the new art in all its glory should go to Santa Maria Novella, and study the fresco of the Trinity. Here, by the aid of archi-

tecture, and the use of intersections, four zones are developed towards the background, and the illusion of space is astonishing. Beside this, Giotto's work looks absolutely flat. His frescoes in Santa Croce have the effect of a carpet; the uniform blue of the sky suffices in itself to bind the various pictures together in a common effect of flatness. It would seem as if the artist had had no idea of laying hold of some element of reality; the flat surface of the division is at best uniformly filled up to the top, as if the painter had been required to decorate it in some ornamental fashion. All round the design are bands with mosaic patterns, and when these patterns are again repeated in the picture itself, the imagination is not constrained to make any distinction between the frame and the thing enframed, and the suggestion of a flat wall-decoration becomes unpleasantly obtrusive. Masaccio enframes his scenes between painted pilasters, and seeks to produce the illusion of a continuation of the picture behind these.

Giotto barely indicates the shadows cast by solid bodies, and for the most part altogether ignores the shadow cast by a body in light upon a light ground. It was not that he had never noticed them, but that it seemed to him unnecessary to insist upon them. He looked upon them as disturbing accidents in a picture, by which the subject was in no wise elucidated. In Masaccio's hands, light and shade become elements of first-rate importance. It seemed to him essential to render the actual condition of things, and to show the full force of natural effects on material objects. His manner of treating a head with a few vigorous indications of form gives a totally new impression. Bulk is expressed here with unprecedented power. And it is the same with all other forms. As a natural consequence of this treatment, the high tones of the earlier pictures with their shadowy effects give place to a more substantial system of colour.

The whole structure of pictures was consolidated, so to speak, and here we may appropriately quote another remark of Vasari's, to the effect that it was Masaccio who first made figures stand on their feet.

Besides this there is something else, the intensified feeling for the personal, for the peculiarities of the individual. Even Giotto differentiates his figures, but his are only general distinctions. Masaccio gives us clearly marked individual characteristics. The new age is termed the century of 'Realism.' The word has now passed through so many hands that it no longer has any clear meaning. Something proletarian clings to it, a

semblance of bitter opposition, where coarse ugliness wishes to force itself in, and claims its rights, since it too exists in the world. The quattrocentist realism is, however, essentially joyous. It is the higher estimate, which brings new elements. Interest is no longer confined to the individual head, but the vast variety of individual attitudes and movements is included in the realm of worthy motives for representation, attention is given to the will and mood of each particular material, and the artist rejoices in the stubborn line. The old laws of beauty seemed to do violence to nature; the swaying attitude, the varied modulations of the drapery, were felt to be merely beautiful phrases, of which men had become weary. A mighty need arose for reality, and if one thing shows sincere belief in the value of the newly comprehended sense of vision more strongly than another, it is the circumstance that even supernatural beings for the first time appear credible in earthly dress, with individual features, and without a trace of idealism in their representation.

It was not a painter, but a sculptor, in whom the new spirit was next destined to manifest itself most synthetically. Masaccio died young, and could therefore but briefly express himself, but DONATELLO is a conspicuous figure throughout the entire first half of the fifteenth century; his works form a long series, and he is indisputably the most important personality of the Quattrocento. He took up the peculiar tasks of the time with unrivalled energy, and yet he was never carried away by the one-sidedness of an unbridled realism. He was a portrayer of men who pursued the characteristic form to the very depths of ugliness, and then again in all calm and purity, reproduced the image of a tranquil and bewitching beauty. There are statues of his in which he drains an abnormal individuality to the very dregs, as it were, and side by side with these are figures like the bronze *David*, where the High Renaissance feeling for beauty already rings out clear and true. He is withal a storyteller of unsurpassable vividness and dramatic force. A panel like the *St. John* relief at Siena may be fitly designated the best narrative of the century. At a later date, in the *Miracles of St. Anthony* at Padua, he attacks veritable cinquecentist problems, introducing excited and dramatic crowds, which, compared with the quiet rows of bystanders in contemporary pictures, represent a really memorable anachronism.

The counterpart of Donatello in the second half of the Quattrocento is VERROCCHIO (1435-1488), who is in no way comparable to him in personal

David, by Donatello.

greatness, but is the manifest representative of the new ideals of a new generation.

From the middle of the century a growing desire for delicacy, grace of limb, and elegance is discernible. The figures lose their ruggedness; they are of a more slender type, small of wrist and ankle. The plain blunt stroke is resolved into a smaller, finer movement. The artist begins to take pleasure in exact modelling. The most delicate undulations of surface are noticed. Tension and movement are aimed at rather than repose and reticence; the fingers are spread out with a conscious elegance, there is much turning and bending of the head, much smiling and emotional uplifting of the eyes. Affectation, by the side of which natural feeling has not always been able to hold its own, gains ground. The contrast is already evident when Verrocchio's bronze *David* is compared with the similar figure by Donatello. The sturdy youth has become a lithe-limbed boy, still very spare, so that many outlines are visible, with a pointed elbow, which is deliberately included in the chief silhouette by the placing of the hand on the hip.[1] Tension is expressed in every limb. The outstretched leg, the compressed knee, the straining arm with the sword are all in strong contrast to the repose which marks Donatello's figure. The whole conception is based on an impression of movement. The head even is now required to express movement, and a smile steals over the features of the youthful conqueror. The master's desire for grace

[1] The illustration unfortunately does not give quite the true front view. In the original there is also a difference of size; Verrocchio's *David* is about one-third smaller than Donatello's.

finds satisfaction in the details of the armour, which delicately follows and interrupts the fine lines of the body, and when we note the thorough modelling of the nude, Donatello's summary process seems empty indeed compared with Verrocchio's wealth of form.

The same spectacle is offered by a comparison of the two equestrian figures, those of Gattemelata at Padua and of Colleoni in Venice. Verrocchio expresses the utmost tension in the seat of the rider and the movement of the horse. His Colleoni is riding with rigid legs, and the horse presses forward in a way that conveys the impression that it is being pulled. The manner in which the commander's bâton is grasped, and the turn of the head show the same intention. Donatello by contrast appears infinitely simple and unpretentious. And again, he presents his large unbroken planes, where Verrocchio breaks them up, and goes into minute details. The trappings of Verrocchio's horse are meant to reduce the planes. The armour in itself, as well as the treatment of the mane, is a very instructive piece of late quattrocentist decorative art. The elaboration of the muscular parts was carried so far by the artist, that soon afterwards the criticism was passed that Verrocchio had made a horse from which the hide had been stripped.[1]

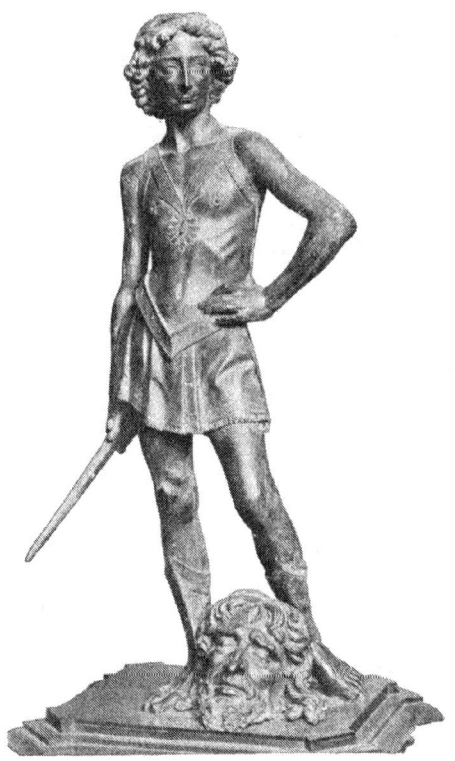

David, by Verrocchio.

[1] Pomponius Gauricus, *De Sculptura*.

14 THE ART OF THE ITALIAN RENAISSANCE

The danger of losing himself in petty details was clearly imminent.

Verrocchio's chief title to fame is his work in bronze. It was in his day that the real merits of the material were developed. Men set about to break up the mass, to separate the figures and to silhouette them with delicacy. Even from the pictorial side bronze possessed beauties which were recognised and fully turned to account. The luxuriant wealth of folds in drapery, as in the group of Christ and St. Thomas at Or San Michele

Madonna. Relief by Rossellino.

depends not only on the impression to be made by line, but also on the effect of glittering lights, dark shadows, and scintillating reflections.

Workers in marble soon turned the reaction in taste to account. The eye had learnt to appreciate the slightest *nuances*, and stone was worked with unprecedented delicacy. Desiderio carves his dainty festoons of fruit, and shows us the joy of life in his busts of Florentine maidens. Antonio Rossellino, and the somewhat broader Benedetto da Majano, rival painters in wealth of expression. The chisel renders the soft flesh of children as accurately as the fine veil of a head-dress. And if we look care-

fully, the wind seems here and there to have lifted the end of a drapery, causing a playful crumpling of the folds. In the perspectives of architecture or landscape the depth of the relief is greatly increased. It may be said that all treatment of flat surfaces shows a desire to leave an impression of life-like quivering and trembling.

The typical ancient motives of plastic art are wherever possible changed in style, so as to express movement. The kneeling angel with the candlestick, as Luca della Robbia simply and beautifully depicted him, is no longer sufficient; he too is summoned to join in the tumult of movement, and thus a figure such as Benedetto's Angel bearing Candelabrum in Siena is conceived. With smiling countenance and playful turn of the head the little satellite makes his obeisance, his dress fluttering in many folds round his shapely ankles. The higher development of such running figures is seen in the flying angels. who seem to cleave the air with a stupendous commotion of lines in their clinging drapery, whereas being simply reliefs against a wall, they only simulate the impression of detached figures. (Antonio Rossellino, tomb of the Cardinal of Portugal in San Miniato.)

Angel bearing Candelabrum, by Luca della Robbia.

The painters in the second half of the century advance on parallel lines with this group of sculptors of the delicate style. They are naturally far better exponents of the spirit of the age. It is they who colour our conception of quattrocentist Florence, and when the early Renaissance is mentioned, we think at once of Botticelli and Filippino and the sumptuous pictures of Ghirlandajo.

FRA FILIPPO LIPPI was the immediate successor of Masaccio; he modelled his style on the frescoes of the Brancacci Chapel: about the middle of the century he executed some very creditable work in the choir-

paintings of the Cathedral of Prato. He is not wanting in dignity and as a Painter in the special sense he stands quite by himself. His easel-pictures treat subjects like the twilit forest depths, which do not appear again in art till the time of Correggio, and in his frescoes he surpasses all the Florentines of his century in charm of colour. Every one indeed who has seen the apse of the Cathedral of Spoleto, where he aimed at producing a tremendous marvel of colour in his *Coronation of the Virgin*, will acknowledge that it has no parallel. For all this, his pictures are faultily constructed. They lack space and clarity, and have an incoherence that makes us regret that he was so little able to profit by the achievements of Masaccio: the next generation had much to clarify, and it carried out the task. If after a visit to Prato one goes on to Ghirlandajo and studies the frescoes of S. Maria Novella in Florence, it is amazing to find how limpidly and calmly he works, how the space clears itself, as it were, how assured the effect is, how transparent and comprehensible the whole. Similar merits will be noticeable on a like comparison of the works of Filippino or Botticelli, in whose veins, nevertheless, the blood ran far less calmly than in Ghirlandajo's.

BOTTICELLI (1446–1510) was a pupil of Fra Filippo, but only his very early works show any trace of this. They were men of quite distinct temperaments, the Frate with his broad laugh and his uniformly good-tempered pleasure in the things of this world, and Botticelli, impetuous, fiery, full of suppressed emotion, an artist to whom the superficial elements of painting appealed but little, who found expression in vigorous lines, and gave to his heads at all times a wealth of character and expression. Recall his Madonna with the thin oval face, the silent mouth,

Angel bearing Candelabrum, by Benedetto da Majano.

Allegory of Spring, by Botticelli.

the sad and heavy eyes; how different is his outlook from Filippo's contented twinkle. His saints are not healthy beings with whom all goes well; he gives his Jerome the consuming fire of the spirit, and he thrills us with the expression of rapture and asceticism in his youthful St. John. He is earnest in his treatment of the sacred legends, and his earnestness grows with age, till he abandons all charm of outward appearance. His beauty has a careworn air, and even when he smiles it seems but a passing gleam. How little mirth there is in the dance of the Graces in his *Allegory of Spring*, how strange are the forms! The crude spareness of immaturity has become the ideal of the time. In representing motion the artist seeks the strained and angular, not rich curves, and every form is delicate and pointed, not full and rounded. The master's daintiness is all confined to the flowers and grasses on the ground, the gauzy raiment and jewelled ornaments, and here the style becomes almost fantastic. But contemplative lingering over details was far from characteristic of Botticelli. Even in the nude he soon wearied of minute elaboration, and tried to achieve a simpler method of representation by broader lines. Vasari, notwithstanding his training in the school of Michelangelo, admits that he was an eminent draughtsman. His line is always significant and impressive. It has a certain violence. He is incomparably effective in the representation of rapid motion, he even gives a certain fluidity to solid masses, and when he groups his picture homogeneously round a centre, some new result of great consequence is produced. His compositions for the *Adoration of the Magi* are examples in point.

FILIPPINO LIPPI (circa 1459–1504) must be mentioned in the same breath with Botticelli. An identity of atmosphere unites two distinct individualities until they become similar. Filippino inherited from his father a fund of talent as a colourist, which Botticelli did not possess. The outer surface of things attracted him. He treated flesh-tints more delicately than anyone. He gives softness and lustre to the hair; what was a question of lines to Botticelli, was a problem of painting to him. He shows great discrimination in his colours, especially in the blue and violet tones. His line is softer and more undulating; it may be said that he has a certain effeminacy of sentiment. Early pictures by Filippino exist which are charming in their grace of feeling and execution. Sometimes he seems almost too soft. The St. John in the picture of the Virgin with Saints of 1486 (in the Uffizi) is not the rugged desert-preacher,

but a sentimental enthusiast. The Dominican in the same picture no longer holds a book firmly in his hand, but merely balances it upon the ball of the thumb with a piece of cloth between, while the lithe delicate fingers move like sensitive feelers. The subsequent development does not correspond to these beginnings. The inner thrill becomes an irregular outward movement, the pictures are hurried and confused, and the painter who was able to complete Masaccio's chapel with dignity and restraint, can hardly be recognised in the later frescoes in S. Maria Novella. He has an infinite wealth of decorative ornament, and the fantastry and exaggeration, of which Botticelli merely shows a trace, are in him strongly marked features. He threw himself eagerly into the representation of movement and often achieves magnificent results by a superabundance of motion. The *Assumption* in S. Maria sopra Minerva with angels revelling like Bacchantes, is a painted Jubilate—then again he sinks into mere uproar and becomes even crude and commonplace. When he paints the martyrdom of Philip, he chooses the moment when the cross, drawn up on ropes, dangles in the air, to say nothing of the grotesque costumes in the picture. The impression is conveyed that a consummate ability has been ruined from want of mental discipline, and we understand why men of far coarser fibre, like Ghirlandajo, outstripped him. In S. Maria Novella, where the two are seen together on adjacent walls, we soon tire of Filippino's convulsive episodes, while Ghirlandajo, solid and sincere, fills the spectator with real pleasure.

GHIRLANDAJO (1449–1490) never suffered from excess of sensibility : he was of phlegmatic temperament, but his frank cheerful spirit, and his delight in the pageants of life enlist men's sympathies. His work is very entertaining, and he is the painter who tells us most of social life in Florence. He pays little attention to the subject of the legends. He had to tell the story of the Virgin and of the Baptist in the choir of S. Maria Novella ; he has indeed told it, but anyone who did not know it would hardly understand it. What a picture Giotto made of the Presentation of Mary in the Temple ! How cunningly he brings the whole scene before us ; the little Mary, who of her own free will mounts the steps of the Temple, the priest bending towards her, the parents who follow the child with eye and hand ! Ghirlandajo's Mary is a smartly-dressed school-girl, casting coquettish side-glances in spite of her rapid advance ; the priest is hardly visible, for he is concealed by a pillar, and the parents look on at the scene

with indifference. In the Marriage, Mary makes undignified haste to exchange rings, and the Visitation is a pretty but quite secular presentment of a greeting between two women in the street. In the Message of the Angel to Zacharias, Ghirlandajo cares nothing that the real action is completely obscured by the numerous portrait-figures in the foreground, who stand unsympathetically around. He is a painter, not a narrator. The object itself gives him pleasure. His heads are admirably life-like, but when Vasari praises his delineation of emotion, no eulogy could be less appropriate. Ghirlandajo excels in repose rather than in movement. Scenes such as the Massacre of the Innocents are better rendered by Botticelli than by him. In general he restricts himself to a simple, quiet presentment, and pays his tribute to the prevailing taste for movement by inserting a hurrying maid or some similar figure. His observation is never minute. While many in Florence were making the most searching enquiry into the problems of modelling and anatomy, of the technique of colour and aërial perspective, he was content with results already achieved. He was no experimentalist, no pioneer of pictorial science, but an artist who possessed the average culture of the day, and thus equipped, aimed at new and monumental effects. He raised his art from the small style to one dealing with the effects of large masses. He was rich and yet distinct, gay and sometimes even great. The group of the five women in *The Birth of the Virgin* has no equal in the fifteenth century. And the essays which he made in motives of composition, centralisation of episodes and treatment of corner-figures are such that the great masters of the Cinquecento could make them their starting point.

We must take care, however, not to overestimate the value of his work. Ghirlandajo's paintings in S. Maria Novella were completed about 1490; in the years immediately succeeding Leonardo's *Last Supper* was painted, and if this were available for comparison in Florence, the 'monumental' Ghirlandajo would at once appear poor and limited. The *Last Supper* is a picture infinitely grander in form, and form and subject are completely in harmony here.

The assertion often erroneously made of Ghirlandajo, that he summed up in his art the results of the Florentine Quattrocento, is in the highest degree true of LEONARDO (born 1452). He is subtle in his observation of detail, and sublime in his conception of the whole; he is a distinguished draughtsman, and no less consummate a painter; there is no artist who

has not found his own special problems treated by him, and further developed, and he excels all others in the depth and intensity of his personality.

As Leonardo is usually discussed among the Cinquecentists, we are prone to forget that he was only a little younger than Ghirlandajo, and actually older than Filippino. He worked in Verrocchio's studio, and his fellow-pupils there were Perugino and Lorenzo di Credi. The latter was a star, which did not shine itself, but received its light from another planet ; his pictures seem like careful exercises on a set theme; Perugino, on the contrary, had originality, and is of great significance in the continuity of Florentine art, as we shall see later. These pupils have made Verrocchio's teaching famous. His *atelier* was clearly the most versatile in Florence. The combination of painting and sculpture was the more desirable since it was precisely the sculptors who were disposed to make a methodical attack upon nature, and there was thus less danger of falling into the *cul-de-sac* of an arbitrary individual style. An intimate affinity seems to have existed between Leonardo and Verrocchio. We learn from Vasari how closely allied their interests were, and how many threads Leonardo took up which Verrocchio had begun to weave. Nevertheless it is a surprise to see the pupil's youthful pictures. The Angel in Verrocchio's *Baptism* (Florence Academy) moves us indeed, like a voice from another world, yet how entirely unique a picture like the *Madonna of the Rocks* seems in the series of Florentine Madonnas of the Quattrocento !

Everything in it is significant and new ; the motive in itself as well as the treatment of form ; the freedom of movement in the details, and the strict observance of rules in the grouping of the whole, the infinitely subtle animation of forms, and the new pictorial value given to light and shadow, the intention evidently being to give the figures a powerful plastic effect by means of the dark background, and at the same time to entice the imagination into the depths by a novel method.[1]

[1] The picture of the *Madonna of the Rocks* in the Louvre is so superior to the London example, that it seems inconceivable that there should have been any doubt as to its originality. The pointing finger of the angel is not beautiful, and the omission of the hand in the London picture is quite intelligible in view of the later idea of beauty. Leonardo, however, if he had supervised the replica, would certainly have known how to fill up the resulting gap : in spite of the more prominently advanced shoulder of the angel there is now a hole

The predominant impression of the work at a distance is the reality of the figures, and the painter's intention of gaining the effect by means of pyramidal grouping strictly according to rule. The picture has a tectonic structure quite different to the mere symmetrical arrangement of earlier pictures. Here there is at once more freedom and more observance of rule, and the parts have been essentially conceived in their connection with the whole. This is the Cinquecentist style. Leonardo early shows traces of it. There is in the Vatican a kneeling *St. Jerome with the Lion* by him. The figure is noteworthy and has been long admired, as a study of movement, but the question may well be asked whether anyone besides Leonardo would have so blended the lines of the lion with those of the saint. I know of no one.

Raphael's Madonna di Foligno.
From Marc Antonio's engraving.

None of the early pictures of Leonardo have exercised greater influence than the unfinished *Adoration of the Magi* (Uffizi). This work dates from about 1480, and shows traces of the old school in the multiplicity of objects. The Quattrocentist delight in complexity is still noticeable, but a new spirit is expressed by the prominence given to the principal motive. Both Botticelli and Ghirlandajo have painted the *Adoration of the Magi* in such a way that Mary sits in the centre of a circle, but she invariably loses by this arrangement. Leonardo was the first to make the main motive dominate. The position of the outer figures at the edge of the picture forming a sharply defined enclosing line is again a motive fruitful in results, and the contrast between the thronging crowd, and the Madonna

in the picture. The drawing and modelling have been strengthened and simplified in the Cinquecentist style, by which much delicacy has been destroyed, however spiritual the new expression of the angel may be felt to be.

in the spacious freedom of her attitude, is a specimen of that most effective style which can be attributed to Leonardo alone. Had we nothing but this group of Mother and Babe, we should have to reckon him as a creator, so unprecedently subtle is the posture and the co-ordination of the two figures. The others have represented Mary straddling more or less upon the throne, he gives her the more graceful feminine attitude, with knees drawn together. Later painters took all this from him, and the charming motive of the turn of the figure with the Boy bending away to the side was repeated exactly by Raphael in the *Madonna di Foligno*.

II

LEONARDO

1452—1519

No artist of the Renaissance took more delight in the world than Leonardo. All phenomena attracted him, corporeal life and human emotions, the forms of plants and animals and the crystal brook with the pebbles in its bed. The narrowness of the mere figure-painter was incomprehensible to him. "Do you not see how many various kinds of beasts there are, what different trees, herbs, and flowers, what variety of mountains and of plains, of springs, rivers and towns, what diversity of dresses, ornaments and arts?"[1]

He is a born aristocrat among painters, very susceptible to all that is delicate. He appreciated taper hands, transparent drapery, tender skins. He especially loved beautiful soft, waving hair. In Verrocchio's picture of the *Baptism* he painted a tuft or two of grass; one sees at a glance that they are his work. No one else has his feeling for the beauty of plants.

Strength and tenderness are equally sympathetic to him. If he paints a battle he surpasses everyone in the expression of unchained passion and mighty movement, and yet he can surprise the most delicate emotion, and fix the most fleeting expression. He seems when painting some typical head to have been seized with the unruliness of a sworn realist; then suddenly he casts off that mood, abandons himself to ideal visions of almost supernatural beauty, and dreams of that soft, sweet smile which seems the reflection of an inner radiance. He feels the pictorial charm of superficial things, and yet has the mind of a man of science and an anatomist. Qualities, which would seem incompatible, are combined in

[1] Leonardo, *Trattato della Pittura*.

him, *i.e.* the enquirer's unwearying zeal to observe and collect, and the most subtle artistic sensibility.

He is never satisfied to judge things, as a painter, by their outward appearance, but with the same passionate interest he eagerly explores the inner structure and the conditions of life in every creature. He was the first artist who systematically examined the proportions of the body in men and animals, and took account of the mechanical conditions in walking, lifting, climbing or carrying, and he was also the one who carried out the most comprehensive physiognomical observations, and consistently thought out the method of expressing the emotions.

The painter is to him the keen universal eye, which ranges over all visible things. Suddenly, the inexhaustible treasure-house of the universe was unlocked, and Leonardo seems to have felt himself bound by an intense love to every form of life. Vasari relates a characteristic trait; he was sometimes seen to buy birds in the market in order to set them at liberty. The fact appears to have made a great impression on the Florentines.

In so universal an art there are no higher and lower problems; the last subtleties of chiaroscuro are not more interesting than the most elementary task of giving corporeal shape to the three dimensions on the flat surface, and the artist, who made the human face the mirror of the soul with unrivalled skill, can still repeat that modelling is the chief consideration, the very soul of painting.

Leonardo had so many new conceptions of things that he was forced to discover new technical means of expression. He became an experimentalist, who could hardly ever satisfy himself. He is said to have considered the *Monna Lisa* unfinished when he delivered it to the owner. Its technique is a mystery. But where the work is quite transparent, as in the ordinary silver-point drawings, which all belong to his earlier period, the effect is none the less astonishing. It may be said that he was the first to treat line sympathetically. His manner of making his outline rise and fall in waves is absolutely unique. He compasses modelling merely by parallel straight strokes; it is as if he only needed to stroke the surface in order to bring out relief. No greater result was ever achieved by simpler means, and the parallel lines, akin to those of the older Italian engravings, give an inestimable homogeneity of effect to the sheets. We have only a few completed works by Leonardo. He was an indefatigable observer

Study of a Girl's Head, by Leonardo da Vinci.
(The eyebrows and lines on lids added by a later inferior hand.)

and an insatiable student, always setting himself new problems, but it seems as if he only wished to solve them for himself. He did not care to decide or definitely complete any subject, and the problems he set himself were so enormous, that he may well have considered any conclusions merely provisional.

1. THE LAST SUPPER

After Raphael's Sistine *Madonna*, Leonardo's *Last Supper* is the most popular picture in all Italian Art. It is so simple and expressive that it stamps itself on all memories: Christ in the middle of a long table, the Apostles symmetrically arranged on either side of Him. He has said "One among you shall betray me!" and this unexpected saying throws the whole assembly into confusion. He alone remains calm, and keeps His eyes fixed downwards, and His silence seems to repeat the utterance; "Yea, it is so, one there is among you, who will betray me." It would seem as if the story could not have been told in any other way, and yet *everything* is new in Leonardo's picture, and its very simplicity is the triumph of the highest art.

If we look back at the preliminary stages in the Quattrocento, we shall find it well represented by Ghirlandajo's *Last Supper* in Ognissanti, which bears the date 1480, and was therefore painted some fifteen years earlier. The picture, one of the most sterling works of the master, contains the old typical elements of the composition, the conventional scheme which came down to Leonardo; the table with the return at either end: Judas sitting in front by himself; the twelve others in a row behind; St. John, asleep by the side of the Lord, his arms on the table. Christ has raised His right hand, and is speaking. The announcement of the treachery must, however, have been already made, for the disciples are full of consternation; some are asserting their innocence, and Judas is challenged to speak by St. Peter. Leonardo has at once broken with tradition in two points. He takes Judas out of his isolation, placing him among the rest, and abandons the incident of St. John lying on his Lord's breast (sleeping, as was added by a later tradition); in the modern way of sitting this incident must have always produced an intolerable effect. He thus obtained a more perfect uniformity of scene, and the disciples could be symmetrically divided on each side of the Master. The necessity for a

The Last Supper, by Ghirlandajo.

tectonic arrangement governs him. But he at once goes further, and forms two triad groups on the right and on the left. Thus Christ becomes the dominating central figure, differing from any other. In Ghirlandajo's work there is an assemblage without a centre, a juxtaposition of more or less independent half-length figures, enframed between the two great horizontal lines of the table, and of the wall at the back, the cornice of which is close over their heads. Unfortunately a corbel of the vaulted roof is placed exactly in the middle of the wall. What does Ghirlandajo do? He moves his Christ quietly to one side, and does not feel any hesitation in doing so. Leonardo, who considered it most important to bring out the chief figure prominently, would never have tolerated such a corbel. On the contrary, he looks for new aids to his object in the formation of the background; it is not a mere accident that his Christ is seated exactly in the light of the door behind. Then he breaks away from the tyranny of the two horizontal lines. He naturally retains that of the table, but the silhouettes of the groups are free above. Novel effects are aimed at. The perspective of the room, the shape and decoration of the walls, are made to reinforce the effect of the figures. His chief preoccupation is to make the bodies appear plastic and imposing. Hence the depth

of the room, and the partitioning of the wall with tapestried panels. The intersections assist the plastic illusion, and the repetition of the vertical line emphasizes the divergence of direction. It will be noticed that there are nothing but small surfaces and lines, which in no way seriously distract the eye from the figures. A painter of the older generation such as Ghirlandajo, with his background of great arches, at once created a standard of proportion in his picture, measured by which the figures necessarily appear insignificant.[1] Leonardo, as we have said, only retained a single great line, the inevitable line of the table. And even out of this he made something new. I do not mean the omission of the rectangular corners, in which he had been anticipated; the new point is the courageous representation of the impossible in order to secure a greater effect; Leonardo's table is far too small! If the covers are counted, we find that the required number could not possibly be seated. Leonardo wished to avoid the dispersal of the disciples down the long table, and the impressiveness thus given to the figures has such force that no one notices the want of room. Thus it became possible to bring the figures into compact groups, and keep them in close contact with the central figure.

And what groups these are! What action they convey! The word of the Lord has struck like a thunderbolt. A storm of passionate feeling bursts forth. The demeanour of the Disciples is not undignified; they bear themselves like men from whom their most sacred possession is to be taken away. An immense fund of completely new expression is here added to Art, and when Leonardo works on the same lines as his predecessors, it is the unprecedented intensity of expression which makes his figures appear unrivalled. When such power is brought into play, it is obvious that many pleasing accessories of conventional art are necessarily omitted. Ghirlandajo still reckons on a public which will thoughtfully scrutinize every corner of a picture, and must be gratified by rare garden-flowers, birds, and other living creatures. He devotes much care to the service of the table, and counts out a certain number of cherries to each guest. Leonardo restricts himself to bare essentials. He is entitled to

[1] The outer lines of Leonardo's picture do not correspond with the section of the room; there is a considerable space above the upper edge of the picture. This intersection is one of the devices which makes it possible to compose with large figures in a confined space, without a cramped effect. Both the representation of the room and the effect aimed at by this motive were alien to Quattrocento tradition.

expect that the dramatic interest of his picture will prevent the spectator from regretting the absence of such minor attractions. This tendency to simplify was carried much farther at a later date.

It is not our present purpose to describe in detail the figures according to the motives, yet we must notice the scheme observed in the distribution of the characters.

The figures at the edges are tranquil. Two profiles, absolutely vertical, enframe the whole. These reposeful lines are maintained in the second group. Then there is movement, rising to a mighty crescendo in the groups on the right and left of the Saviour. The figure on his left hand throws his arms out widely " as if he suddenly saw an abyss opening before him." On the right, quite close to the Saviour, Judas recoils with an abrupt gesture.[1] The greatest contrasts are juxtaposed. St. John sits in the same group with Judas.

The manner in which the groups are contrasted, the relation they bear to each other, and their skilful connection in the foreground on the one side, and in the background on the other, offer matter for constant reflection to every student, all the more that intention is so skilfully concealed by the apparent inevitability of the arrangement. These are, however, points of secondary importance compared with the one great effect, which is reserved for the main figure. In the midst of the tumult Christ sits motionless. His hands are stretched out listlessly with the gesture of one who has said all that he has to say. He is not speaking, as He is in every earlier picture; He does not even look up, but His silence is more eloquent than words. It is that terrible silence, which leaves no hope.

In the gesture of Jesus and in His form there is that tranquil grandeur, which we term aristocratic, in the sense akin to the term " noble." The epithet does not suggest itself before the work of any Quattrocentist. We should have thought that Leonardo had gone for his model to a different class of men, if we did not know that he himself created the type. He has here worked out the best of his own nature, and certainly this distinction is the common property of the Italian race of the sixteenth century. How the Germans from Holbein onwards have striven to achieve the charm of such a gesture!

[1] Goethe's mistake, which has since been repeated, must be corrected. He thought that St. Peter's movement was to be explained by his having struck Judas in the side with a knife.

The Last Supper, from an engraving by Marc Antonio.

It might, however, be said again and again that the point, which makes the Christ in this picture appear so absolutely different from the older presentations, is not completely explained by His form and mien, but that the essential difference is found rather in the part assigned Him in the composition. The unity of the scene is lacking in the earlier painters. The Disciples are talking together, and the Saviour is speaking, and it is open to question whether a distinction has always been made between the announcement of the treachery and the institution of the Lord's Supper.

In any case it was quite alien to the Quattrocentist conception to make the utterance of the speech the *motif* of the chief figure. Leonardo was the first to venture to do so, and by this boldness he gains the boundless advantage that he can now hold fast the dominant tone throughout an infinity of supplementary notes. That which has caused the outbreak of excitement still continues to ring in our ears. The scene is at once momentary, permanent, and exhaustive.

Raphael is the one master who has grasped Leonardo's meaning here.

There exists a *Last Supper* of his school, which Marc Antonio has engraved, where Christ is depicted in a psychologically similar attitude, motionless, gazing fixedly before Him. With widely opened eyes He looks into space. His is the only full face in the picture, an absolutely vertical line.[1] Andrea del Sarto appears very inferior by contrast. In a composition of much pictorial beauty he chose the moment when the traitor is made known, by the dipping of the sop, and thus depicts Christ as turning to St. John, whose hand he takes soothingly into his own. (Florence, S. Salvi). A beautiful idea, but this single trait destroys the domination of the principal figure and the unity of feeling. Andrea may have certainly said to himself that it was impossible to compete with Leonardo.

Others have attempted to effect a new result by the introduction of the trivial; in Baroccio's large *Institution of the Lord's Supper* (Urbino) some of the Disciples during the speech of the Saviour are ordering a servant in the foreground to bring up fresh wine, as if there were some question of drinking a health.

There is one last remark to be made on the relation of Leonardo's picture to the space in which it was painted. As is well known, it forms the decoration of the upper end of a long narrow refectory. The room is only lighted from one side, and Leonardo took the existing light into consideration, in determining the illumination of his picture, a proceeding by no means unique. It comes from high on the left, and partially illuminates the opposite wall in the picture. The differences of tone in the light and shade are so marked that Ghirlandajo seems monotonous and flat in comparison. The table cloth stands out clearly, and the heads irradiated with the light are thrown into strong relief against the dark wall. One further result followed from this acceptance of the actual source of light. Judas, who no longer sits apart as in earlier pictures, but is introduced among the rest of the Disciples, is nevertheless isolated. He is the only one who sits quite with his back to the light, and whose features are therefore in shadow. A simple but effective means of characterisation, which the young Rubens perhaps bore in mind, when he painted his *Last Supper*, now in the Brera.

[1] The pen and ink drawing in the Albertina (Fischel, *Raffael's Zeichnungen*, 387) which is now correctly ascribed to Giov. F. Penni, cannot be accepted as the drawing made for Marc Antonio's engraving; it is quite different in composition.

2. The Monna Lisa

The Quattrocentists had already attempted at various times to go beyond the mere drawing of a model in a portrait, they had attempted to present something more than the sum of separate features which make up likeness, to show more than the permanent fixed forms which stamp the character. Something of the spirit of the hour, some indication of the passing emotion of the soul, was to be reflected on the face. There are busts of young girls by Desiderio which produce this effect completely. They are smiling, and the smile is not stereotyped, but seems the reflection of the happy moment. Who does not know these young Florentines with laughing mouths, and eyebrows uplifted above eyes which even in the marble seem to flash?

There is a smile, too, on the face of Monna Lisa, but only a faint smile:[1] it rests in the corners of the mouth, and ripples almost imperceptibly over the features. Like a breath of wind which ruffles the water, a movement passes over the soft contours of this face. There is a play of lights and shadows, a whispered dialogue, to which we never weary of listening.

Bust of a Florentine Girl, by Desiderio.

The brown eyes look at us from the narrow oval of the lids. They are not the flashing Quattrocentist eyes; their glance is veiled. The lower lids run almost horizontally and recall the Gothic forms of eyes, in which this motive is used to produce the effect of fulness and liquidity. The whole surface under the eyes speaks of an intense sensitiveness, of delicate nerves beneath the skin. One striking trait is the absence of eyebrows. The curved planes of the eye-sockets pass without any sort of accentuation into the excessively high forehead. This is no individual peculiarity. It can be shown from a passage in *Il Cortigiano*[2] that it was fashionable for

[1] Politian, *Giostra* I. 50. "Lampeggiò d'un dolce e vago riso."

[2] Baldassare Castiglione, *Il Cortigiano* (1516). It is said there (in Bk. I.) that the men copy the women in plucking out the hairs of the eyebrows and forehead (*pelarsi le ciglia e la fronte*).

ladies to pluck out their eyebrows. It was also considered a beauty to show a wide expanse of forehead, and therefore the hair on the front of the head was sacrificed. This accounts for the immense foreheads in the statues of young girls by Mino and Desiderio. The delight in the modelling of the white surfaces, which the chisel reproduced so tenderly in marble, outweighed every other consideration. The natural divisions were eliminated and the upper parts exaggerated out of all measure. The style of the *Monna Lisa* in this respect is thoroughly Quattrocentist. The fashion changed immediately afterwards. The forehead was made lower, and a distinct advance is noticeable in the rigorously defined eye-brows. In the Madrid copy of the *Monna Lisa* the eyebrows have been deliberately added. Even in Leonardo's own drawings (for example in the beautiful full-face with the head inclined in the Uffizi) they have been inserted by a later hand (cf. the illustration on p. 27). The hair, chestnut brown like the eyes, falls along the cheeks in graceful waves, together with a loose veil which is thrown over the head.

The lady sits in an arm-chair, and it is astounding to note the stiff perpendicular carriage of her head in the midst of such softness of execution. She clearly holds herself according to the fashion of the day. An upright bearing implied distinction. We notice this peculiarity in the Tornabuoni ladies in Ghirlandajo's frescoes; when they pay visits they sit bolt upright. Popular opinion on this point changed, and the altered ideas reacted directly on the position of the figures in portraits.

For the rest, the picture is not deficient in animation. Here Leonardo passed for the first time from the bust with its scanty segment of the body, to the three-quarters length. He now makes the model sit in profile, giving a half-turn to the head and shoulders and bringing the face full to the front. The action of the arms is also expressive. The one rests on the arm of the chair, the other comes foreshortened from the background, and one hand is laid over the other. Leonardo does not add the hands as a mere superficial enrichment to the portrait. Their easy indolence of pose adds immensely to the individuality of the sitter. We can trace the delicacy of the sense of touch in these truly soulful fingers. Verrocchio anticipated Leonardo here, in introducing the hands even in his busts.

The costume is fastidiously simple, almost prim. The line of the bodice must have seemed hard to a riper Cinquecentist. The pleated gown is green, of that green which Luini retains; the sleeves, a yellow-brown;

Portrait of Monna Lisa, by Leonardo da Vinci.

not, as formerly, short and narrow, but reaching to the wrists, and crumpled into many transverse folds, they form an effective accompaniment to the rounded compact surfaces of the hands. The shapely fingers are not burdened by any rings. The neck too is without any ornament.

The background consists of a landscape, as in the works of older painters. But it is not, as formerly, immediately connected with the figure; there is a balustrade between, and the view is enframed by two pillars. It requires minute inspection to detect this motive, which is not unimportant in its consequences, for the pillars have the appearance of mere narrow stripes, save at the bases. The later style was not long content with such suggestive drawing.[1] The landscape itself, which stretches away towards the top of the picture above the level of the sitter's eyes, is of a strange kind; fantastically peaked mountain-labyrinths, with lakes and streams in the foreground. The strange result of the shadowy execution is, that the background has a dream-like effect. Its reality is of a different degree to that of the figure, and this is no caprice, but a means of achieving the impression of corporeality. Leonardo here applies certain theories as to the appearance of distant objects, which he has discussed in his treatise on painting (*Trattato della Pittura* No. 128. 201). The consequence is that in the Salon Carré of the Louvre, where the *Monna Lisa* hangs, everything else, even pictures of the seventeenth century, seem flat by comparison. The gradations of colour in the landscape are precisely the same as in Perugino's *Apollo and Marsyas*—brown, greenish-blue, and bluish-green into which the blue sky blends.

Leonardo called modelling the soul of painting. It is before the *Monna Lisa*, if anywhere, that the meaning of this dictum may be learnt. The soft undulations of the surface become a living fact, as if the observer himself were gliding over them with a spirit-hand. The aim in view is as yet not simplicity, but complexity. Anyone who has studied the picture repeatedly will agree that it calls for close inspection. At a distance it soon loses its real effect. (This is true also of photographs.) It is in this respect that it is principally to be distinguished from the later portraits of the Cinquecento, and in a certain sense it represents the conclusion of a tendency, which had its beginnings in the fifteenth century, the completion of that "subtle" style, to which the masters of plastic art above all devoted their

[1] *Cf.* the sketch for the *Maddalena Doni* by Raphael in the Louvre.

energies. The neo-Florentine school did not sympathise with this. It was only in Lombardy that its delicate threads were gathered up and continued.[1]

3. St. Anne with the Virgin and the Infant Christ

In comparison with the *Monna Lisa*, Leonardo's other picture in the Salon Carré, the *St. Anne with the Virgin and the Infant Christ* fails to attract the sympathies of the public. This picture, which was perhaps not entirely the work of Leonardo's own hand, has deteriorated in colour, and the essential merit of the drawing is little valued and hardly perceived by modern eyes. And yet in its time (1501) the mere cartoon caused great excitement in Florence, so that there was a general pilgrimage to the monastery of the Annunziata, where Leonardo's new miracle was to be seen.[2] The theme might have been barren enough. We remember the chilly combination of the three figures in the older masters, one in the lap of the other, and all facing the spectator. Out of this unattractive arrangement Leonardo developed a group of the richest beauty, and the lifeless framework was transformed into a motive of the liveliest animation.

Mary sits diagonally on the lap of her mother; she bends forward smilingly and with both hands seizes the boy at their feet, who is trying to bestride a lamb. The Child looks round enquiringly; He grasps the poor shrinking animal firmly by the head, and has already thrown one leg across its back. The (youthful) grandmother also looks on smilingly at the merry sport.

The problems of grouping attacked in the *Last Supper* are further developed here. The composition is most inspiriting; much is said in a limited space; all the figures show a contrast of movement and the conflicting directions are brought together into a compact form. It will be noticed that the whole group may be contained in an equilateral triangle.

[1] It has been frequently felt that the *Belle Ferronière* (Louvre) is not in harmony with Leonardo's work. This fine picture has lately, by way of experiment, been ascribed to Boltraffio. It may be remarked that the figures of the saints at the feet of the *Risen Lord* in Berlin may belong to this same Boltraffio; its affinity to the *Madonna with the Child*, a half length, in the National Gallery, is obvious. It extends even to the pattern of the flowered robe of St. Leonard.

[2] The cartoon no longer exists. The execution of the picture took place much later. Cf. *Gazette des Beaux-Arts* 1897 (Cook).

This is the first of efforts, which have been already noticed in the *Madonna of the Rocks*, to arrange the composition according to simple geometrical forms. But how loose is the effect of the older work as compared with the compact richness of the St. Anne group! It was no artistic caprice which led Leonardo to pack more and more action into a continually diminishing space; the strength of the impression increases in proportion. The only difficulty was to prevent any injury to the clarity and repose of the representation. This was the stone, on which the weaker imitators stumbled. Leonardo attained a perfect lucidity, and the chief motive, the inclination of Mary's body, is irresistibly human and beautiful. All the unmeaning prettiness by which the Quattrocento was so often beguiled, has here melted away before an unparalleled power of expression. It is well to realise in detail the conditions under which the lines of the shoulder and of the neck are developed—light against dark—in all their marvellous bloom and brilliance. How quiet and how forceful! The reticent figure of Anne forms an excellent contrast, and at the bottom the boy with his upturned face and his lamb, rounds off the group most happily.

St. Anne with the Virgin and Infant Christ, by Leonardo da Vinci.

There is a small picture of Raphael's in Madrid which reflects the impression made by this composition. As a young man at Florence he attempted to work out a similar problem—taking St. Joseph in place

of St. Anne—but with very poor success. How wooden is the lamb! Raphael never became an animal-painter, while Leonardo succeeded in all he attempted. (In the *Alba Madonna* he afterwards more successfully adopted the motive of Leonardo's Mary in the turn of the head.) But a stronger rival than Raphael entered the lists against Leonardo in the person of Michelangelo. Of this we shall speak later.

There are no traces here of the grasses, the flowers, and the shimmering pools of the *Madonna of the Rock*. The figures are everything. They are life-size. But more important to the impression than the absolute scale of size, is the relation of the figures to the space. They fill the canvas more effectually than formerly, or, to put it differently, the canvas is here smaller in proportion to the contents. This is the scale of dimensions which became typical of the Cinquecento.[1]

4. The Battle of Anghiari

Of the battle-scene, which was intended for the Council Chamber at Florence we can say but little, since the composition no longer exists even in the cartoon, but only in an incomplete copy by a later hand. It cannot, however, be passed over, for the whole question of its origin is full of interest. Leonardo had studied horses more perhaps than any other Cinquecentist. He was familiar with the animal from habitual intercourse.[2] He was occupied at Milan for years in designing an equestrian statue of Duke Francesco Sforza, a figure which was never cast, though a completed model of it once existed, the disappearance of which must be reckoned among the great losses of art. As regards the motive, he seems at first to have intended to surpass Verrocchio's Colleoni in movement: he achieved the type of the galloping horse, which has a prostrate foeman at its feet; the same idea which occurred to Antonio Pollaiuolo.[3]

[1] The impression made on contemporaries is clearly depicted in a report of Fra Piero di Novellara to the Marchesa of Mantua dated April 3, 1501, where he speaks thus of the cartoon in this connection: "These figures are life-size, but stand on a small canvas, because all are either seated or bending forward, and one rather in front of the other." (*Archivio storico dell' Arte*, I.) The London cartoon (Royal Academy) of a group of two women with two boys does not possess the same charm, and might well be a slightly earlier and less limpid composition. It plays its part again in Leonardo's school. (Luini, Ambrosiana.)

[2] Vasari, IV. 21. [3] Vasari, III. 297. Cf. drawing in Munich.

The misgiving, which has been expressed now and again, that Leonardo's figure might have become too pictorial, can, if it is at all justified, only refer to sketches of this kind: in any case his idea of the prancing horse cannot be looked upon as definitive: on the contrary in the course of the work a gradual advance towards repose and simplicity seems to have taken place similar to that which may be observed in the sketches for the *Last Supper*. Leonardo ended by representing the horse stepping forward, and thus modifying the marked opposition of direction in the turn of the head of horse and rider. We still find the arm with the *bâton* somewhat bent backwards, by which contrivance Leonardo wished to enrich the silhouette, and to fill up the empty right hand corner at the back of the rider.[1]

A sketch in the Louvre, ascribed to Rubens, is the only original document from which we may gather a true notion of that great battle-picture of the Florentine Council Chamber, in which Leonardo turned his Milanese studies to account. As is well known, Edelingk engraved an excellent plate from it.[2] It is hard to say how far the drawing may be considered trustworthy in detail, but it corresponds in essentials to the description Vasari gives of it.

Leonardo intended once for all to show the Florentines how to draw horses. He took a cavalry episode as the chief motive of his battle-piece: the Fight for the Standard. Four horses and four riders in the most violent excitement and the closest juxtaposition. The problem of plastic richness of grouping has here reached a height which almost verges on indistinctness. The northern engraver's interpretation of the picture from the pictorial side, is that a border of lights would have surrounded a dark central passage, an arrangement with which we may certainly credit Leonardo in the first instance.

The representation of crowded masses was then the real "modern" task. It is surprising that battle-pictures are not more often met with. The school of Raphael is the only one which produced a large work of the

[1] The results of the latest researches connected with the Milanese monument, and with a later mounted figure with a tomb beneath, for General Trivulzio, are recorded by Müller-Walde in the *Jahrbuch der Preussischen Kunstsammlungen*, 1897.

[2] I do not venture to give an opinion as to Rubens' authorship of the drawing in the Louvre. Rooses emphatically supports it. In any case Rubens was familiar with the composition. His *Lion Hunt* at Munich clearly proves this.

sort, and the *Battle of Constantine* represents the one classical battle-piece in the conception of the West. Art has advanced from the mere episode to the representation of real masses in action, but if the famous picture by this means shows far more than Leonardo did, it is on the other hand so fettered by indistinctness of conception that the coarsening of taste and the decay of art are already apparent. Raphael had certainly nothing to do with this composition.

Leonardo left no school behind in Florence. All indeed, learnt from him, but his influence was dimmed by that of Michelangelo. It is obvious that Leonardo developed the idea of large figures; the figure finally became all in all for him. Nevertheless Florence would have had a different physiognomy, had she been more Leonardesque. The traces of Leonardo that survive in Andrea del Sarto or in Franciabigio and Bugiardini signify on the whole very little. A direct continuation of his art is only found in Lombardy, and even here it is a partial one. The Lombards are artistically gifted, but they are entirely wanting in a sense of the architectonic. Not one of them ever understood the structure of the *Last Supper*. Leonardo's grouping and his crowded movement were unfamiliar problems to them. The more vivacious temperaments among the Milanese became confused and wild when they attempted movement; the others are wearisome in their uniformity. It is typical of the art of the Milanese that they could treat the *Beheading of John the Baptist* as still-life; placing the severed head neatly on an agate-dish. (Picture by Solario in the Louvre, 1507.) This would have been inconceivable in Florence. And equally so the crudeness with which in another case a naked arm without any figure belonging to it protrudes from behind the frame to present the severed head to Salome. This was done by Luini (Milan, Borromeo). In such districts the soil is not favourable to great art. What the Lombards assimilated was the feminine side of Leonardo's art, the passive emotions, and the delicately suggested modelling of youthful forms, especially female forms. Leonardo was highly susceptible to the beauty of the female form. He it was who first perceived the softness of the skin. It is therefore surprising that the nude is not more frequent in his pictures. The femininely delicate *St. John* in the Louvre (the authenticity of which indeed is not beyond suspicion), is not a favourite; most people will feel a desire for less ambiguous female forms. The *Leda* with the swan would have been the ideal picture. It is only known from drawings

and imitations, in the two versions, standing and crouching. (Cf. *Jahrbuch der Preussischen Kunstsammlungen.* 189) (Müller-Walde). In both the action is of consummate interest. The Lombard followers however studied only the treatment of the surfaces, and were quite content with the half-length figure as a design. Even the subject of *Susanna at the Bath*,

Abundantia, by Gianpietrino.

where if anywhere a richly modelled figure might reasonably be expected, is restricted to this barren design. (Picture by Luini in Milan, Borromeo.) The unpretentious half-length *Abundantia* by Gianpietrino may be given here as a type of such works.[1]

[1] The picture is in the Borromeo Gallery in Milan. It should be compared with Leonardo's *Monna Lisa.* Cf. also the rough life-study in the St. Petersburg Gallery, which shows a model in the attitude of the *Monna Lisa*, but with none of Leonardo's art. "It is inconceivable how Waagen could have taken this miserable *pasticcio* for a study of Leonardo's." F. Harck, *Repertorium* XIX. 421.

III

MICHELANGELO (to 1520)
1475—1564

MICHELANGELO overwhelmed Italian art like a mighty mountain-torrent, at once fertilising and destructive; irresistible in impression, carrying everything away with him, he became a liberator to few, a destroyer to many. From the first moment Michelangelo was a complete personality, almost terrible in his isolation. His conception of the world was that of a sculptor, and of a sculptor alone. What interested him was the definite form, and the human body alone seemed to him worthy of representation. The complexity of things did not exist for him. His humanity was not the humanity of this world differentiated in thousands of individuals, but a race in itself, a genus that approached the gigantic.

In contrast to Leonardo's joyousness, Michelangelo stands before us as the lonely figure, the scorner to whom the world as it is offers nothing. Once indeed he drew an Eve, a woman in all the superb beauty of luxuriant nature. For a moment he retained the image of indolent soft loveliness, but only for a moment; consciously or unconsciously, all that he created was steeped in bitterness.

His style aims at concentration, at massive concentrated effects. The widely comprehensive, undefined outline repelled him. The condensed method of arrangement, restraint in demeanour, were the outcome of temperament with him.

The vigour of his grasp of form and the clearness of his inward conception are absolutely incomparable. There is no groping, no uncertainty; with the first stroke he gives the definite expression. Sketches by him have a strangely penetrating power. They are impregnated with form; every trace of the inner structure, the mechanism of movement,

seems to have been transmuted into expression. Thus he forces the spectator to share directly in his feelings.

And it is marvellous how every turn, every bend of the limbs has a mysterious power. Very trifling changes of position work with inconceivable force, and the impression is often so great that we do not inquire into the motives of the action. It is a characteristic of Michelangelo that he strains his means remorselessly to secure the greatest possible results. He enriched Art with unsuspected new effects, but he also

Pietà, by Michelangelo.

impoverished her, by taking from her her pleasure in the simplicity of everyday life. It is through him that the unharmonious found its way into the Renaissance. By his conscious employment of dissonance on a large scale, he prepared the ground for a new style, the *baroque*. We shall not discuss this till later. The works of the first half of his life (to 1520) speak another language.

1. Early Works

The *Pietà* is the first great work from which we can judge Michelangelo's aims. It is at present most barbarously placed in a chapel of St. Peter's, where neither the delicacy of the details, nor the charm of the action can be felt. The group is lost in the vast space, and is raised so high that it is impossible to get the chief point of view.

To combine into a group two life-sized bodies in marble was something new in itself, and the task of placing the body of a full grown man on the lap of the seated woman, was one of the most difficult imaginable. We might expect a hard horizontal line of intersection, and harsh right angles; Michelangelo accomplished what no other artist then living could have done.

By a series of wonderful bends and turns, the lines of the bodies are brought into an easy harmony. Mary supports, and yet is not crushed by, the burden; the corpse stands out clearly on all sides and is also full of expression in every line. The contraction of the shoulders and the backward droop of the head give an accent of agony of incomparable force to the dead figure. The Virgin's attitude is still more surprising. The tearful countenance, the distortion of sorrow, the fainting form, had been portrayed by others. Michelangelo says: the Mother of God shall not weep like an earthly woman. She bends her head calmly; the features betray no emotion and only the drooping left hand is eloquent: half-opened, it accentuates the mute monologue of pain.

The Madonna of Bruges, by Michelangelo.

This is the sentiment of the Cinquecento. Even the Christ shows none of the disfigurement of suffering. On the formal side the traces of Florence and the style of the fifteenth century are more obvious. The head of Mary is, indeed, like no other, but it is of the delicate narrow type, preferred by the older Florentines. The bodies are in a similar style. Michelangelo soon afterwards becomes broader and fuller, and even

the actual grouping of these figures, would have afterwards seemed to him too slight, too transparent, too loose. The corpse, more heavily modelled, would have been a greater burden, the lines would not have diverged so widely, and the two figures would have been combined into a more compact mass.

A somewhat obtrusive richness prevails in the draperies. There are bright ridges of folds, and deep shadowy hollows, which the sculptors of the Cinquecento gladly took as models. The marble, as later also, is highly polished, producing intensely brilliant lights. There is, on the other hand, no longer any trace of gilding.

Closely connected with the *Pietà* is the seated figure of the *Madonna of Bruges*,[1] a work which went out of the country immediately after its completion, and therefore left no marked traces in Italy, although the completely new problem treated in it would have made the greatest impression.

Madonna and Child, by Benedetto da Majano.

The seated Madonna with the Child, the endlessly varied theme of the altar-picture, is rarely found among the Florentines as a plastic group. It is more frequent in clay than in marble, and the material, unattractive in itself, was usually elaborately painted. But with the sixteenth century the use of clay became less popular. Increased pretensions to monumentality could only be satisfied in stone, and when clay was still used, as in Lombardy, it was left uncoloured by preference.

[1] The figure shows in subordinate parts a second weaker hand. Michelangelo seems to have left it behind unfinished on his second journey to Rome in 1505.

Madonna with the Book. Relief by Michelangelo.

Michelangelo at once diverges from all the older representations by taking the Child out of the Mother's lap and placing Him, a figure of considerable size and strength, between her knees, clambering about. He was enabled by this motive of the Child, standing upright and moving, to give new interest to the group, and as a direct consequence, the variety of effect was also enhanced by the unequal level of the feet of the sitting figure.

The Boy is occupied with a child-like game, but He is serious, far more serious than He had been even when He was in act of blessing. Similarly, the Madonna is thoughtful, mute; none would venture to address her. A grave, almost solemn earnestness broods over them both. This manifestation of a new awe and reverence for sacred things must be compared with figures so fully expressive of Quattrocento sentiment as the terra cotta group by Benedetto da Majano in the Berlin Museum. We feel convinced that we have already seen this worthy dame somewhere, good naturedly managing her household, and the Child is a merry little urchin. He certainly lifts His hand to bless, but there is no need to take the matter seriously. The mirthfulness which lights up the faces and smiles from the speaking eyes is quite quenched in Michelangelo's figures. The head of his Virgin is as little suggestive of a middle-class woman as is her dress of worldly pomp and magnificence.

The spirit of a new art sounds strongly and audibly, with long drawn chords, in the *Madonna of Bruges*. Indeed it may be said that the

Holy Family, by Michelangelo.

vertical pose of the head alone is a motive which in its grandeur transcends any product of the Quattrocento.

In one very early work, the small relief with the *Madonna on the Steps*, Michelangelo had tried to realise a similar conception. He wished to represent the Madonna gazing into vacancy with the Child asleep against her breast. His absolutely unconventional purpose is apparent in the still timid sketch. Now, in full possession of the required expression he once more reverts to the motive in a relief, the unfinished *tondo* in the Bargello; the Child, tired and serious, resting on the Mother, and Mary, like a prophetess, gazing out of the composition, upright and full-faced. The relief is noteworthy also from another aspect. A new ideal of the female form is evolved, a more forceful type, which entirely abandons the early Florentine delicacy. Large eyes, full cheeks, a strong chin. New motives in the drapery enforce the impression. The neck is exposed, and the important tectonic attachments are emphasised. The impression of forcefulness is supported by a new way of filling the space, with the figures touching the frame. No longer the flickering profusion of an Antonio Rossellino, with its unceasing undulation of light and shade, from the

great projections down to the last ripples of the surface, but a few impressive accents. Once more the strict vertical of the head strikes as it were the keynote of the whole.

The Florentine tablet has a pendant in London, a scene of the most charming invention and of a perfected beauty which only flashes forth momentarily in Michelangelo in exceptional cases.

How strange in comparison is the joyless *Holy Family* of the Tribuna, and how strongly opposed to the long series of Quattrocento *Holy Families*. The Madonna is a masculine woman with mighty bones, her arms and feet bare. Her legs bent under her, she crouches on the ground and reaches over her shoulder for the Child, whom Joseph, seated in the background, hands to her. A tangle of figures, curiously crowded in action. This is neither the maternal Mary (this is indeed never found in Michelangelo's work), nor the solemn Virgin, but merely the heroine. The contradiction to the treatment demanded by the subject is too marked for the observer not at once to notice that the artist here aimed at the mere representation of an interesting *motif*, and at the solution of a definite problem of composition. The picture was painted to order; there may be some truth in Vasari's anecdote that Angelo Doni, who gave the commission, made some difficulties about accepting it. In his portrait by Raphael he looks as if he would not have been easily attracted by the ideal " l'art pour l'art."

The artistic problem was clearly this: how is it possible to express the greatest amount of action in a very limited space? The real value of the picture lies in its concentrated plastic richness. It is perhaps to be regarded as a sort of competitive work, with which Leonardo was to be surpassed. It belonged to the period when Leonardo's cartoon of St. Anne with the Virgin and Child caused a sensation by the concentration of the figures in a new style. Michelangelo puts Joseph in the place of St. Anne; in other respects the task is similar; two adults and a child were to be brought into as close a juxtaposition as possible, without confusion and without a cramped effect. Certainly Michelangelo excelled Leonardo in wealth of axis, but at what a cost! The outlines and modelling are of a metallic accuracy. It is in fact no picture, but a painted relief. The strength of the Florentines lay at all times in plastic presentment; they were a race of sculptors, not of painters, but here the national talent rises to a height which discloses quite new ideas as to the province of " good

drawing." Even Leonardo has nothing which admits of comparison with the Virgin's outstretched arm. All is astonishingly life-like and significant, every joint and every muscle. It was to some purpose that the arm was bared up to the shoulder.

The impression made by this painting with its sharply defined contours and bright shadows did not die away in Florence. Again and again in this land of drawing the opposition to the obscurantists in painting crops up, and Bronzino and Vasari, for example, are in this respect, the direct successors of Michelangelo, although neither even remotely attained the expressive strength of his modelling. From the *Pietà* and the seated *Madonna of Bruges*, the Madonna reliefs and the *tondo* of the Holy Family, we look round with eager anticipation for those works of Michelangelo's youth, in which he must have displayed his personality most distinctly, *i.e.*, nude male figures. He had commenced with a gigantic nude *Hercules* which has not come down to us; then, he executed in Rome at the same time as the *Pietà* a drunken *Bacchus* (the figure in the Bargello), and soon afterwards the work which outshines all in fame, the Florentine *David*.[1]

[1] The *Giovannino* of the Berlin Museum, which is there ascribed to Michelangelo and is assigned a date about 1495, *i.e.* earlier than the *Bacchus*, cannot be passed over here entirely in silence, but I do not wish to repeat what I have already said elsewhere about this figure, which I cannot associate with Michelangelo nor indeed with the Quattrocento at all. (Cf. Wölfflin, *Die Jugendwerke des Michelangelo*, 1891.) The excessively artificial *motif* and the general smoothness of the treatment point to an advanced period of the sixteenth century. The treatment of the joints and drawing of the muscles are derived from the school of Michelangelo, but not that of his youth: the motive with the freely overstretched arm would have been hardly possible even to the master himself before 1520, and the soft modelling, which does not admit of the indication of a rib or the fold of skin in the armpits, would find no analogy among the most effeminate of the Quattrocentists. But who then was the author of this puzzling figure? It must have been a man who perished young it has been said, otherwise it would have been impossible for us to know nothing more of him. I believe that he must be looked for in the person of the Neapolitan Girolamo Santacroce (born *c.* 1502, died 1537), whose life is to be found in Vasari. (Cf. de Domenici, *Vite dei Pittori, Scultori, ed Architetti Napolitani*, II. 1843.) He died early and was spoilt still earlier, sinking in the waters of Mannerism. His coming mannerism is unmistakeable even in the *Giovannino*. He was called the second Michelangelo, and the greatest hopes were entertained of him. A work, closely akin to the *Giovannino*, is the splendid *Altar* of the Pezzo family (1524) in Montoliveto at Naples, by which the remarkable ability of the precocious artist may be thoroughly judged. It stands near a similar design of Giovanni da Nola's, who is usually called the representative of Neapolitan plastic art in the Cinquecento, but is much less important. How little the relation of these works in Naples is understood is shown by the fact that the scanty and inappropriate mention made of them by Jacob Burckhardt has stood unaltered from the first to the last edition of the *Cicerone*.

David, by Michelangelo.

In the *Bacchus* and the *David* is to be recognised the concluding expression of Florentine Naturalism in the sense of the fifteenth century. It was a thought quite in the spirit of Donatello to represent the drunken stagger suggested in the *Bacchus*. Michelangelo seizes the moment when his toper, no longer quite secure on his feet, blinks at the full cup which he raises aloft, and is obliged to look to a small companion for support. He chose for his model a plump young fellow and completed the body with intense pleasure in the individual form and the effeminately tender structure. He never again experienced this pleasure. Both motive and treatment are here pronouncedly Quattrocentistic. This *Bacchus* is not an amusing figure; it will move no one to laughter; but still there lurks a trace of youthful humour in it, so far as Michelangelo ever could be young.

The *David* is still more striking from the harshness of the figure. A David ought to be the likeness of a handsome and youthful victor. Donatello thus portrayed him as a stalwart boy; thus too, in a different taste, Verrocchio represented him as a slim angular youth. What does Michelangelo put forth as his ideal of youthful beauty? A gigantic hobbledehoy, no longer a boy and not yet a man, at the age when the body stretches, when the size of the limbs does not appear to match the enormous hands and feet. Michelangelo's sense of realism must have been completely satisfied for once. He shrank from no consequences, he even ventured to enlarge the uncouth model into the colossal. Then we have

the unpleasant attitude, hard and angular, and the hideous triangle between the legs. Not a single concession has been made to the line of beauty. The figure shows a reproduction of nature, which on this scale approaches the marvellous. It is astonishing in every detail, and causes renewed surprise from the elasticity of the body as a whole, but, frankly speaking, it is absolutely ugly.[1]

In this connection it is noteworthy that the *David* has become the most popular piece of sculpture in Florence. There exists in the Florentines together with the specifically Tuscan grace,—which is something distinct from the Roman dignity—a feeling for expressive ugliness, which did not die out with the Quattrocento. When some time ago the *David* was removed from its public position near the Palazzo Vecchio into the shelter of a closed Museum, it was found necessary to let the people have a view of their "Giant," if only in a bronze cast.

Apollo, by Michelangelo.

It was then indeed that the authorities decided on an unfortunate manner of exhibiting it, which is illustrative of the modern want of taste. The bronze figure has been erected in the centre of a large open terrace, where the most monstrous aspects have to be endured before any sight of the man can be obtained. The question of position was discussed in its day, immediately after the completion of the figure, by an assembly of artists, and the minutes of

[1] For an explanation of the motive, cf. Symonds, *Life of Michelangelo Buonarroti*, I. 99. According to him David is holding in his right hand the wooden handle of a sling, the bag of which (Symonds says, "centre,") lies with the stone in the left hand.

the meeting are still extant; everyone then held that the work should be placed in some recess, either in an arcade of the Loggia dei Lanzi or in front of the walls of the Palace of the Signoria. The figure requires this, for it is flat in workmanship, and is not intended to be looked at from all sides. The main result of its present central position is that its ugliness has been intensified.

What indeed was Michelangelo's own later opinion of his *David*? Apart from the fact that such a careful study from the model became absolutely contrary to his ideas, he would also have felt the motive to be too barren. We may perceive his matured idea of the excellence of a statue, if we examine the so-called *Apollo* of the Bargello, which was finished twenty-five years after the *David*. It is a youth about to draw an arrow from the quiver. Simple in its detail, the figure is infinitely rich in action. It shows no especial expenditure of force, no prominent gestures. The body as a bulk is closely compacted. There is however such an impression of depth, such animation and movement in the back planes that the *David* appears poor in comparison, a mere panel. The same holds good of the *Bacchus*. The flat expansion of the surface, the projection of the limbs, the perforation of the marble block, are merely Michelangelo's youthful mannerisms. He afterwards looked to compactness and restraint for effect. He must certainly have soon perceived the value of such treatment, for it is conspicuous in the figure of *St. Matthew the Evangelist* (Florence, courtyard of the Accademia), which was designed immediately after the *David*.[1]

Nude forms and movement—these were the objective of Michelangelo's art. He had commenced with them when as a mere boy he chiselled the *Battle of the Centaurs*. On reaching man's estate he repeated his task and performed it so excellently that a whole generation of artists modelled themselves upon it. The cartoon of the *Bathers* is certainly the most important monument of the early Florentine period, the most comprehensive revelation of the new method of studying the human body. The few samples of the lost cartoon which the burin of Marc Antonio[2] has preserved for us are sufficient to give some idea of the scope of the " great drawing " (*gran disegno*).

[1] The *St. Matthew* belongs to a series of the Twelve Apostles which was intended for the Cathedral at Florence, but not even this first figure was ever completed.

[2] Bartsch. 487, 488, 472. Also *Ag. Veneziano*, B. 423.

It is reasonable to suppose that Michelangelo had a share in the choice of the subject. A battle scene in which swords had been drawn and armour donned had evidently been proposed as a pendant to Leonardo's fresco in the Council Chamber. The artist, however, was permitted to depict the moment when a company of bathing soldiers were called out of the river by an alarm. This incident had occurred in the Pisan wars. Nothing however speaks more clearly for the high tone of the general artistic feeling in Florence than the fact that such a scene was admitted as the subject of a monumental fresco.

Fragment from the Cartoon of the Bathing Soldiers, by Michelangelo.

The clambering up the steep bank, the kneeling and reaching down to the water, the erect figures donning armour, and seated forms hastily drawing on their garments, the shouting and running, gave opportunities for the most varied movement; and the artist could represent nude forms to his heart's content without violating historical accuracy. Later historical painters would have gladly accepted the idea of the nude figures, but would have condemned the subject as too insignificant and too anecdotic.

The anatomists among the Florentine artists had always taken as subjects fights between nude combatants. We know of two engravings of this kind by Antonio Pollaiuolo, and we are told that Verrocchio made a sketch of nude warriors, which was intended to be reproduced on the façade of some house. Michelangelo's work should be compared with such productions. It would then be seen that he has not only invented, so to speak, all movement afresh, but that the human figure first becomes coherent in his hands.

The older scenes might exhibit excited combatants, but the figures seem as if they were fixed between invisible barriers. Michelangelo first

exhibits the utmost power of movement of which the human form is capable. There is more resemblance between all the earlier figures than between any two figures of Michelangelo. He seems to have first discovered the third dimension and foreshortening, although most earnest attempts had already been made in that direction.

The reason of this liberal employment of movement can be traced to his intimate knowledge of anatomy. He was not the first to prosecute anatomical studies, but he was the first to realise the organic connection of the human body. He knew on what the impression of movement depended, and brought out the expressive forms, giving eloquence to every joint.

2. The Paintings on the Ceiling of the Sistine Chapel

The spectator may justly complain that the Sistine ceiling is a torture to him. He is forced to study a series of episodes with his head bent back. The whole place seems alive with figures which claim to be seen. He is drawn this way and that, and finally has no option left but to capitulate to redundance and abandon the exhausting sight.

It was Michelangelo's own choice. The original design was far simpler. The *Twelve Apostles* were to have been in the spandrils, and the flat surface in the middle would have been filled with a mere geometrical ornamentation. A drawing of Michelangelo's in London,[1] shows us how the whole would have looked. Some competent critics are of opinion that it is a pity he did not adhere to this project, since it would have been "more organic." In any case such a ceiling would have been easier to examine than the present one. The Apostles ranged along the sides would have been comfortably seen, and the ornamental patterns of the flat middle surface would have given the spectator no trouble. Michelangelo refused for a long time to undertake the commission at all. But it was his own desire that the ceiling should be painted on this colossal scale. It was he who represented to the Pope that the figures of the Apostles alone would make but a meagre decoration. In the end he was given a free hand to paint whatever he wished. If the figures on the ceiling did not so clearly show the triumphant joy of a creator, we might say that the painter vented his ill humour and took his revenge for the

[1] Published in the *Jahrbuch der Preussischen Kunstsammlungen* 1892 (Wolfflin).

uncongenial commission. The Lord of the Vatican should have his ceiling, but he should be forced to stretch his neck to look at it!

In the Sistine Chapel Michelangelo first enunciated the axiom which became significant for the whole century, that no beauty is comparable to that of the human figure. The principle of the decoration of flat surfaces by botanical designs is abandoned, and where we might expect the tendrils of foliage we have nothing but human forms. There is not an atom of ornamental filling on which the eye can rest. Michelangelo certainly employed gradations and treated certain classes of figures as subordinate. In their colour, too, he made distinctions, giving them the tints of stone or of bronze, but this is no equivalent, and however one may regard the matter it is certain that the complete covering of the flat surface with human figures implies a sort of ruthlessness which furnishes subject for reflection.

On the other hand, the Sistine ceiling remains a marvel, which can hardly be matched in Italy. This decoration is as the thunderous revelation of a new force in its contrast to the timid pictures, which the masters of the previous generation had painted on the walls beneath. The spectator should always begin by studying these Quattrocentist frescoes, and should not raise his eyes upwards until he has familiarised himself somewhat with them. Then and then only will the mighty waves of life on the vaulted ceiling exercise their full power on him, and he will feel the sublime harmony which links and joins the huge masses above him. In any case, on entering the chapel for the first time the visitor will do well to ignore, *i.e.* turn his back on, the *Last Judgment*, painted on the wall above the altar. By this work of his old age Michelangelo greatly injured the impression produced by the ceiling. The colossal picture has destroyed the proportions of everything round, and has set up a standard of size which dwarfs the ceiling.

If we attempt to explain to ourselves the causes which produce the effect of this ceiling painting we shall meet with a series of ideas even in the arrangement which Michelangelo was the first to conceive. In the first place he treated the entire surface of the vaulted roof as a whole. Any other artist would have separated the spandrils (as for example Raphael did in the Villa Farnesina). Michelangelo did not wish to break up the space. He devised a comprehensive structural system, and the thrones of the prophets which rise within the spandrils are so incorporated

with the central framework that they cannot be detached from the whole.

The distribution lays little stress on the existing formation of the ceiling. It was far from the artist's intention to accept and explain the given conditions of structure and space. He certainly carried the main cornice over the triangles above the lunettes with much precision, but as the thrones of the prophets in the spandrils disregard the triangular shape of these parts, so also is the rhythm that informs the entire system quite independent of the real structure. The contraction and the expansion of the intervals in the central axis, and the alternation of large and small spaces between the transverse arches, in combination with the striking groups in the spandrils, appearing at intervals on the less accentuated parts, make up so splendid a composition that Michelangelo in this alone surpasses all earlier achievements. He helps the effect by the darker colouring of the neighbouring divisions—the ground of the medallions is violet, the triangular segments near the thrones are green—by which the lighter main *motifs* are shown off, and the shifting of the accent from the centre to the sides, and then back again to the centre, becomes more impressive.

Combined with this, we get a new standard of size, and a new gradation in the dimensions of the figures. The seated Prophets and Sibyls are of colossal proportions. Next to them come small and still smaller figures. We do not notice at once how far the scale of size diminishes; we only note the wealth of forms and accept it as inexhaustible.

A further factor in the composition is the distinction between figures which were meant to make a plastic effect, and historical subjects which appear merely as pictures. The Prophets and Sibyls and all their accompaniments exist as material objects, and have a reality quite distinct from that of the figures in the historical subjects. Occasionally the figures (Slaves) seated on the frame-work invade the surface of the picture. This distinction is connected with a contrast in direction. The figures in the spandrils are at right angles to the pictures. They cannot be seen together, and yet they cannot be entirely separated. A part of another group is always included in the view, and thus the imagination is kept continually on the alert.

It is marvellous that a collection of so many striking figures could ever have been combined so as to present a unity of effect. This would have been impossible but for the extreme simplicity of the strongly marked

architectonic framework. Festoons, cornice and thrones are of plain white, and this is the first great example of monochrome. The many-coloured dainty patterns of the Quattrocento would in fact have been meaningless here. The repetition of the white tint and the simple forms is admirably adapted to bring an element of repose into the prevailing tumult.

The Subject Pictures

Michelangelo claims from the first the right to tell his stories by means of nude figures. The *Sacrifice of Noah*, and the *Drunkenness of Noah* are compositions mainly of nudities. The buildings, costumes, furniture, all the magnificent details which Benozzo Gozzoli presents to us in his Old Testament pictures, are absent, or are indicated as slightly as possible. There is no attempt to introduce landscape. Not a blade of grass, if not absolutely necessary. Here and there in a corner a roughly drawn fernlike vegetation appears. This symbolised the creation of the vegetable world. A tree signifies the Garden of Eden. All means of expression are combined in these pictures. The sweep of the lines and the spacing are made to add to the expressiveness, and the story is told with a concentrated pregnancy without parallel. This does not apply so much to the earlier pictures as to the more advanced works. We shall note the process of development.

Of the first three pictures the *Drunkenness of Noah* takes the foremost place for concentration of composition. The *Sacrifice of Noah*, notwithstanding a clever motive, of which later artists made full use, stands on a lower plane. The *Flood*, which from its subject might be compared with the *Bathing Soldiers*, and is crowded with large figures, appears as a whole somewhat fragmentary. The idea that the people behind the mountain are advancing towards the spectator is a remarkable device for the suggestion of space. We do not see how many there are, and imagine a vast multitude. It would have been well if many painters, who have attempted to represent the *Crossing of the Red Sea* or similar scenes of crowding masses, had been able to achieve such results. The Sistine Chapel itself shows in its frescoes an example of the older and poorer style.

As soon as Michelangelo obtained more space his powers grew. In the picture of the *Fall* and the *Expulsion* he spreads his wings, now fully

grown, and in the succeeding pictures soars upwards to heights which no other painter has ever reached.

The *Fall* is familiar to us in earlier art as a group of two standing figures, hardly turned towards each other, and only connected by the incident of the proffered apple. The tree forms the centre of the picture. Michelangelo strikes out a new conception of the scene. Eve, reclining with all the indolent ease of a Roman, her back to the tree, turns for a moment towards the serpent, and receives the apple from him with apparent indifference. Adam, who is standing, stretches his hand over the woman into the branches. His movement is not very intelligible and the figure is rather indistinct. But we see from the Eve, that the story is treated by an artist, who not only has new ideas of form, but has been able to interpret the spiritual essence of the scene: the indolence of the woman engenders sinful thoughts.

The vegetation of the Garden of Eden is indicated by a few leaves only. Michelangelo did not wish to characterise the spot materially. Yet by the sweep of the lines of the ground and the expanse of atmosphere behind he produced an expression of richness and vividness, which is strongly contrasted with the bare horizontal lines of the neighbouring scene, in which the misery of the Expulsion from the Garden is depicted. The figures of the unhappy sinners are thrust forward to the farthest edge of the picture, and an empty yawning space is produced, as sublimely grandiose as a pause of Beethoven's. The woman with bent back and sunken head hurries on, loudly lamenting; Adam walks away with more dignity and composure, trying however to avert the menacing sword of the angel—a significant gesture which Jacopo della Quercia had already created.

The Creation of Eve. God Almighty appears for the first time in an act of creation, which takes place at his word. All the details of earlier painters, the grasping of the woman by the forearm, the more or less violent parting of body from body, are omitted. The Creator does not touch the woman; without any exercise of force, but with a quiet gesture, he utters the command "Arise!" Eve obeys, in a way that shows how dependent she is on the movement of her Creator, and there is infinite beauty in the manner in which the act of rising becomes the gesture of adoration. Michelangelo has shown here his conception of sensuous physical beauty. It is of Roman blood. Adam lies sleeping by a rock, an inert corpse-like form,

with the left shoulder prominent. A stump of wood in the ground, on which his hand partly rests, produces a further effect of dislocation in the joints. The line of the hill covers and enfolds the sleeper. A short bough corresponds in direction with Eve. The whole is sharply concentrated, and there is so little margin to the picture that the Almighty could not have held himself upright. The action of creation is repeated four times, but ever with new and enhanced powers of movement. First, the Creation of Man. God does not stand before the recumbent Adam, but hovers above him, with a choir of angels, all enclosed in the swelling folds of His mantle. The creation is performed by contact. The Almighty touches the outstretched hand of the man with the tip of His finger. Adam lying on the hill-side is one of the most famous figures conceived by Michelangelo. He is a combination of latent power and absolute helplessness. The man lies there in such an attitude that we are sure he cannot rise of himself. The drooping fingers of the outstretched hand are eloquent; all he can do is to turn his head towards God. And yet what gigantic action lies dormant in that motionless form, in the upraised leg, in the turn of the hips! How powerful the contrast between the torso which we see confronting us, and the profile of the lower limbs.

God upon the Waters. An unsurpassable representation of the all-pervading benediction of the Almighty. The Creator appears in the air and stretches out His beneficent hands over the face of the waters. The right arm is sharply foreshortened. The picture is very abruptly terminated by the frame. Next, the sun and the moon. The motive force grows stronger. We recall Goethe's words: " A mighty crash heralds the coming of the sun." God the Father, with thunder in His wake, stretches out His arms, while He abruptly turns and throws back the upper part of His body. A momentary check to His flight, and sun and moon are already created. Both the arms of the Creator are in motion simultaneously. The right is the more strongly emphasised, not merely because the eye follows it, but because it is more boldly foreshortened. Movement always produces a more vigorous effect when foreshortened. The figures are still larger than before. There is not an inch of superfluous space.

We here notice the extraordinary licence that Michelangelo took when he represented God Almighty twice in the same picture. His back only is seen, hurrying into the depth of the background, as if shot from a cannon. He might be taken at first for the departing demon of darkness, but the

creation of herbs and plants is intended by this. Michelangelo thought that a mere hasty gesture was sufficient for this creative act. The countenance of the Creator is already turned towards new purposes. There is a trace of primitive art in the double appearance of the same figure in the picture, but the spectator can convince himself by covering up the one side of the composition how greatly the impression of movement is enhanced by the repetition of the flying figure.

In the last picture, where Light and Darkness are separated, and God Almighty is borne along on sweeping clouds, we can no longer follow the artist quite devoutly. Yet this fresco is calculated above all the others to bring before our eyes the marvellous technique of Michelangelo. It is clearly apparent how at the last moment, that is, during the actual painting, he abandoned the hastily drawn outlines of the preliminary sketch, and tried something different. This, it must be noted, was done with colossal figures and by an artist who, lying on his back, was unable to study the whole effect.

It has been said of Michelangelo that he was interested in motives of form as such, and would not accept them as expressive of some given subject. This may be true of many of his single figures, but where he had a story to tell he always respected its meaning. The Sistine ceiling is a proof of this, as well as the frescoes painted by him at a very advanced age in the Pauline Chapel. At the corners of the ceiling there are four soffits, on which, among other figures, is *Judith*, giving the head of Holofernes to a slave. This subject had often been treated and always as a more or less indifferent process of giving and receiving. No special emotion was usually shown by Judith or by the servant. Michelangelo makes his Judith look round towards the bed on which Holofernes is lying, at the very moment when the attendant bends down to receive the head on the uplifted charger. It is as if the corpse had moved. The scene thus gains immeasurably in interest. If we knew nothing of Michelangelo this sample of his powers would be enough to mark its author out as a dramatic painter of the first rank.

3. The Prophets and Sibyls

A commission for standing figures of the twelve Apostles for the Cathedral at Florence had been given to Michelangelo, and twelve seated

Apostles had also figured in the first scheme of the Sistine Chapel. Prophets and Sibyls were afterwards substituted for these. The unfinished *St. Matthew* shows how Michelangelo proposed to heighten the expression of outward and inward emotion in the case of an Apostle! What might not be expected of him when he created prophetic types! He paid no attention to conventional attributes, and soon abandoned even the traditional scrolls. He went far beyond a representation, in which the names were the first consideration, and the figures were merely intended to proclaim with violent gesticulation that they had said something in life. He depicts moments of spiritual life, inspiration itself, rapt soliloquy and deep absorbing reflection, tranquil study and eager search through the pages of a book. In the midst of such scenes a commonplace motive is introduced, such as the fetching of a book from the shelf, the whole interest being concentrated on the physical movement.

The series contains youthful and aged figures. The expression of prophetic contemplation has been reserved by Michelangelo for the youthful figures. He does not conceive this as a look of longing ecstasy in the spirit of Perugino, or as an absorption, a passive receptivity, in the manner of Guido Reni, in whose pictures it is often hard to distinguish between a Danaë and a Sibyl. In Michelangelo it is an active condition, as of the soul going out to meet an esoteric influence. The types have little of the individual. The costumes are completely ideal. What characteristic then marks out the Delphic Sibyl from all figures of the Quattrocento? What gives such grandeur to her action and invests the figure with such fateful inevitability? The motive is the sudden listening attention of the prophetess, as she turns her head and raises her arm with the scroll for an instant. The head is shown in the simplest aspect, absolutely full face. This attitude is a triumph over difficult conditions. The upper part of the body is turned aside and bent forward, and the outstretched arm forms another opposition which the head had to overcome by a turn. Its force is due to the very peculiarity, that the full face is presented, notwithstanding difficulties, and that the vertical is elaborated from contradictory elements. It is evident that the sharp encounter with the horizontal line of the arm lends energy to the direction of the head. The treatment of light is also important; the shadow bisects the face and accentuates the middle line, while the vertical line is again emphasised by the pointed head-cloth.

The Erythræan Sibyl, by Michelangelo.

The eyes of the prophetess follow the turn of the head to the right with a peculiar movement. It is the powerful, widely opened eyes that fix the spectator from afar. But the effect would be less strong without the accompanying lines, which take up and continue the movement of the eyes and head. The hair streams in the same direction, as well as the great enfolding mantle, which surrounds the whole figure like a sail.

In this motive of drapery there is a contrast between the right and left of the silhouette which is frequent in Michelangelo's works. On the one side the line is smooth and unbroken, on the other jagged and agitated. The same principle of contrast is repeated in the various limbs. While the one arm is raised aloft with vigorous action, the other seems a mere dead weight. The fifteenth century thought it necessary to give equal animation to every detail, the sixteenth century obtained more powerful results by laying the accent on isolated points. The Erythræan Sibyl is seated with one leg thrown across the other. In parts the figure is completely in profile. The one arm is extended, the other hangs down and follows the compact outline. The drapery here is peculiarly monumental. An interesting comparison may be made by glancing back at the figure of Rhetoric on Pollaiuolo's tomb of Sixtus, where a very similar motive has produced a very dissimilar effect under the fanciful treatment of a Quattrocentist.

Michelangelo represents the aged Sibyls crouching with bowed backs. The Persian Sibyl holds a book before her dim eyes. The Cumæan Sibyl grasps with both hands a book which lies at her side, thus giving a contrast of action in the lower limbs and the body.

The action of the Libyan Sibyl is most complex. She fetches down a book from the wall behind the seat. She does not rise for this operation, but reaches for the book with both arms, and looks in another direction. Much ado about nothing.

The line of development in the male figures passes from Isaiah and Joel (not from Zacharias) to the more grandly conceived figure of Daniel writing, and past the strikingly simple Jeremiah to Jonah, who with a Titanic gesture bursts through all the tectonic bounds enframing him.

We cannot do justice to these figures if we do not carefully analyse the motives, and consider in every case the posture of the body as a whole, and the movement of the limbs in detail. Our eyes are so unaccustomed to grasp the relations of bodies to space as thus rendered that we shall find it difficult to recall to memory one of the motives, even directly after looking at it. Any description seems pedantic and also gives the erroneous impression that the limbs are arranged on a definite system, whereas the idiosyncrasy of the conception consists in the blending of formal intention with the overpowering expression of a psychological moment. This is not equally the case everywhere. The Libyan Sibyl, one of the last figures on the ceiling, shows a splendid wealth of line and curve, but the conception of the figure is superficial. In the same group of later figures is Jeremiah, sunk in profound reverie, and this form, though simpler than any other, touches our hearts the most.

4. The Slaves

Nude youthful figures are seated above the pillars of the thrones of the Prophets. Facing each other, in pairs, each couple has one of the bronze medallions between them, and seems about to garland it with festoons of fruit. These are the so-called Slaves. Drawn on a smaller scale than the Prophets, their part in the tectonic scheme is to furnish a freely treated finial to the pillars. As crowning figures they display the greatest liberty of gesture.

This gives us twenty more seated figures! They present new possibilities, for they do not sit facing the spectator, but in profile and on very

Figures of Slaves, by Michelangelo. (From the first group.)

low seats. They are also—and this is the most important point—nude figures. Michelangelo wished for once to treat the nude to his heart's content. Once more he entered the domain which he had trodden in his cartoon of the *Bathing Soldiers*. Here, if anywhere in the decoration of the ceiling, he threw himself body and soul into the task. Boys with garlands of fruit were no unusual subject. Michelangelo demanded more athletic figures. We must not inquire too precisely what each is doing. The motive was chosen, because it justified an infinite variety of gestures incidental to pulling, lifting, or carrying. We cannot bind the artist down to a direct explanation of each gesture.

There is no peculiar tension of muscles, but this series of nude figures seem to have the faculty of infusing currents of vitality into the spectator; they constitute "a life-communicating art," to use the words of B. Berenson. The proportions are so massive, and the contrasts afforded by the disposition of the limbs are so powerful that we feel ourselves face to face with a new phenomenon. What parallels can the whole fifteenth

Figures of Slaves, by Michelangelo. (From the third group.)

century produce to these imposing figures? The divergence from the normal type in the structure of the bodies is unimportant in comparison with the conditions under which Michelangelo presents the limbs. He discovered entirely new effects of proportion. He brings the one arm and the shins closely together as three parallel lines, he then makes the downstretched arm cut the line of the thigh almost at right angles, and keeps the figure, from the foot to the crown of the head, in an almost vertical line. These are not mathematical variations of some problem which he set himself. The unusual gesture has a convincing effect. He is master of the figures because of his anatomical knowledge. This is the secret of his drawing. Anyone who has seen the right arm of the Delphic Sibyl knows that there is much in store. He treats a simple problem like the support of an arm in such a way as to convey an entirely new impression. The truth of this may be seen by a comparison of the nude youth in Signorelli's fresco of *Moses* in the Sistine Chapel with Michelangelo's Slaves above the figure of the prophet Joel. And these Slaves are among the

Figure of a Slave, by Michelangelo.

earlier and tamer figures. Later, he added the effects of foreshortening, more and more boldly, until he arrived at the hasty *scorzi* of the last figures. The wealth of movement gradually increases. At first the coupled figures have some sort of symmetrical correspondence, but at the last they form almost complete contrasts. Michelangelo, far from wearying at length of the ten times repeated motive, found that ideas occurred to him in ever fresh profusion.

To judge of this gradual development, we may compare an early group, the Slaves over Joel, with a late group, that over Jeremiah. In the one a simple seated posture in profile, no great difference in the arrangement of the limbs, and an approximately symmetrical correspondence between the figures. In the other we have two figures, which have no points of resemblance either in structure, gesture, or illumination, but which mutually enhance their effect by contrast. The indolent figure of this pair may well be acclaimed the finest of them all, and not merely so because he has the noblest features. The figure is in repose, but he presents grandiose contrasts of direction, and the peculiar movement, with the forward inclination of the head, leaves a marvellous impression. The most daring foreshortening is combined with absolute clarity and breadth of appearance. Even taking into account the important effects due to the light here, it is marvellous that the figure can look so motionless. This effect would not be made but for the clear relief-like breadth of the painting. As a mass the figure is very compact, and can even be inscribed in a regular geometrical figure. The centre of gravity is high up, and this produces an extraordinary lightness in the whole, in spite of the herculean limbs. Modern art has certainly never surpassed the negligent

ease of this type of seated figure. Strangely enough, we involuntarily recall a figure from the distant foreign world of Greek Art, the figure of the so-called Theseus of the Parthenon.

The remaining decorative figures on the ceiling cannot be discussed here. The small surfaces with the lightly sketched figures look like a sketch book of Michelangelo's and are full of interesting motives, showing the dawning possibility of figures such as those on the Tombs of the Medici. Far more important are the fillings of the pointed arches, recumbent groups covering broad triangular spaces, such as later art required in abundance. Then in the lunettes we have those *genre* scenes, doubly marvellous in Michelangelo's work, the most astonishing conceptions and improvisations. The artist himself seems to have felt the necessity for letting the excitement die down here, after the violent physical and psychological stress of the upper compartments. These " Ancestors of Christ " depict a peaceful uniform existence, the ordinary life of man.

A few words in conclusion as to the course of the work. The ceiling is not absolutely homogeneous. There are seams in it, so to speak. Everyone will notice that the *Flood* and its two companion pictures the *Drunkenness* and the *Sacrifice of Noah* are painted with much smaller figures than the other episodes. The work was begun with these three, and there is good reason to assume that Michelangelo found the size of the figures inadequate from below. But it is a pity that the scale had to be altered, for it was clearly intended that the size should gradually diminish in the various classes of figures. There is at first a uniform gradation from the Prophets to the nude Slaves, and thence to the figures in the episodes, and this produces a pleasantly calm effect. Later the inside figures tower far over the heads of the Slaves, and the scale becomes uncertain. If the original proportions had been adhered to, the smaller surfaces would have been as successful as the larger, for the scale was uniform. Later a change, inevitable but not profitable, ensued. The figure of the Almighty in the *Creation of Adam* is gigantic, and in the *Creation of Eve* we find the same figure considerably smaller.[1]

[1] It is probable that with the new scale of proportion a change in the general scheme was made and a new series of scenes adopted, for it cannot be imagined that the scenes of the *Creation* with their few figures could have filled up the space if drawn on the scale of the *Flood*. Some such change in the general scheme must be assumed, because the *Sacrifice*

The second "seam" appears in the middle. A fresh increase in size is suddenly noticeable. This time the change is in every part, and the Prophets and Slaves are so large that the architectonic system could no longer be uniformly carried out. The engravers have indeed disguised the irregularities, but photographs afford a convincing proof of it. We know that there was a long interruption in the middle of the work, and Michelangelo, when he resumed the painting, was bent on an increase of scale. At the same time the colour-scheme was altered. The early historical scenes are bright in tone. The skies are blue, the fields green, and there are only brilliant tints and light shadows. Later everything is subdued, the sky is whitish grey, the draperies dull. The colours lose body and become watery. The gold disappears. The shadows become more intense.

From the commencement Michelangelo worked at the ceiling in its full breadth, and therefore progressed simultaneously with the "histories" and the figures of the Prophets. He continued similarly after the great interruption and it was only quite at the last that he rapidly painted in the lower figures in the pointed arches and lunettes continuously.

5. The Tomb of Julius

The ceiling in the Sistine Chapel is a monument of that pure style of the High Renaissance which did not yet know, or did not yet acknowledge, any discordant note. The tomb of Pope Julius, if it had been carried out according to the original intention, would have been its plastic counterpart. As is well known, it was executed much later on a very reduced scale, and in a different style. Of the original figures carved by the master only the Moses found a place on the monument. The so-called Dying Slaves went their separate way, and eventually found a resting place in the Louvre. We have not only to lament that a monument planned on a grand scale was reduced to insignificance, but that its suppression left us absolutely without a monument of Michelangelo's "pure" style. The work nearest to it, but separated by a wide interval, the San Lorenzo Chapel, is in a very different manner.

It will not be out of place here to make some general remarks on

of Noah is admittedly out of its place, so much so that early critics (Condivi) described it as the *Sacrifice of Cain and Abel*, to preserve the chronological continuity. This explanation, however, is not tenable.

sepulchral monuments. The Florentines had developed a type of gorgeous mural tombs, which may be best exemplified by the tomb of the Cardinal of Portugal by Antoni Rossellino in San Miniato. The characteristic feature is the flat niche, in which the sarcophagus is placed with the figure of the deceased above it on a couch. In a roundel above it is the Madonna who looks down smilingly on the corpse, while laughing angels uphold the garlanded medallion as they fly. Two little nude boys, seated on the bier, try to show tearful faces. Above them, on the top of the pilasters, are two full-grown angels, grave and majestic, offering the crown and palms. The niche is enframed by a draped curtain in stone.

Tomb of the Cardinal of Portugal, by Antonio Rossellino.

In order to picture to ourselves the original effect of the monument an important factor has to be imagined, *i.e.* colour. The violet marble of the background, the green surfaces between the pilasters, and the mosaic pattern of the floor under the sarcophagus are still visible, since stone does not lose its colour, but all the painted colours have disappeared, destroyed by an age hostile to colour. Traces still remain however, enough to allow us to imagine the original effect. Every detail was coloured. The robes of the cardinal, the cushion, and the brocade of the pall in which the pattern is also suggested in low relief. The monument glittered with gold and purple. The lid of the sarcophagus had a brightly coloured scale pattern, and the ornamental pilasters as well as the

mouldings of the frame were gilded. The rosettes of the soffit were gold on a dark ground. The festoons and the angels were also ornamented with gold. The triviality of a stone curtain is only endurable if carried out with colour. The pattern of the brocaded surface and the checkers of the lining are still quite discernible.

This colouring of statues and monuments ceased suddenly with the sixteenth century. The grandiose tombs of Andrea Sansovino in Santa Maria del Popolo show no trace of it. Colour is replaced by effects of light and shade. The figures stand out white from the dark niches.

A second element appears in the sixteenth century; the architectonic sense makes itself felt. The early Renaissance was still fanciful in its buildings, and according to our ideas there is something adventitious in its combination of figures and architecture. Rossellino's tomb is itself a striking example of the inorganic style of the fifteenth century. Take, for instance, the kneeling angels. Their tectonic coherence is nil, or at any rate of the very loosest. The manner in which they stand on the top of the pilasters with one foot, with the other in space, offends a later taste. Still more offensive is the intersection of the enframing moulding by the out-thrust foot, and the absence of any incorporation of the figure with the surface of the wall. The topmost angels also float in space without any form or setting. The series of pilasters inserted in the niche have no real relation to the whole conception. The crudeness of the architectonic feeling generally is shown by the treatment of the soffit, which is lined from top to bottom with over-large coffered compartments, no distinction being made between the arch and the impost. The same strictures apply to the motive of the marble curtain.

In Sansovino's work a definitely organised architectural system is the governing idea. Every figure has its appropriate place, and the parts form a homogeneous whole. There is a large niche with a flat background, smaller vaulted side-niches, and all three are blended into a harmonious arrangement of semi-columns with a complete entablature running right across.

Michelangelo's Tomb of Pope Julius would have been a similar combination of architecture and sculpture. Not a mural tomb, but a free structure of several storeys—an elaborate marble erection, in which sculpture and architecture were to combine, as in the Santa Casa at

Loretto. In wealth of sculpture it would have surpassed all existing monuments, and the master who created the Sistine ceiling would have been the man to have breathed a mighty rhythm into the whole. The figure of the deceased was usually represented in the fifteenth century as recumbent, as if sleeping, the legs stretched out straight, the hands simply folded one on the other. Sansovino retained the idea of sleep, but the traditional way of lying was too simple and conventional for him. His figure lies on its side; the legs are crossed, one arm is thrust under the head, and the hand hangs away from the pillow. Later the figures become more agitated, as if evil dreams tormented the sleeper. Lastly the idea of sleep is abandoned and the figure is represented as reading or praying. Michelangelo's conception was quite original. He planned a group showing the Pope laid to rest by two angels. The figure is still partly raised, so that it is quite visible; presently it was to be entombed like a Dead Christ.[1]

Tomb of a Prelate, by Andrea Sansovino.
(The upper part omitted.)

This would have been a mere incident in comparison with the wealth of figures which had been planned. We have, as has been said, only three of them, the two Slaves from the lower storey of the monument and the Moses from the upper storey.

[1] Cf. *Jahrb. d. Preuss. Kunstsammlungen*, 1884 (Schmarsow), in which the chief document, the drawing in the possession of Herr von Beckerath of Berlin, is published.

These Slaves are fettered, less by their actual bonds, than by their structural purpose. They were to be placed in front of pillars and they share the restraint of the architectonic form. They are subject to a force which prohibits any movement of their own. The tense posture of the body, giving the impression that the limbs could not move from a definite spot, which is noticeable in the unfinished *St. Matthew* at Florence, is repeated here with a more pronounced reference to the function of the figure. The representation of the gradual awakening of movement in the body is unsurpassable. The sleeper stretches himself, his head still languidly inclined; his hand passes mechanically over his breast, and the thighs rub one against the other. There is the deep drawing of a breath before complete waking consciousness. The block of marble that remains unhewn so enhances the impression of self-liberation that it seems essential to the composition.

The second slave is not presented full-face, but in profile.

In his *Moses* Michelangelo again represents a certain restraint of movement. The cause of this is to be sought here in the volition of the person himself: it symbolises the last moment of self-control before giving way to impulse, *i.e.* before starting up. It is interesting to compare the *Moses* with the earlier series of colossal seated figures sculptured by Donatello and his contemporaries for the cathedral at Florence. Donatello even then tried to represent the typical seated figure as instinct with life, but how different is Michelangelo's conception of movement! The relation of this figure to the Prophets of the Sistine ceiling is at once apparent. Michelangelo required an absolutely compact mass for a plastic as opposed to a pictorial presentation. This constituted his strength. We must go back very far to find a similar appreciation of coherent bulk. Quattrocentist sculpture seems very fragile even where it aims at powerful effects. The *Moses* displays clear traces of Michelangelo's early style. Later he would hardly have approved of the multiplicity of the folds and the deep hollows. In this statue as also, *e.g.*, in the *Pietà*, he aimed at obtaining bright reflections by means of a highly polished surface.

The figure was intended to stand diagonally; it is in semi-profile. It is necessary to get a clear sight of the leg which is drawn back, since the action of the figure depends chiefly on this. From this point of view the main directions, the angle formed by the arm with the leg, and the jagged outline of the left side, are remarkably distinct. The head, which is turned

round, gradually dominates the whole with its vertical line. The side turned away from the spectator is carelessly executed, and the action of the arm and of the hand which pulls at the beard could never have produced an interesting effect.

The figure was finally placed to confront the spectator, and it is difficult to realise what the effect would be if it were seen obliquely. The colossus was thrust into a niche, and the detached shrine projected by the master became a mural tomb of modest proportions. Forty years after its inception the work was brought to an end with this lamentable compromise. Meanwhile the artist's style had undergone a complete modification. The statue of *Moses* was intentionally brought into surroundings which seem too cramped for him. He was put into a frame which he threatens to burst. The necessary resolution of this dissonance lay in the accessory figures. This is a *baroque* conception.

IV

RAPHAEL

1483—1520

RAPHAEL spent his youth in Umbria. He won special distinction in the school of Perugino, and so completely assimilated the emotional style of the master that in Vasari's judgment it is impossible to distinguish between the pictures of the teacher and his pupil. Never perhaps did a pupil of genius so entirely absorb the manner of his master as did Raphael. The angel which Leonardo painted in Verrocchio's *Baptism of Christ* at once strikes the spectator as something peculiar, the boyish productions of Michelangelo resemble nothing else, but Raphael in his early works is not to be divorced from Perugino. Then he went to Florence. Michelangelo had just completed all the great works of his youth, had set up his *David*, and was employed on his *Bathing Soldiers*. Leonardo meantime had designed the cartoon of his battle-piece, and in his *Monna Lisa* was achieving unprecedented results. He was already in the prime of life and had won a brilliant reputation; Michelangelo was on the threshold of manhood with an assured future before him, while Raphael had barely passed his twentieth year. What prospect of success could he hope for when pitted against these giants?

Perugino was highly esteemed on the Arno. The youthful Raphael may well have been told that he might alway find a public for his master's style. He may have been encouraged to hope that he would become a second or even a better Perugino. His pictures did not seem to promise any more strongly marked individuality.

Free from any trace of Florentine realism, simple in his conception, and modest in his treatment of the line of beauty, Raphael entered the lists against the great masters with very slight prospects of success. But

he brought with him a talent peculiar to himself, a capacity for grasping fresh notions, and changing preconceived ideas. He gave the first great proof of this when he abandoned the tenets of the Umbrian School and devoted himself to Florentine problems. Few artists would have been able to do so, but if we survey the brief career of Raphael we shall be compelled to admit that no one else has ever shown similar development in so limited a time. The Umbrian visionary

The Virgin with SS. Sebastian and John the Baptist, by Perugino.

became the painter of great dramatic scenes: the youth who hardly ventured on contact with the things of earth, became a portrait-painter who had a powerful grasp of his subject. The draughtsmanship of Perugino's style changed into a pictorial manner, and the narrow taste for beauty in repose gave place to the craving for bold effects of moving masses. We note the first indication of the virile Roman master.

Raphael had not the fine nerves and the delicacy of Leonardo, still less the strength of Michelangelo. We might say that he possessed average powers, abilities that all could understand, if this expression were not liable to be misinterpreted as a disparagement. That happy mean of temperament is a thing so rare among us that nowadays it would be far easier for most of us to understand a Michelangelo than the frank, bright and kindly personality of a Raphael. The attractive amiability of his nature, the trait which impressed itself most deeply on all his associates still radiates unmistakeably from his pictures.

We cannot discuss the art of Raphael without first dealing with Perugino. Praise of Perugino was once considered an infallible means for

acquiring a reputation as a connoisseur (Goldsmith's *Vicar of Wakefield*). At the present day it would be advisable to adopt the opposite course. It is known that he employed assistants to repeat his sentimental heads, and that the copies escape detection if looked at from a distance. But if only one of his heads were admittedly genuine, we should still be impelled to ask what artist had won from the Quattrocento that marvellously intense look, so full of soul. Giovanni Santi knew why he coupled Perugino and Leonardo in his rhyming *Chronicle*, as " par d'etade e par d'amori." Perugino further possesses a rhythm of line he owes to himself alone. He is not only far simpler than the Florentines, but he has an appreciation of calm and repose which forms a striking contrast to the restless nature of the Tuscans and the elaborate daintiness of the late Quattrocento style. We must compare two such pictures as Filippino's *Appearance of the Madonna to St. Bernard* in the Badia of Florence, and the same subject treated by Perugino in the Pinacothek at Munich. In the former the line is sprawling, and there is a confused medley of detail in the picture; in the latter there is absolute repose, quiet lines, noble architecture with a wide outlook into a distant landscape, a range of hills fading away delicately on the horizon, an absolutely clear sky, an all-pervading silence, so intense that one might think to hear the rustling of the leaves when the breath of evening stirs the slender trees. Perugino felt the harmony of landscape and architecture. He built his simple, spacious halls, not as fanciful decorations to his pictures, as Ghirlandajo sometimes does, but as an effective resonance. No one before him had so wedded figures and architecture. (Cf. the illustration of the *Madonna* of 1493 in the Uffizi.) He is from the first a master of the art of construction. Where he has to deal with several figures together, he builds up a group on a geometrical plan. The composition of his *Pietà* (1495) in the Pitti would have been judged by Leonardo to be empty and tame, but in Florence it had then a special significance. Perugino with his fundamental doctrines of simplicity and observance of law was an important factor when Classical Art was dawning, and we realise how greatly he shortened the road which Raphael was to take.

1. THE MARRIAGE OF THE VIRGIN AND THE ENTOMBMENT

Raphael's *Marriage of the Virgin* (in the Brera at Milan) bears the date 1504. It was the work of the artist in his twenty-first year. The pupil of

Perugino here shows what he had learnt from his master, and we can easily distinguish the original and the borrowed features in the picture, because Perugino has painted the same subject (the picture is at Caen).[1] The composition is practically identical, except that Raphael has reversed the two sides, putting the men on the right and the women on the left. The other points of divergence are slight. Yet the two pictures are separated by all the difference between a painter who works on traditional lines and a more accomplished pupil of fine susceptibilities who, while still restricted in style, tries to put fresh life into every particle of the accepted motive.

It is necessary first to realise this motive. The ceremony of the marriage differs somewhat in detail from the usual renderings. There is no exchange of rings, but the bridegroom holds out to the bride a ring, in which she places her finger. The Priest holds the wrists of both and joins their hands. The minute detail of the procedure presented great difficulties to the artist. It is necessary to look very closely into Perugino's picture to discover the real meaning of the act. Raphael has here worked independently. He places Mary and Joseph farther apart and alters their attitudes. Joseph has already made his gesture and the ring has been brought into the middle of the picture. It is Mary's turn to act, and the attention of the spectator is directed to the movement of her right arm. This arm forms the real centre of action in the group, and the reason why Raphael altered the position of the figures is easily understood. He wanted to display the important limb in the front of the picture and uncovered. Nor is this all: the direction of the movement is now taken up by the Priest who guides Mary's hand, and instead of standing as in Perugino's painting, a stiff central line, follows the action with his whole person. The movement of his body suggests the "Put it on" at any distance. This shows the genius of the born painter, whose instinct at once fastens upon the true pictorial elements of the legend. The idea of the standing figures of Mary and Joseph is the common property of the school, but Raphael endeavoured to individualise and differentiate while retaining the types. How delicate is the differentiation of the way in which the two hands are grasped by the Priest!

The subordinate figures are so arranged that they do not distract the eye, but rather serve to concentrate the effect. There is an almost

[1] Berenson assigns the picture to Lo Spagna, painting under the influence of Raphael (*Gazette des Beaux-Arts.* 1896).

audacious interruption of the symmetry by the figure of the suitor breaking his rod in the right-hand corner of the picture. Perugino also has this figure, but brings it further back.

The beautiful little temple in the background is placed so high that it in no way interferes with the lines of the figures. This again is in Perugino's purest style. He adopted the same arrangement in the great fresco of *Christ delivering the Keys* at Rome. Figures and architecture stand apart like oil and water. His figures are intended to stand out in clear silhouette against a symmetrically paved floor. How different is the story of the Marriage of Mary when told by a Florentine! Everything is clamorous. Gaily coloured fashionable dresses are *de rigueur*. The public stand and gape, and instead of the quietly resigned suitors there is a band of stalwart youths who pommel the bridegroom with their fists. There seems to be a general free fight, and the wonder is how Joseph can remain calm. What was the meaning of this? The motive occurs in the fourteenth century [1] and has a juristic significance: the blows are intended to make the marriage vow impressive. The reader may perhaps recall a similar scene in Immermann's *Oberhof*, where, however, the motive is rationalised thus: the future husband ought to know how it feels to be beaten!

Into this Florence Raphael came to create a second school. He was hardly recognisable when, three or four years after, he produced the

[1] Cf. Taddeo Gaddi (S. Croce). Also Ghirlandajo (S. Maria Novella) and Franciabigio (S. Annunziata).

The Entombment; by Raphael.

Entombment in the Borghese Gallery. He had abandoned all his characteristics, soft lines, clear grouping and gentle sensibility. Florence had worked a revolution in him. Movement and the nude had become the problems that absorbed him. He wished to present lively action, displays of mechanical power, strong contrasts. Michelangelo and Leonardo had made a profound impression on him. How poor his Umbrian style must have seemed to him compared with their achievement!

The picture of the *Entombment* was a commission from Perugia, but the order was certainly given not for this subject but for a *Pietà* such as Perugino had painted (his picture in the Palazzo Pitti is well known [1]). Perugino avoids all movement, and only represents the weeping bystanders

[1] It may be mentioned in this place that the youthful figure on the extreme right of the picture corresponds in every detail to the *Aless. Braccesi* of the Uffizi, which was formerly ascribed to Lorenzo di Credi.

round the dead body, a collection of mournful faces and gracefully drawn figures. Raphael's first idea was a *Pietà*. Sketches for this subject are extant. He then adopted the new idea of the carrying of the dead body. He painted two men bearing the pitiful burden up to the rock-tomb. He assigns a different age and type to each, and makes the motive complex by drawing one of them going backwards, and therefore obliged to grope with his heels for the steps he has to mount.

Amateurs are slow to grasp the merit of such purely physical motives, and would prefer as much psychological expression as possible. Everyone will however admit that under any circumstances it is a gain to introduce contrasts into the picture, that repose is more impressive side by side with movement, and that the sympathy of the mourners is emphasised by the indifference of those who are only concerned with their mechanical labour. Perugino chills our emotion by the uniform expression of his heads, whereas Raphael strives to heighten the intensity of the effect by strong contrasts.

The most beautiful feature of the picture is the body of Christ, with the shoulder thrust forward and the drooping head. The motive is the same as in Michelangelo's *Pietà*. The artist's knowledge of anatomy is still superficial, and the heads show no strength of characterisation. The articulations of the limbs are but slightly defined. The younger of the two bearers is not very firm on his legs, and the indistinctness of his right hand is distressing to the eye. The inclination of the elder man's head is the same as that of Christ's, and the effect of this is disturbing. The preliminary studies had avoided this result. Then the whole composition is confused. The disagreeable medley of legs has always been criticised, and we may further ask, what is the meaning of the second old man? Once more an originally lucid idea seems to have become obscure. In the original sketch he was looking down on the Magdalen as she hurried towards him, but here he gazes incomprehensibly into the air, and by the vagueness of his action only accentuates the disagreeable impression produced by the cluster of the four heads. The beautiful motive of the Magdalen holding the hand of Christ as she follows the procession may have been adopted from an antique model.[1] The action of her right arm is indistinct. The group of the fainting Virgin surpasses as a motive anything of Perugino's. The

[1] Relief in the Capitoline Museum (Hector?). Righetti, *Campidoglio*, Vol. I. plate 171. H. Grimm has already referred to it in this connection.

kneeling figure in the foreground was certainly suggested by Michelangelo's Madonna in the *Holy Family*. It is strange that we should have to accept such harsh intersections of arms from the refined Raphael. This group as a whole is unpleasantly compressed in the picture. Raphael's original design was more justly conceived. He brought the women into the moving procession of the chief group, but let them follow at a short distance. The picture is incoherent as it stands. It must be added that the square shape is in itself injurious to its effect. To produce the idea of a procession the field of action must have a definite direction. Titian's *Entombment* owes much to the mere proportions of the canvas. What share in the Borghese *Entombment* must be ascribed to the second hand which finished it is a disputed point. It was certainly a task which at the time Raphael could not satisfactorily accomplish. He had attacked the Florentine problems with a marvellous capacity for learning, but for the moment he lost his way over the work.

2. THE FLORENTINE MADONNAS

Intention and execution are more equal in the Madonna pictures than in the *Entombment*. It is as a painter of Madonnas that Raphael has achieved popularity, and it may indeed seem superfluous to test the charm of these pictures by the coarse methods of formal analysis. They have been familiar to us all from our youth up through reproductions more numerous than the works of any other artist in the world have called forth.

The traits of deep maternal love and of childish innocence, of solemn dignity and of a strange supernatural beauty appeal to us so strongly that we do not ask for any further artistic meaning. And yet a glance at Raphael's drawings would teach us that the problem for the artist did not lie where the public thought. The task was not merely the creation of some beautiful head or delicious childish attitude, but involved the arrangement of the group as a whole, the harmonising of the directions of limbs and bodies in various attitudes. No one need be debarred from approaching Raphael on the emotional side; but a large proportion of his artistic intention will only be revealed to the spectator when he disregards the pleasurable emotions produced by the picture, and proceeds to consider its form.

86 THE ART OF THE ITALIAN RENAISSANCE

The Madonna del Granduca; by Raphael.

It will be well to arrange pictures representing the same subject according to a scheme of progressive development. In this connection it is unimportant whether the Madonna holds a book or an apple, whether she is seated in the open air or not. The basis of classification must not depend on material but on formal distinctions. The important questions artistically are: whether the Madonna is depicted as a half-length or full-length figure, whether she forms a group with one or two children, or whether other adult figures are added. Let us begin with the simplest motive, the half-length Madonna, and consider first the *Madonna del Granduca* in the Pitti Gallery. An absolute simplicity marks the vertical line of the standing principal figure and the (as yet) somewhat timid attitude of the seated Child. The vitality of the picture is due to the slight inclination of the *one* head. However perfect the oval of the face and however marvellously conceived the expression, the effect would not have been attained without this simple system of *direction*, in which the diagonal line of the head which is inclined, but still seen full face, marks the only deviation. The atmosphere of Perugino still breathes from this tranquil picture. At Florence something more was demanded, greater freedom and more vigorous movement. The rectangular disposition of the seated Child is discarded in the *Casa Tempi Madonna* at Munich, and is as a rule superseded by a half-recumbent posture; the Child has turned round and throws his limbs vigorously about (*Orleans* and *Bridgewater Madonnas*); the Mother is no longer standing but seated, and as she bends forward and then again turns aside, the picture becomes at once rich in axes of direction. From the *Granduca* and the *Tempi* there is a regular progressive development to the *Sedia* (Pitti), in which the little St. John

first appears, thus giving scope for the utmost wealth of plastic effect by the play of limbs and depth of treatment; and these are the more striking owing to the compression of the group, which is adapted to a closely fitting frame.

Quite analogous is the development of a second theme, that of the full-length *Madonna* with Jesus and St. John. Raphael first timidly constructed the simple, delicately-outlined pyramid of the *Madonna del Cardellino* (in the Uffizi), where the children stand symmetrically on each side of the seated Virgin. This is a composition on the lines of the equilateral triangle. The lines are drawn with a delicacy of feeling unknown in Florence, and the proportions of the figures are balanced with all the accuracy of the goldsmith's scales. Why does the Virgin's robe slip from her shoulder? To prepare for the projection of the book in the silhouette; by this device the line glides downwards in a harmonious rhythm. Gradually the master feels the need of more movement. The children are distinguished more clearly; the St. John is made to kneel down (*Belle Jardinière* in the Louvre) or both children are placed on one side (*Madonna in the Meadow* at Vienna). At the same time the Madonna is seated further in the background, so that the figures may be more closely knit, and the contrasts of direction more sharply expressed, till at last a picture is evolved of the marvellously compressed richness seen in the *Casa Alba Madonna* (at St. Petersburg), which, like the *Madonna della Sedia*, belongs to Raphael's Roman period.[1] In this we note an unmistakeable reminiscence

The Madonna della Sedia; by Raphael.

[1] The *Madonna with the Diadem* (Louvre) which enjoys a curious popularity (engraving by F. Weber) shows how little of this art permeated Raphael's immediate

of Leonardo's *Madonna with St. Anne* (in the Louvre).[1]

A still richer theme is treated in the Holy Families in the style of the *Madonna della Casa Canigiani* at Munich, in which Mary, Joseph, and the mother of St. John are collected round the two children, *i.e.* a group of five figures had to be arranged. Here again the first solution of the problem was a simply constructed pyramid. The two kneeling women who hold the children between them form the base, and the standing figure of Joseph the apex. The *Canigiani Madonna* is a masterpiece of composi-

The Madonna del Cardellino, by Raphael.

tion, far beyond the powers of a Perugino. It has the Umbrian transparency and clearness, and is instinct with the Florentine wealth of movement. Raphael's Roman development was in the direction of solid effects and strong contrasts. An instructive antithesis of the later Roman period might be found in the *Madonna del divin Amore* (Naples), which, though not original in execution, affords a thorough illustration of the new ideas.[2] The typical changes are, that the former equilateral triangle has de-

circle. The coarse motive of the Madonna, the awkwardness of the posture and the movement of the hand preclude all idea of an original composition. (According to Dollmayr the picture is by G. F. Penni.)

[1] Cf. the almost identical circular composition of the so-called *Madonna del Lago* of the school of Leonardo. The engraving by G. Longhi is well known.

[2] Dollmayr (*Jahrbuch der Sammlungen des Allerhöchsten Kaiserhauses*, 1895) assigns the picture both as regards execution and design to G. F. Penni (*Il Fattore*).

veloped unequal sides, that the apex has been considerably lowered, and that what was formerly light and limpid has become ponderous and heavy. The two women now sit together on one side, and Joseph, an isolated figure, thrust far into the background, balances the composition on the other side.

In the *Madonna of Francis I.* (Louvre), a picture with many figures, the construction of a group is definitely abandoned, and in its place we have a picturesque representation of intricate masses which negatives any sort of comparison with the earlier compositions.[1]

The Madonna della Casa Alba, by Raphael.

Finally, the Florentine Raphael gave us his conception of the Madonna enthroned, and surrounded by Saints, in his large altar-piece, the *Madonna del Baldacchino.* The simplicity of Perugino is here blended with motives in the style of Fra Bartolommeo, that mighty personality who of all the Florentines approached Raphael the most closely. The plainness of the throne is quite in the manner of Perugino. The magnificent firmly modelled figure of St. Peter, on the other hand, is clearly due to the influence of Fra Bartolommeo. A complete estimate of the picture would have to take into account not only these two factors, but the additions made much later in Rome, *i.e.* the angels above the Madonna, probably all the architecture in the background, and certainly the extensive addition to the height of the picture.[2] Roman taste required more space. If Raphael had been given a completely free hand, he would have brought the two pairs of Saints into closer groups, would have placed the Madonna lower down, and would have given a more compact form to the combined figures. A comparison that may be made on the spot, in the Palazzo

[1] Dollmayr is inclined to believe that Raphael designed at least the group with the Virgin. Penni and Giulio Romano may have shared the execution.

[2] The St. Augustine appears to have been added by an inferior hand. On the other hand the boy-angels certainly belonged to the original picture. (This point is disputed, *e.g.* in the *Cicerone.*)

Pitti, will clearly show how the taste of a decade later would have decided these questions. It is only necessary to compare Raphael's picture with Fra Bartolommeo's *Risen Christ with the four Evangelists*. This is at once simpler and richer, more diversified and more homogeneous. In making the comparison we shall also feel that the maturer Raphael would not have introduced the two nude boy-angels standing before the throne, charming as they are. There are sufficient vertical lines in the picture; lines of contrast are required; and therefore the boys are seated in Fra Bartolommeo's work.

3. The Camera della Segnatura

It was fortunate for Raphael that no subjects of a dramatic nature were required from him at the beginning of his sojourn in Rome. His task was to paint calm assemblies of philosophers, pictures of peaceful intercourse, where all depended on the artist's inventiveness in the treatment of simple movements and his delicacy of arrangement. These were undertakings peculiarly suited to his talents. He could now display on a large scale that appreciation of harmonious outline and proportion which he had developed in the composition of his Madonnas. He found in the *Disputa* and the *School of Athens* scope for that skill in the filling of spaces and grouping of figures which formed the basis of his later dramatic paintings.

It is difficult for the modern public to do justice to the artistic qualities of these frescoes. It looks for the merit of the works in the expression of the heads, in the thoughtful relation of one figure to the other. The traveller wishes above all to learn what the figures mean, and is not satisfied until he knows their names. He therefore listens gratefully to the information given by the guide, who knows the name of each person, and is convinced that he understands the picture better after receiving this information. Many people are quite satisfied with this, while some more conscientious visitors try to realise thoroughly the expression of the heads, and rivet their attention on the features. Few are able to grasp the movement of the figures as a whole in addition to studying the faces, and to appreciate the beauty of motive in the various postures of the leaning, standing, or sitting figures. Still fewer have any suspicion that the real value of these works does not lie in the details but in the arrange-

ment of the whole, in the harmonious animation of the space. They are decorative works of the grandest style, decorative, however, in a sense other than that in which the word is commonly used; I mean that they are paintings where the chief accent is laid not on the individual head, or the psychological connection, but on the arrangement of the figures upon a given surface, and in their relative positions in the space. Raphael had a stronger instinct for all that pleases the human eye than any painter before him. A profound knowledge of history is not essential to the comprehension of these frescoes.[1] The subjects are familiar ones, and it is a mistake to try and find any expression of abstruse philosophical or historical ideas in the *School of Athens*, or an epitome of ecclesiastical history in the *Disputa*. Where Raphael wished to be distinctly understood, he added inscriptions, but such cases are few. We are left without explanation even of the chief figures, the very pillars of the composition. The contemporaries of Raphael did not ask for such explanations. The material or spiritual motives of action seemed to them everything; the names were unimportant. No questions were asked as to the meaning of the figures. Men took them as they were.

To share such a point of view as this a sensitiveness of eye is necessary, rarely found in modern days, and it is peculiarly hard for the Germanic races to appreciate fully the importance attached by the Roman to physical deportment and bearing. The northern traveller must not therefore become prematurely impatient if he finds himself forced to repress a feeling of disappointment in this place, where he expected to see a representation of the highest spiritual forces. Rembrandt would certainly have painted Philosophy differently.

Anyone who honestly intends to enter closely into the spirit of these paintings will find that the only method is to analyse each figure separately, learning it by heart, and then noticing the chain of connection, how each link presupposes and requires another. This advice has already been given in the *Cicerone*. Probably few have followed it, travellers cannot spare the time. Much practice is needed before any firm footing is to be found. Our power of vision has become so superficial through its dealings with the mass of illustrative painting of the day, the end and aim of which is a vague general impression, that when dealing with such works of the old masters we have to spell out the rudiments.

[1] Cf. Wickhoff's lucid essay (*Jahrb. der K. Preuss. Kunstsammlungen*, 1893).

The Disputa

The four Doctors of the Church to whom the formulation of the dogma is referred, Jerome, Gregory, Ambrose and Augustine are seated round an altar on which is a monstrance. The faithful are grouped around; dignified divines, standing in calm meditation; fiery youths impetuous in prayer and praise. On the one hand reading, on the other demonstration. Nameless figures and famous types are assembled in close juxtaposition. A place of honour is reserved for Pope Sixtus IV., uncle of the reigning Pope.

That is the earthly scene. But above it the Persons of the Trinity are enthroned and with them in a wide semicircle sit a band of saints. At the top are hovering angels in parallel lines. Christ, seated and showing His wounds, dominates the whole. The Virgin and St. John attend Him. Over Him is God the Father in the act of benediction, beneath Him, the dove. Its head is the exact centre of the vertical axis of the picture. Vasari calls the picture *La Disputa del santissimo Sacramento* and the name has survived to the present time, inappropriate as it is. There is no disputation in this assembly, hardly any speech. It is intended to represent the profoundest certainty, the assured presence of the supreme secret of the church, confirmed by the manifestation of the Divine Persons themselves.

Let us try to realise how the problem would have been solved in the spirit of the earlier school. The elements demanded had furnished the theme of innumerable altar-pictures: a number of holy men tranquilly co-existent, and above them the denizens of Heaven, calm as the moon above the forest. Raphael saw at once that mere motives of standing or sitting would be inadequate. The tranquil community must be replaced by an assembly with movement, and a more vigorous activity. He first differentiated the four figures of the main group (the Doctors of the Church) by the motives of reading, contemplation, rapture and dictation. He created the fine group of the impetuous youths, and so obtained a contrast to the peaceful aspect of the standing divines. The emotion portrayed is echoed in a more subdued fashion in the pathetic figure in front at the altar steps, turning his back to the spectator. As a contrast to this, Pope Sixtus stands on the other side, calm and confident, looking to the front with uplifted head, the true prince of the church. Behind him is a purely secular motive: a

lad leaning over the balustrade, to whom a bystander points out the Pope.[1] Opposite in the other corner of the picture is the same motive reversed, a youth who invites the attention of an old man. The old man stands bending over a book on a balustrade, others are looking at it, and he seems to be expounding the contents. The youth, however, invites him to go up to the altar in the middle to which all are pressing. It may be said that Raphael wished to depict here heterodoxy or sectarianism,[2] but each person in the composition was certainly not determined beforehand with such precision, and the motive in itself can hardly have figured in the programme prescribed to Raphael. He had to introduce the Doctors of the Church, Pope Sixtus, and other celebrities of popular interest. This he did, but in other respects he retained absolute freedom, and was able to work out the motives he required in anonymous figures. This then is the kernel of the matter. The significance of the work does not lie in its details, but in its general composition, and justice can only be done to it, when it is understood that every separate part serves to help the general effect and is designed with due regard to the whole.

But let none feel disappointed at the conclusion that the psychological aspect is not the most interesting factor here. Ghirlandajo would have given his heads more individuality, and Botticelli would have been more convincing in the expression of religious feeling. No single figure here could be put on a level with the St. Augustine in the Ognissanti. Raphael's work is on a different plane; to paint a picture of such dimensions, with such depth, such wealth of action, yet clear in its development and harmonious in every component part, was an unprecedented achievement. The first problem of composition was in connection with the Doctors of the Church. These constituted the chief group and had to be brought into due prominence. If the figures were to be large, they could not be placed too far back, but on the other hand, if this condition had been observed the picture would have become a mere strip. After some preliminary hesitation, Raphael, in order to give depth to the picture, ventured to remove the Fathers of the Church to the background, raising them on a step. By this expedient the composition was started upon the happiest course. The idea of the step proved

[1] As has been often observed, the figure of the pointing man comes from Leonardo's *Adoration of the Magi*, where it appears in a similar place.

[2] Cf. a similar group in Filippino's picture *The Triumph of St. Thomas* (S. Maria sopra Minerva).

most fertile: all the figures join hands to some extent and lead up to the centre of the picture. A further result was achieved by the addition of the gesticulating men on the further side of the altar; they are placed there in order to call attention to Jerome and Ambrose, who are sitting at the back.[1]

There is a distinct trend from the left side to the centre of the picture. The young man who is pointing, the praying figures, and the pathetic figure seen from behind combine to produce a sum of uniform action which readily attracts the eye. Later in his career Raphael continued to show this same attention to the guidance of the spectator's eye. If then the last of the central figures, Augustine, who is dictating, has turned round, the object of this posture is apparent: it is intended to be the connecting link with the right side, where movement becomes quiescent. Such considerations of form are complete innovations on the methods of the fifteenth century. In other respects Raphael has presented the Fathers of the Church in the most simple aspects. A lowered profile and a raised profile differentiate the first two figures, while the third shows but a slight divergence of attitude. They are also seated as naturally as possible. This is his system. The remoter figures, if they are to produce the effect of size, admit of no other treatment. A Quattrocento picture like Filippino's *Triumph of St. Thomas* fails in this very respect.

The action is more diversified as the figures approach the foreground. The most varied movements are presented by the bending figures with their companions in the corners. These corner-groups are arranged symmetrically, and are similarly connected with the more central personages by pointing figures.[2] Symmetry pervades the whole picture, but is everywhere more or less disguised in particular cases. The greatest divergences exist in the middle zone. Even here however there are no violent dislocations. Raphael still proceeds cautiously, he wishes to combine and to calm, not to agitate and tear asunder. The lines are drawn with a delicacy of

[1] They were an afterthought.

[2] The motive of the parapet is due on the one side to the gap caused by a door, which Raphael tried to remedy by building a little wall above it. He then repeats the motive on the other side as a balustrade. The advanced Cinquecentists could not tolerate such encroachments in a picture. In the *Heliodorus* room therefore the ground-line of the picture is taken at the height of the lintel of the door. It is characteristic of Venice that Titian in his *Presentation of the Virgin* did not hesitate to sacrifice the lower limbs of some figures to a door. Such a solecism would have been impossible in Rome.

feeling that might be called reverent, so that no one jars on the other, and amidst all the prevailing abundance the impression of tranquillity predominates. The two portions of the assembly are united by the line of the landscape in the background and harmonised with the upper belt of figures with a like intention.

Throughout this system of tranquil lines a higher object is kept in view in the individual distinctness which Raphael gives to every person. Where the earlier masters crowded their figures together, and placed one head behind another, the artist who had been educated in the simplicity of Perugino separated his figures so that each is clearly perceptible. Here again a novel regard for the eye of the spectator determines the treatment. The treatment of masses of figures by Botticelli or Filippino required a concentrated examination at close quarters, if one really wished to grasp any particular point of the surging mass. The first requirement of the Art of the sixteenth century, which rivets attention on the whole, was simplification.

Such qualities as these determine the value of the work, and not its details of draughtmanship. No one will be able to deny that the composition contains a considerable amount of essentially new movement. Much of it, however, is still timid and uncertain. The figure of Sixtus IV. is vague in its effect. It is not clear whether he is moving or standing still, and it takes some time to discover that he is propping a book against his knee. The pointing youth opposite him is an unfortunate figure derived from a motive of Leonardo's. The want of character in the heads, when they are not portraits, has an unpleasant effect. We hardly venture to think how the picture would have looked, had Leonardo represented the congregation of the faithful by men of *his* creation.

But, as we have already said, the great qualities of Raphael's *Disputa* and the real conditions of its effectiveness are the general motives. The division of the pictorial surface as a whole, the conduct of the lower figures, the bold sweep of the upper semi-circle with the saints, the contrast between movement and stately enthronement, the combination of richness and repose produce a picture which has often been praised as a perfect example of the monumental religious style. Its special characteristic is given it by the most charming commingling of youthful timidity with the consciousness of dawning power.

The School of Athens

Theology has its antithesis in Philosophy, the pursuit of profane knowledge. The name given to the next fresco, *The School of Athens*, is almost as fanciful as that of the *Disputa*. It would be more permissible, indeed, to call this a *Disputa*, for the central motive is the two leaders of philosophy, Plato and Aristotle, engaged in argument. Rows of attentive listeners stand around them. Socrates is near them with his own circle of scholars. He is engaged in his favourite interrogation, and counts off his premisses on his fingers. Diogenes, in the costume of one who has no needs, is lying on the steps. An elderly man writing, before whom is displayed a tablet containing the musical scale, may be Pythagoras. If we name Ptolemy and Zoroaster, the astronomers, and Euclid, the geometrician, we have exhausted the historical components of the picture.

The difficulty of the composition was greater here, because of the absence of the heavenly zone. Raphael was driven to call architecture to his aid. He constructed an immense vaulted hall, and placed in the foreground a flight of four steps which extend the full breadth of the picture. He thus obtained a double stage, the space below the steps and the platform above them.

In contradistinction to the *Disputa*, where all the parts converge to the centre, the whole picture is here broken up into a number of isolated groups and even isolated figures. This is the natural expression of the diversity of scientific investigation. Any search for definite historical allusions is as misplaced here as in the *Disputa*. We seem to divine an illuminating thought in the manner in which the master has grouped the physical sciences below, and left the upper space free for speculative philosophy; but perhaps even this interpretation overshoots the mark. The material and spiritual motives are far richer here than in the *Disputa*. The subject required a greater variety of treatment, but it is noticeable that Raphael's own power of suggestion had developed. The situations are more clearly defined, the gestures more significant. It is easier to remember these figures.

Raphael's treatment of the group of Plato and Aristotle is especially noteworthy. The theme was no new one. We may take, for comparison, Luca della Robbia's relief of *Philosophy* on the Campanile at Florence. Two Italians are engaged in a hot dispute with characteristic southern

energy. The one insists on the text of his book, the other, gesticulating with all his ten fingers, shows him that his argument is absurd. Other disputations are to be found on Donatello's bronze doors at St. Lorenzo. Raphael was obliged to reject all these motives. The taste of the sixteenth century insisted on reticence of gesture. The great philosophers stand side by side in dignified composure; the one who extends his arm and stretches his outspread hand over the earth is Aristotle, the great constructor; the other, Plato, points upwards with his finger. We do not know whence Raphael gained the knowledge that enabled him to bring out the distinctive characteristics of the two philosophers so ably, that these two figures seem to us credible portraits.

The figures which stand to the right against the frame are also full of expression. The isolated figure with the white beard, wrapped in a cloak, quite simple in silhouette, is marked by a grand tranquillity. Near him another, leaning on the parapet, looks at the writing boy, who sits bending over his work, with legs crossed, facing the spectator. It is by such figures that the progress made by Raphael must be estimated.

The motive of Diogenes' recumbent position was new. It is that of the beggar who lies lazily on the steps of the church.

The richness of detail increases more and more. Not only is the scene of the geometrical demonstration excellently conceived from the psychological point of view—not only are the different degrees of intelligence in the scholars well contrasted—but the movements of kneeling and bending in the individual characters deserve to be accurately studied and impressed on the memory.

The Pythagoras group is still more interesting. A man writing, in profile, sitting on a low seat, with one foot on a stool, and behind him other figures, pressing forward and bending over; a perfect garland of curves. Then a second scribe, also seated, but confronting the spectator, his limbs in a more complicated posture. Between the two a standing figure, who holds an open book against his thigh and seems to be quoting a passage from it. There is no need to trouble about the meaning of all this. The figure was not a link in a spiritual sequence; it owes its being to its material motive. The upraised foot, the outstretched arm, the turn of the upper part of the body and the contrasted inclination of the head give it a distinctly plastic character. If the northern student is inclined to think that this fertile motive has been introduced too artificially,

he must be warned against hasty criticism. The Italian has so much more capacity for movement than we have, that his limits of the natural do not coincide with ours. Raphael here is clearly treading in the steps of Michelangelo, and in following that stronger will he has temporarily abandoned his natural tendency.[1]

We need not limit our examination to the individual figures. The motives of movement that Raphael presents here and there are a minor achievement compared with the art displayed in the grouping. Earlier Art can show nothing in the least comparable to the varied arrangement of these figures. The group of geometricians solves a problem which very few have essayed: five persons facing towards one point, clearly developed, " pure " in line, and displaying a marvellous variety of attitudes. The same may be said of the group opposite, conceived on a still larger scale: the way in which the multiple movements complete each other, in which the numerous figures are brought into the required connection, forming as it were a chorus of many voices, everything appearing natural and inevitable, is a proof of consummate art. If we look at the construction as a whole, we shall understand what place the youthful figure at the very back has in this company. It is conjectured to be a portrait of some prince—that may be, but its formal function is merely to supply the necessary vertical line in the tangle of curved lines.

As in the *Disputa*, the wealth of motives has been brought to the foreground. At the back on the platform, a forest of perpendicular lines: in the foreground, where the figures are large, curved lines and complicated groupings.

Everything round the central figures is symmetrical; then the tension relaxes, and on one side the upper mass itself spreads unsymmetrically down the steps, a disturbance of the equilibrium which is rectified by the irregularity of the groups in the foreground. It is certainly astonishing that in this crowd the figures of Plato and Aristotle in the distant background produce the effect of being the chief figures. This is doubly incomprehensible, if we notice the scale of size, which according to an

[1] The ideas borrowed from Donatello's Paduan reliefs (cf. Vöge, *Raffael und Donatello*, 1896) appear in such subordinate figures that they seem to have been introduced as a jest. In any case there is no question of borrowings due to poverty of ideas or difficulties of execution. Koopmann (*Raffael's Handzeichnungen*, 1897, p. 380 *et seq.*) has attempted to prove on remarkable evidence that they were introduced without the sanction of the master. He treats the matter altogether in too serious a spirit.

ideal calculation, diminishes too rapidly. Thus the Diogenes on the steps is abruptly drawn on a scale different to that of the nearest figures in the foreground. The marvel is explained by the use made of the architecture. The disputing philosophers stand exactly in the light under the last arch. Their figures would be lost, but for this halo, which finds an effective repetition in the concentric lines of the nearer vaulting. A similar motive, it may be remembered, is employed in Leonardo's *Last Supper*. If the architectonic element were removed the whole composition would fall to pieces.

The relation of the figures to the space is conceived in an entirely new spirit. The immense vaulted roof extends far above the heads of the persons, and the tranquil, solemn atmosphere of this atrium communicates itself to the spectator. Bramante's new St. Peter's was designed in this spirit, and according to Vasari, Bramante should be considered the creator of the architecture of this fresco.[1]

PARNASSUS

It may be imagined that Raphael was glad not to find himself confronted with a similar wall for the third task, the fresco of *The Poets*. The narrower surface here with the window in the middle naturally suggested new ideas. Raphael surmounted the window with a hill, a

[1] The *Disputa* and the *School of Athens* are chiefly known in Germany by engravings, and the profound impression of space given by the frescoes is reproduced better by even a superficial engraving than by any photograph. Volpato in the eighteenth century engraved the *Stanze* in a set of seven plates. These have been for generations the mementoes the traveller brings home with him from Rome, and these plates are not to be despised even now that Keller and Jacoby have essayed the task with other eyes and different means. Jos. Keller's *Disputa*, which appeared 1841-1856, puts all earlier reproductions into the shade by the size of the plate, and, while Volpato only attempted to reproduce the general configuration, the pencil of the German explored all the depths of Raphael's individual manner. He places his figures on the surface clearly and firmly with strong shadows. He wishes above everything to be distinct, and makes no attempt to reproduce the light tone of the fresco. Here Jacoby takes up the task. His *School of Athens* is the result of ten years' work (1872-1882). The layman can have no idea what an amount of consideration it required to find equivalent tones for each colour-value of the original on the copper-plate, to reproduce the softness of the painting, and to achieve distinctness while retaining the light scale of tones of the original. The engraving was an unparalleled achievement. Jacoby, in his essay, went perhaps altogether beyond the limits imposed on the graphic arts in such cases. There are still many amateurs who in such reductions of the original prefer the abbreviated expression of the simple old line-engraving, because in this it is easier to retain some trace of the monumental impression.

veritable Parnassus, and thus obtained two small foregrounds below and a somewhat broader podium at the top. Here Apollo is seated with the Muses. Homer too is there, and further in the background Dante and Virgil[1] are recognisable. The other poets throng the slopes of the hill, strolling alone or standing together in groups. Here a desultory conversation is being kept up, there some spirited recitation arrests attention. As the composition of poetry is not a social task, it was difficult to give any psychological characteristics to a group of poets. Raphael confined himself to giving the expression of inspiration twice; to Apollo, who is playing the violin and looking upwards in rapture, and to Homer, who is reciting in poetic frenzy and also looking heavenward, but with sightless eyes. Artistic economics required a diminution of excitement in the other groups. The divine madness shows itself only in the vicinity of the god. Beneath, we are amongst mortals like ourselves. Here again we do not feel called upon to give any definite names. Sappho is pointed out by an inscription, since otherwise no one would have known who the maiden was. Raphael clearly wanted a female figure as a contrast. Dante is insignificant, almost an accessory. The really striking figures are types to whom no names are assignable. Two portraits only are distinguishable among the crowd; one, quite on the edge of the picture to the right, is probably Sannazaro; the other, to whom Raphael has given the pose of his portrait of himself, has not yet been satisfactorily identified.

Apollo is seated, as are the two Muses at his side. He is painted fullface, while the Muses are in profile. They thus form a broad triangle, the centre of the composition. The other Muses stand about in the background. The line is terminated on the right by a dignified figure, turned away from the spectator, and balanced by the full face of the Homer on the opposite side. These two forms are the corner pillars of the Parnassian assembly. This grandly constructed group resolves itself in the boy at Homer's feet, who transcribes his verses. On the opposite side the composition takes an unexpected direction, extending into the background; the man next to the female figure, turning her back, is only three parts visible; he is walking from the farther side of the hill into the picture.

[1] Virgil is no longer fantastically arrayed, with a pointed crown, as Botticelli still represented him, but in the antique dress of the Roman poet. Signorelli was the first to represent him thus. (Orvieto). Cf. Volkmann, *Iconografia Dantesca*, S. 72.

The impression of this movement is intensified by the laurel-bushes which appear in the background. Attentive study of the disposition of the trees in the picture will show how important their share in it is. They introduce a diagonal movement into the composition and modify the stiffness of the symmetrical arrangement. Were it not for the trees in the centre, Apollo would be lost among the Muses.

A contrast between the groups of the foreground is attained, in so far as the left group, with a tree as its focus, appears quite isolated, while on the right the connection with the upper figures is maintained. There is the same trend of movement as in the School of Athens.

The *Parnassus* shows less beauty of space than the other pictures. There is a sense of narrowness and crowding on the hill, and few of the figures are convincing. Too many of them suffer from a certain pettiness. The most unsuccessful creations are the Muses, mere shapes who are none the more interesting for certain details taken from "antique" art. One of the seated figures imitates Ariadne in her drapery, the attitude of the other might be traced back to a figure like that of the so-called "Suppliant Woman." The exposure of the shoulder, a motive obtrusively repeated, is also taken from the antique. If only Raphael could have shown us more life-like shoulders! In spite of all the roundness of form we think regretfully of Botticelli's angular Graces. One simple touch of naturalism strikes us, that is the neck of the figure standing with its back towards us; it is the true neck of a Roman woman. The best figures are the absolutely simple ones. The contorted Sappho shows to what preposterous inventions the desire to be interesting in movement could lead the artist. Here Raphael momentarily lost his way, and entered into competition with Michelangelo without properly understanding him. We need but compare one of the Sistine Sibyls with this unfortunate poetess to appreciate the difference.

Another *tour-de-force*, which we do not wish to censure, is the sharp foreshortening of the arm of the man who is pointing to the front. Every artist of that day had to solve problems of this sort. Michelangelo expressed his opinion on the subject in his figure of God Almighty creating the sun.

Something must now be said of a peculiarity in the calculation of space in the picture. It is apparent that the Sappho and the figure corresponding to her project over the frame of the window. This effect is

unpleasant, because the figures thus seem to leave the flat surface. It is difficult to understand how Raphael could have perpetuated such a brutality. The truth is that he calculated quite otherwise. He thought that, by means of the archway, painted in perspective, which encircles the picture, he would be able to push the window back, and give the impression that it was somewhere in the background of the picture. This calculation was false, and Raphael never again made a similar attempt. Modern engravers have however intensified the mistake, by engraving the picture without the outside border, which alone explains the arrangement of the space.[1]

JURISPRUDENCE

Raphael was spared the task of painting an assembly of Jurists. For the fourth wall only two small ceremonial scenes from legal history were required at the sides of the window, and over it, in the filling of the arch, are the sitting figures of Fortitude, Prudence, and Temperance, the virtues necessary for the administration of the law.

As an expression of the virtues they are intended to typify, these symbolic figures will rouse but faint enthusiasm. They are uninteresting female figures, the two outside ones animated in gesture, the other calmer. They are all placed low down, in order to secure ampler motives of movement. Temperance is seen to raise her bit and bridle with incomprehensible deliberation. In her general action she is a pendant to the Sappho in the *Parnassus*. The turn of the upper part of the body, the outstretched arms, and the posture of the legs are similar. She is however drawn on a better and larger scale and is more compact. The increasing strength of style is well seen here. The Prudence, the repose of which is in itself pleasant, further possesses great beauty of line. In the drawing it shows a higher conception of clarity than the *Parnassus*. We may compare the arm on which the figure leans with the same motive in the

[1] The *grisaille* under the *Parnassus* cannot in my opinion be considered as co-temporary with the other paintings in the room. As opposed to the new interpretation of them lately propounded by Wickhoff, the older reading, which takes them to represent Augustus preventing the burning of the *Æneid*, and Alexander hiding Homer's poems in a coffin, seems still to have its advantages, since the gestures at least cannot be otherwise accounted for. There is no burning of books represented, but a prevention of the act, and the documents are being placed in a sarcophagus, not taken out. Every unprejudiced observer will, in my opinion, come to this conclusion.

Muse to the left of Apollo, where the meaning of the attitude is not well expressed. From this point there is gradual development, culminating in the Sibyls in S. Maria della Pace: there is an enormous addition to the wealth of action, and a similar progress in lucidity of motive. The third of the Sibyls must be specially mentioned in this connection. How convincingly are the structural elements worked out in the head, the neck, and the turn of the elbow.

The Sibyls are placed upon a dark background of tapestry, while the legal Virtues stand out against a brilliantly blue sky. This is an essential mark of the difference of style.

The two scenes from the history of Jurisprudence, the delivery of the secular and the ecclesiastical codes, are interesting as the representation of a ceremonial function in the spirit of the dawning sixteenth century. But it is also surprising to see here, just where the *Disputa* joins on, how Raphael at the close of his labours in the Camera della Segnatura, began to work with greater breadth and repose, and how, even in the size of his figures, he had far exceeded the original scale. It is a pity that the room no longer has its old wood panelling. The effect would at any rate be more restful than at present, with the white standing figures painted on the plinth. There is always some danger in placing figures below figures. The motive is repeated in the following rooms. It is far more endurable where it is part of the original arrangement, since these plastically treated Caryatides form a distinct contrast to the picturesque style of the paintings. It may be said that it is largely due to them that the pictures look like paintings, since they drive them back to the flat surface. But this relation does not exist in the first room, where the style is still far from picturesque.

4. THE CAMERA D'ELIODORO

Leaving the emblematic pictures of the Camera della Segnatura we enter the room of the historical frescoes. More than this: It is also the room of the new grand pictorial style. The figures are larger in size, and more imposingly plastic in effect. It looks as if a hole had been made in the wall. The figures stand out from a deep and dark recess, and the enframing mouldings are treated with painted shadows that give a plastic illusion. If we look back at the *Disputa*, it appears like a piece of

tapestry, flat and light. The paintings contain less, but this less produces a more striking effect. There are no artificial and subtle configurations, but imposing masses strongly contrasted. No trace is left of specious daintiness, no display of attitudinising philosophers and poets. In place of this, there is abundance of passion and expressive movement. The first apartment will always rank higher as decorative art, but in the Stanza of Heliodorus Raphael has provided a model of monumental narrative for all time.

The Chastisement of Heliodorus

We read in the second book of the Maccabees how the Syrian general, Heliodorus, set out for Jerusalem, at the command of his king, to carry off from the temple the money belonging to the widows and orphans. The women and children, thus threatened with the loss of their property, ran weeping about the streets. The High Priest, pale with fear, prayed before the altar. No representations or entreaties could deter Heliodorus from his purpose. He broke into the treasury and emptied the coffers. Then suddenly a heavenly horseman, in golden armour, appeared and hurled the robber to the ground, trampling him beneath his horse's hoofs, while two youths scourged him with rods.

This is the received story. Raphael has combined the various incidents into one picture, not in the manner of the old painters, who did not hesitate to place different scenes in close juxtaposition, but without violating the unities of time and place. He does not give the scene in the treasury, but shows Heliodorus in the act of leaving the temple laden with the plunder. He introduces the women and children, who are described as running screaming through the streets, into the same place, and makes them witnesses of the divine interposition. The High Priest, who prays to God for help, naturally finds a place in the picture.

The greatest surprise for the public of the day was the way in which Raphael arranged his scenes. It was customary to find the chief action in the middle of the picture, but here there is a great empty space in the centre and the culminating scene is pushed away to the extreme edge of the picture. At the present day we can hardly adequately appreciate the impression produced by such a composition, for we have since been educated to accept very different manifestations of "formlessness." People then

must have really believed that they saw the story taking place under their very eyes, with all the suddenness of miracle.

In addition to this, the scene of the punishment is worked out on new dramatic laws. The way in which the Quattrocento would have told the story is obvious. Heliodorus would lie bleeding under the horse's hoofs, and the youths, one on each side, would be striking him with their scourges.[1] Raphael depicts the moment of suspense. The evil-doer has just been thrown down, the rider wheels his horse in order to trample him. The youths are only just rushing forward with the rods. Giulio Romano, later, composed the beautiful *Stoning of Stephen* (in Genoa) on a similar plan; the stones are lifted, but the saint is still unharmed.[2] Here the movement of the youths has the special advantage that the impetuosity of their rush lends additional spirit to the horse, repeating as it does, the same motive of lightning swiftness. The speed of movement, in which their feet hardly seem to touch the ground, is depicted with marvellous skill. The horse is less good, for Raphael was no animal painter.

The prostrate Heliodorus, on whom vengeance falls, would have been depicted by the Quattrocento as a common rascal, a nursery ogre without a single redeeming feature. The sixteenth century held other views. Raphael did not make him ignoble. His companions are shouting. He himself, though fallen, is calm and dignified. The head itself is a masterpiece of Cinquecentist force of expression. The painful upraising of the head, the essentials of which are indicated in the fewest possible forms, is unparalleled in earlier artists, and the motive of the body must be considered both new and far-reaching in its influence.[3]

The women and children stand opposite to the group of the horseman, huddled together, all movement arrested, and showing a compact outline. The impression of numbers is produced by very simple means. If we count the figures, we shall be surprised to find how few they are, but all the movements, the inquiring upward glance, the pointing hand, the shrinking and seeking for concealment, are developed in telling lines and extremely effective contrasts.

[1] This is the version adopted by Michelangelo, who introduces the story in the Sistine ceiling, on a small scale (in one of the bronze medallions).
[2] The same idea had been worked out in the *Stoning of Stephen* in the Sistine tapestries.
[3] I do not support the view, occasionally put forward, that the idea is borrowed from the antique. (Motive of a river-god.)

Pope Julius, seated calmly in his litter, is seen above the crowd. He is looking into the picture, towards the background. His retinue, also portrait-figures, take no part in the event, and it is difficult to understand how Raphael could have consented to abandon the emotional unity of the picture. It was probably a concession to the taste of the Pope, who wished to be present in person in the fashion of the fifteenth century. The canons of art might insist that every person in the picture should be represented as taking part in the action, but there were perpetual deviations from this rule. In this particular instance the Pope's whim was so far salutary, that it gave Raphael the advantage of a peaceful contrast to the general excitement of his story.

Two boys may be seen clambering on the pillar towards the background. What are they there for? It may be supposed that so conspicuous a motive is no mere incident, which might be omitted at will. They are necessary for the composition, as a set off to the fallen Heliodorus. The scale of the balance, depressed on the one side, rises on the other. The " Down, down!" of the victor is effectively accentuated by this contrast.[1]

The treatment of the clambering boys discharges another function: they guide the eye towards the centre of the picture, where we finally discover the priest praying. He is kneeling at the altar, and does not know that his prayer has been already heard. Imploring helplessness is the keynote of the centre of the composition.

The Deliverance of Peter

Raphael has told us in three frescoes how Peter lay in prison and was called by an angel at night; how, still dreaming, he went out accompanied by the angel, and how the watch was roused when his flight was discovered. The pictures seem almost to have arranged themselves, on the scanty surface of a wall broken by a window. In the middle we have the dungeon, the front of which is merely a grating affording an unimpeded view. Right and left are steps, which lead up from the foreground and are important as giving the impression of depth and distance to the picture. The master thus avoided the disagreeable effect which would have been

[1] The indication of a similar motive in Donatello's relief, the *Miracle of the Ass*, is not to be taken as an indictment against Raphael. It would be absurd to talk of borrowing in this case.

produced if the recess of the dungeon had seemed to be immediately above the recess of the window-niche.

Peter sits asleep on the floor, his hands folded over his knees as in prayer, his head a little bowed. The angel, in a glory, bends down to him, lays a hand on his shoulder and points with the other. Two warders, encased in armour, stand on either side leaning against the wall overcome with sleep. Could the scene be more simply presented? And yet it required a Raphael to see it thus. Never since has the story been told so simply and so impressively. There is a picture

The Deliverance of St. Peter; by Domenichino.

of the Deliverance of Peter by Domenichino, which is universally known, for it hangs in the church where the holy chains are preserved, in S. Pietro in Vincoli. There too the angel is bending down and grasping Peter by the shoulder. The old man awakes and starts back in terror at the apparition. Why did Raphael represent him sleeping? Because only thus could he express the pious resignation of the prisoner, for fear is an emotion common to the good and the bad. Domenichino attempted foreshortening, and the effect is disturbing. Raphael painted a simple full-length figure, and the effect is reposeful and quiet. In Domenichino's picture again there are two warders in the prison, the one lying on the floor, the other leaning against the wall. With their obtrusive movement and their carefully executed heads, they claim

attention as insistently as the chief figures. What delicate discrimination Raphael shows here! His warders blend into the wall, they are merely living adjuncts to the walls, and we do not require to notice their coarse features, in which we take absolutely no interest. It need hardly be said that Raphael avoids all detail in the drawing of the prison-walls.

In the *Exit from the Prison*, which earlier art used to represent as the kernel of the story, Peter was always represented in the act of talking with the angel. Raphael remembered the words of the text: he went out as if in a dream. The angel leads him by the hand, but he does not see the angel, he does not look at the road; staring into vacancy with widely opened eyes, he walks away like a dreamer. The impression is greatly enhanced by the way in which the figure emerges from the darkness, partly hidden by the radiance of the angel. The painter's instinct speaks here in Raphael, who had already created a very novel effect in the twilight of the dungeon. And what shall we say of the angel? He is the incomparable type of a swiftly-moving guiding force.

The steps above and below are occupied by sleeping soldiers. The sacred narrative mentions that the alarm was given. It is supposed to have been given in the morning. Raphael observes the unity of time, and in order to balance the light to the right, he places a crescent moon in the sky, while in the east the dawn begins to break. Then he ventures on a pictorial audacity; the flickering light of a single torch casts a ruddy reflection on the stones and polished armour.

The *Deliverance of Peter* is the one of Raphael's works best calculated to win for him the admiration of doubtful adherents.

The Mass of Bolsena

The Mass of Bolsena is the legend of an unbelieving priest, in whose hands the wafer began to bleed at the altar. It may be imagined that this would produce a highly effective picture. The priest starting back awe-struck, the spectators overcome by the sight of the miracle. The scene has been painted thus by other artists; Raphael does not adopt this method. The priest, who is kneeling before the altar and is seen in profile, does not start up, but motionless, holds the bleeding wafer in his hand. A

struggle is going on within him more interesting psychologically than a sudden outburst of ecstasy. By making the chief actor motionless Raphael gains the opportunity for a marvellous *crescendo* in the effect of the miracle on the crowd of believers. The choristers who are the nearest whisper together, and sway their bodies. The foremost boy involuntarily bows in adoration. On the steps men are pressing and pushing. The excitement reaches its climax in the woman in the foreground, who has leapt up, and straining forward with look and gesture, indeed with her whole figure, might be an embodiment of belief. Earlier artists have represented Faith in such an attitude, and there is a relief by Civitali, which shows a marked similarity in the upturned head and the half-hidden profile. (Florence, Museo Nazionale.) The end of the line is formed by crouching women and children grouped before the steps, the indifferent multitude, ignorant as yet of the miracle.

In this fresco again the Pope wished to appear with his retinue. Raphael reserved one half of the picture for him. After some preliminary hesitation he actually placed him on a level with the principal figure. Thus the two are kneeling opposite each other, profile to profile; the astonished young priest, and the old Pope in his formal attitude of prayer, calm and unmoved as the ecclesiastical principle. Considerably more to the background is a group of Cardinals, excellent portraits, but no one of them can compare with their sovereign. In the foreground are the Swiss Guards with the papal litter. They too are kneeling, clearly pronounced types, untouched by any spiritual excitement. The reflex action of the miracle expresses itself merely in a prosaic eagerness among some of them to find out what is happening.

The composition is therefore based on a great contrast of motives, suggested by the nature of the mural surface. There could be no representation of the interior of a church. A window which had to be taken into consideration again broke the wall. Raphael constructed a terrace with steps leading down at the sides, and placed the altar on it so as to form the centre of the picture. He surrounded the terrace with a circular parapet, and in the background alone there is a trace of ecclesiastical architecture. As the window is not in the middle of the wall, there is an inequality between the two divisions of the fresco, which Raphael counteracted by raising the left or narrower side somewhat higher. This justifies the introduction of the men who appear behind the priest on the

parapet, and who would not have been necessary for the mere purpose of pointing out, and so elucidating the phenomenon.[1]

The last picture in the room, the *Meeting of Leo I. and Attila*, is a disappointment. It is of course obvious that the quiet dignity of the Pope and his retinue is designed to dominate the excited hordes of the Hunnish king, although the papal *cortège* occupies the inferior position as regards space, but this effect was not attained. It cannot be said that the apparition of the divine helpers, Peter and Paul, who threaten Attila from the sky, destroys its impressiveness. The contrast in itself is not well worked out. It is difficult to find Attila at all. Subordinate figures intrude themselves perplexingly; there are discords in the lines and obscurities of the most unfortunate kind. Raphael's authorship of this work, which does not agree with the others in tone, cannot be unreservedly accepted. It need not be reckoned with in our demonstration.[2]

In the same way we cannot follow Raphael into the third room, and examine the *Burning of the Borgo*. The chief picture, which gives its name to the room, contains very beautiful individual motives, but the good is mixed with the indifferent, and the whole lacks the compactness of an original composition. The woman carrying water, the man extinguishing the fire, and the group of fugitives will be readily accepted as inventions of Raphael's, and are typical instances of his creation of beautiful individual figures in his last years. But the further development of his grand narrative manner must be looked for in the cartoons for the tapestries of the Sistine Chapel.

[1] Raphael assumes that the spectator stands exactly in the middle axis opposite the picture, the left-hand side of the window-frame therefore projects a little into the pictured space.

[2] I may draw attention to certain obscurities in drawing which are incompatible with Raphael's consummate mastery :

(a) Attila's horse. The hind-legs are indicated, but in a ludicrously fragmentary manner, as far as the hoofs.

(b) The gesticulating man, between the black horse and the white. Only a piece of his second leg appears.

(c) One of the two spearmen in the foreground is very defective in form.

The ground and the landscape are not in Raphael's style. A strange hand, talented but untrained, shared the work. The good portions are to the left.

5. The Cartoons for the Tapestries

The seven cartoons in the South Kensington Museum, all that remain of a series of ten, have been called the "Parthenon Sculptures" of modern art. They certainly surpass the great Vatican frescoes both as regards fame and influence. Lending themselves well to reproduction as compositions containing few figures, they have been widely diffused as models, by means of wood-cuts and engravings. They were the treasury, from which the various forms of expression of human emotions were obtained, and Raphael's fame as a draughtsman is mainly based on these achievements. The West, in many instances, has seemed quite incapable of imagining other forms of gesture to express astonishment, fear, the distortions of grief, dignity, and majesty of bearing. The number of expressive heads and of eloquent figures in these compositions is astonishing. This produces the loud, almost strident effect of some of the pictures. They are unequal in merit, and not one contains Raphael's actual handiwork.[1] But some of them are so perfect that we recognise the immediate presence of Raphael's genius.

The Miraculous Draught of Fishes. Jesus had gone out on the lake with Peter and his brother. At His command the nets had been once more let down, after the fishermen had toiled all night in vain. They then made so stupendous a draught that a second boat was called up to help haul the net in. Peter is struck by the evident miracle—*stupefactus est*, the Vulgate has it—; he throws himself down at the Lord's feet: "Depart from me, O Lord, for I am a sinful man." Christ therefore gently calms the excited man: "Fear not."

That is the incident. Two boats out on the lake. The net has been hauled in; the vessels are full of fish, and in the midst of this confusion we have the scene between Peter and Christ.

The initial difficulty was how to give proper emphasis to the chief figures in the midst of so many men and objects, especially since Christ could hardly be presented otherwise than seated. Raphael made the boats small, unnaturally small, in order to insure the prominence of the figures. Leonardo had thus reduced the size of the table in the *Last Supper*. The

[1] Cf. H. Dollmayr, *Raffael's Werkstätte* (*Jahrbuch der Kunsthistor. Sammlungen des Allerhöchsten Kaiserhauses*, 1895). "In the essential parts only one hand worked on the cartoons, that of Penni" (p. 253).

classical style sacrificed reality to the essential. The shallow boats are close together, and are parallel to the picture-plane, the second being slightly overlapped by the first. All the mechanical work is assigned to the second and farther boat. Here two young men are seen drawing up the nets—Raphael shows the draught just at its completion, while the oarsman is seated, and strains every muscle to keep the boat balanced. These figures, however, have no independent action in the composition, but serve only as a starting point or introduction to the group in the foremost boat, where Peter has sunk on his knees before Christ. With marvellous skill, the occupants of the boats are all brought into one great line, which rises by the rower, mounts over the bending forms, finds its culminating point in the upright figure, then suddenly sinks and finally rises once more in the figure of Christ. Everything tends towards Him, He gives the movement its object, and, although insignificant in mass and placed quite at the edge of the picture, His figure dominates all the others. No such composition had ever yet been seen.

The attitude of the central standing figure determines the impression of the whole, and it is noteworthy that this was an afterthought. It had long been part of the scheme that there should be an upright figure at this place in the picture, but it was to have been merely a rower, who, save that he was required for the boat, took no intimate share in the action. Ultimately Raphael felt the necessity of strengthening the emotional effect. He associated the man—we must call him Andrew—in Peter's action and thus adds a singular intensity to the act of adoration. The kneeling down is to some degree expressed in two actions. The plastic artist represents a gradual process which he could not otherwise depict by simultaneous pictures. Raphael frequently made use of this motive. We may remind the reader of the horseman with his companions in the *Heliodorus*.

The group is developed with the utmost rhythmic freedom yet as inevitably as an architectural composition. Each part, down to the smallest detail, has its due relation to the rest. Note how the lines are balanced, and how each section of the surface seems precisely adapted for the subject which fills it. It is this which produces the restful effect of the whole.

The lines of the landscape are also drawn with a definite intention. The coast line exactly follows the ascending contour of the group, then the

The Miraculous Draught of Fishes.
From N. Dorigny's Engraving after Raphael's Cartoon.

horizon becomes open, and the outline of a hill again rises over Christ. The landscape emphasises the important cæsura in the composition. The earlier representations showed trees, hills and dales, the more the better, it was thought. Now the landscape in a picture serves the same purpose as the architecture, that of helping the figures.

Even the birds, which elsewhere dart aimlessly about in the air, aid the main action. Flying forward from the background, they sink precisely where the cæsura occurs, and even the wind is called upon to strengthen the general effect.

The high horizon is somewhat singular. Raphael clearly wished to give his figures on the surface of the water a quiet uniform background. Here he applies what he had learnt from Perugino, whose *Delivery of the Keys* shows a similar intention in the buildings he has thrust far into the background. The foreground is varied and full of movement, in contrast with the uniform surface of the lake. A strip of the foreshore is visible, although

the scene is supposed to take place in the middle of the lake.¹ Some herons stand there, splendid birds, perhaps too conspicuous when the picture is only known by reproductions in black and white. On the tapestry their brown tones blend with the water, and are not very noticeable by the side of the luminous human figures.

Raphael's *Miraculous Draft of Fishes*, like Leonardo's *Last Supper*, belongs to the pictures which henceforth cannot be conceived otherwise. How inferior is Rubens to Raphael! By the one motive, the starting up of Christ, he has robbed the scene of its nobility.

"*Feed my Lambs.*" Raphael here deals with a theme which had been already painted by Perugino in the Sistine Chapel, the place for which the tapestry was intended. The scene as rendered by Perugino is only the *Delivery of the Keys*, here the stress is laid on the words of the Lord; "Feed my Lambs!" The motive is the same, and in this connection it is immaterial whether Peter already holds the key in his arms or not.² In order to indicate the charge, an actual flock had to be included in the picture, and Christ emphasises the command by a vigorous twofold gesture. What with Perugino was merely an emotional attitude, is here effective action. The episode is treated with historic gravity. Peter, kneeling and gazing intently upwards, is full of the emotion proper to the moment. And the rest? Perugino gives us a series of beautiful motives with his standing figures and bowed heads. How could he do otherwise? The disciples, however, have nothing to do with the incident. It is unfortunate that they were so numerous, for the scene becomes somewhat monotonous. Raphael introduces a new and unexpected effect. They stand together in a dense mass, from which Peter emerges but slightly. But what a wealth of varied expression animates this crowd! The nearest disciples, attracted by the radiant figure of Jesus, feast their eyes on Him, ready to fall, like Peter, on their knees. Then there is a hesitation, a feeling of doubt, a casting of inquiring glances, and the last hold back in pronounced distrust. It is the risen Christ who has appeared to the disciples, and has spoken to them; but is it really He or is it a spirit? Raphael's conception of the theme is to show how the feeling of conviction gradually steals over the

[1] Was it an instinct of style that made Raphael require some solid object in the foreground? Botticelli, too (*Birth of Venus*), did not bring the water up to the edge of the picture. The *Galatea* is an instance to the contrary, but a fresco is not bound by the same conditions.

[2] The latter was at any rate Raphael's original idea.

"Feed my Lambs."
From N. Dorigny's Engraving after Raphael's Cartoon.

group, how first the foremost members are attracted, while the more remote ones remain unmoved. This conception requires much power of psychological expression, and was quite beyond the capacities of the elder generation.[1]

Perugino shows Christ in the middle of the picture and the bystanders symmetrically distributed on either side, but in Raphael's cartoon Christ stands alone facing the others. He does not turn towards them, but is passing by them. The disciples only see Him from one side. In another instant He will be there no longer. He is the only figure which reflects the light in broad surfaces. The others have the light against them.

The Healing of the Lame Man. The spectator looking at this picture always begins by inquiring the meaning of the great twisted columns. He recalls the halls of the Quattrocento, those transparent structures, and cannot comprehend how Raphael arrived at the elephantine forms which are so conspicuous here. The source of the motive of the twisted column

[1] This interpretation follows Grimm, *Leben Raffaels*.

can be traced. There was one such in St. Peter's, which, according to tradition, was brought from the Temple at Jerusalem, and the "Beautiful Gate" of that very temple was the scene of the healing of the lame man. The conspicuous feature here is not so much the peculiar shape, as the combination of human forms with architecture. Raphael does not draw the pillars as stage-scenery or as a background. He shows the people in the portico, a seething throng, and he gets this effect with comparatively few figures, because the columns themselves fill up the space.

It is indeed easy to see that the pillars were very desirable as a means of dividing and enframing the subjects. It was no longer sufficient to present the people standing about, arranged in rows, as the Quattrocentists had done. Yet if a real crowd were painted, there was considerable risk that the chief figures would be lost in it. This danger has been obviated, and the spectator notices the beneficial effect of such an arrangement before he can account for the way in which it is done. The scene of the healing itself is a splendid example of the virile and powerful manner in which Raphael was now able to represent such an incident. St. Peter, who works the cure, does not strike an attitude; he is not the exorcist, who utters a magic formula, but the capable physician, who simply grasps the hand of the cripple, and with his right hand makes the sign of benediction. The incident is depicted with very little action. The Apostle stands upright and only slightly bows his massive neck. Earlier artists represented him bending down to the sufferer, but the miracle of raising him up appears less marvellous so; St. Peter looks steadfastly at the cripple, who gazes at him wistfully and expectantly. The two profiles are opposite each other, and the tension of the two figures is evident. The psychical illumination of the scene is unparalleled.

St. Peter has a companion figure in St. John, who stands by, his head slightly bent, with a kindly gesture of encouragement. The cripple has his antithesis in a colleague who looks on with dull envy. The crowd pressing forward in doubt or curiosity, presents a great variety of expression, and contrast is afforded by a proportion of indifferent passers-by. Raphael has introduced into this scene of human misery a contrast of another kind; two naked children, ideal forms, whose luminous flesh-tints shine out from the picture.

The Death of Ananias is a thankless subject for a picture, since it is impossible to represent death as the result of transgression. The painter

The Death of Ananias.
From N. Dorigny's Engraving after Raphael's Cartoon.

can depict the commotion, the awe-struck bystanders, but how can the moral lesson of the incident be enforced, or how can it be shown that this is the death of the unrighteous? Raphael has done his best to express this, at least superficially. The composition of the picture is very austere. On a podium in the middle stands the entire band of Apostles, a compact and impressive mass against a dark background. On the left the gifts are being brought, on the right they are being distributed, a very simple and perspicuous motive. In the foreground is the dramatic incident. Ananias lies convulsed on the ground. Those nearest to him start back in horror. The circle of these figures in the foreground is so constructed that Ananias, falling backwards, makes a gap in the composition which is visible from a distance. We now understand why everything else is so severely ordered. The object was to give all possible emphasis to this one break in the symmetry. The judgment has fallen like a thunder-bolt, and the victim lies low. Now it is impossible to overlook the connection of this with the other group of the Apostles, who stand for destiny here. The eye is

immediately directed towards the centre, where Peter stands and stretches out an eloquent arm towards the prostrate man. There is no noisy movement: he does not fulminate, he wishes only to say " God hath judged thee." Paul, close by, repeats the verdict with uplifted hand, gazing at Sapphira, who is entering. The Apostles are not unnerved at what has happened ; they all remain calm ; the crowd alone, which does not perceive the connection of events, breaks up in violent alarm. Raphael introduces few figures, but they are types of intense bewildered fear, which have been repeated countless times by the art of succeeding centuries. They have become academical models of expression. Infinite harm has been done by transplanting this Italian gesture-language to a northern soil. But even the Italians have sometimes completely lost the feeling for natural expression and have lapsed into artificiality. As foreigners we will not attempt to decide how far the action in this picture is natural. But we may note here how the delineation of types gives way to the delineation of expression. The interest in the expression of passionate emotions was so strong in itself that individuality of feature was willingly abandoned in its favour.

The Blinding of Elymas. Elymas the sorcerer is suddenly struck blind, when he attempts to withstand the Apostle Paul in the presence of the pro-consul of Cyprus. It is the old legend of the Christian saint conquering his adversary in the presence of the heathen ruler. The scheme of composition which Raphael used, is thus the same that Giotto knew, when he painted St. Francis in the scene before the Sultan with the Mohammedan priests. The pro-consul is in the centre and to the front, right and left, the two parties face each other, as with Giotto, only the incidents of the picture are more vigorously concentrated. Elymas has advanced towards the middle of the picture, and suddenly recoils, as it grows dark before his eyes, stretching out both hands and throwing up his head—an unsurpassable picture of the man struck blind. Paul has remained calm ; he is quite on the edge of the picture, his back partly turned to the spectator. The face is in shadow (while the light falls full on Elymas) and appears in "lost profile." He gesticulates with the arm which is stretched out towards the sorcerer. It is no impassioned gesture, but the simplicity of the horizontal line, which joins the great vertical line of the imposing upright figure, has a very striking effect. He is the rock from which evil must recoil. In comparison with the

protagonists in the scene, the other figures, even if they had been treated with less indifference, could hardly have proved interesting. The pro-consul Sergius, who is only a spectator in the scene, throws back his arms, a characteristic attitude of the Cinquecento. He may have been thus conceived in the original sketch, but the other persons are complementary figures, more or less superfluous and distracting, which, combined with slovenly architecture and certain cheap picturesque effects, make the picture somewhat restless. Raphael does not seem to have superintended the completion of this work.

This impression is conveyed still more strongly by the *Sacrifice at Lystra*. This much-praised picture is a complete enigma. Nobody could guess that a cripple had been healed there, that the people wished to sacrifice to the man who had wrought the miracle as to a god, and that he—the Apostle Paul—was rending his garments in deprecation of the act. The chief stress is laid on the representation of an antique sacrificial scene, imitated from a relief on an ancient sarcophagus, and everything is made subservient to the archæological interest. The extensive use made of this model is in itself a reason for rejecting Raphael's authorship, to say nothing of the fact that every deviation from the original has been for the worse. The composition is awkwardly arranged and confused in direction. The picture of *St. Paul preaching at Athens* is, on the other hand, a great and original creation. The preacher, both arms uplifted, dispensing alike with the adjuncts of lofty attitude and flowing draperies, is grandiose in his earnestness. He is seen only from one side, almost from behind. He is standing on a height, preaching into the picture, and has stepped forward, to the very edge of the steps. This gives him an air of passionate appeal, in spite of his calm. His features are in shadow. The whole expression is concentrated in the simple and imposing line of the figure, which triumphantly dominates the picture. All the preaching saints of the fifteenth century are mere tinkling cymbals in comparison with this orator.

By an ideal calculation the listeners below are far smaller figures. It was a task entirely congenial to the Raphael of that day to represent the working of the speech on so many faces. Some figures are worthy of him; in others it is difficult to resist the impression that some other pencil has been at work (especially in the coarse heads of the foreground).

The architecture is somewhat obtrusive. The background to the figure

of St. Paul is good in its place, but one would gladly see the circular temple (of Bramante) replaced by some other building. The Christian orator is echoed, in a diagonal line, by the statue of Mars, an effective method of enforcing the direction of the composition.

We will omit the compositions which no longer exist as cartoons, and are known only in the textile form, but we must make a general observation as to the relation of the drawings to the tapestry. The process of working, as is well known, reverses the picture, and it would be expected that the models should provide for this. Strangely enough, the cartoons are not uniform in this respect. The *Miraculous Draught of Fishes*, the *Charge to Peter*, the *Healing of the Cripple*, and the *Death of Ananias* are drawn in such a way that their full effect is reserved for the tapestry, while the *Sacrifice at Lystra* and the *Blinding of Elymas* lose in being reversed. (The *Preaching at Athens* is not affected.)[1] It is not merely the fact that the left hand becomes the right hand, and that a blessing given with the left hand would be incongruous: a composition of Raphael's in this style cannot be reversed at will, without destroying some elements of its beauty. Raphael, according to the style he learnt, leads the eye from left to right. Even in the compositions which show no movement, such as the *Disputa*, the trend is in this direction. In the great representations of action no other arrangement will be found: Heliodorus had to be thrust into the right hand corner, to add cogency to the movement. When in the *Miraculous Draught of Fishes* Raphael wishes to guide us past the curve of the fishermen to the figure of Christ, it is again natural for him to go from left to right; but where he wishes to emphasise the sudden prostration of Ananias, he makes him fall in a contrary direction.

Our reproductions, which have been made from N. Dorigny's engravings, give the right view, for the engraver, working without a mirror, unintentionally reversed the picture.

6. The Roman Portraits

In passing from the historical picture to the portrait it may be fitly said that the portrait was now destined to become the historical picture. Quattrocentist likenesses have a something naïve and an air of being

[1] It seems however to require to be reversed, since it is only then that the figure of Mars holds the shield and spear correctly.

studies from models. They present the person without any very definite expression. The sitters gaze out from their portraits with an indifferent, an almost disconcerting self-possession. The aim of the artist was a striking likeness, not any special emotion. Exceptions occur, but, on the whole, it was thought sufficient to perpetuate the sitter in his habitual character, and the impression of reality did not seem to suffer when conventionalities of attitude were preserved.

The new art demands that portraits should show a personally characteristic situation, a definite moment of individual life. The painter will no longer trust to the forms of the heads to speak for themselves, the movement and gestures must now be full of expression. There is a transition from the descriptive to the dramatic style.

The heads too, show a new vigour of expression. It will be readily seen that this art has ampler means of characterisation at its command. The treatment of light and shade, the use of line, the distribution of mass, have been enlisted in its service. Everything is intended to produce a definite impression. And in order to accentuate the personality further, certain forms are now brought into special prominence, while others are repressed, whereas Quattrocentists gave an almost equal value to each part.

We cannot yet look for this style in Raphael's Florentine portraits. It was only in Rome that he became an accomplished portrait-painter. The youthful artist hovered round the model like a butterfly, and as yet he failed to grasp the individuality of form, to extract its characteristic essence. The *Maddalena Doni* is a superficial portrait, and it seems to me impossible to ascribe to the same author the excellent female portrait of the Tribuna (the so-called *Doni's Sister*). In his Florentine period Raphael clearly did not possess the power of thus assimilating the object before his eyes.[1] His development presents this curious spectacle: his strength of characterisation increases *pari passu* with the grandeur of his style.

The portrait of *Julius II.* will always be looked upon as his first great essay in this *genre*. I refer to the Uffizi example, for that in the Pitti is distinctly later, even allowing it to be original. It assuredly deserves the name of a historical picture. The Pope, as he sits there, his mouth firmly closed, his head somewhat bent in a moment of reflection, is no model placed in

[1] The attribution to Perugino seems to me irrefutable, taking into account its great affinity with the *Timete Deum* head in the Uffizi (portrait of Francesco dell' Opere).

the correct position, but rather a fragment of history, the Pope in a typical attitude. The eyes no longer gaze at the spectator. Their cavities are in shadow, but on the other hand the massive forehead, and the powerful nose, the chief mediums of expression, stand out prominently in a uniform high light. These are the accentuations of the new style, and later they would have been still more pronounced. One would gladly have seen this very head treated by Sebastiano del Piombo. The problem was different in the *Leo X.* (Pitti). The Pope had a fat heavy face. Here the master seeks to divert attention from the broad expanse of sallow flesh, by the play of light, and to bring out the spirituality of the head, the delicacy of the nostrils, and the wit of the sensuous, eloquent mouth. It is marvellous how the dull short-sighted eye has gained in power, without changing in character. The Pope is represented suddenly looking up from the study of an illuminated codex. There is something in his look which characterises the ruler better than if he had been represented on his throne, wearing the tiara. The hands are even more individual than those of Julius. The accompanying figures, very significantly treated in themselves, only serve as a foil, and are in every respect subordinate to the chief motive.[1] Raphael has given no inclination to any of the three heads and we must admit that this thrice-repeated vertical line spreads a sort of solemn calm throughout the picture. The *Julius* portrait has an uniform (green) background, whereas we see here a foreshortened wall with pillars, which possesses the double advantage of heightening the plastic illusion, and of giving alternations of light and dark surfaces as foils to the chief tones. The colour, however, has been toned down considerably and tends to neutral tints. The old gaily coloured background is abandoned, and all emphasis is reserved for the colours of the foreground. Thus the papal crimson makes as splendid a show as possible against the greenish grey background.

Raphael has given another sort of momentary animation to a squinting scholar, *Inghirami*. (The original formerly at Volterra is now at Boston, an old copy in the Pitti Gallery.) Without suppressing or concealing the natural defect, he was able to neutralise it by the intensity of the serious and thoughtful expression. A look of indifference would be unendurable under the circumstances, but the spectator's attention is diverted from the

[1] Is it by an artistic licence that they appear so low down, or are we to assume that the Pope is seated on a podium?

Portrait of Francesco dell' Opere, by Perugino.

disfigurement to the expression of intellectual intensity in this gifted savant's up-turned face.

The *Inghirami* is one of the earliest Roman portraits. If I am not mistaken, Raphael, at a later date, would have avoided this strong accentuation of a momentary action, and would have chosen a quieter motive for a portrait which demands long and repeated inspection. Perfect art can give all the charm of momentariness even to repose. Thus the *Count Castiglione* (Louvre) is very simple in the action, but the slight inclination of the head and the folding of the hands are full of a momentary and

individual attraction. The man looks out of the picture with a calm, soulful gaze, unmarked by any obtrusive sentiment. Here Raphael had to paint the noble courtier, the embodiment of the type of the perfect cavalier described by Castiglione himself in his little book, *Il Cortigiano*. Modesty is the keynote of his character. The nobleman here adopts no aristocratic pose; he is distinguished by an unpretentious and unobtrusive tranquillity of bearing. The richness of effect of the picture is won by the turn of the figure,—on the same plan as the *Monna Lisa*,—and the grandly arranged costume. How imposing is the development of the silhouette! If for purpose of comparison we take a somewhat earlier picture, such as the *Portrait of a Man* by Perugino in the Uffizi, we shall discover that the figure bears quite a novel relation to the surface, and we shall feel how much the wide space, and large, quiet planes of the background enhance the imposing appearance of the sitter. The hands now begin to disappear. The master seems to have feared that they would divert attention from the features in a half-length portrait. If they were intended to play a conspicuous part, the picture was made a three-quarters length. The background here is a neutral grey full of shadows. The costume is also grey and black, so that the flesh-tints remain the only warm tones. Masters of colour, such as Andrea del Sarto and Titian, have, like Raphael, introduced the white tones of the shirt in a similar scheme of colour.

Clarity of drawing has perhaps reached its highest perfection in the Madrid *Portrait of a Cardinal*.[1] The whole effect is obtained by absolutely simple lines, and has the grandeur and repose of architecture.

The portraits of the two Venetian scholars, Navagero and Beazzano (in the Doria Gallery) cannot be positively assigned to Raphael's own brush, but they are in any case splendid examples of the new style, and instinct with life and character. In the *Navagero* we have the vigorous vertical line; the head is abruptly turned to look over the shoulder, and a broad light falls on the muscular neck. The power of the bony framework is accentuated, and every detail adds to the expression of vigorous activity. Beazzano is the antithesis, the gentle self-indulgent nature, with the head mildly inclined and softly illuminated.

[1] The title of the picture is still doubtful. The statement in the *Cicerone* that the *Cardinal Bibbiena* in the Pitti is an "inferior copy" of the Madrid picture is incorrect. The two pictures have no connection whatever.

Portrait of a Cardinal, by Raphael.

The Violin-Player, by Sebastiano del Piombo.

The *Violin-Player* (at one time in the Palazzo Sciarra, Rome, now in the Rothschild collection, Paris) was formerly attributed to Raphael, but is now universally considered a work of Sebastiano del Piombo. This highly attractive head, with its wistful look and determined mouth, eloquent of some intimate tragedy, is noteworthy as a product of Cinquecentist portraiture, even if compared with Raphael's youthful portrait of himself. It is not a mere difference in the models, but a difference in grasp of the

subject that is evident. There is new restraint in expression, and an amazing power and certainty in the effect. Raphael had already tried the experiment of putting the head to one side of the canvas. Sebastiano goes still farther in this respect. A slight inclination, almost imperceptible, is shown. The arrangement of the light is very simple, one side being completely in shadow. The contours are very strongly marked. Then we have a great contrast of direction, the eyes turned to look over the shoulder. At the same time enough of the right arm is shown to make a decisive contrast of direction to the upright line of the head.

Raphael painted few female portraits, and has left the curiosity of succeeding ages as to the beauty of his *Fornarina* unsatisfied. Formerly, liberal loans were made from Sebastiano's *œuvre*, and any beautiful woman by him was attributed to Raphael and assumed to be his mistress. This was the case with the *Venetian Maiden* in the Tribuna, and the *Dorothea* from Blenheim (Berlin). More recent criticism has been warier; the *Donna Velata* (in the Pitti), universally accepted as the work of Raphael, has been declared not only to have been the model for the Sistine *Madonna*, but also to be the idealised portrait of the missing *Fornarina*. The connection in the first case is obvious; in the second it has at least an old tradition in its favour.

The *Fornarina* in the Tribuna, dated 1512, is a somewhat expressionless Venetian beauty, and in no way to be compared to the Berlin *Dorothea*. This later production possesses all the aristocratic calm, the majestic harmony, and the spacious movement of the High Renaissance.[1] We involuntarily think of Andrea del Sarto's beautiful woman in the *Birth of the Virgin* of 1514. In contrast to these voluptuous creations of Sebastiano's, Raphael in his *Donna Velata* represents majestic womanhood. Her bearing is erect and dignified: the costume rich, but subdued by the solemn simplicity of the enframing veil. The eyes are not searching, but firm and clear. The flesh-tints gain great warmth from the neutral ground, and hold their own triumphantly against the white satin. If we compare this with an earlier female portrait, such as the *Maddalena Doni*, the great grasp of form, and the unerring certainty in the realisation of effects

[1] The Berlin catalogue, on the contrary, dates the *Dorothea* earlier than the picture in the Tribuna, following the untenable arguments of Jul. Meyer. (*Jahrb. d. Preuss. Kunstsammlungen* 1886). It belongs to the immediate period of the *Violin-Player* and the splendid *Martyrdom of St. Agatha* in the Pitti. (1520.)

Dorothea (Portrait), by Sebastiano del Piombo.

characteristic of this style, will be obvious. But the very foundation of this is a conception of the dignity of the human form, to which the youthful Raphael was still a stranger.

The *Donna Velata* shows such a surprising similarity to the *Dorothea* in composition, that we are naturally led to think the two pictures may have been painted in some sort of competition. If this were so, it might be permissible to couple with these the *Bella* formerly in the Sciarra collection, which certainly is an early Titian [1] and must have been painted about the same time. It would be a remarkable spectacle to see the new-born beauty of the Cinquecento displayed in three such different examples side by side.

La Donna Velata, by Raphael.

However, we must hasten from these prototypes of the Sistine Madonna to the picture itself. The road has several stages, and among the Roman altar-pieces the *St. Cecilia* has the first claim on our consideration.

7. Roman Altar-pictures

St. Cecilia (Bologna Gallery). The saint is represented in the centre with four others, St. Paul and Mary Magdalen, a bishop (Ambrose) and St. John the Evangelist, not as a privileged person, not as a specially distinguished member of the group, but as a sister of the rest. They are all standing. She has let her organ fall, and is listening to the song of the angels above their heads. Umbrian harmonies are unmistakeably re-echoed in this sympathetic figure. And yet, when we make a comparison with Perugino, we are astonished at Raphael's moderation. The way in

[1] It is now universally ascribed to Palma, but the correspondence with the so-called *Maîtresse de Titien* in the Salon Carré of the Louvre is so evident, that it would be advisable to return to the old name.

which the further foot is planted, and the head bent back is simpler than Perugino would have made it. There is no longer the yearning face with the parted lips, the sentimentality in which Raphael still delighted, even when he painted the *St. Catherine* of the London National Gallery. The mature artist presents less, but he makes the little he does present more effective by contrasts. He calculates on pictorial effects which are lasting. Excessive rapture shown in a single head is offensive. The picture derives its freshness from the restrained expression, suggesting possible intensification, and from the contrast of divergent figures. St. Paul and the Magdalen are conceived in this way: the former manly and collected, gazing before him, the latter quite unconcerned, a neutral foil. The two others stand apart, and whisper one to the other.

It is an injury to the artist to take the chief figure out of its setting, as modern engravers have done. The sentiment of the picture requires completion as much as the line of the bent head calls for a contrast. The down-cast eyes of St. Paul balance the upturned face of St. Cecilia, and the unconcerned Magdalen forms the pure vertical line, by which all deviations from the perpendicular may be measured.

We will not examine further the subsequent development of contrasts in the position and aspect of the figures. Raphael is still discreet; a later artist would certainly not have grouped five standing figures without some strong contrast of movement. The engraving of the picture by Marc Antonio (B. 116) displays interesting variations in the composition. If the design is assumed to be Raphael's own, and no other conclusion can be arrived at, it must be an earlier sketch, for the arrangement is defective. The very features which make the picture interesting are lacking. The Magdalen, full of emotion, looks upward, and so competes with the chief figure, and the two saints standing in the background are obtrusive. In the revision of the picture the change has been made which is the criterion of progress, *i.e.* the substitution of subordination for co-ordination. There is a careful choice of motives, so that everything occurs only once, but each motive forms an integral part of the composition.[1]

The *Madonna of Foligno* (in the Vatican at Rome) must have been painted at nearly the same date as the *St. Cecilia*, about 1512. We have

[1] Ecclesiastical prudery seems to have lengthened the dress of St. Cecilia in the picture, for originally her ankles seem to have been visible.

in it the theme of the Madonna in a glory, an old motive, and yet to some extent new, since the Quattrocentists seldom adopted it. The ingenuous century preferred to seat the Madonna on a substantial throne rather than to exalt her in the clouds, while a change of sentiment in the sixteenth and seventeenth centuries, tending to the avoidance of any immediate contact between the earthly and the heavenly, led to the adoption of this ideal scheme for an altar-picture. A picture which dates from the close of the Quattrocento, Ghirlandajo's *Madonna in Glory* at Munich, is a convenient one for purposes of comparison.

In this picture also there are four men, who stand below on earth, and Ghirlandajo already felt the necessity of distinguishing between the attitudes. Two of them are kneeling, as in Raphael's picture. But Raphael at once surpasses his predecessor by the variety and the intensity of the physical and emotional contrasts, in a way which forbids any possibility of comparison, and at the same time he adds another feature, the combination of contrasts. The figures are intended to participate equally in the expression of emotion, whereas earlier, no fault was found with an altarpiece if the attendant saints stood round in stolid indifference. One of the kneeling figures is the donor, an unusually ugly man, but his ugliness is forgotten in the imposing dignity of the treatment. He is praying, while his patron, St. Jerome, lays his hand on his head and presents him to the Madonna. His formal prayer finds a splendid antithesis in the figure of St. Francis, who looks fervently upward, and including by a significant gesture of one hand the whole congregation of believers in his intercession, shows how the saints pray. His gesture is taken up, and vigorously continued by the St. John behind him, who is pointing to the Madonna.

The Madonna's glory is picturesquely dissolved, though not as yet completely; the old formal disc of radiance is retained in part as a background; but all around clouds are floating, and the cherubs who encircle her, to whom the Quattrocento conceded at most a shred or strip of cloud on which to rest a foot, now riot in their element like fish in the water.

Raphael introduces an exceedingly beautiful and fertile motive in representing the Madonna seated. We have already said that he did not create this motive. The distinctive character of the lower limbs, the turn of the body, and the inclination of the head may be traced to the Madonna in Leonardo's *Adoration of the Kings*. The Christ-Child is very affected in attitude, but it was a charming thought to represent Him as looking

down, not on the praying donor as His mother does, but on the "putto" who stands among the men below in the centre, and who, for his part, is looking upwards.

What is the meaning of this naked boy with his tablet? It may be said that in any case it is desirable that a type of childish innocence should be found among all these severe and serious male types. Besides this, the child is indispensable as a formal connecting link. There is a gap in the picture here. Ghirlandajo did not concern himself about this. The Cinquecento style, however, demanded that the masses should be in touch one with the other, and here in particular some horizontal line is required. Raphael met this want by the introduction of a boy-angel, holding a blank tablet. Here we see the idealism of great Art.

Raphael makes his effects with larger masses than Ghirlandajo. The Madonna has been brought down so low, that her foot comes to the level of the shoulder of the standing figures, while on the other hand, the lower figures come quite to the edge of the picture. The eye is not intended to wander away behind them into the landscape, as in the older works, an arrangement which produced a certain looseness and slightness of effect.[1]

The Madonna with the Fish (in the Prado at Madrid). In the *Madonna del Pesce* we have Raphael's Roman version of the enthroned Madonna. A Madonna was required, with the two companion figures of St. Jerome and the Archangel Raphael. The young Tobias with a fish in his hand is usually added as a distinctive attribute of the latter. Whereas the boy used to stand quite by himself, and was felt to be only a disturbing feature, he becomes in Raphael's hands the centre of an episode, and the old typical votive-picture has been changed into a "narrative." The angel introduces Tobias to the Virgin. We need not look for any special allusion in this. It is the natural outcome of Raphael's art that every character in his picture should take part in the action. St. Jerome is kneeling on the other side of the throne, and looks up for a moment from his volume to the group of the angels. The Infant Christ seems first to have been turned towards him, but now He looks towards the new arrivals, childishly stretching out one hand to them, while His other hand still

[1] The landscape has already been recognised by Crowe and Cavalcaselle as Ferrarese in construction. (*Dosso Dossi*). Perhaps the famous apparition of the thunderbolt in the background is only one of the well-known Ferrarese pyrotechnic displays, to which no further importance should be attached. The minutely-treated tussocks in the foreground are of course by the auxiliary hand.

rests on the old man's book. Mary, a very dignified and noble figure, looks down on Tobias without bending her head. She forms an absolutely vertical line in the composition. The timid boy approaching the group and the exquisitely beautiful angel, a figure with all the Leonardesque bloom and delicacy, combine to form a group which has no rival in the world. The upward glance of the pleading angel is strengthened by the diagonal of the green curtain, which

Madonna with two kneeling Saints, by Albertinelli.

runs parallel to it. This curtain, standing out sharply from the bright sky, constitutes the only embellishment of this extremely simple composition. The throne shows a Peruginesque plainness of construction. The richness of the picture is due entirely to the correlation of all movement, and the close grouping of the figures. As Frizzoni lately demonstrated, the execution is not original, but the perfect coherence of the composition shows clearly that Raphael superintended the work to the end.

The Sistine Madonna (Dresden). She is no longer represented seated on clouds as in the *Madonna di Foligno*, but upright, moving over the clouds, like an apparition which is only visible for a moment. Raphael painted this Madonna for the Carthusians of Piacenza. She is attended by St. Barbara and Pope Sixtus II., from whom the picture takes its name of the *Sistine Madonna*. The merits of this composition have already been discussed by so many writers that only a few points need be mentioned here.

The effect of a figure apparently emerging from the picture and advancing upon the spectator must be to some extent unpleasant. Some

modern pictures indeed aim at this coarse effect. Raphael, on the other hand, employed every method of restraining movement and keeping it within bounds. It is not hard to recognise what these methods were. The motive of action is a marvellously light, floating progression. If we analyse the peculiar conditions of equilibrium in this figure, and in the line of the inflated mantle and floating drapery, the marvel will be only partially explained. It is an important point, that the saints on either side are not kneeling on the clouds, but sinking into them, and that the feet of the Virgin are in shadow, the light shining only on the billowy clouds on which she stands. The floating movement of the figure is greatly re-inforced by these details.

The whole is so arranged that the central figure has no counterpart, but a number of favourable contrasts. The Madonna alone is standing; the others are kneeling, and on a lower level.[1] She alone confronts the spectator in an absolutely vertical line, a simple mass, completely silhouetted against a bright background. The others are incorporated with the wall; their costumes are multi-partite, and they are fragmentary as masses. They have no *raison d'être* in themselves. They exist only in reference to the form in the central axis, for which the utmost clarity and power are reserved. This sets the standard, the others show the deviations, but in such a way that even these appear regulated by hidden law. The scheme of direction is clearly as follows: the upward line of the Pope had to be counterbalanced by a downward line in the St. Barbara, the pointing outwards in the one case by an inward movement in the other.[2] Nothing in this picture is left to chance. The Pope looks up at the Madonna, St. Barbara down at the children on the edge of the picture, and thus care is taken that the eye of the spectator is at once led into certain channels.

I need not dwell on the strange effect of the trace of embarrassment in the expression of the Virgin, who is given an almost architechonic vigour of form. The God is the Child in her arms: her function is only to carry Him. He is borne aloft, not because He could not walk, but

[1] We may compare with this Albertinelli's arrangement in his picture of 1506 in the Louvre, which is in every respect an instructive parallel to the *Sistine Madonna*. (See illustration).

[2] The two female saints in Fra Bartolommeo's picture at Lucca of *God Almighty* (painted 1509) represent a preliminary stage.

because He is a prince. His body is on a superhuman scale, and the way in which He lies has something heroic in it. The Child is not giving a benediction, but He gazes at the people in front of Him with a steady, unchildlike look. He fixes them in a manner unknown among mortal children. His hair is dishevelled, like that of a prophet. The two " putti " below offer the contrast of normal infant nature.[1] The picture had to be hung high, the Madonna is descending. If it is placed too low, the finest effect is lost.[2] The frame which has been given it at Dresden is perhaps over-heavy: the figures would look more imposing without the large pilasters.[3]

The Transfiguration (Vatican). The picture of the Transfiguration shows a double scene; the transfiguration above, and the incident of the demoniac boy below. This combination is certainly exceptional. It was only once treated by Raphael. In it he has given us his last word as to the representation of historical events. The Transfiguration has always been a difficult subject. Three men standing upright close together, and three others semi-recumbent at their feet. A picture as sincere as that of Bellini in the Museum at Naples, with all its charm of colour and detail, cannot disguise from us the difficulty experienced by the artist himself, when he was compelled to lay before the feet of the glistening transfigured

[1] Has it been noticed that the larger angel has only one wing? Raphael shrank from the overlapping a second would have entailed. He did not wish to make the bottom of the picture too massive. This licence agrees with others of the classical style.

[2] This may be seen from the copy which hangs in the Leipzig Museum.

[3] The *Sistine Madonna*, as is well known, has been reproduced in many excellent engravings. First of all by F. Müller (1815) in a greatly admired masterpiece of engraving, which many even now consider the finest of all the reproductions. The expression of the heads comes very close to the original, and the plate is distinguished by an incomparably beautiful and tender brilliance. (There is a copy of it by Nordheim.) Then Steinla essayed the task (1848). He was the first who gave the top of the picture correctly (the curtain-rod). Notwithstanding some improvements in detail his work is not equal to that of F. Müller. If any engraving can be compared to this, it is that of J. Keller (1871.) Very discreet in the means he employed, he yet succeeded in reproducing the shimmer of the apparition in a wonderful manner. Later critics discovered that he had lost too much of the definite modelling of the original in the process, and Mandel accordingly set to work making extraordinary efforts to realise the expressive drawing of Raphael. He extracted an unexpected wealth of form from the picture, but the charm of the whole has suffered, and in places his very conscientiousness has resulted in absolute ugliness. Instead of the luminous vapour he gives us a blurred raincloud. Kohlschein lately made another departure. He exaggerated the lights, and changed the shimmer into a flare, wilfully abandoning the effect aimed at by Raphael.

The Transfiguration, by Giovanni Bellini.

Lord and His companions the three prostrate figures of the dazzled disciples. But there was an earlier, more ideal scheme, according to which Christ did not stand on the ground, but was represented in a nimbus raised above the earth. Perugino had painted the scene thus in the Cambio at Perugia. By this device the picture certainly gained much in form, but with Raphael there can have been from the first no question as to which type he should choose. His heightened perception felt the need of the miraculous. He found the gesture of the outspread arms already existing, but the floating and the expression of rapture could not have been derived from any source Attracted by the action of flight, Moses and Elijah follow the Christ, turning towards Him and dependent on Him. He is the source of their strength and the centre of the light. The others only approach the borders of the radiance which surrounds the

Fragment from the Transfiguration, by Raphael.

Saviour. The disciples beneath complete the circle. Raphael drew them on a much smaller scale, so as to connect them closely with the ground. They are no longer separate independent personalities, which distract the attention. They seem essential components of the circle which the transfigured Lord has drawn round Him, and it is by contrast with these circumscribed forms that the floating figure gains the full effect of freedom and emancipation. If Raphael had bequeathed nothing to the world but this group, it would be a complete monument of art as he conceived it.[1]

[1] The feeling for proportion and arrangement was soon completely dulled in the Bolognese Academicians, who essayed to continue the traditions of the classical period. Christ, haranguing the disciples from the clouds, squeezed in between the sprawling seated figures of Moses and Elijah, and the herculean disciples, beneath, vulgarly exaggerated in gesture and attitude—this is Ludovico Carracci's picture in the Bologna Gallery. (See illustration).

But he did not wish to end there. He wanted a strong contrast, and this he found in the episode of the demoniac boy. It is the logical development of those principles of composition which he had adopted in the Heliodorus Stanza. Above, peace, solemnity and celestial rapture; beneath, noisy crowds and earthly lamentation.

The Apostles stand there, closely packed together. There are confused groups and strident outlines. The chief motive is a diagonal path, over which the crowd has spread. The figures in the lower part of the picture are on a larger scale than those in the upper, but there is no danger of their outweighing the Transfiguration scene. The clear geometrical disposition triumphs over all the tumult of the multitude. Raphael was not able to finish this picture. Many details of form are repellent, and the whole is unattractive in colour. But the great contrast in arrangement must have been his original thought.

Titian's *Assumption* was produced in Venice at about the same time (1518). The object here is different, but in principle the two pictures are akin. The Apostles beneath form of themselves a close wall, a sort of plinth, in which the individual counts for nothing. The Virgin stands above them, in a great circle, the upper circumference of which coincides with the semi-circular frame of the picture. It may be asked why Raphael did not also choose this semi-circular form for the completion of his picture. Perhaps he was afraid of exaggerating the ascending movement of the Christ.

The pupils who finished the *Transfiguration* worked their will in other places also under the name of their master. It is only in very recent times that any attempt has been made to free Raphael from this partnership. The products of Raphael's atelier, harsh in colour, mean in conception, false in gesture, and above all, devoid of proportion, are, for the most part, strangely unpleasant productions.

We can understand the anger of Sebastiano when he found his road blocked by such people in Rome. Sebastiano was all his life a spiteful rival of Raphael, but his talent entitled him to aspire to the highest tasks. He never completely freed himself from a certain Venetian awkwardness. In the middle of monumental Rome he still adhered to the scheme of the half-length picture, and he may be said never to have attained a thorough mastery over the drawing of the human body. He was deficient also in the finer feeling for space, he was easily bewildered, and as a consequence

he appears cramped and confused at times. But he had truly great powers of conception. As a painter of portraits he stood in the very first rank, and in historical pictures he achieved now and again powerful effects, only comparable to those of Michelangelo. We do not indeed know how much he was indebted to the latter. His *Flagellation* in S. Pietro in Montorio at Rome and the *Pietà* in Viterbo are among the most magnificent creations of the golden age. The *Raising of Lazarus*, painted in competition with Raphael's *Transfiguration*, hardly deserves to be ranked so highly. Sebastiano excelled in the representation of a few figures rather than in depicting a crowd, and the half-length may be considered, generally, the domain in which he felt himself most secure. His very

The Transfiguration, by L. Carracci.

distinguished style finds its best expression in the *Visitation* in the Louvre. The *Visitation* of the school of Raphael in the Prado, in spite of its large figures, looks commonplace by comparison.[1] Even the *Christ bearing His Cross* in Madrid (replica in Dresden) may be considered superior in the expression of its chief figure to the suffering Christ of Raphael's *Spasimo*. (Prado).[2]

[1] It is impossible that this very poor composition was designed by Raphael. (Cf. Dollmayr, p. 344 : by Penni).

[2] This celebrated picture was not only executed by other hands, but must also have been copiously "edited" in composition. The chief motive of Christ looking round over His shoulder is striking, and is undoubtedly genuine, as is also the development of the procession as a whole. But, together with this, there are lamentable obscurities and motives borrowed from other works by Raphael, so that any idea of the personal share of the master in the composition is precluded.

If any painter may be named as a third with the two great masters in Rome, it is Sebastiano. He gives us the impression of a personality destined for the highest achievements, who had never completely developed; who never produced what he might have done with his talents. He lacked the sacred enthusiasm for work. In this he was the antithesis to Raphael, whose diligence Michelangelo praised as his essential characteristic. What he meant by this was obviously Raphael's capacity for gaining fresh strength from every fresh task.

Vintage. From the engraving by Marc Antonio.

V

FRA BARTOLOMMEO
1475—1517

In Fra Bartolommeo the High Renaissance has its type of the monastic painter.

The great experience of his youth had been the preaching of Savonarola and the spectacle of his death. After that he retired to a monastery and renounced painting for a time. This must have been a painful resolution, for in him, more than in most painters, we divine the need of pictorial expression. He had not much to say, but the thought that inspired him was a noble thought. The pupil of Savonarola cherished an ideal of a potent simplicity, by force of which he would annihilate the worldly vanity and the petty conceits of the Florentine church-pictures. He was no fanatic, no soured ascetic. His songs are joyous lays of triumph. He must be seen in his votive pictures, where the saints stand in serried masses round the enthroned Madonna. In these his utterance is clear and pathetic. Ponderous masses, co-ordinated by strict rule, imposing contrasts of direction, and a splendid energy of combined movement are his characteristics. His is the style which dwells in the resounding vaults of the High Renaissance.

Nature endowed him with a feeling for the grandiose, for majestic bearing, stately draperies, and magnificently undulating line. Can anything be compared to his *St. Sebastian* for buoyant beauty, or where can the gesture of his *Risen Saviour* be equalled in Florence? A robust sensuality preserved him from mere hollow pathos. His Evangelists are full-necked and athletic. Those who stand are absolutely firm on their feet, and those who are holding anything have an iron grip. He makes the gigantic his normal scale, and anxious to give his pictures the most

powerful plastic effect, he so intensifies the darkness of his shadows and backgrounds, that many of his pictures, owing to the inevitable deepening in tone, no longer give us any pleasure. He felt but a qualified interest in the accurate presentment of the individual. He aimed at general effects, not particular types. He treated the nude superficially, because he calculated on the impression produced by the motive of movement and line as a whole. His characters are always significant from the sincerity with which they are conceived, but even here he hardly goes beyond general traits. We accept his generalisations because we are carried away by the gestures of his figures, and feel his personality in the rhythm of the composition. Very occasionally he went beyond his depth, as in the heroic seated figures of prophets. The influence of Michelangelo bewildered him for a moment. In attempting to compete with the movement of this giant he became empty and insincere. It is obvious that, among the older painters, Perugino with his simplicity must have been the one who most strongly appealed to him. He found in him what he himself was seeking, disregard of amusing detail, quiet spaces, and concentrated expression. He follows him even in beauty of movement, adding to this, however, his individual feeling for strength, mass, and compact outline. Compared with him, Perugino at once seems petty and affected.

How much of his broad pictorial style can be traced to Leonardo, and how far the latter was responsible for his bold treatment of light and shade, and his rich gradations, are questions for a monograph. Such discussion would further have to take into account the impression produced by Venice, which the Frate visited in the year 1508. He saw there a style adapted to large surfaces in its highest development, and found in Bellini a perception and a feeling for the beautiful which must have affected him like a revelation. We shall return to this point presently.

It is not easy to predict the future development of Bartolommeo from his fresco of the *Last Judgment* (in the Hospital of Sta. Maria Nuova, Florence), a work of the expiring Quattrocento. The upper group, the only part of the picture he himself executed, suffers especially from want of cohesion. The chief figure, the Saviour, is too small, and among the rows of seated saints, which converge towards the background, the cramped arrangement and the close juxtaposition of the heads has a dry and anti-

quated effect. If it has been justly said that the composition was the stimulating influence in Raphael's *Disputa*, a comparison of the two works also shows very clearly the real achievement of Raphael, and the difficulties he surmounted. The inorganic arrangement of the whole and the removal of the principal figure into the background are defects found in the preliminary sketches for the *Disputa*, and finally overcome. Raphael, on the other hand, from the first found no difficulty in the clear development of the seated saints. He shared Perugino's taste for perspicuity and spacious grouping, whereas all the Florentines expected the spectator to pick out particular heads from densely packed rows.

Very different is the appeal made to the spectator by the *Virgin appearing to St. Bernard* (1506, Florence, Accademia), the first picture painted by Bartolommeo as a monk. It is not a pleasing work, and its condition leaves much to be desired, but it is a picture which produces an impression. The apparition is represented in an unexpected manner. It is no longer Filippino's delicate, timid woman who advances to the desk of the holy man and lays her hand on the book. It is a supernatural apparition, which floats down in the majestic waves of a cloak, escorted by a choir of angels, in crowded masses, all filled with reverence and adoration. Filippino had painted girls half-shy, half-curious, who accompany the Virgin on her visit. Bartolommeo does not wish to raise a smile, but to stir devotion. Unfortunately his angels are so ugly that the devout feeling is slightly chilled. The saint receives the miracle with pious astonishment, and this impression is so beautifully rendered that in comparison Filippino seems ordinary, and even Perugino in his picture at Munich, mediocre. The heavy, trailing white robe has a novel grandeur of line.

The accompanying details of landscape and architecture still show the uncertain touch of the young artist. The space is on the whole cramped, so that the apparition has a somewhat overwhelming effect. Three years later the inspiration which gave rise to the *St. Bernard* flamed out once more in the picture of *God the Father* with two kneeling female saints (1509, Academy at Lucca), where the worshipping Catherine of Siena, repeats the motive in a larger and more emotional form. The turn of the head with its "lost profile," and the forward inclination of the body strengthen the impression, just as the movement of the dark habit blown out by the wind, is a very effective translation of mental excitement into agitated external form.

The other saint, the Magdalen, is motionless. She holds out the box of ointment with hieratic solemnity, and raises an end of her mantle high before her breast, while her lowered eyes rest on the congregation. We have here a contrast of arrangement of the kind Raphael afterwards repeated in the *Sistine Madonna*. Both figures are kneeling, not on the surface of the earth, but on clouds. In addition to this Bartolommeo gives an architectonic framework with two pillars. The eye is carried into the distance of the background over a flat quiet landscape. The faint line of the horizon and the great expanse of atmosphere produce a marvellously solemn effect. Similar intentions are noticeable in Perugino's works, as the reader may remember, but it is rather impressions of Venice that are re-echoed here. In contrast to the palpitating abundance of Florentine motives this picture speaks significantly of new ideals. Where Bartolommeo takes in hand the ordinary picture of the Virgin with Saints, as for example, the marvellously painted picture of 1508 in the Cathedral of Lucca,[1] his chief concern is once more a simplification of effects, quite in the manner of Perugino : plain draperies, quiet backgrounds, and a mere cube as a throne. He surpasses Perugino in his more vigorous movement, his lustier figures, and more compact design. His line is rounded and undulating, averse to all harsh intersections. How admirably the silhouettes of Mary and Stephen are harmonised![2] The uniform filling up of the surface has an antiquated effect, but with a new feeling for mass, the standing figures are brought close to the edge of the picture, which is enframed by two lateral pillars, whereas the earlier artists always allowed a glimpse of space between the pillars and the margin.

Henceforward Bartolommeo strikes chords ever fuller and richer in his altar-pieces, creating rhythms more and more spirited and sweeping in the arrangement of his figures. He understood how to subordinate his crowds to a grand leading motive, and to oppose contrasting groups of dark and liquid tones. With all this wealth of effect his pictures are full of breadth and space. The most perfect expression of his art is found

[1] He gives a memento of his Venetian journey to Florentine art in the *putto* playing the lute.

[2] Inartistic engravers, such as Jesi, have placed the Madonna higher in the picture, misled by an arbitrary desire to improve it, and thus have dislocated the arabesque.

The Virgin appearing to St. Bernard, by Fra Bartolommeo.

in the *Marriage of St. Catherine* (Pitti) and in the cartoon of the *Patron Saints of Florence* with St. Anne and two others (Uffizi): both were painted in 1512.

The space in these pictures is closely filled in. Bartolommeo wanted a dark background. A wide landscape claiming the attention of the spectator would have been disturbing to the harmony of his pictures. He demanded the accompaniment of heavy, solemn architecture. A large empty semicircular niche is often the motive; he may have learnt the effect of this at Venice. The shadow thrown by the vaulting constitutes the value of this motive. Strong colour is abandoned, just as the Venetians themselves, by the sixteenth century, had given up bright hues in favour of neutral tints.

To secure animation of line for his figures, Bartolommeo placed two or three steps rising from the foreground to the background. This

motive of steps, which Raphael used with grandiose effect in the *School of Athens*, became indispensable in the Frate's altar-pieces with their numerous figures.

The point of sight is thus put far back, so that the figures behind are lowered. This may have been intended as the natural point of sight for the spectator in the church. Bartolommeo's strongly accentuated composition is especially benefited by this perspective. The rise and fall of the rhythmical theme is clearly marked. With all his fulness, Bartolommeo never produces a disturbing or confusing effect. He constructs his pictures on a definite plan, and the pillars on which his composition rests are at once apparent.

In the *Marriage*,[1] the figure in the right-hand corner is a singularly characteristic type, a motive proper to the wealth of movement of the sixteenth century, and one which Pontormo and Andrea del Sarto have made their own: one foot planted on the step, the arm outstretched, the turn of the head contrasting with that of the body. The grasping hands and curving body are full of energy. In order to display the muscles and the joints the arm is nude to the elbow. Michelangelo had set this fashion, but he would certainly have drawn this arm differently. The wrist lacks expression.

The St. George on the left side forms a happy contrast by its simplicity. The gleaming armour emerging from the dark background was a novelty to Florentine eyes.

Lastly, the suggestive group of the Child and His Mother, who directs the movement downwards by giving the wedding-ring to St. Catherine, is of wonderful sweetness, and very characteristic of Bartolommeo in the liquid flow of the line.

Pictures of this type, with their rich rhythmic life, the severe correctness of their tectonic structure, and their unfettered movement, made a great impression on the Florentines.

That which had been so much admired formerly in Perugino's geometrically arranged *Pietà* (1494), was here presented in a higher form. In his fresco of the *Visitation* (outer court of the Annunziata) Pontormo has attempted, and not unsuccessfully, to imitate the composition of the Frate. He raises the chief group in front of a niche, he sets powerfully con-

[1] The marriage of St. Catherine is not the central motive of the picture, but the name must be tolerated for purposes of distinction.

trasted corner-figures near the margin in the foreground, he employs the motive of the steps to fill up the middle space, and by these means achieves a truly monumental impression. The value of each individual figure is increased by its forming part of so striking a whole.

The *Madonna* at Besançon claims particular notice, in that it contains a most beautiful figure of a St. Sebastian. The movement is magnificently fluent, and the painting has the Venetian breadth. The combined influences of Perugino and Bellini are noticeable. The light falls only on the right side of the body, where the action is most lively, and so, to the immense advantage of the figure, the essentials of the motive are made prominent. But the picture is also noticeable for its subject. The Madonna is represented on clouds, and these clouds are enclosed in an architectonic interior, which only allows a glimpse into the open air through a door in the background. This is idealism of a novel kind. Bartolommeo seems to have wanted the dark background and the depth of shadow. He also obtained in this way new contrasts in the figures of the standing saints. The impression of space is, however, inadequate, and the open door, instead of increasing this, seems to contract it further. The picture originally terminated differently at the top. There was a Coronation in the lunette. It is possible that by this means the general effect was improved. This picture seems to have been painted about 1512.

Madonna with Saints, by Fra Bartolommeo.

The Frate's emotional power culminated in the deep pathos of the *Madonna della Misericordia* of the year 1515 at Lucca (Academy). These Misericordia pictures in their familiar form are oblong in shape: the Madonna stands in the middle, and clasps her hands in prayer. To the right and left under her cloak kneel the devout persons who place themselves under her protection. In Bartolommeo's hands they become large upright pictures rounded at the top. The Virgin stands raised above the earth. Angels spread out her cloak, and thus she offers her loud and urgent intercession with a magnificently triumphant gesture, her arms extended, one upwards, the other downwards; Christ, granting her prayer, answers her from heaven. His figure, too, is enveloped in a fluttering mantle.

In order to give ease to Mary's action Bartolommeo was forced to raise one of her feet above the other. What was to be excuse for this inequality of height? He was not for a moment at a loss; to carry out the idea, he placed a small step under one foot. The classical age found no fault with these expedients, at which the modern critic would cry out. The congregation is ranged in stages from the podium down to the foreground, and groups are formed of mothers and children, of praying and gesticulating persons, who may from the standpoint of form be compared with those in the *Heliodorus*. This comparison is somewhat dangerous, for it at once reveals the real defect in the picture. It is deficient in continuity of movement; the movement, that is, which is carried on from one member of the group to another. Bartolommeo continually renewed his attempts to represent such mass-movements, but he seems here to have reached the limit of his talent.[1]

Titian's *Assumption* was painted a few years after the *Madonna della Misericordia*. A reference to this unique creation can hardly be avoided, seeing how closely the motives of the two works are connected, but it would be unfair to measure Bartolommeo's merit by Titian. The importance of Bartolommeo for Florence was immense, and the picture at Lucca is a convincing expression of the lofty spirit of that time. How quickly such lofty conceptions are debased is best shown by Baroccio's popular picture on the same theme, known as the *Madonna del Popolo* (Uffizi). Admirably bold and bright in its picturesque design, it is absolutely trivial

[1] The relation to the *Heliodorus* is still clearer in the *Rape of Dinah* in Vienna, the drawing for which was due to Bartolommeo.

in essence. Akin to the *Madonna della Misericordia* is the *Risen Christ* of the Pitti (1517). All that was uncertain and false in the former is eliminated here. The picture may be regarded as the most perfect of the Frate's works. He had become more tranquil. But the restrained pathos of this gentle, beneficent Christ has a more searching and convincing effect than any violent gesture: " Behold I live, and ye shall live also !" Bartolommeo had been in Rome just previously, and may have seen the *Sistine Madonna* there. The magnificent simplicity of the folds of the drapery is of a very similar kind. In the silhouette he introduces a gradually ascending triple undulation, a splendid motive which was destined to be further employed in his pictures of the Madonna. The drawing of the uplifted arm and the knowledge of anatomy shown in it would have satisfied Michelangelo. Here again we have the great niche in the background. Christ rises above it, and His figure thus gains in dignity. He is raised above the Evangelists by a pedestal, an apparently obvious contrivance, which is quite alien to the whole Florentine Quattrocento. The first examples of it are found in Venice.

The four evangelists are sterling personalities, firm and massive of type. Only two are accentuated. The two at the back are completely subordinated to the two in front, with whom they combine in silhouette. This illustrates Bartolommeo's feeling for mass. The profiles and full-faces, the upright and stooping positions, are distributed with an absolutely mature calculation of effect. The vertical line of the full-face to the right is not so impressive in itself; it acquires special force from its connection, and from the architectonic accompaniments. We recognise their inevitability.

Lastly, the group of mourners, the *Pietà*, has been treated by Bartolommeo with the most noble restraint of expression, as the greatest artists of his time treated it. All the details of this picture combine with and emphasise the rest. (Picture in the Pitti.) The lamentation is subdued. There is a gentle meeting of two profiles; the mother has raised the dead hand, and stoops to imprint a last kiss on the forehead. That is all. The Christ shows no trace of the sufferings He has undergone. The position of His head is not that of a corpse. Even here idealism prevails. The features of the Magdalen, who has thrown herself in passionate grief at the feet of the Lord, are indistinguishable. The expression of the St. John, however, shows, as Jacob Burckhardt remarked, traces of the exertion of bearing

The Risen Christ with the Four Evangelists, by Fra Bartolommeo.

the body—a truly dramatic touch. The emotions are thus strongly differentiated, and the parallelism of expression, found in Perugino's works, is replaced by vigorous contrasts, reciprocally enhanced. A similar economy governs the physical movements. Two figures are now wanting in the composition, for a St. Peter and a St. Paul were once in the picture. We must imagine them also bending down, above the Magdalen, the ugliness of whose silhouette would thus be modified.[1] The absence of these figures has shifted the accent of the whole. There was, however, no symmetrical distribution of masses, such as the picture now seems to suggest; a free rhythmical arrangement was aimed at, but the three heads to the left certainly require some counterpoise. Later, the base of a cross was added in the middle of the group, obviously incorrectly; for this particular place should be unaccented.

Compared with Perugino, who seemed so calm among his contemporaries, Bartolommeo is even more restrained and impressive in line. The great parallel horizontal lines on the border of the foreground only serve to express the very simple, *relievo*-like grouping of the figures, with the two dominating profiles. Bartolommeo must have realised the beneficial results of thus giving repose to the picture. He succeeds in conveying a similar

[1] The figures were put in, but were expunged. For the complete group see Albertinelli's *Pietà* in the Academy.

impression of repose by lowering the group. Perugino's lofty triangle has become an obtuse-angled group of inconsiderable height. The oblong shape of the picture was perhaps selected with the same object.

Bartolommeo might have been able to continue his work still further, tranquilly bringing the whole range of Christian subjects nearer to their classical form. We gather from his sketches that his imagination rapidly kindled, evoking definite pictorial forms, to which he applied the laws of effect with unerring precision. Yet it was not the application of rule which decided the effect in his case, but the personality which had created rules of its own. How little academic instruction could be gleaned in his studio is shown by the example of Albertinelli, who was one of his closest intimates.

Pietà, by Fra Bartolommeo.

Mariotto Albertinelli (1474–1515) was called by Vasari "a second Bartolommeo." He was long his collaborator, but he was of a very different temperament. He lacks the Frate's conviction. Endowed with great talents, he essayed problems now and again, but arrived at no logical result, and at intervals he abandoned painting altogether, and took to inn-keeping.

The early picture of the *Visitation* (1503) shows him at his best; the conception of the group is pure and beautiful, blending harmoniously with the background. The subject of the mutual greeting is not very easy to master; to get the four hands into their places is a difficult feat. Ghirlandajo had treated the theme not long before (picture in the Louvre, dated 1491). He makes Elizabeth kneel and stretch out her arms, while Mary lays her hands soothingly on her shoulders. But by this arrangement one of the four hands has entirely disappeared, and the parallel movement of the arm of Mary is not one which we should care to see repeated. Albertinelli is at once richer and clearer. The women clasp their right hands, and the

The Holy Trinity, by Albertinelli.

disengaged left arms are differentiated by making Elizabeth embrace her visitor, while Mary modestly places her hand before her bosom. The motive of kneeling is abandoned. Albertinelli wanted to bring the two profiles quite close together. By the rapid step of the elder woman and the slight inclination of her head, he has clearly marked her subordination to Mary, while by casting a strong shadow on her face he further emphasises the idea. No Quattrocentist would have yet thought of making the distinction thus. The two stand in front of a vestibule, the architecture of which clearly owes its origin to Perugino, and the vast peaceful background of sky is conceived quite in his style. Later artists would have avoided the further glimpses of landscape on either side of the picture. The drapery and the flowery foreground still show traces of the Quattrocento.

The great *Crucifixion* in the Certosa (1506) also shows Perugino's influence. But four years afterwards Albertinelli created the new and classic emendation of the figure on the cross in his picture of the *Trinity* (Academy, Florence). All earlier artists separate the legs widely at the knees. But a finer pictorial result is obtained when subordination takes

the place of co-ordination, *i.e.* when one leg is pushed over the other. Hereafter, the painter went further still, and made a counter-movement of the head correspond to this movement of the legs. If the direction of the lower limbs is towards the right, then the head leans towards the left. Thus the theme, apparently so stiff and incapable of any beauty of rendering, gains a rhythm which is never afterwards wanting.

The interesting *Annunciation* (in the Academy) of the same year must be mentioned. He devoted much labour to this picture, which is important in the history of general development. We may remember how insignificant a rôle was commonly assigned to the

The Annunciation, by Albertinelli.

First Person of the Trinity in pictures of the *Annunciation*. He appears as a small half-length figure somewhere in the top corner, and sends down the Dove. Here he is depicted full length, placed in the centre, and surrounded by a garland of angels. These flying angels, with their instruments of music, demanded labour, and the artist, who in disgust exchanged the duties of a painter for those of an innkeeper, in order to be freed from the eternal talk about foreshortening, has made a creditable effort here. In the celestial motive some trace of the nimbi of the

seventeenth century is already discernible. Everything, however, is still symmetrical, and on one plane, while the celestial figures of the seventeenth century usually advance diagonally from the depth of the picture. The calmly dignified Mary harmonises with the increased solemnity of the rendering. She stands in a graceful posture, and does not face towards the angel, but looking at him over her shoulder, receives his reverent salutation. Without this picture, Andrea del Sarto would never have created his *Annunciation* of 1512. It is interesting also pictorially, since it shows as background a large dark interior in greenish tints. The work was intended to be hung high up, and the perspective takes this into account, but the abruptly descending line of the cornice produces a harsh effect in relation to the figure.

VI

ANDREA DEL SARTO
1486—1531

ANDREA DEL SARTO has been termed superficial and soulless, and it is true that there are commonplace pictures by him, and that in his later years he was prone to become stereotyped. He is the only one among the painters of the first rank who seems to have had some defect in his moral constitution. By birth he was the refined Florentine of the race of the Filippinos and Leonardos, most fastidious in his taste, a painter of elegance, of soft luxurious attitudes and dignified movements of the hand. He was a child of the world, and his *Madonnas* have a certain worldly elegance. He does not aim at strong movement and effect, and hardly ever goes beyond stately standing and walking. In this way, however, he develops a fascinating sense of beauty. Vasari reproaches him with excessive timidity and tameness, and a want of proper audacity. It is only necessary to have seen one of the great " machines " Vasari was accustomed to paint himself, to understand this criticism, but Andrea's works also appear tame and simple by the side of the mighty constructions of Fra Bartolommeo or the Roman school. Yet he was gifted with versatile and brilliant powers. Brought up to admire Michelangelo, he could claim for a period to be reckoned the best draughtsman in Florence. He treated the articulations with an incisiveness, and brought out their functions with an energy and vigour which must have secured wide-spread admiration for his pictures, even if the hereditary Florentine skill in draughtsmanship had not in his case been coupled with a gift for painting which was almost unique in Tuscany. He paid little attention to picturesque phenomena, and did not, for example, show much perception of the material characteristics of

things, but the mild radiance of his flesh-tints and the soft atmosphere in which his figures repose have a great charm. In his feeling for colour, as in his feeling for line, he has the soft, almost languid beauty, which makes him appear more modern than any one else.

Without Andrea del Sarto, Cinquecentist Florence would have lacked her festal painter. In the great fresco of the *Birth of Mary* in the outer court of the Annunziata we have that which Raphael and Bartolommeo do not give: humanity's exquisite delight in life at the moment when the Renaissance was at its apogee. We would gladly have had many more such pictures of real life from Andrea; he should not have painted any other. It was, however, not entirely his own fault that he did not become the Paolo Veronese of Florence.

1. The Frescoes of the Annunziata

The traveller usually receives his first great impression of Andrea in the outer court of the Annunziata. Here we have nothing but early and serious subjects. Five scenes from the life of *San Filippo Benizzi*, the last dated 1511, and then the *Birth of the Virgin* and the *Procession of the Three Kings* (1514). The pictures are in a beautiful light tone, at first still somewhat dry in the juxtaposition of colours, but in the picture of the *Birth* the rich harmonious modelling of Andrea is fully apparent. In the first two pictures his handling of the composition is loose and *insouciant*, but in the third he becomes severe, and builds up a design with an accentuated centre and symmetrically developed side scenes. He drives a wedge into the crowd, making the central figures retreat, and the picture gains depth, in contrast to that array of lines along the front edge of the picture, which Ghirlandajo still employed almost exclusively. This central scheme is in itself no innovation in an historical picture, but the way in which the figures stretched out their hands to each other is novel. There are no separate rows placed one behind the other, but the various members emerge from the depth of the background in a clearly arranged and unbroken sequence. This is the identical problem which Raphael set himself at this same time, but on a far larger scale, in the *Disputa* and the *School of Athens*. The last picture, the *Birth of the Virgin*, marks Sarto's transition from the strictly tectonic to the freely rhythmical style. The composition swells in a magnificent curve:

The Birth of the Virgin, by Andrea del Sarto.
(The upper part omitted.)

beginning from the left with the women by the fire-place, the movement reaches its climax in the two walking women, and dies away in the group by the bed of the mother. The freedom of this rhythmical arrangement is indeed very different from the licence of the earlier unrestrained style. Law exists here, and the way in which the standing women dominate and bind the whole picture together first becomes imaginable as a motive in the sixteenth century.

As soon as he substituted strict composition for the preliminary loose juxtaposition, Andrea del Sarto felt the necessity of calling in architecture to his aid. He looked to it to bind the whole together and to give stability to the figures. This was the beginning of that combined idea of space and figures, which may be said to have been on the whole quite alien to the Quattrocento pictures, in which buildings played rather the part of an incidental accompaniment and embellishment. Andrea was but a beginner, and it can never be said that he was successful in his treatment of architecture. We notice the difficulty he found in dealing adequately with a

very large space. His architectural background is generally too heavy. Where he makes an opening in the centre, its effect is to contract rather than to expand, and where he allows a glimpse of the landscape at the sides of the picture, he only distracts the attention of the spectator. His figures throughout have a somewhat forlorn appearance. It is the interior of the *Birth of the Virgin* that first solves the problem.

Any comparison with Raphael shows how little competent Andrea was to deal with the dramatic nature of the scenes here represented. The gestures of the wonder-working Saint are neither imposing nor convincing, and the spectators are content to stand by listlessly with some languid gesture of surprise. Where for once he has treated some scene of vigorous action, where the lightning causes the triflers and scoffers to fly in terror, he shows these figures quite small in the middle distance, although this would have been a suitable opportunity for applying his studies of Michelangelo's cartoon of the *Bathing Soldiers*. The chief motives are all quiet, yet it is worth while to trace out the thought of the artist in each particular case, and we shall find very beautiful motives conceived with the delicacy of youth in these very pictures, where he had three times successively the task of working from a centre, and arranging the figures, whether standing, approaching or sitting, symmetrically as a whole, though unsymmetrically in detail. The simplicity has often the effect of timidity, but we gladly abandon for a moment the forms made interesting merely by antithesis of position. Andrea first achieves absolute freedom in the picture of the *Birth of the Virgin*. Aristocratic nonchalance, and indolent self-abandonment have found no more able interpreter. The whole rhythm of the Cinquecento lives in the two advancing women. The lying-in mother is also more richly treated. The flat position and the stiff back given her in Ghirlandajo's work now seem as barbarously antiquated as the manner in which Masaccio makes her lie on her stomach must have seemed vulgar to the noble Florentines.

The lying-in woman went through a development similar to that of the recumbent figure on tombs. In both there is now much turning and differentiation of the limbs.

The most fertile motive of a lying-in room from the point of view of rich effects is the cluster of women who are busied with the baby. Here is scope for a splendid multiplicity of curves, and the sitting and stooping figures combine into a close knot of movement. Sarto is still

reticent in working out this theme, but later artists make it the central idea of such pictures. The group of women is put right into the foreground, and the bed with the mother is pushed back. In this way the idea of the visit naturally disappears. In a colossal picture in S. Maria del Popolo (Rome) Sebastiano del Piombo presents the scene for the first time in this form, which was universally adopted during the seventeenth century.

In the upper part of the picture an angel is seen swinging a censer. Familiar as the cloud-motive in this place is to us from examples of the sixteenth century, we are still much surprised to find it introduced here by Sarto. We have become so accustomed to the bright clear realism of the Quattrocento, that such miraculous appearances are not accepted as matters of course. A change of sentiment has obviously taken place. Men's thoughts are once more fixed on the ideal, and scope is given to the miraculous. We shall meet with a similar symptom in the *Annunciation*.[1]

In spite of this ideality Andrea retained the Florentine fashion of his day in the costume of the women, and in the furniture of the room. It is a Florentine room in the modern style, and the dresses—as Vasari expressly states—are those worn at the date of the picture (1514).

If in this *Birth of the Virgin* Andrea attempted the free rhythmical style, this does not mean that he regarded the stricter tectonic composition as a preliminary stage he had accomplished. He returns to it in another place, the cloisters of the Scalzo. The entrance court of the Annunziata itself contains an admirable example of the kind in the *Visitation* by Pontormo, which was painted immediately after. Vasari was right in saying that anyone who wished to rival Andrea del Sarto in this field must create a work of extraordinary beauty. Pontormo has done this. The *Visitation* not only produces an imposing effect by the increased size of the figures; it is intrinsically a great composition. The central scheme, according to the design which Andrea had thoroughly tested five years before, is now for the first time raised to the height of an architectonic effect. The greeting of the two women takes place on a platform, raised on steps, in front of a niche. By means of these steps, which are brought

[1] Andrea knew Dürer and made use of him. This is clear from other cases. It is possible that even here the angel was suggested by Dürer's *Life of Mary*. The artist must have been glad to be able to fill up the superfluous space at the top of the picture in some way or other.

well into the foreground, a suggestive difference of height is given to the accessory figures, and a spirited undulation of lines results. Amid all this movement the great structural notes are still clearly heard: the vertical lines at the margins, and between them a line rising and falling, a triangle, its apex formed by the bending figures of Mary and Elizabeth, and its base terminated by the seated woman on the left and the boy on the right. The triangle is not equilateral, the longer line is on Mary's side, the shorter on that of Elizabeth. The nude boy beneath has not stretched out his leg by chance: it was essential that he should continue the line in this direction. Everything works together, and every single figure participates in the dignity and solemnity of the great and uniformly harmonious theme. It is obvious that the picture is greatly indebted to the altar-pieces of Fra Bartolommeo. An artist of the second rank, sustained by the great epoch, has produced a really important and effective work here.

The *Sposalizio* of Franciabigio seems somewhat thin and meagre in comparison, in spite of the delicacy of its details. We may therefore pass it over.

2. The Frescoes of the Scalzo

On the walls of the little colonnaded courtyard of the Scalzi (Barefooted Friars), Andrea del Sarto painted the story of John the Baptist, not in colour, but in monochrome, and in modest dimensions.

Two of the frescoes are by Franciabigio, the other ten and the four allegorical figures are entirely by Sarto's own hand. They are not uniform in style, for the work dragged on for fifteen years with many interruptions, so that almost the whole development of the artist may be traced here.

Painting in chiaroscuro or monochrome had long been practised. Cennino Annini says that it is adopted on surfaces which are exposed to the weather. It is also found in conjunction with colour painting in places of minor importance, such as parapets or dark walls with windows. But in the sixteenth century a certain predilection was shown for it, which is comprehensible in connection with the new style.

The small courtyard has a delightful air of repose. The unity of colour, the harmony of frescoes and architecture, the style of the framework, all combine to give the pictures an admirable setting. The student of Sarto will not expect to find the significance of these works in their

psychical moments. The St. John is a dull preacher of repentance and the scenes of terror have no striking dramatic effects. We must not expect strong characterisation, but Sarto is always clear and full of beautiful movement. We see here how the interest of the age tended more and more to concentrate itself on beauty of form, and how the merit of a story was assessed according to its adaptation to a given space.

We will discuss the frescoes in the order of their completion.

1. *The Baptism of Christ.* (1511). This picture may at once be recognised as the earliest of the series, by the way in which the figures fail to fill the space, but stand about in detached groups. There is too much room. The finest figure is that of Christ, which is marvellously delicate in the action and light in effect. The weight of the body is taken off the right leg, but the heels are quietly brought together. The legs are partly crossed, and the narrowing of the silhouette near the knees gives an unusually elastic effect. It is to be noticed that the feet are not immersed in the water, but are still visible. Some minor schools of idealists had always so represented them, but the interests of plastic clearness now required it. Similarly, the uncovering of the hips meets the demand for a more distinct image. The old loin-cloth, tied horizontally, interrupted the line of the body precisely where the greatest clarity was required. Here the apron which falls diagonally not only gives distinctness but a pleasing line of contrast results spontaneously. The hands of the Saviour are crossed on His breast, not clasped in prayer as formerly.

We shall not find the same delicacy in the St. John. There is still some timidity in the angular irregular figure. The only improvement is that he is standing still; Ghirlandajo and Verrocchio had represented him in the act of stepping forward. The angels have a family-likeness to the still more beautiful pair in the picture of the *Annunciation* (1512).

2. *The Preaching of John the Baptist.* (*ca.* 1515). Here the figures are larger in proportion to the pictorial space, and the more massive filling of the surface at once gives the picture a different appearance. The scheme of composition suggests Ghirlandajo's fresco in S. Maria Novella. The raised figure in the middle and the disposition of the circle of listeners with the standing figures at the sides are identical; as is also the turn of the preacher towards the right. Thus some examination of the deviations in details is all the more justifiable.

Ghirlandajo represents his orator as enforcing his words by stepping

The Preaching of John the Baptist, by Andrea del Sarto.

forward; Sarto places all the movement in a turn of the figure upon its own axis. This turn is at once quieter and more expressive. Here, too, the marked contraction of the silhouette at the knees is especially effective. The antiquated oratorical gesture, the extended forefinger, now seems petty and feeble. The hand is made to be effective as a mass, and while in the one picture the arm is kept stiff in the same plane, in the other it is extended more freely and acquires a new vitality from the foreshortening. The expressive action of the limbs, and the clear definition of the whole figure afford a splendid example of Cinquecentist drawing.

Sarto has less space to exhibit his audience. He was able however to produce the effect of numbers more convincingly than Ghirlandajo, who only creates bewilderment with his score of heads, each intended to be seen singly. The figures which close the composition on either side give

The Preaching of John the Baptist, by Ghirlandajo.

an effect of mass,[1] and the preacher's gesture, addressed to persons not not visible in the picture, tends to heighten the impression of multitude.

The imposing effect of the central figure in Sarto's fresco is to be explained not only by the relative scale of size, but by the fact that everything is calculated to throw the chief accent upon it. Even the landscape is designed with this end in view. It forms a solid background to the preacher and gives him atmosphere in front. The orator stands out as a detached tangible silhouette, whereas in Ghirlandajo's version not only is he planted in the middle of the crowd, but he conflicts unhappily with the lines of the background.

3. *The Baptism of the People.* (1517). The style now tends to become restless. The drapery is jagged and irregular, the movement exaggerated.

[1] As is well known, the man with the cowl, as well as the woman sitting and holding up her child are borrowed from Dürer.

The minor figures, which were intended to relieve the severe design by the charm of the incidental, exceed their function. The figure of a nude youth who, with his back turned to the spectator, looks listlessly down, is very characteristic of the master.

4. *The Arrest*. (1517). This episode also, though singularly ill adapted for the purpose, is made the main subject of a composition. Herod and John are not placed opposite each other, profile to profile, but the prince sits in the middle, the Baptist opposite to him diagonally on the right, while to restore the symmetry we have on the left the impressive figure of a spectator with his back turned. But as John has a gaoler on each side, the fresco requires another counterpoise, and this is given by the (unsymmetrical) figure of the captain of the watch advancing from the depth of the picture to the left. The rich group of the arrest has a very vivid effect compared with the massive repose of the one standing figure seen from behind. We may grant that this is nothing more than a draped lay figure; nevertheless such calculations of contrast imply an advance in art for Florence. Formerly it was customary to arrange the figures uniformly, and to express movement uniformly. Besides this, the figure of John, who has some difficulty in fixing the king with his eye, is very beautiful. Even if the gaolers might be more vigorous in their action, the mistake at any rate is avoided, into which others have fallen, of making their gestures so violent that attention is distracted from the central figure.

5. *Salome Dancing*. (1522). The dance which was formerly inappropriately combined with the scene where the head of John is brought to Salome, is here treated in a separate picture. Andrea seems to have found the subject very attractive, and the dancing Salome is one of his most beautiful creations, enchantingly harmonious in movement. The figure shows no violent movement, the action being confined to the upper part of the body. A contrast to the dancer is provided by the figure of the retainer, his back turned to the spectator, who brings in the platter. It is necessary to compare the two figures: the one is the complement of the other, and it is due to the position of the retainer further back in the picture that the momentary pause of Salome, a most dramatic touch, produces its full effect. The style has become calmer again, the line more flowing. The picture is an admirable example of ideal simplicity of scene and suppression of all unnecessary details.

6. *The Beheading*. (1523). It might have been thought impossible for

Salome Dancing before Herod, by Andrea del Sarto.

Sarto, in this theme, to have avoided the representation of violent physical action. The headsman brandishing his sword is a favourite figure with artists who have sought movement for its own sake. But Sarto evaded the obligation. He does not give the execution, but the quiet incident of the gaoler placing the head in the platter which Salome holds out. He stands in the middle, with legs far apart; she is on the left, and on the other side stands an officer; thus again we have a central composition. The sight of the bloody head is obtruded as little as possible.

7. *The Offering.* (1523). Once more the banqueters. This time the figures are placed further back; it is a narrower picture. The young girl carrying the head is as graceful as she was in the dance. The stiff attitudes of the spectators form the contrast to the elegant turn of her figure. The more lively action is brought into the middle. The sides of the picture are filled in with pairs of figures.

8. *The Announcement to Zacharias.* (1523). The artist was now sure of himself. He had methods of his own by which he attained definite results

under all conditions, and relying on this, he allowed himself more and more airiness of treatment. The convention of the side-figures does duty once more. The angel advances into the background; he bows silently with crossed arms before the priest, who recoils in amazement. Everything is superficially suggested, but the absolute confidence shown in the economy of effects and the calm solemnity of the architectonic setting give a dignity to the representation, which Giotto himself, who felt so much more deeply, would have found it difficult to equal.

9. *The Visitation.* (1524). The symmetrical side-figures are abandoned. The main group of the women embracing is placed diagonally, and this diagonal determines the whole composition. The figures form a *quincunx*, *i.e.* they are arranged like the five pips on a die. The architectonic background gives a sense of calm.

10. *The Naming.* (1526). Once more a fresh scheme. The nurse with the new-born child stands in the centre of the first zone, facing Joachim seated at the side. A seated female figure on the other side is an exact pendant. The mother in bed and a servant are symmetrically inserted in the second zone between the figures of the foreground. Vasari speaks of a "ringrandimento della maniera" (increased grandeur of style), and eulogises the picture. So far as I see there is no specially new style in it. All the elements had served before, and the peculiarly bad condition of this fresco does not even prompt the wish to see more of it. We can see all that Sarto cared to give at that late period.

The two pictures which Franciabigio contributed to this cycle both bear early dates. As the inferior artist he does not appear to advantage by the side of Sarto. Merely to instance one case, where the infant John receives the paternal blessing (1518), the impetuosity of movement in the figure of the father produces quite an antiquated effect. Subordinate figures, in themselves very beautiful, such as the boys on the balustrade, are too conspicuous, and a more refined artist would never have introduced the broad staircase in this connection. It is the only motive in the Scalzo cloisters which offends the eye. This fresco immediately adjoins the earliest work of Andrea, the *Baptism of Christ*, which it surpasses in size, but not in beauty.

The series of historical pictures is interrupted—as already noticed—by four allegorical figures, all of which Sarto painted. They are intended to imitate statues standing in niches. The arts once more begin to amalga-

mate. Hardly any large pictorial composition of this epoch can be found in which recourse has not been had to plastic art, either real or imitated. The best of the figures here is perhaps the *Caritas* who with one child in her arms, is stooping down to a second one, merely bending her knee, in order to preserve her equilibrium. There is a similar group on the ceiling of the *Heliodorus* Stanza, in the picture of *Noah*. The *Justitia* is clearly suggested by Sansovino's similar figure in Rome (S. Maria del Popolo). One foot, however, is raised, to obtain more movement.[1] The figure reappears in the *Madonna delle Arpie*.

3. MADONNAS AND SAINTS

Justice, by A. Sansovino.

The abatement of earnestness of conception and execution, which is perceptible in the Scalzi frescoes from about the year 1523 onwards, does not mean that the artist was wearied of that particular task, for the same symptoms are found in his easel pictures of the same date. Andrea became careless, stereotyped, confident in the splendid resources of his art. His works, even where he makes an obvious effort, no longer show traces of enthusiasm. The biographer will tell us why this came about. His youthful works do not lead us to foresee any such development. No better example can be found to show what spirit originally animated him, than the large picture of the *Annunciation* in the Pitti Palace, which Andrea must have painted in his 25th or 26th year.

The Mary is noble and severe, as Albertinelli painted her, but the

[1] Quattrocentist taste demanded that the sword should be held upwards, Cinquecentist that it should be lowered. Sansovino here represents the old, Sarto the new style. The same remark may be made of St. Paul with his sword. A colossal statue, like that of *St. Paul* by P. Romano on the bridge of St. Angelo, still represents the old type.

movement shows more delicacy of feeling. The angel is as beautiful as Leonardo could have made him, with all the charm of youthful rapture in the bowed and slightly inclined head. He utters his greeting, stretching out his arm towards the astonished Mary, while he bends his knee. It is a reverent salutation from a distance, not the impetuous entrance of a school-girl, as with Ghirlandajo or Lorenzo di Credi. The angel comes on clouds, for the first time since the Gothic century. The miraculous is once more allowed in sacred pictures. The strain of rapture which has been struck is taken up and continued in two attendant angels, with curling hair and softly shadowed eyes.

The Annunciation, by Andrea del Sarto.

Contrary to traditional arrangement, Mary stands to the left, and the angel comes from the right. Andrea perhaps was anxious that the outstretched arm should not cover the body. It is this that gives the figure its perfect and expressive clarity. The arm is nude, as are also the legs of the accompanying angels, and the draughtsmanship certainly betrays the teaching of Michelangelo. The manner in which the left hand holds the stalk of the lily is quite Michelangelesque. The picture is not entirely free from distracting detail, but the architecture of the background is excellent of its kind and very novel. It gives force and cohesion to the figures. The lines of the landscape also harmonise with the principal action.

The Pitti Palace contains a second *Annunciation*, of Andrea's later period (1528), originally painted in a lunette, and now made into a square picture. It is a complete illustration of the difference between his early and his final manner. Far superior to the first in its picturesque bravura,

this second representation shows an emptiness of expression, not to be disguised by all the charm of the treatment of atmosphere and drapery.[1]

In the *Madonna delle Arpie*, Mary appears as the mature woman and Andrea as the mature artist. This is the most regal Madonna in Florence, queenly in her appearance, and conscious of her dignity, very different to Raphael's *Sistine Madonna*, who is utterly self-forgetful. She stands statuesquely on a pedestal, looking down. The Child hangs on her neck, and she supports the heavy weight lightly on one arm. The other is stretched downwards and holds a book resting on her thigh. This again is a motive of the monumental style. There is nothing motherly or intimate, no *genre*-like toying with the book; merely the ideal pose. She can never have read or wished to read thus. The way in which the hand is outspread over the edges of the book is a remarkably fine example of the grand gestures of the Cinquecento.[2]

The companion figures, St. Francis and St. John the Evangelist, both rich in movement, are made subordinate to the Madonna by only appearing

The Madonna delle Arpie, by Andrea del Sarto.

[1] The pictures are confounded in the *Cicerone*, and a third *Annunciation* in the Pitti Palace may be set aside altogether. The dubious painting (an *Annunciation* with two attendant saints) is—as regards the figure of Mary—only a repetition of the figure of 1528, and is clearly by an inferior hand. Other motives have been taken from different sources. The notice in Vasari, V. 17 (note 2) is obviously an error: the work cannot belong to the period of 1514.

[2] On the model of the Peter in Raphael's *Madonna del Baldacchino*.

Disputa, by Andrea del Sarto.

in profile. The figures, brought closely together, form one complex whole. The suggestive group acquires fresh force from the conditions of space in the picture; there is not an inch of superfluous room, the figures actually touch the frame. Yet, strangely enough, no feeling of contraction is produced. One of the counteracting causes is the upward spring of the two pilasters.

The pictorial richness of the presentation equals its plastic force. Andrea tries to entice the eye from the silhouettes on which it might dwell, and, in place of the connected line, offers it isolated brilliant contours. Here and there an illuminated [part gleams out of the dim light, only to disappear once more in the shadow. The uniformly bright expansion of the contours in the light is discontinued. The eye is continually passing with pleasure from one point to another, and the result is a living, tactile quality in the figures, far surpassing all preceding splendours of modelling on the flat.

A still higher pictorial stage is marked by the picture of the *Disputa* in the Pitti Palace. Four men standing, engaged in conversation. We are involuntarily reminded of Nanni di Banco's group in Or San Michele. Here, however, we have no mere indifferent Quattrocentist gathering, but a real argument in which the rôles are distinctly distributed. The Bishop (Augustine?) is speaking, and the person addressed is Peter Martyr, the Dominican, a refined intellectual head, in comparison with which all Bartolommeo's types seem coarse. He is listening intently. St. Francis,

on the contrary, lays his hand on his heart and shakes his head: he is no dialectician. St. Lawrence, as the youngest, refrains from any expression of opinion. He is the neutral foil, and plays the same part here, as the Magdalen in Raphael's picture of *St. Cecilia*; like hers, his figure makes a strongly accentuated vertical line.

The stiffness of a group of four standing figures is lessened by the addition of two kneeling figures in the foreground (a little lower down). These are St. Sebastian and the Magdalen, who take no part in the discussion, but, in compensation, form the richest colour-passages of the composition. Sarto gives them bright flesh-tints, while the men are in a sober key, chiefly grey, black and brown, with a passage of subdued carmine quite in the background (in the figure of St. Lawrence). The background is dark.

In colour and drawing this picture marks the zenith of Andrea's art. The nude back of the Sebastian and the upturned head of the Magdalen are marvellous interpretations of human form. And then the hands! How feminine is their delicate clasp in the Magdalen, and how expressive their form in the disputants! It may be said that no artist has drawn hands with such skill as Andrea, if we except Leonardo.

There is a second picture of four standing figures in the Academy, which was painted some ten years later (1528), and indicates the development and the decay of Andrea's style. It is bright in tone, like all his later work; the heads are loosely modelled, but the grouping and treatment of the figures are marked by all Andrea's skill and brilliance.[1] We see how easy it was for him to produce compositions so rich in effect, but the impression produced is purely superficial.

The *Madonna delle Arpie* had no worthy successor. The theme, which had recently become fashionable, of the Madonna in a nimbus or rather in clouds, must have been peculiarly well adapted to Andrea's taste. He opened the heavens, and let an intense brilliance appear, and, in accordance with the style of the day, brought the Madonna low down on her clouds, into the middle of a band of encircling saints. The variations on standing and kneeling figures, and the systematic employment of contrasts between turning outwards or inwards, of looking up or down, etc., are more or less matters of course, but Sarto adds to this the contrasts of

[1] There were originally two "putti" in the centre, which have been taken out, and hung separately.

bright and dark heads, and in the distribution of these accents no respect is paid to the source of the light and shadow. A general strongly marked undulation in the picture is kept in view throughout. We soon perceive that the effects are won by a somewhat stereotyped receipt, but there is undeniably a certain inevitability in the impression produced, which springs from Andrea's own temperament.

Let us instance, as an example, the *Madonna* of 1524 (Pitti). We must not look for character; the Madonna is indeed absolutely commonplace. The two kneeling figures are repeated from the picture of the *Disputa*, with the characteristic additions of the more practised hand. The St. Sebastian may have been painted from the same model as the well-known half-length of the youthful St. John (see below). Here the master's taste has led him so to treat the contour, that it is comparatively meaningless; all the expression is given to the bright expanse of the bare breast.

Finally all his powers are exhibited in the great Berlin picture of 1528. The clouds are here enclosed in a well-defined architectonic framework, just as they appear in Bartolommeo's pictures. Then there is a niche, intersected by the frame: and we have the motive of the staircase, with the saints on the steps, who could thus be strongly differentiated by their position in the space. The foremost figures appear only as half-lengths, a motive which high art had hitherto intentionally avoided.

Of the *Holy Families* we may say what has already been said of

The Madonna with six Saints (1524), by Andrea del Sarto.

The Madonna del Sacco, by Andrea del Sarto.

Raphael's versions of this theme. Andrea's artistic aim also was to produce rich effects in a small space. He makes his figures stoop and kneel, thus bringing them close to the bottom of the picture, and making knots of three, four, and five persons. The ground is usually black. There is a series of pictures of the kind. The best are those where the spectator is first impressed by the naturalness of the gestures, and afterwards thinks of the problems of form. The *Madonna del Sacco* of 1524 (Cloisters of the Annunziata, Florence) holds a special position, even compared with the works of Raphael. This picture is a splendid example of tender and accomplished fresco-work in general, and of picturesque effects of drapery in particular. It has the further merit of a boldness of design in the arrangement of the figures never again achieved by the master. Mary is not sitting in the middle of the picture, but to one side. The balance of the composition is restored by the Joseph opposite. Being further in the background he appears smaller as a mass, but owing to his greater distance from the central axis of the picture he has an equal value in its equilibrium. A few clear general indications f direction ensure a monumental effect at a distance. Very simple outlines are

combined with great richness of content. The magnificent breadth of the motive of the Madonna is due to the low position in which she is seated. Her upturned head will never fail to impress, even if we feel the impression to be superficial. The point of sight is low, corresponding to the actual position of the fresco, which is over a door.

Among Andrea's single figures of saints, the youthful John the Baptist in the Pitti is world-famed. It is one of the half-dozen pictures which are invariably to be found in the windows of the photograph-sellers during the tourist-season in Italy. It might not be uninteresting to ask how long it has held this position, and to what fluctuations of fashion these recognised favourites of the public are liable. The strenuous, impassioned beauty, for which it is praised (*Cicerone*), evaporates at once when it is compared with Raphael's boyish St. John in the Tribuna. But it must be admitted to be the presentment of a handsome lad.[1] The picture unfortunately has been much damaged, and we can only guess at the intended pictorial effect of the flesh-tints emerging from the dark background. The grip of the hand with the turn of the wrist is in Andrea's best manner. A characteristic point is the way in which he interrupts the outline, and allows one side of the body to disappear completely. The bunch of drapery, which was intended to suggest a contrast in direction to the dominating vertical line, foreshadows the extravagance of the seventeenth century. It may be compared with Sebastiano's *Violin-Player* as regards the shifting of the figure to one side and the empty space to the right.

This St. John has a companion picture in the seated figure of St. Agnes in the Cathedral of Pisa, one of the most charming works of the master, in which he seems for once to have approached the expression of the ecstatic, though the actual result is merely a half timid upward glance. Those highest realms of inspiration were quite beyond his reach, and it was a mistake to entrust such a subject as the Assumption to him. He painted it twice, and the pictures hang in the Pitti. As might have been foreseen, neither expression nor movement is adequate. What can we think when, after 1520, we find the Virgin of the Assumption depicted as a seated figure! Even so, however, some more suitable solution might have been found. But Sarto's rendering of prayer is as meaningless as

[1] Sarto used the same model for the Isaac of his *Abraham's Sacrifice* (Dresden), which was painted soon after 1520. I think he is to be recognised also in the *Madonna* of 1524.

the ludicrous look of embarrassment with which Mary grasps the mantle on her lap. He has twice made St. John the chief figure of the Apostles round the grave, and given him that delicate movement of the hands which is found in his youthful pictures. It is impossible, however, to entirely shake off the impression of conscious elegance, and the excitement of the astonished Apostles is never very intense. Yet after all, this placidity is far pleasanter than the noisiness of the Roman school among the followers of Raphael.

The illumination is so contrived that the brilliancy of Heaven should find a contrast in the darkness of the scene on earth. In the second and later picture, however, he left a bright rift open from the very bottom, and a greater master of movement, Rubens, followed him in this, for it is inadvisable to bisect a picture of the Assumption with so strongly defined a horizontal line.

St. John the Baptist, by Andrea del Sarto.

The two kneeling saints in the first Assumption are derived from Fra Bartolommeo. In the second version the motive of the three-quarter length figures in the foreground was retained, and for the sake of a contrast, a certain petty detail was again admitted: one of the men, here an Apostle, looks out of the picture at the spectator during the solemn scene. This is the beginning of the unconcerned figures in the foregrounds of the Scicentists. The forms of art had already been misused as meaningless formulæ.

We need say nothing about the *Pietà* in the Pitti Palace.

4. A Portrait of Andrea

Andrea did not paint many portraits, and he would not *prima facie* be credited with any special qualifications for the task, but there are some

youthful male portraits by him, which attract the spectator by a mysterious charm. These are the two well-known heads in the Uffizi and the Pitti, and the half-length figure in the National Gallery, London. They show all the nobility of Andrea's best manner, and we feel that the painter has expressed himself here with peculiar significance. It is not surprising that they have passed for portraits of himself. But it may be definitely said that they cannot be such. The case is identical with that of Hans Holbein the younger, where a prejudice, hard to eradicate, was early formed in favour of the handsome unknown.

A genuine portrait is extant (a drawing in the collection of portraits of painters in Florence) but there is a reluctance to draw the obvious conclusion that it excludes others, because the idea of the more beautiful type is reluctantly abandoned. The genuine portrait of the youthful Andrea is found in the fresco of the *Procession of the Kings* in the court of the Annunziata, and his likeness as an older man is in the collection of Painters' Portraits (Uffizi). They can be positively identified; Vasari speaks of both. The pictures mentioned above are irreconcilable with these, in fact they do not seem to agree with each other; the London example and the Florentine pictures might well represent a different man. The two latter may be reduced to one, since they correspond line for line, to the very details of the folds. The example in the Uffizi is clearly the copy, and the original is the picture in the Pitti, which, although not intact, shows more delicate workmanship.[1] We shall only speak of this one.

The head stands out from a dark background. It is not sharply relieved against a black surface, as is sometimes the case in Perugino's portraits, but remains almost modestly in the greenish shadow. The strongest light does not fall on the face, but on a scrap of shirt accidentally displayed at the neck. The hood and collar are neutral in tint, grey and brown. The large eyes look calmly out of their orbits. With all its quivering pictorial vitality, the form gains absolute firmness by the vertical line of the head, the full-face view, and the quiet application of light, which relieves one half of the head, and illuminates exactly the necessary points. The head seems to have suddenly turned round and to have

[1] The *Cicerone* holds a contrary opinion: "The finest (probably his own portrait) is in the Uffizi (No. 1147); there is a replica, of inferior merit, in the Pitti (No. 66)." In the posthumous *Beiträge zur Kunstgeschichte von Italien*, J. Burckhardt protested for the first time against the presumption that the pictures are portraits of the painter himself.

Supposed Portrait of Himself, by Andrea del Sarto.

presented for a moment the view, in which the vertical and horizontal axes are seen in absolute purity. The vertical line passes right up to the peak of the cap. The simplicity of the line, and the repose given by the great masses of light and shade, are combined with that clear definition of form characteristic of Andrea's mature style. A firm touch is everywhere distinguishable. The way in which the angle between the eye and nose is brought out, in which the chin is modelled, and the cheek-bone indicated, recalls the style of the *Disputa*, which was obviously painted at the same period.[1]

This delicate and intellectual head may fairly be considered an ideal example of sixteenth century conceptions. One would be glad to include it and the *Violin-player*, to which it bears an intrinsic and extrinsic affinity, in the series of Artists' Portraits. In any case it is one of the finest examples of those lofty conceptions of the human form in the Cinquecento, whose common inception is to be traced to Michelangelo. The impression of the genius which created the Delphic Sibyl is unmistakable here.

The meditative youth in the Salon Carré of the Louvre may be mentioned as a more Leonardesque pendant to this portrait of Andrea's. This fine picture has borne the most various names, but is now rightly, in my opinion, ascribed to Franciabigio, as is also the dark head of a youth (of 1514) in the Pitti Palace, whose left hand rests on the balustrade with a somewhat antiquated gesture.[2] The Paris picture was painted later than this (about 1520), and the last traces of stiffness or embarrassment have disappeared. The young man, whose soul is stirred by some sorrow, gazes before him with downcast eyes. The slight turn and inclination of the head have an extraordinarily characteristic effect. One arm rests on a balustrade, and the right hand is laid on it. This action again has something personal in its gentleness. The motive is not dissimilar to that of the *Monna Lisa*. Here, however, everything resolves itself into a momentary expression, and the imposing portrait becomes an emotional study with all the charm of a *genre* painting. The spectator does not at once ask who the sitter is, but is interested above all in the emotion depicted. The

[1] This portrait cannot possibly be one of the painter by himself, for when he painted in this style he was no longer the young man here represented.

[2] The movement of the hand reappears in the chief figure of Franciabigio's *Last Supper* (Calza, Florence), and might, in the last instance, be traced back to the Christ in Leonardo's *Cenacolo*, which was known and used by Franciabigio.

deep shadow that veils the eyes serves in particular to characterise the pensive dreamer. The distant horizon is also an expressive factor. The only disturbing effect is produced by the space, which has been enlarged on each side. Our reproduction attempts to restore the original look of the picture.

Peculiarly modern tones echo from this dreamy work. It is conceived with far greater delicacy than Raphael's youthful portrait of himself. The sentiment of the fifteenth century always seems somewhat obtrusive when compared with the restrained expression of emotion in the classical age.

Portrait of a Youth, by Franciabigic.

VII

MICHELANGELO (AFTER 1520)
1475—1564

NONE of the great artists exercised from the very first so profound an influence on his contemporaries as Michelangelo, and fate willed that this mightiest and most original genius should also enjoy unusual length of life. He remained at work almost a generation after all his contemporaries had sunk into the grave. Raphael died in 1520, Leonardo and Bartolommeo even earlier. Sarto lived until 1531, but his last decade was the least important of his career, and we see no sign of his having had yet a further stage of development before him. Michelangelo never was stationary for a moment, and does not seem to have concentrated his powers fully till the second half of his life. Then he gave the world the Tombs of the Medici, the *Last Judgment,* and St. Peter's. Henceforth one art only existed for Central Italy, and Leonardo and Raphael were completely forgotten in the new revelations of Michelangelo.

1. THE CHAPEL OF THE MEDICI

The memorial chapel of S. Lorenzo is one of the rare instances in the history of art, in which building and figures were created not only contemporaneously, but with a definite regard one for the other. The whole fifteenth century was disposed to regard things apart from their surroundings, and found beauty in the beautiful object wherever it might be placed. In magnificent buildings such as the memorial chapel of the Cardinal of Portugal at S. Miniato the tomb is an erection which happens to be placed there, but which might just as well have been anywhere else, without

detriment to its effect. Even in the proposed tomb of Julius, Michelangelo would have had no control over the surroundings; it was to have been a building inside a building. But the proposition that he should build a *façade* to S. Lorenzo as an architectural and plastic monument to the Medici in their family church at Florence offered the possibility of combining figures and architecture on a large scale with a definite calculation of effect. The plan fell through. Though the architecture would only have been the frame, it was artistically more desirable that the new scheme for the chapel should not only afford space for a more liberal use of sculpture, but should put the lighting entirely into the hands of the artist. Michelangelo indeed accepted it as an important factor in his scheme. In his figures of *Night* and of the *Penseroso* he contrived that the features should be entirely in shadow, an effect unprecedented in sculpture.

The chapel contains the monuments of two members of the family who died in youth, Duke Lorenzo of Urbino and Giuliano, Duke of Nemours. An earlier plan, which aimed at a more extensive representation of the family, had been abandoned.

The scheme of the tombs is based on the grouping of three figures: the deceased, not sleeping, but a living, seated figure, and on the sloping lids of each sarcophagus, two recumbent figures in attendance. In this case Night and Day were chosen in place of the Virtues, out of which it was usual to form a guard of honour for the dead.

A peculiar feature in this arrangement is immediately noticeable. The tomb does not consist of an architectural design with figures, placed against the wall. The sarcophagus alone, with its crowning figures, stands free; the hero is seated in the wall itself. Two elements of space, quite distinct, are combined to produce a united effect, and in such a manner that the seated figure is brought down as low as the heads of the recumbent figures.

These latter bear the strangest relation to their supporting surfaces. The lids of the sarcophagi are so narrow and so steep that the figures seem doomed to slip down. It has been conjectured that the lids were perhaps intended to be completed by terminal volutes, rising from the ends, which would have given the figures support and security. This was actually done in the Tomb of Paul III. in St. Peter's, a monument inspired by Michelangelo. On the other hand it is asserted that the figures would be prejudiced by such additions, that they would become tame, and lose

the elasticity which they now exhibit. It is in any case probable that so unusual an arrangement, which challenges the criticism of every amateur, must be due to an author who could afford to run risks. In my opinion it was Michelangelo's deliberate intention to leave the monument in its present state.

The manner in which the figures are supported is not the only jarring element; higher up there are discords, almost incomprehensible at first sight. The figures are allowed to cut the line of the cornice of the stylobate behind with an unprecedented recklessness. Here the sculpture is clearly at war with its lord and master, architecture. This antagonism would be unendurable, if it did not find some mitigation. This is afforded by the third and concluding figure, in its perfect union with its niche. The scheme therefore was not only to build up a triangular structure with the figures, but to develop the figures in their relation to the architecture. In Sansovino's work everything appears uniformly hushed and concealed within the space of the niches, but here we are met by a discord which has to be resolved. The principle is identical with that adopted by Michelangelo in his last plan for the tomb of Julius, when the compression of the central figure is disguised by the spacious adjoining

The Tomb of Lorenzo de' Medici, with the figures of Morning and Evening, by Michelangelo.

[1] There is also a direct proof of this. In a drawing in the British Museum, published by Symonds (*Life of Michelangelo*, I. 384), there is a figure on a similarly constructed lid. It is drawn hastily, but is quite distinct.

compartments. He further employed these new artistic effects on the vastest scale in the exterior elevation of St. Peter's.[1]

The niche enshrines the general closely, there is no superfluous space to weaken the effect. It is very shallow, so that the statue projects. We cannot here discuss the further working of the master's thought, why for instance, the central niche has no pediment and the accent is shifted to the sides. The chief intention of the architectonic arrangement was to set off the figures by means of a variety of small adjuncts, and this perhaps was also the justification of the short lids of the sarcophagus. The figures resting on them are colossal, but they are intended to produce a colossal effect. Nowhere in the world does sculpture produce a more powerful impression on the spectator. The architecture with its slender panels and its sparing use of massive motives is entirely subordinated to the effect of the figures.

We might almost suppose that the figures were deliberately made disproportionately large for the space. One remembers how hard it is to stand at the proper distance from them and how cramped one feels. And then we read that four more figures (recumbent river-gods)[2] were to have been introduced. The impression would have been overpowering. These are effects which have nothing in common with the liberating beauty of the Renaissance.

Michelangelo was not permitted to finish his work unaided (the chapel, as is well known, received its present form from Vasari), but we may assume that we have before us the main features of his plan.

Some portions of the chapel have been stained dark, otherwise it is completely in monochrome, white on white. It is the greatest example of the modern disuse of colour (achromatism).[3]

The recumbent figures of *Day* and *Night*, *Morning* and *Evening* take the place of the customary Virtues. Later artists continued to make use of the latter in a similar connection, but the motives of *Day* and *Night* offered possibilities of characteristic movement so much greater that Michelangelo's determination is sufficiently explained. The first consideration was the necessity of a recumbent motive, by which, in combination

[1] Cf. Wölfflin, *Renaissance und Barock*, p. 48.
[2] Michelangelo, *Lettere* (ed. Milanesi) 152.
[3] If paintings ever existed in this chapel they were in any case merely monochromes. The probability seems remote, and is not supported by the records.

with the perpendicular line of the seated figure, he was able to achieve an entirely new configuration.

The ancients had their river-gods, and a comparison with the two splendid antique figures, for which Michelangelo himself prepared a place of honour on the Capitol, throws an instructive light on his style. He enriches the plastic motive in a manner that leaves all previous achievements far behind. The turn of the body in *Morning*, who faces the spectator, and the way in which the upraised knee of *Night* cuts the outline, are incomparable. The figures are marvellously stimulating, because of their divergences of surface and contrasts of direction. Yet in spite of this variety the effect is full of repose. The strong tendency towards formlessness encounters a stronger desire for form. The figures are not only clear in the sense that all essential clues to the idea are furnished and that the main features are at once impressively prominent,[1] but they are enclosed by very simple boundaries. They are enframed and stratified, and might be considered as pure reliefs. The *Morning*, with all her movement, is strangely panel-like in effect. Her raised left arm quietly suggests the level of the background, and every thing in front is on a parallel plane. Later artists learned movement from Michelangelo and attempted to surpass him in it, but they never comprehended his repose. Bernini least of all.

Recumbent figures give scope for very striking effects of contraposition, as the limbs, with their opposing movements, can be brought closely together. But the significance of these figures is not confined to the problem of form they offer; physical phenomena contribute strongly to the effect. The wearied man, whose limbs relax, is a touching representation of Evening, which seems also to typify the evening of life, and a reluctant waking was never more convincingly depicted than here.

A change of feeling is perceptible in all these figures. Michelangelo no longer breathes as freely and gladly as in the Sistine Chapel. All his movement is harsher, stiffer, more abrupt. His bodies are ponderous as mountain-boulders, and they seem to obey the will reluctantly and unequally. The two pairs of figures are far from uniform in style. *Day* and *Night* were obviously later than the others. The force of the contrasts is accentuated in them, and they conflict still more violently with the

[1] In the *Night* the right arm seems to be lost to view, but this is only apparent: it is in the unworked piece of marble above the mask.

architecture. The deceased appear as seated figures. These tombs do not present the sleeping image of the dead, but are memorials of the living. This idea had been anticipated by Pollaiuolo in the tomb of Innocent VIII. in St. Peter's. There, however, the figure of the Pope, giving a blessing, does not appear alone, but is introduced together with the recumbent corpse.

Michelangelo had to deal with the figures of two great soldiers. It may seem surprising that he should have selected a sitting posture, and indeed an indolently sitting posture, in which there is much individuality. The one figure is absorbed in meditation, the other casts a momentary side-glance. Neither takes an official or representative pose. The conception of distinction had changed since the times when Verrocchio made his *Colleoni*, and the type of the seated general was afterwards retained for the statue of no less a commander than *Giovanni delle Bande Nere* (in the Piazza before S. Lorenzo). The treatment of the seated figures as such is interesting from the numerous earlier solutions of the problem which Michelangelo had already given. The one resembles the *Jeremiah* of the Sistine ceiling, the other the *Moses*. In both, however, we note characteristic alterations all tending to increased richness of effect. In the *Giuliano* (with the Marshal's bâton) we may instance the differentiation of the knees and the inequality of the shoulders. Henceforth these models formed the standard by which the plastic value of all seated figures was judged. There was soon no end to the painful efforts made to arouse interest by twisting a shoulder, raising a foot, and

The Medici Madonna, by Michelangelo.

turning a head, efforts which necessarily entailed the loss of any spiritual meaning.

Michelangelo made no attempt to characterise the deceased, or to portray their features. Their costume is also ideal. No word of inscription explains the monument. This may have been in deference to express orders, for the tomb of Julius again bears no inscription.

The chapel of the Medici contains a seated figure of a different kind, a *Madonna with the Child*. This shows the mature style of Michelangelo in its most perfect form, and is all the more valuable, as a comparison of it with the analogous youthful work, the *Madonna of Bruges*, elucidates his artistic development, and leaves no further doubt as to his intentions. An inquiry into the growth of the *Madonna of the Medici* out of the *Madonna of Bruges* would be a suitable prelude to initiation into the secret of Michelangelo's development. It might be pointed out how the simpler possibilities are replaced by the more complicated. How, for example, the knees are no longer close together, but one leg crosses the other; how the arms are differentiated, one being advanced, and the other drawn back, so that the two shoulders are distinct in every dimension; how the bust is bent forward, and the head turned to one side; how the Child sits astride on His mother's knee, His figure confronting the spectator, but turns His head back and feels for her breast. This motive thoroughly mastered, there would be another consideration : why is the effect so full of repose, in spite of the richness of the action? The first quality, variety, is easily imitated, but the second, unity, is very difficult to achieve. The group appears simple because it is clear and can be comprehended at a glance, and its effect is reposeful, because its whole significance is brought into one compact form. The original block of marble seems to have been but slightly modified.

Crouching Boy, by Michelangelo.

Michelangelo achieved perhaps the highest success of this kind in the figure of the boy at St. Petersburg, who is crouching down and tending his feet.[1] The work looks like the solution of a definite problem. We might imagine that his object had been to produce the most varied figure possible with the smallest amount of disturbance and disruption of the block. It is thus that Michelangelo would have represented the boy extracting the thorn. It is an absolute cube, but full of stimulating motives for plastic representation.

The *Christ* of the Minerva in Rome shows how a standing figure was treated at this epoch. This statue, which was spoilt in its final execution, must be termed a great work in conception and highly important in its consequences. Michelangelo had obviously renounced draped figures; he therefore represents the Christ nude, as the Risen Lord, giving Him in place of the banner of victory, the cross (and with it the reed and sponge). This was required to ensure a massive effect. The cross stands on the ground, and Christ grasps it with both hands. The immediate result is the important motive of the outstretched arm, which crosses the breast. It must be borne in mind that the idea was new, and that in the *Bacchus*, for example, such a possibility would never have been entertained. The sweep of the arm is intensified by the sharp turn of the head in the opposite direction. A further variation

Christ, by Michelangelo.

[1] Springer, erroneously, refers him to the tomb of Julius and supposes him to represent a conquered foe. *Raphael und Michelangelo*, II. 530.

is brought about in the hips, by drawing back the left leg, while the breast is turned towards the right. The feet are planted one behind the other. The figure therefore shows a surprising depth. This development is, however, only effective when seen, or photographed, in its normal aspect. The normal aspect is that in which all the contrasts are simultaneously effective.[1]

Michelangelo entered a domain presenting still richer possibilities when he combined standing and kneeling figures, as in the so-called *Victory* in the Bargello. This is not a pleasing creation, according to our taste, but it had a peculiar charm for his disciples, as the countless imitations of the motive prove. We may pass it over and consider the last plastic ideas of the master, the different designs for a Pietà, the richest of which, a composition of four figures (now in the Cathedral at Florence) was destined for his own tomb.[2] The feature common to them all is that the body of the dead Christ no longer lies diagonally across His mother's lap, but is partly upright, and huddled together on her knees. It was hardly possible to get a beautiful outline with such a figure, nor did Michelangelo attempt it. The last thought he wished to express with his chisel was the shapeless collapse of a heavy

An Allegory, by Bronzino.

[1] Unfortunately no such photograph could be obtained for reproduction in this volume. The point from which it should be taken is more to the left.

[2] Besides the familiar group in the Palazzo Rondanini at Rome a similar sketch in the Castle of Palestrina might also be examined.

mass. Painting appropriated this scheme, and when we see Bronzino's version of such a group, with its harsh, zigzag lines, and offensive crowding of the figures, it seems hardly credible that this was produced by the generation which succeeded to the age of Raphael and Fra Bartolommeo.

2. THE LAST JUDGMENT AND THE PAULINE CHAPEL

Michelangelo certainly did not enter upon the great pictorial tasks of his extreme old age with the repugnance with which he had painted the Sistine ceiling. He felt the need of luxuriating in masses. In the *Last Judgment* (1534–41) he enjoyed the "Promethean happiness" of being able to realise all the possibilities of movement, position, foreshortening and grouping of the nude human form. He wished to make these masses stupendous and to overwhelm the spectator. He attained his purpose. The picture seems too large for the chapel: the one enormous painting extends frameless along the wall, and annihilates all that was left of the earlier frescoes. Michelangelo showed no respect for his own painting on the ceiling. It is impossible to look at the two works together, without feeling the harsh discord. The arrangement is in itself magnificent. The figure of Christ, raised high in the picture, is intensely effective. About to spring up, He seems to grow as the eye dwells on Him. Around Him is an awe-inspiring throng of martyrs, calling for vengeance. They approach in ever denser throngs: their forms become more and more colossal—the scale is wilfully altered—and the gigantic figures combine into unprecedentedly powerful masses. No individual objects are now emphasised, nothing is considered but the grouping of masses. The figure of Mary is attached to that of Christ just as in architecture a single pillar is strengthened by a companion half or quarter pillar.

The secondary lines are two diagonals, which meet in the Christ. The movement of His hand passes down through the whole picture like a lightning-flash, not dynamically, but as an optical line, and this line is repeated on the other side. It would not have been possible to give any emphasis to the chief figure without this symmetrical arrangement.

In the Pauline Chapel on the other hand, where we find the historical pictures of Michelangelo's last years (*Conversion of St. Paul* and *Crucifixion of St. Peter*), all symmetry is thrown to the winds, and there is once

more a growing tendency to sacrifice form. The pictures come into immediate contact with the real pillars, and half-length figures rise from the lower border. This is indeed far from the spirit of classic art. There is, however, no senile feebleness. Michelangelo excels himself in the vigour of his rendering. The Conversion of St. Paul could not be rendered more powerfully than here. Christ appears high up in the corner of the picture. A beam of His radiance strikes Paul, and he, with eyes staring out of the picture, listens for the voice which comes from the heavens behind him. Thus the story of the Conversion is told once for all, in a way that completely surpasses the rendering of the theme in Raphael's tapestries. In this latter, apart from the individual movement, the main point of the incident is not grasped. The prostrate Paul has the wrathful God too fully before his eyes. Michelangelo, with true genius, places the Christ above Paul, on his neck, as it were, so that the latter cannot see Him. As Paul raises his head and listens, we fancy we see before us the blinded man in whose ears the heavenly voice rings. On the tapestry, the horse is represented galloping away to the side; Michelangelo placed it near Paul, in a diametrically opposite direction, facing into the fresco. The whole group is unsymmetrically pushed towards the left edge of the picture, and the one great line, which descends steeply from the Christ, is then continued at a less acute inclination towards the other side. This is his last style. Harsh lines seam the picture. Heavy conglomerations of mass alternate with yawning gaps. The companion picture, the *Crucifixion of St. Peter*, is made up of equally glaring discords.

3. The Decadence

No one would wish to make Michelangelo personally responsible for the destiny of central Italian art. He was what he was bound to be, and he remained sublime even amid the distortions of his later style. But his influence was disastrous. All beauty was measured by the standard of his works, and an art which had been created under exclusively individual conditions became universal.

It is necessary to examine somewhat more closely this phenomenon of "Mannerism."

All artists began to aim at bewildering effects of mass. Raphael's methods of construction were forgotten. Spaciousness and beauty of form

were ignored. Men's ideas of the capacities of surface had become dulled. Painters vied with each other in the hideous crowding of their canvases, and in a disregard of form which intentionally aimed at an opposition between the space and its contents. It was not necessary that there should be numerous figures. Even a single head was given a size disproportionate to its frame, and in isolated sculptures, colossal figures were placed on minute pedestals (Ammannati's *Neptune* in the Piazza della Signoria, Florence).

The greatness of Michelangelo was referred to the wealth of movement in his pictures. Michelangelesque work composition became a synonym for the bringing into action of every muscle, and thus we enter that world of complicated turns and bends, in which the uselessness of the action cries aloud to heaven, and in which simple gestures and natural movements were unknown. If we think of the reclining nude female figures of Titian, how happy may he be accounted when compared with a Vasari, who was compelled to introduce the most artificial movements, in order to make a *Venus* attractive to the eyes of his public. (As an example of this, the *Venus* in the Colonna Gallery may be compared with the motive of the *Heliodorus*.) The worst aspect of the question is that any sympathetic regret would have been vigorously deprecated by the later artist.

Art became absolutely formal and no longer regarded nature. It constructed schemes of movement after receipts of its own, and the human body became a mere mechanism of joints and muscles. If we stand before Bronzino's *Christ in Limbo* we fancy we are looking at an anatomical museum. There is nothing but anatomical pedantry, not a trace of unsophisticated vision. The sense of the material, the feeling for the delicacy of the human skin, and the charm of the surface of things seemed to be extinct. Plastic art reigned supreme, and painters became pictorial sculptors. In their infatuation they threw away all their wealth and found themselves paupers. The charming subjects of earlier times, such as the *Adoration of the Shepherds*, or of *The Three Kings*, were now merely pretexts for more or less perfunctory combinations of curves, a multiplicity of nude forms. (Cf. Tibaldi's *Adoration of the Shepherds*.)

It may be asked, what had become of the splendid scenes of the Renaissance? Why should a picture like Titian's *Presentation in the Temple* of 1540 have become inconceivable in Central Italy? Men had lost all joy in themselves. They looked for some universal principle, which lay

Venus and Amor (*Il Giorno*), by Vasari.

beyond this present world, and systematising formed a profitable alliance with learned antiquarianism. The difference between the local schools disappeared. There was no longer a popular art. Under these circumstances art was beyond all aid, it was dying at the roots, and the baneful ambition to produce nothing but monumental works only hastened the calamity.

It could not revive by its own efforts, its salvation had to come from without. It was in the Germanic North of Italy that the fountain of a new naturalism began to flow. Caravaggio caused a memorable impression at a time when men had gazed until they were stupid at the spiritless productions of the Mannerists. Once more there was originality of idea and sentiment, based on the real experience of the artist. The *Entombment* in the Vatican Gallery may appeal to few of the modern public by its main features, but the reasons must have been good which induced an artist who felt such gigantic powers in himself as the young

Rubens, to copy it on a large scale. If we simply look at a single figure like that of the weeping girl, we shall find in it a shoulder, painted with such colour and such light, that all the false pretensions of Mannerism melt away like an evil dream in the beams of this sunshine. Once more the world becomes rich and joyous. The Naturalism of the seventeenth century, and not the Bolognese Academy was the true heir of the Renaissance. Why it was doomed to succumb in the conflict with the " ideal" art of the Eclectics is one of the most interesting questions which can be propounded in the history of art.

The Adoration of the Shepherds, by P. Tibaldi.

PART II

I

THE NEW FEELING

In the Campo Santo of Pisa, Benozzo Gozzoli depicts the *Drunkenness of Noah*, among other incidents of Old Testament history. The story was told with the breadth and detail characteristic of the Quattrocentist narrator, who shows his pleasure in representing the course of the patriarch's debauch as circumstantially as possible. He begins at the very beginning: it is a fine afternoon in autumn, and the old man takes his two grandchildren with him to see the vintage. We are shown the men and women picking the grapes, filling the baskets with them, and treading them in the vats. The scene is enlivened by happy creatures everywhere; birds perch near the tiny pools, and one of the children busies himself with a dog. The grandfather stands and enjoys the cheerful scene. Meantime the new wine has been pressed and is handed to the master for approval. His own wife brings him the cup and all wait expectant while he tastes the liquor critically. The verdict was favourable, for the patriarch now disappears into a retired arbour, where a large cask of "vino nuovo" has been placed. Then the disaster occurs. The old man lies in drunken stupor before the door of his fine brightly-painted house, indecently exposed. The children see the strange transformation with deep astonishment, while the wife takes care to send the maidservants at once about their business. They hide their faces with their hands, but reluctantly, and one of them tries to catch a glimpse of the spectacle through her outspread fingers.

After 1500 we find no more of these narratives. The scene is crisply worked out in a few figures, without accessories. There are no descriptions; only the dramatic kernel of the story is presented. The

subject is not spun out, it is treated seriously. The artist does not wish to amuse the spectator, but to stir his emotions. Human passion becomes the main preoccupation, and, compared with the interest taken in man, all that the world contains is of small account.

A spectator in a gallery where the Cinquecentists hang side by side, is struck first by the narrow range of material. Cinquecentist art depicts nothing but human forms, mighty forms that fill the whole picture, and secondary incidents are rigorously excluded. What is true of the easel-pictures holds good of the frescoes. In both we behold a new race of men, and art aims at effects which are no longer compatible with contemplative joy in the rich variety of inanimate things.

Baptism of Christ, by Verrocchio.

1

The Cinquecento sets out with a totally new conception of human greatness and dignity. All movement becomes more emphatic, and emotion draws a deeper and more passionate breath. A general exaltation of human nature is noticeable. Men developed a feeling for the important, the solemn, and the grandiose, in comparison with which the fifteenth century must have appeared awkward and timid in its attitude. Thus every expression was translated into a new language. The curt bright tones became deep and sonorous, and the world once more heard the splendid periods of an emotional style. When the *Baptism of Christ* is depicted—let us say, for example, by Verrocchio—the ceremony is performed

with a pressing haste, and a conscientious care, which may have been honestly felt, but appeared vulgar to the new generation. Let us compare A. Sansovino's group in the Baptistery with Verrocchio's *Baptism*. The former gives a perfectly novel rendering of the theme. The Baptist is not advancing, he stands calmly in his place. His breast is turned towards the spectator, not towards Christ. The head alone, boldly facing sideways, follows the direction of the hand, which holds the bowl of water at arm's length over the Redeemer's head. There is no anxious following after Jesus, no straining forward of the body. The Baptist, calm and reticent, performs the ceremony, a symbolic action, which does not depend for its efficacy on any precise method of execution. Verrocchio's John is bending over like an apothecary pouring a draught into a bottle, and full of anxiety lest a drop should be wasted. His eye follows the water: in Sansovino's group it rests on the face of Christ.[1]

Baptism of Christ, by A. Sansovino.

Among the pencil-drawings in the Uffizi there is a corresponding sketch for a *Baptism* in the Cinquecento style by Fra Bartolommeo.

The figure of the *Christ* is likewise changed. He is represented as a ruler, not as a poor teacher. Verrocchio depicts him standing unsteadily in the river, the water swirling round his shrunken legs. A later age gradually dispensed with the standing in the water, unwilling to sacrifice the clear representation of the figures to commonplace realism, but the pose itself became easy and dignified. Sansovino's attitude is graceful and buoyant; the leg on which no weight is thrown, is thrust out to the side. There

[1] Sansovino's Baptist holds the bowl almost horizontally. Formerly the inverted vessel was represented with archaic exactness, and Bellini makes the contents drain away to the last drop. (Picture at Vicenza.)

is a beautiful continuous line in place of the angular jagged movement. The shoulders are squared, the head only being slightly sunk. The arms are crossed over the breast, the natural development of the conventional motive of the hands clasped in prayer.[1]

This is the grand gesture of the sixteenth century. Leonardo had already used it with all the reticence and refinement characteristic of him. Fra Bartolommeo vibrates with the new pathos, and carries his public away as with the blast of a hurricane. The prayer of his *Mater Misericordiæ*, and the benediction of his *Salvator* are creations of the highest class. The way in which entreaty breathes from every line of the Virgin, the impressive dignity with which Christ gives the blessing, make all earlier representations appear as child's play. Michelangelo was from the first no emotionalist. He makes no long speeches, and his pathos is subdued as the murmur of a mighty subterranean spring, but in force of gesture he was incomparable. It is enough to instance the figure of the *Creator* on the Sistine ceiling. Raphael, during the years of his manhood at Rome, had drunk deeply of the new ideas. What intense emotion lives in the sketch for the tapestry of the *Coronation of the Virgin*, with what vigour do the gestures express the action of donor and recipient! A strong personality is required to keep these motives of vigorous expression well under control. An instructive example of the way in which they sometimes run away with the artist is given by the composition of the so-called *Five Saints* at Parma.[2] It is a work of the school of Raphael, which might be compared with the still timidly-drawn group of Christ in the *Disputa* of the youthful Master.

We have the literary parallel to this excess of pathos in Sannazaro's famous poem of the Birth of Christ (*De partu Virginis*).[3] The poet had determined to avoid as far as possible the simple style of Biblical narrative, and to adorn the story with all the pomp and pathos which he could contrive. Mary is from the first the goddess, the Queen. The humble *Fiat mihi secundum verbum tuum* ("Be it unto me according to Thy

[1] A similar criticism might be applied to the bronze group of *Christ and St. Thomas* by Verrocchio in Or San Michele. Christ, who is exposing the wounds with His own hands and following the action with His eyes, is too trivial in motive. A later artist would have conceived the scene differently.

[2] Engraving by Marc' Antonio, B. no. 113.

[3] The work appeared in 1526. The author is supposed to have elaborated it for twenty years.

word") is changed into a long highflown speech, which does not correspond in the least with the Biblical situation: she looks up to heaven.

" oculos ad sidera tollens
adnuit et tales emisit pectore
 voces :
Jam, jam vince fides, vince
 obsequiosa voluntas :
En adsum : accipio venerans
 tua jussa tuumque
dulce sacrum pater omnipotens,"[1] etc.

Brightness fills the room. She conceives. Thunder is heard in a clear sky
" ut omnes
audirent late populi, quos
 maximus ambit
Oceanus Thetysque et raucisona Amphitrite."[2]

2

Together with a desire for large and prominent forms we find a tendency to weaken the expression of emotion, which characterises the physiognomy of the century in a still higher degree. This is the quality referred to by those who speak of the "classic repose" of these figures. Examples are not far to seek. At a moment of the most intense emotion, when Mary sees her Son dead before her, she does not scream, nor even weep. Calm and tearless, her features undistorted by grief, she stretches out her arms and

Pietà.
From Marc Antonio's engraving after Raphael.

[1] "raising her eyes to the stars, she bowed her head and uttered these words from her heart: Prevail, O faith, prevail, willing obedience! Behold I am here; I receive and worship thy commands, Omnipotent Father," &c.
[2] "that all the lands might hear, which mightiest Ocean and Thetys and hoarse-sounding Amphitrite encircle."

gazes upwards. Raphael has drawn her thus (engraving by Marc. Antonio). Fra Bartolommeo makes her imprint a quiet passionless kiss on the forehead of a dead Christ who shows no trace of His recent sufferings. Michelangelo, still greater and more restrained than the others, had already represented the scene on these lines in the *Pietà* of his first visit to Rome.

When, in the *Visitation*, Mary and Elizabeth, great with child, embrace each other, it is the meeting of two tragedy queens, a slow, solemn, silent greeting (Sebastiano del Piombo, Louvre). We have done with the cheerful hasty visit, when a kindly young woman with a graceful gesture tells the old cousin not to stand so much on ceremony.

In the scene of the *Annunciation* Mary is no longer the girl gazing in joyful alarm at the unexpected visitor, as Filippo, Baldovinetti or Lorenzo di Credi painted her, nor the modest maiden, casting her eyes down like a candidate for confirmation but, absolutely composed, with a royal bearing, she receives the angel like a fashionable lady who is not to be taken by surprise.[1]

Even the emotions of maternal love and tenderness are subdued. The *Madonnas* of Raphael's Roman period are very different in expression to his first conceptions. It would no longer seem decorous for the Madonna, now become so stately, to press the child to her cheek, as the *Madonna della Casa Tempi* does. A distance is put between them. Even the *Madonna della Sedia* is the proud mother, not the loving mother who forgets the world around her, and if in the *Madonna* of Francis I. the Child hastens to His mother, it should be noticed how little the latter advances towards Him.

3

Italy in the sixteenth century stereotyped the idea of distinction which still prevails in the west. A number of gestures and movements disappeared from pictures; they were felt to be too commonplace. We have a distinct sense of passing into another rank of society. Art

[1] Leonardo blames a contemporary painter, who represents Mary in such agitation at the message that she seems ready to leap out of the window. Albertinelli and Andrea del Sarto first struck the true Cinquecento note. Piero dei Franceschi anticipated this representation in his *Annunciation* at Arezzo. The subject has found its most grandiose realisation in the picture by Marcello Venusti (Lateran), a conception which betrays the spirit of Michelangelo. (There is a replica in the rarely accessible Church of S. Caterina ai Funari in Rome.)

is no longer middle-class, but aristocratic. All the distinctive criteria of manner and feeling prevailing in the higher classes were adopted, and the whole celestial world of the Christian, his saints and heroes, had to take on an aristocratic stamp. The gulf between the popular and the refined was then fixed. When in Ghirlandajo's *Last Supper* of 1480 Peter points with his thumb at Christ, we have a popular gesture, which High Art at once rejected as inadmissible. Leonardo was fastidious enough, yet even he now and again commits an offence against pure Cinquecentist taste.

The Visitation, by Sebastiano del Piombo.

I place in this category the gesture of the Apostle at the *Last Supper* (to the right), who has placed one hand open on the table, and strikes it with the back of the other, a gesture still ordinary and intelligible, but one which the "high style" will admit no more than the other. It would take us too far, if we were to attempt to describe fully this process of "purification." One or two instances will be typical of many.

At the banquet of Herod, when the head of John is placed on the table, Ghirlandajo makes the King bow his head and clench his hands; we hear him lamenting. The later age thought this unkingly. Andrea del Sarto shows the arm outstretched and languidly deprecatory, a silent repudiation.

When Salome dances, Filippo or Ghirlandajo makes her spring round

the room with the wild impetuosity of a schoolgirl. The decorum of the sixteenth century demands a more reticent bearing; a princess should dance only stately measures, and Andrea has represented her thus engaged.

General ideas are formed as to decorous sitting and walking. Zacharias, the father of John, was a plain man, but the laying of his leg over his knee, when he wrote down the name of the new-born boy, as pictured by Ghirlandajo, was an attitude unworthy of the hero of a Cinquecentist story.

The true aristocrat is careless in his bearing and movements. He does not attitudinise, nor stiffen his back in order to make himself presentable; he is content to appear as he is, for he is always fit for any company. The heroes whom Castagno painted are for the most part common swaggerers; no gentleman would look like them. Even the type of the Colleoni in Venice must have been felt by the sixteenth century to be that of a braggadocio. The way in which the women march bolt-upright when, in Ghirlandajo's picture, they visit the lying-in room, seemed later to have a middle-class touch about it; the high-born dame's deportment should be marked by an easy negligence.

If we want Italian testimony to these new conceptions, it is to be found in Count Castiglione's *Cortigiano*, the treatise on the Perfect Cavalier (1516). It gives the idea prevalent at Urbino, and Urbino was then the place where all who laid claim to rank and breeding resorted, the recognised school of polite manners. The expression for high-bred, elegant nonchalance was "la sprezzata disinvoltura." The duchess, who dominated the court, was famed for the unpretentious distinction of her manners: the "modestia" and "grandezza" of her words and gestures made her regal. We glean many further details as to what was compatible with the dignity of a nobleman. A sober gravity of demeanour is repeatedly put forward as his essential characteristic, that "gravità riposata" which marks the Spaniard. We are told (and this was clearly a new departure) that it is indecorous for a man of breeding to take part in rapid dances ("non entri in quella prestezza de' piedi e duplicati ribattimenti"). The ladies were similarly advised to avoid all hasty movements ("non vorrei vederle usar movimenti troppo gagliardi e sforzati"). Everything was to be marked by "la molle delicatura."

The discussion of good manners naturally extends to language, and if Castiglione still allows considerable freedom, the popular book on decorous

behaviour by Della Casa (il Galateo) contains far stricter rules. Even the old poets are taken to task, and the critic of the sixteenth century is surprised that Dante should put the locutions of the pothouse into the mouth of his Beatrice.

In the sixteenth century men strove perpetually for dignity of demeanour, and became serious in the process. The Quattrocento must have seemed a petulant and thoughtless child to the new generation. It was thought, for example, an incomprehensible piece of *naïveté* to allow two laughing boys to be placed on a tomb, holding the coats of arms, as on the tomb of Marsuppini by Desiderio in S. Croce. There ought to have been weeping " Putti " in their places, or, better, large mourning figures (Virtues), for children can never be really serious.[1]

4

Only important events were considered worthy of notice. In the stories of the Quattrocentists there are a number of homely idyllic touches, which have little to do with the real theme, but delight the modern spectator by their simplicity. We have given instances in the history of Noah by Gozzoli. The painter was not anxious to convey one definite impression, he wished to gratify the public by a wealth of incidents. When the Saints in Signorelli's fresco in Orvieto are receiving their heavenly crowns, angels are making music in the skies. One of them finds it necessary to tune his instrument, and at the most solemn moment he gravely sets about this task in the most conspicuous place. He might have seen to this beforehand!

Botticelli painted the *Exodus of the Jews from Egypt* in the Sistine Chapel. The exodus of a nation, a truly heroic scene! Yet what is the main motive? A woman with two little boys; the youngest is led by the elder brother, but he is rebellious; he clings tearfully to his mother's arm and is being scolded. It is a charming incident, but who among the new generation would have been bold enough to introduce the motive in such a connection?

Cosimo Rosselli represented the *Last Supper* in the same chapel. He introduces into the foreground a still life of great polished metal dishes;

[1] The mourning "Putti" are found as early as the fifteenth century in Rome, always more solemn than Florence. The seventeenth century recurs to the artless motive of smiling children on sepulchral monuments. These are, however, very infantine.

then he paints a dog and cat romping together, and another dog, begging on his hind legs. The tone of the sacred theme is of course quite ruined, yet he offended nobody, and the painter was decorating the private chapel of the Head of Christendom.

There were individual artists, like the great Donatello, who showed a perfect sense of unity in their conception of a historic moment. His historical pictures are the best narratives of the fifteenth century. It was extraordinarily difficult for others to concentrate themselves, to abandon all that was merely entertaining, and to represent the subject seriously. Leonardo's axiom was that a picture telling a story, ought to make the same emotional impression on the spectator as if he had been present at the occurrence.[1] But how was this possible so long as a crowd of persons was tolerated in the pictures who were uninterested bystanders or apathetic spectators? In Giotto's scenes everyone present took, either actively or passively, a personal part in the action, but the Quattrocento ushered in that silent chorus of persons who were tolerated, because interest in the representation of mere existence and of characteristic life had become stronger than interest in action and the relation of individual to individual. It was often the purchaser of the picture and his family who wished to figure on the stage, or perhaps some local celebrity whom the painter honoured in this way, without imposing any definite rôle on them. L. B. Alberti, in his treatise on painting, does not hesitate to solicit this honour for himself.[2]

If we examine the cycle of frescoes on the walls of the Sistine Chapel, we are struck by the indifference of the artist to his subject. It is strange how little he cares to emphasise the real factors in the story, how, more or less universally, in the conflict of various interests, the essential threatens to disappear before the unessential. Did ever Lawgiver like Moses have before him so inattentive an audience as that in Signorelli's fresco? It is almost impossible for the spectator to realise the situation. One might have thought that Botticelli was of all others the man to depict, in the *Rebellion of Korah*, the passionate excitement which had spread among great masses of people. But even with him how soon does the fire of movement die out in the ranks of the stolid bystanders!

When Raphael's tapestries with the stories of the Apostles appeared, they must have produced a profound impression in contrast to these historical pictures of the Quattrocento. Raphael had treated his subject

[1] *Trattato della Pittura.* [2] *Minor Writings.*

with the utmost seriousness, his stage was cleared of all superfluous figures, and a vigour of dramatic animation was displayed which appealed directly to the feelings of the spectator. When Paul is preaching at Athens, the bystanders are not mere supernumeraries with typical heads, but the features of each individual show what impression the words make on him, and how far he can follow the speaker. When some marvellous event occurs, as the sudden death of Ananias, all who see it start back with the most eloquent gestures of surprise and horror, whereas the whole Egyptian nation might be drowned in the Red Sea, and a Quattrocentist painter would not show a single Hebrew excited at the catastrophe.

It was reserved for the sixteenth century, not to discover the great world of human emotions and passions, but to turn it to artistic account. Its art is characterised by keen interest in the psychological aspect of events. The *Temptation of Christ* would have been a theme entirely congenial to the new era. Botticelli could make nothing of it, and filled his picture with the representation of a mere ceremony. On the other hand, where the Cinquecentists had to treat subjects lacking in dramatic elements they often made the mistake of introducing passion and intense emotion into scenes where they are out of place, for example the idyllic scenes of the Birth of Christ.

The intimate pleasure of the artist in his work ceased in the sixteenth century. Delight in the breadth of nature and the wealth of objects dies away. A Quattrocentist, painting an *Adoration of the Shepherds*, would introduce any and every motive. There is a picture of the sort by Ghirlandajo in the Academy of Florence. How carefully the animals are painted, the ox, the ass, the sheep, the goldfinch; then we have flowers, pebbles, a smiling landscape. We are introduced to the family baggage; a well-worn saddle lies on the ground, and a wine cask by it. The painter, to suit the antiquarian taste of the day, has thrown in one or two ornamental adjuncts: a sarcophagus, an antique pillar or two, and in the background a brand new triumphal arch, with an inscription in golden letters on a blue frieze.

The "great style" knows nothing of these diversions offered to a sight-loving public. We shall speak later of the way in which the eye looked elsewhere for pleasing effects; it need only be said in this place that the interest of the later historical picture was concentrated entirely on the actual event, and that the attempt to produce the main effect by great

emotional action excluded the mere gratification of the eye by miscellaneous incidents. This entailed a rigorous condensation of the diffuse elements hitherto introduced in Lives of the Virgin, and kindred subjects.

5

Even portraits tended to become somewhat dramatic in the sixteenth century. From the time of Donatello occasional attempts had been made to do more than merely describe the passive model, but this was the exception, and the rule was that the portrait exactly represented the person as he sat to the painter. The heads of the Quattrocento are invaluable in their simplicity. They were not intended to produce any special impression, but on comparison with the classical portraits they seem somewhat indifferent. The Cinquecento demanded definite expression. We see at once what the person is thinking and what he wishes to say. It was not enough to show the permanent features of a face; some moment of vivid actuality had to be depicted.

At the same time the painter tried to grasp the most significant aspect of his model. There is a higher conception of the dignity of man, and we receive the impression that the race which stood on this side of the threshold of the sixteenth century was one of fuller emotions and greater powers. Lomazzo in his treatise has laid down as a rule for the portrait painter, that setting aside the imperfect traits, he should work out and strengthen the great dignified features. This is a belated theoretical formulation of what the Classics had done of themselves: " al pittore conviene che sempre accresca nelle faccie grandezza e maestà, coprendo il difetto del naturale, come si vede che hanno fatto gl' antichi pittori."[1] ("The painter's duty is to enhance the grandeur and dignity of the face, disguising the natural defects, as was the custom of the ancient painters.") It is clear that there was imminent danger that such a tendency would destroy the characteristics of the individual and distort his personality to bring it into harmony with some scheme of expression foreign to it. But it was only the " Epigoni," who succumbed to this danger.

The diminished number of commissions for portraits may have been due to this more exalted conception of the individual. Obviously, artists

[1] He refers to Titian, among others, who had shown in his *Ariosto* "La facundia e l'ornamento" and in his *Bembo* "la maestà et l'accuratezza." Lomazzo, *Trattura della Pittura*. Ed. of 1585, p. 433.

could not be asked to paint every commonplace countenance. It was said indeed of Michelangelo that he regarded it as a degradation of art to copy any earthly object in its individual limitations, unless it was of the most surpassing beauty.

6

It was inevitable that this ideal of dignity should determine the conception and representation of celestial beings. Religious feeling might express itself for or against this view. The higher social grade of the sacred figures was a consequence which followed from very different premisses. Attention has already been called to the dignified and reserved figure of the Virgin in the *Annunciation*. The shy maiden has become a princess, and the *Madonna with the Bambino*, who in the fifteenth century might have been an honest middle-class wife from the next street, becomes aristocratic, stately and unapproachable.

She no longer smiles at the spectator with laughing eyes, nor is she the Mary who lowers her gaze modestly and humbly, nor the young mother intent upon her Babe. She regards the worshipper with dignity and assurance, like a queen accustomed to see men kneeling before her. The characterisation is not uniform; at one time we see a worldly superiority, as with Andrea del Sarto, at another a heroic elevation above the world, as with Michelangelo, but the transformation of the type is noticeable everywhere.

The Infant Christ again is no more the merry playful Child, who examines a pomegranate and offers His mother a seed (Filippo Lippi), nor the laughing urchin raising His hand to give a blessing which cannot be taken seriously. If He is smiling, as in the *Madonna del Arpie*, it is at the spectator, with a rather unpleasant coquetry, for which Sarto is responsible, but usually He is serious, very serious. Raphael's Roman pictures prove this. Michelangelo, however, was the first who represented the Child thus without forcing Him into unchildlike attitudes (such as the act of blessing). He represents the Boy with absolutely natural gestures, but whether awake or asleep He is a joyless Child.[1]

[1] The highest period of German Art shows an analogy to this emancipation of the Infant Christ from the unchildlike function of blessing. The gesture of the Boy in Holbein's *Madonna* at Darmstadt, as He stretches out His left arm, is no longer a benediction.

Among the Quattrocentists, Botticelli clearly preludes in this strain; he became more and more serious as he grew older, offering a vigorous protest against the smiling superficiality of a Ghirlandajo. Yet he cannot be included in the types of the new century. His *Madonna* certainly has a serious look, but she is a depressed and sorrowful being, and her Child is not yet the kingly Child. Am I mistaken in supposing the rarity of the representation of the Madonna with the Babe at her breast to be connected with this development? It is imaginable that the idea of the suckling mother appeared deficient in dignity to the Cinquecento. Bugiardini still represents the *Madonna del latte*, but his Mary points with her hand to her breast, as if she wished to say to the spectator: "This is the breast which fed the Lord" (picture in the Uffizi). In the picture of the *Betrothal of the Infant Christ and St. Catherine* (Bologna Gallery), the same artist does not treat the ceremony as one incomprehensible to the Child; in fact the little Boy is fully conscious of the situation, and seems to be admonishing the modest bride with upraised finger.

Corresponding to the inner change there was a complete transformation in external form. All the treasures of the world had formerly been collected round the throne where Mary sat, and our Lady was endowed with every adornment of dainty robes and costly jewels. Brightly-patterned carpets from the East were unfolded, and marble canopies glittered against the blue sky. Mary was enshrined in graceful foliage, or a heavy purple curtain drooped from above, brocaded with gold, edged with pearls and lined with rich ermine. With the sixteenth century all this varied splendour disappears at once. No more carpets and flowers are seen, no artistically decorated throne, no charming landscapes. The figure is predominant, and if architecture is introduced, it is a great and serious motive, while all profane ornaments are banished from the dress. The queen of heaven must be shown in grandiose simplicity. I do not inquire if a deeper piety finds expression in this change. There are people indeed who affirm on the contrary that anxious avoidance of the "profane" argues an uncertainty of religious conviction.[1]

An analogous elevation of types took place in the ranks of the saints.

[1] Others may express an opinion as to the share in these phenomena which may be ascribed to the influence of Savonarola. There is some risk of making too many issues depend on this one personality. We are dealing with a general and not an exclusively religious manifestation.

The artist is no longer allowed to introduce any and every type of person from the street, and place them near the throne of the Madonna. The fifteenth century still accepted from Piero di Cosimo an old dotard, with spectacles on nose and somewhat dirty attire, as a Saint Antony. Other artists had aimed higher, but the sixteenth century insisted on a striking personality. It was not necessary that the type should be ideal, but the painter had to select his models. Raphael, who represented incomparable characters, may be put out of the question, but even in his superficial moments Andrea del Sarto never gives us the mean and bourgeois type, and Bartolommeo strains every nerve in constantly renewed attempts to give his saints the expression of power.

More might be said as to the relations of the persons who belong to the family of Mary and her Child; we might note how the former playmate, John, becomes reverential and kneels in adoration; but we will confine ourselves to a few remarks about the angels of the new century.

The Cinquecento took over from its predecessor two forms of angels, the child-angel and the half-grown girl-angel. Everyone will at once recall most charming examples of the latter by Botticelli and Filippino. Such figures were sometimes introduced into the picture bearing tapers, as in Botticelli's "tondo" at Berlin, where one of them is looking at the flickering flame with a naïve stupidity of expression; sometimes they are allowed to linger round the Bambino as flower-girls or singers, as in the daintily conceived early picture by Filippino in the Corsini Gallery, which we reproduce. One of the girl-angels, with downcast eyes, timidly offers a basket of flowers to the Infant Christ, and while He rolls over delightedly to one side and grasps at the present, two other angels gravely sing a hymn from music, although one glances up for a moment, and a smile passes over her features. Why did the sixteenth century never return to such motives? The new angels have lost the charm of youthful timidity, and have thrown off their ingenuous *naïveté*. They now have some share in the kingly state and behave themselves with corresponding dignity. The spectator is no longer to be allowed to smile.

In representing the movement of flying angels the Cinquecento reverts to the old solemn hovering familiar in Gothic art. Those incorporeal figures with the beautiful outlines of flowing drapery had become incomprehensible to the realism of the fifteenth century. It required a more matter-of-fact movement, and represented the angels not as hovering, but

Madonna and Child with Angels, by Filippino Lippi.

as walking or running on a small substratum of cloud. Hence arose those figures of hurrying girls who, in a fashion neither beautiful nor dignified, but very convincing, throw out their legs and naked heels. Attempts to represent the "swimming" flight were once more revived, with vigorous action of the legs, but it was High Art which first discovered that expression for deliberate and solemn movement in the air which has since been accepted.[1]

[1] The mediæval flying figures are directly derived from the antique. The Renaissance, by the invention of the running scheme, reverted unconsciously to the style of movement in flight with which the most ancient Greek art had begun, and which is known in archæology as the "running with bent knee" scheme (the type is seen in the *Nike* of Delos, to which the angel by Benedetto da Majano in the illustration on page 16 may be compared.) The more perfect scheme, derived from the motion of the swimmer, continued for a time side by side with the other (cf. Studniczka, *Die Siegesgöttin* 1898, p. 13), and there are parallels for this also in more modern art. Perugino's *Assumption of the Virgin*

The chief remark to be made about the child-angels is that they too are allowed to share in the childishness of the Bambino. They are only expected to be children, and yet, to suit the occasion, the prevailing lofty and sustained atmosphere of the picture may be reflected in them. The "Putto" with his tablet in the *Madonna di Foligno* produces a more serious impression, though he is not praying, than the two small naked boys, for example, on Desiderio's tabernacle (S. Lorenzo), who devoutly draw near to Christ in the act of blessing. No one can accept the scene as anything but a playful one. Those youthful musicians at the feet of the Madonna who play the guitar and other instruments with skill and vigour, are well known from Venetian pictures. The Cinquecento considered this motive unsuitable also, and entrusted the musical accompaniment of a sacred assembly to older hands, that the loftiness of the sentiment might be sustained. The most popular example of the childish "Putti" of the new century is given by the two figures at the base of the *Sistine Madonna*.

7

Given this manifest tendency to treat an altar-piece more reverentially and to sever the over-close connection between the heavenly and the earthly elements, it is not surprising that the miraculous was immediately adopted, not only by means of aureoles and *nimbi*, but by an ideal representation of events which hitherto had been depicted with great realism and circumstantiality.[1]

Fra Bartolommeo was the first to represent the Madonna hovering in the air when she appears to St. Bernard. Andrea del Sarto imitated him when he depicted the angel of the Annunciation approaching on clouds, a motive for which he had thirteenth century precedents. Angels on clouds

in the Academy of Florence shows both types side by side, and while Botticelli and Filippino make their angels hold themselves upright in the air, one can still find in Ghirlandajo's works traces of the old running angel. Signorelli is possibly the one of the Quattrocentists who gained the most perfect form from the new scheme (Frescoes in Orvieto); Raphael relied on him in his *Disputa*. Later, increased movement and foreshortening became usual, as well as the motives of figures issuing from the depths of the picture, or "head-foremost," examples of which are to be found in the four Sibyls in S. Maria della Pace and the *Madonna del Baldacchino*.

[1] In the Quattrocento we encounter such inveterate realists as Francesco Cossa of Ferrara, who could never be persuaded to give the angel Gabriel in the *Annunciation* a proper aureole, but fastened a tin platter to his head (picture in Dresden).

are introduced into the homely atmosphere of a lying-in room (*Birth of the Virgin* by Andrea, 1514). The Quattrocento preferred to place its Madonna on a substantial throne, but after the end of the fifteenth century Mary is once more raised to the skies, and appears as the Madonna in glory, an antiquated motive which in the *Sistine Madonna* underwent an unexpected and unique transformation in the direction of momentary action.

8

This exaltation of the subject to supernatural aspects brings us to the more general question of the relation of the new art to reality. Reality was the first thought of the fifteenth century. For example, whether the result were beautiful or not, the Christ of the *Baptism* had to stand with His feet in the stream. Once or twice some idealist of the minor schools had disregarded this necessity, and had allowed the feet of the Lord to rest on a level with the water (as P. Franceschi, London), but the Florentines would not have tolerated this. And yet with the new century this ideal conception was naturally adopted in representing the scene, and the same process took place with other subjects. Michelangelo made the Mary of his *Pietà* quite youthful, and disregarded all protests on this point. The diminutive table in Leonardo's *Last Supper*, and the impossible boats in Raphael's *Miraculous Draught of Fishes*, serve further to show how reality was no longer the decisive factor for the new era of thought, and how the unnatural was tolerated when it helped the artistic effect.

When, however, people talk of the Idealism of the sixteenth century, they usually mean something quite different; they imagine a general revolt from limitations of place, time, or individuality, and the antithesis of Idealism and Realism is supposed to characterise the essential difference between Classical and Quattrocentist. The definition is not apt. No one probably would have understood these ideas had they been formulated at that time, and it was not until the seventeenth century that these antitheses really made themselves felt. At the beginning of the Cinquecento the tendency was to elevate, not to repudiate the old art.

The fifteenth century never treated Biblical stories realistically in the sense of attempting to transfer the incidents to modern life, as modern painters do. The object in view was to give a representation appealing

largely to the senses, and to this end familiar motives were employed, though the painter reserved the right to go beyond them so soon as this seemed necessary for his purpose.

On the other hand, the sixteenth century was not ideal in the sense of avoiding contact with the natural world, and aspiring to produce a monumental effect at the cost of definite characterisation. Its trees were rooted in the old soil, though they attained a greater height. Art was still illustrative of the life of the day, but it thought that the increased demand for dignified presentment could only be satisfied by a selection of types, dresses, and architecture which could hardly be brought together in reality.

It would be completely misleading to identify this classical art with the imitation of the antique. The antique may speak to us more distinctly from the works of the Cinquecento than from those of the older generation —this question will be treated in a different connection—but, judging by their aim, the Classicists are not essentially different from the Quattrocentists in their attitude towards antiquity.

It is necessary to particularise. Let us begin with the treatment of locality. We know how much space Ghirlandajo devoted to buildings of every sort in his pictures. Does he show us Florence? One certainly has a view here and there of some street in the city, but he draws on his imagination for his courts and halls. They are structures such as were never actually built, all that concerned him was the magnificence of the impression produced. The sixteenth century retained this standpoint, but its ideas as to what was beautiful were different. Extensive views of a city and vistas of landscape were abandoned, not because artists wished to produce a vague and indefinite impression, but because no further interest was taken in such matters. The *ubiquité* of French Classicism had no part in their conceptions.[1]

The desire to idealise locality leads to results which certainly strike us as strange. A story like the *Visitation*, in which one expects to see the entrance to a house, the home of Elizabeth, is represented by Pontormo in such a way that the scene shows only a large niche with steps leading up to it. But here we must remember that Ghirlandajo in his picture of the

[1] Raphael, however, permitted a Ferrarese to paint an elaborate landscape in his *Madonna di Foligno*, erroneously supposed to be Foligno. The *Madonna di Monteluce* shows the Temple of Tivoli. Other cases will suggest themselves.

Visitation (Louvre) took an archway for his background, a setting not at all calculated to elucidate the text, and it may be said generally that on these questions our Northern taste is not a trustworthy guide. The Italians have a faculty for looking to the individuality of a man, and for disregarding all environment as mere detail, which is incomprehensible to us, who insist on some real correspondence between figure and place. For us, a mere niche, as the architectural background to a *Visitation*, deprives the scene of all convincing vitality, although we perceive the gain in formal effect: for the Italians any background will serve, if only the figures are vital. The vagueness of locality or, as we may say, the want of reality, can never have been felt by Pontormo as we are disposed to feel it.[1]

A still higher degree of idealism led to the placing of the Madonna on a pedestal, as if she were a statue. Even that was a concession of the higher style to form, and must not be judged by northern ideas of reverence. The Italian was able, in this instance also, to overlook the disagreeable effect which the motive, considered materially, must have produced, and he adopted the same line of thought in cases where for the sake of effect a cube or some such object was placed under the feet of the figure without any further explanation.

Leonardo has incidentally raised a note of warning against the employment of modern costumes; they were, he said, usually inartistic, and only good enough for sepulchral monuments.[2] He advises antique drapery, not in order to give the picture an antique tone, but merely because the figure is thus shown to better advantage. Nevertheless Andrea del Sarto ventured, later, to paint his fresco of the *Birth of the Virgin* (1514) as a modern picture of domestic life, perhaps showing himself here more consistent than any one of his predecessors, for even Ghirlandajo mixes ideal motives from the antique with costumes of the day, as was customary still later. Similar classic representations of the life of the day are shown in the pictures of the life of the Virgin by Sodoma and Pacchia at Siena. The one example of Raphael's frescoes in the *Heliodorus* Stanza will be sufficient to show that the æsthetics of that day were untouched by questions as to whether motives from contemporary daily life were com-

[1] Every foreigner is struck by the incidental shocks to the sense of illusion so frequent on the Italian stage. We may note, in this connection, the historically irrelevant personages who are found in the works of Pontormo and others, a tendency observed long before the sixteenth century.

[2] Leonardo, *Trattato della Pittura*.

patible with the monumental style, or whether it would be better to transpose the theme into some higher sphere of reality, such as the antique. The era of Classical Art was already past before these scruples were felt.

What appears strange to us is the nude and the half-nude. Reality seems here to be sacrificed to artistic exigencies, and an ideal world is created. But it is not difficult to prove in this case that the Quattrocento had already introduced the nude into historical pictures, and that Alberti had even prescribed such an introduction.[1] A naked man, such as the one who sits on the Temple-steps in Ghirlandajo's *Presentation* would never have been seen in the Florence of that day, in spite of the prevailing freedom of manners. But no one thought of finding fault with it in the name of realism. Nor can it be said of a composition like the *Incendio del Borgo* that it marks a fundamental departure from Quattrocentist tradition. The Cinquecento gives more nude forms, but this is all.

Allegorical figures especially proclaim the new tendency. One garment after another was taken away from them ; on the tombs of the prelates by A. Sansovino an unhappy *Faith* is seen seated in an antique bathing-cloak, and it is really impossible to divine the meaning of the disrobed body. This indifference to the purport of the figure is inexcusable, but even in earlier times these allegories were not national or familiar types.

The display of nude limbs becomes absolutely unpleasant in sacred figures. Michelangelo's *Madonna* in the Tribuna must not, however, be taken as a typical example of the age. But it must at least be allowed that, if any one person may be held responsible for great transformations in the history of culture, it was Michelangelo, who introduced the universal heroic style and caused considerations of place and time to be disregarded. His idealism is in every respect of the vastest and most unconventional order. He convulsed the existing world of realities, and deprived the Renaissance of its beautiful delight in itself.

The last word in the question of realism and idealism will not, however, deal with costume and locality. All the romancing of the fifteenth century in architecture and dress is after all harmless trifling, the convincing expression of reality depends on the individual character of the heads and figures in the picture. Ghirlandajo is free to add any accessory details that he chooses : on seeing his *Zacharias in the Temple* the spectator says " The place where these people stand must be Florence." Do painters still

[1] L. B. Alberti, *Three Books of Painting.*

produce this impression in the sixteenth century? It is evident that portraits appear more rarely in pictures. One feels less prompted to ask who this or that figure represents. The interest in the characteristics of individuals and the capacity to reproduce them did not disappear—the reader need but recall the portrait-groups of the *Heliodorus* frescoes or the pictures by Sarto in the Annunziata—but the time was past when portrait heads were looked upon as the highest artistic achievement, and any occurrence was in itself important enough to justify its inclusion in a historical picture. As soon as the narrative was treated seriously, and the rows of indifferent spectators were dismissed, the situation was at once fundamentally changed. Individualism now found a dangerous rival. The representation of emotion became a problem which seemed occasionally to replace the interest in character. The movement of the body can be made so interesting that the head may be overlooked to a certain extent. Figures possess a new value as factors of the composition since, without any pronounced interest of their own, they become important in connection with the whole, as mere indications of forces in the architectonic scheme, and these effects of form of which the earlier generation knew nothing, lead of themselves to purely superficial characterisation. Such general types of heads had always been found in the fifteenth century—they are very plentiful in Ghirlandajo's works—and no fundamental antagonism between the old and the new art, in obedience to which the latter had turned away from individualisation, can be inferred therefrom. Portrait motives became rarer, but it is not the case that the Classical Style postulated a universal ideal humanity. Even Michelangelo, who here once more adopts a position of his own, still introduced many realistic heads in the earlier scenes in the Sistine Chapel (in the *Flood*, for example). His interest in the individual then begins to wane, while Raphael, who in the first Stanza seldom went beyond general types, took more and more interest in the particular.

But there is another question. Was the individual conceived and represented in the same way as before? The eagerness to reproduce nature to the minutest detail, and the delight in reality for the sake of reality had subsided. In the picture of man the Cinquecento sought to present his greatness and importance, and thought to attain this end by simplification, and by suppression of all unessential details. It was not dimness of sight that made it overlook certain things, but on the contrary,

an intensified power of comprehension. The loftiest vision is that which idealises the model from within; it has nothing in common with the beautification of the object, the idealisation of externals.[1]

It may be fairly assumed that, at the period of great art, dissatisfaction must have been felt now and again at what was offered by nature. Such feelings are difficult to discuss, and it would be bold to define the difference between two eras, such as the Quattrocento and Cinquecento, by categorical statements, whether positive or negative. There are hundreds of steps in the conscious transformation of the model after the artist takes it in hand. A statement made by Raphael, at the time when he was working at his *Galatea*, has come down to us: that he could do nothing with models, but relied on the idea of beauty which occurred to him spontaneously.[2] Here we have an authentic proof of Raphael's idealism, but would not Botticelli have said the same, and is not his *Venus on the Shell* a purely imaginative creation?

Ideal figures and heads were to be found even in the "realistic" Quattrocento; everywhere we note how gradually differences arose. But the ideal of course fills a far larger space in the sixteenth century. The aspirations of this age are not compatible with the intimacy shown in the past century with ordinary life. It is noteworthy that at the very time when art of itself discovered a higher beauty, the Church also required increased dignity for the chief figures of the Christian faith. The Madonna was no longer to be any ordinary virtuous woman, whose type was a familiar one in the streets; she had become a being who had cast off all traces of lowly human origin. And now once more Italy owned minds that could conceive the ideal. Michelangelo, the greatest of realists, was also the greatest of idealists. Endowed with all the Florentine faculty for characterisation, he was also the man who could most completely renounce the external world and work from the idea. He created his own world, and it was his example, though he must be accounted blameless in the matter, that undermined reverence for nature in the coming generation.

One last remark must be made in this connection: an increased need for the contemplation of the beautiful was felt in the Cinquecento. This craving was not constant, and might temporarily disappear before other

[1] In Lomazzo, *Trattato* (1585), p. 433, the following remark is made on the style of portraits by the great masters: "They always brought out the best qualities of the sitters." (Usavano sempre di far risplendere quello che la natura d'eccellente aveva concesso loro). [2] Guhl, *Künstlerbriefe*, 1 [2]. 95.

interests. The antecedent art of the Quattrocento had also a beauty of its own, but seldom gave it perfect form, because a far stronger desire urged it towards mere expression, and the characterisation of individuals. Donatello may once more be cited. The master who created the bronze *David* in the Bargello, had an insatiable appetite for ugliness; he ventured even to make his saints repulsive, because a convincing living individuality was everything, and impressed by this, the public no longer asked if a thing was beautiful or ugly. The Magdalen in the Baptistery is an "oblong emaciated scarecrow" (*Cicerone*, 1st. ed.) and John the Baptist is a withered ascetic (marble figure in the Bargello), to say nothing of the figures on the Campanile. Towards the end of the century, however, it is noticeable that the idea of beauty is dawning, and in the Cinquecento that general transformation of types appears which not only replaces the lower culture by a higher, but banishes stereotyped forms because they are unlovely. The Magdalen is the frail beauty, and not the emaciated penitent, and the Baptist takes on the strong, virile beauty of a man who has grown up in wind and weather, without a trace of privation or asceticism. The youthful St. John, again, is depicted as the model of a perfectly beautiful boy, and became in this form a favourite figure of the epoch.

The youthful St. John Preaching, by Raphael.

II

THE NEW BEAUTY

When a new style is said to have arisen the first thought suggested is a transformation of tectonic elements. But on closer investigation we shall find that it was not only the environment of man, the various forms of architecture, the furniture and the costumes which had undergone a change, but man himself and his corporeality, and it is in this new conception of the body, and in the new ideas of deportment and movement, that the real essence of a style consists. Far more importance must be attached to this conception than it possesses in modern days. In our age styles are changed as quickly as one changes from one costume to another at a masquerade. But this eradication of styles only dates from our century, and we have properly no longer any right to speak of styles; we should only discuss fashions.

The new corporeality and the new movement of the Cinquecento manifest themselves clearly when we compare such a work as Sarto's *Birth of the Virgin* (1514) with the frescoes of Ghirlandajo and his lying-in-rooms. The gait of the women has quite changed. Instead of a stiff, mincing step there is a dignified progression; the "tempo" has slowed down to an "andante maestoso." There are no longer any short quick bends of the head or limbs, but slow and complete turns of the body, and instead of sprawling attitudes and angular outlines there are easy positions and sustained rhythmic curves. The lean figures of the early Renaissance with their sharp joints no longer realise the ideal of beauty; Sarto depicts magnificently modelled forms and splendidly developed necks. The drapery falls in heavy masses sweeping the ground, whereas Ghirlandajo painted short stiff dresses with tightly-fitting sleeves. Garments, which formerly gave expression to rapid muscular movement, were now intended by their fulness to give an effect of reticence in action.

The Birth of John the Baptist, by Ghirlandajo.

1

The movement in the second half of the fifteenth century is dainty, and often affected. When the Madonna has the Child in her arms, she usually thrusts out the point of her elbow, and extends the little finger of the hand with which she fastidiously holds the Babe. Ghirlandajo is not one of the subtler artists, but he completely assimilated this mannerism. Even a painter of such powerful individuality as Signorelli makes concessions to the prevailing taste, and aims at graceful effects by unnaturally refined methods. The Mother, worshipping the Child, does not clasp her hands simply; only the two first fingers touch, while the others are separated and point upwards.

Sensitive persons like Filippino seem absolutely to shrink from the suggestion of grasping any object firmly. Suppose a holy monk has to hold a book, or the Baptist his cross; they are represented as merely touching these objects. So also Raffaellino del Garbo or Lorenzo di Credi: St. Sebastian holds out his arrow between two fingers with a

conscious daintiness, as if he were offering a pencil.

The standing figures sometimes look as if they were dancing, and this unsteady posture produces a most unpleasant effect in sculpture. Benedetto da Majano's *St. John* in the Bargello is not beyond reproach in this respect. One looks at it with a sincere longing for the firm tread of the next generation. Even the reeling *Bacchus* of Michelangelo stands better on his feet.

A complete summary of this affectation of taste in the late Quattrocento is furnished by

Tobias with the Angel, by Verrocchio (?).
(Or perhaps Botticini.)

Verrocchio's picture of the *Three Archangels* (Academy, Florence), with which the *Tobias* in London may be coupled. In the presence of this elaborate ambling, the thought involuntarily suggests itself that an ancient and delicate style is breaking up, and that we are face to face with the phenomenon of a decadent archaism. The sixteenth century brings back firmness, simplicity, and natural movement. Gesture grows calmer. Petty daintinesses, artificial stiffness and strutting are discarded. Andrea del Sarto's *Madonna delle Arpie*, standing so firmly and strongly on her feet, presents quite a new spectacle, and one can almost believe that she is really able to carry the heavy Boy on one arm. The way in which she has propped the book against her thigh, and rests her hand on the edge, so that a large and coherent design is formed, is a magnificent example of Cinquecento style. Movement everywhere shows fresh force and energy. Let us take Raphael's *Madonna di Foligno*. It

228 THE ART OF THE ITALIAN RENAISSANCE

Attendant carrying Fruit, by Ghirlandajo.

seems hardly credible that we should have to go back to Donatello to find an arm and a hand which grasp as firmly as those of the St. John in this picture.

The turn of the body and the inclination of the head have something indecisive about them in the fifteenth century, as if men had shrunk from vigorous expression. But now pleasure in the powerful movements of a strong nature is revived. New force is suddenly given to the turn of a head or to an outstretched arm. There are traces of a stronger physical life. The mere act of vision gains an unknown energy, and the sixteenth century is once more able to depict a keen, powerful gaze.

The Quattrocento had enjoyed the highest degree of charming movement in the light-footed figures that speed across its pictures. This motive was used, and with good reason, by every artist. The angel with the candle approaches swiftly, and the servant, who brings fruit and wine from the country to the woman recovering from child-birth, comes bursting into the room, her draperies blown out by the breeze. This figure, so characteristic of the age, finds its Cinquecentist counterpart in the water-carrier of the *Incendio del Borgo*. The whole difference in the idea of form lies in the contrast between these two figures. This woman carrying water, who supports her burden with stalwart arms as she walks along quietly

erect is one of the magnificent creations of Raphael's mature and manly sense of beauty. The kneeling woman in the foreground of the *Transfiguration*, with her back to the spectator, comes of a kindred stock, and if we compare with her a similar figure in the group of women of the *Heliodorus*, we have a standard by which to judge the development of power and of strong and simple line in Raphael's last style.

On the other hand, nothing is more intolerable to the new taste than excessive tension and laboured movement. Verrocchio's mounted *Colleoni* possesses energy enough, and an iron strength, but this does not produce beauty of movement. Notions of aristocratic nonchalance are combined with the new ideal, which sees beauty in flowing lines and absence of restraint. In Castiglione's *Cortigiano* a remark is made about riding, which may appropriately be quoted here. A man ought not to sit as stiff as a ramrod on his saddle "alla Veneziana" (the Venetians were reckoned indifferent riders), but quite negligently; "disciolto" is the word used. This, of course, can only apply to a rider without armour. A man lightly clad can sit on his horse, but heavy armour requires him almost to stand. "In the one case the knees are bent, in the other they are kept stiff."[1] Art confined itself to the first form thenceforth. Perugino had once shown the Florentines what soft and pleasing movement was. His motive of a standing figure with the leg on which there is no

Woman carrying Water, by Raphael.

[1] Pomponius Gauricus, *De Sculptura*.

weight thrown out to the side, and with a corresponding inclination of the head, was in his day a novelty in Florence. Tuscan grace was more sprawling and angular, and though others occasionally approached him in motive, no painter could show such softness of line. But the sixteenth century abandoned this motive.[1] Raphael, who as a young man had absolutely revelled in it, never recurred to it later. We can imagine Michelangelo's scorn of such poses. The new motives are more concentrated, more strict in outline. Apart from the emotional expansion that had taken place, the beauty of Perugino was no longer adequate, since it failed to satisfy the taste for mass. Men desired, not the remote and isolated, but the compact and firm. In this way a series of movements of hand and arm were transformed; the arms crossed on the breast in prayer, for instance, became a characteristic motive of the new century.

Venus, by Lorenzo di Credi.

2

It seems as if all at once a new race of beings had sprung up in Florence. Rome had always possessed the full massive forms which had become the artists' ideal, but they may have been rarer in Tuscany. In any case, artists painted as if in Quattrocentist Florence no such models were

[1] It occurs in Sansovino's group of the *Baptism of Christ*, begun in 1502, but is already modified here.

ever seen as those Andrea del Sarto shows somewhat later in his Florentine women. The taste of the early Renaissance inclined to undeveloped forms, and slim, agile figures. The angular grace and the salient outlines of youth had a greater charm than the rounded abundance of womanhood or the ripe strength of manhood. The girl-angels of Botticelli and Filippino, with their sharp joints and lean arms represent the ideal of youthful beauty, and this harshness is scarcely modified in Botticelli's dancing Graces, though they typify a riper age. The sixteenth century had a different standard. Even Leonardo's angels are softer, and a *Galatea* by Raphael or an *Eve* by Michelangelo are beings very different to the Venuses of the late Quattrocento. The neck, formerly long and slim, resting like an inverted funnel on the sloping shoulders, becomes round and short, while the shoulders are broad and strong. The straining action disappears. The limbs assume a full, massive form. Once more the ideal of beauty requires the rounded bust and wide hips of the antique, and the eye demands large, harmonious surfaces. The Cinquecentist counterpart to Verrocchio's *David* is Benvenuto Cellini's *Perseus*. The lean, supple boy is no longer considered beautiful, and if an artist depicts a figure in early youth, he gives it roundness and fulness. Raphael's figure in the *Tribuna*, of the youthful St. John

Venus, by Franciabigio (?).

La bella Simonetta, by Piero di Cosimo.

seated, is an instructive example, showing how mature forms were given to a boyish body, even to an unnatural degree.

The articulation of the beautiful body is clearly shown. The Cinquecento had such a sense of structure and was so bent on expressing the fabric that all charm of detail became insignificant in comparison. Idealisation was soon prevalent in this sphere, and the parallel between the nude study by Lorenzo di Credi (in the Uffizi), and the ideal figure by Franciabigio in the Borghese Gallery, are instructive in more than one respect.

The heads become large and broad; the horizontal lines are accentuated. A firm chin and full cheeks are admired, and there must be nothing dainty and small about the mouth. Formerly a high polished forehead was admired as a most beautiful feature in a woman's face ("la fronte superba," Politian says); and the hair over the brow was sometimes plucked out in order that this charm might be displayed as much as possible. A low forehead appealed to the Cinquecentist as the more noble form, since it was felt to give repose to the face. Even in the eyebrows a straighter, quieter line was now adopted. No longer do we find those highly arched brows which we see in the girlish statues of Desiderio, where in the half-laughing, half-wondering faces the brows are drawn

up even higher, suggesting Polizian's rhyme; they all show—

" nel volto meraviglia
Con fronte crespa e rilevate ciglia." (*Giostra.*)[1]

The pert, *retroussé* nose may once have had its admirers, but it was no longer fashionable, and the portrait-painter would take every pains to smooth down the uneven line, and to give it a straight and dignified shape. That which is now called a noble nose, and which is recognised as such in antique statues, is an ideal which only revived with the Classic Age.

There is beauty in all that gives an impression of repose and power, and

Vittoria Colonna (so-called), by Michelangelo

the notion of " regular beauty " may have been formed at this period, with which it was in perfect harmony. " Regular beauty " does not mean only a symmetrical correspondence between the two halves of the face, but an absolute distinctness and coherent proportion of features, difficult to define in detail, but at once discernible in the general impression. Portrait-painters began to insist on this regularity, and more and more was expected from them in the second generation of the Cinquecento. What smooth, regular features Bronzino paints in some of his undeniably excellent portraits!

Pictures are more explicit than words on these points; an instructive parallel may be drawn between Piero di Cosimo's *Simonetta* and the so-called

[1] " Her wonder each astonished maiden shows
With wrinkling forehead and uplifted brows."

Vittoria Colonna by Michelangelo,[1] both ideal types, which epitomise the taste of the two periods. The fifteenth century busts of Florentine maidens have no parallel in the sixteenth century. The Cinquecento gallery of beauty contains none but nature types, *e.g.* the *Donna Velata*, the *Dorothea* at Berlin, the *Fornarina* of the Tribuna, the magnificent female figure by Andrea del Sarto at Madrid &c. Taste reverted to the fully developed woman.

3

The playful fancy of the fifteenth century let loose all its caprices in the treatment of the hair. Painters depicted magnificent coiffures with infinite wealth of plaits and braids of different kinds, sprinkled with jewels and entwined with ropes of pearls. This fantastically exaggerated adornment must be distinguished from the style in which the hair was really worn, and that was fanciful enough. The tendency was to divide and separate, and to produce delicate details, in contrast to the new style, which aimed at keeping the hair together in a mass, and preferred simplicity of form. Even in ornamentation it did not allow the jewels to produce any separate effect, but only used them when combined in a harmonious design. Loose, flowing hair was superseded by closely bound tresses. The waving curls, dear to Ghirlandajo and his contemporaries, which fall down the cheek and cover the ear, disappear at once, as a merely pretty motive which detracts from the clearness of the picture. The painter insists on the importance of the function of the ear. The hair on the forehead is brought in a simple line over the temples. Its office was to enframe the face, whereas the Quattrocento had no feeling for this motive, and heightened the unframed forehead beyond its natural limits. In this older style the vertical tendency was further emphasised by placing a jewel on the top of the forehead, while the broad Cinquecento taste preferred to end off with a large horizontal line.

And so the change of style progressed. The long, slender neck of the Quattrocentist beauty, which had to appear free and supple, required ornaments different to those demanded by the massive forms of the sixteenth century. The artist no longer trifled with single gems, hanging on a thread, but painted a solid chain, and the light, close-fitting necklace becomes pendant and heavy.

[1] Morelli denies Michelangelo's authorship, but that does not affect our present contention.

To sum up, weighty and sober effects were aimed at, and capricious fancy was led into the path of plain simplicity. Voices were even raised, which extolled hair worn in natural dishevelment, and not a few thought that the complexion was more beautiful in its natural hue ("palidetta col suo color nativo") than when painted red and white, so that the women never changed colour after they had once made their morning toilette. Count Castiglione speaks to this effect; a noteworthy reaction against the gaudiness and artificiality of the later Quattrocentist fashions.

Concerning the coiffure, of men we may say at any rate that their formerly tousled locks were now brushed close round the head. In the portraits by Credi or Perugino the hair waves as if stirred by a gentle breeze, and this was an intentional effect demanded by the elaborate coquetry of the style. Pictures of the sixteenth century show the masses of hair brought into order and laid smoothly against the head.

In the sixteenth century men usually allowed their beards to grow. It added to the impression of dignity. Castiglione leaves each man to exercise his own judgment in this matter. In his own portrait by Raphael he wears a full beard.

The new inclination speaks still more clearly and emphatically in the costumes. Clothing is the direct expression of men's conception of the human body and of its movement. The Cinquecento necessarily had recourse to soft, heavy materials, long, full-sleeves, and immense trains. This is seen in the female figures of Andrea del Sarto's *Birth of the Virgin* (1514), where, as Vasari expressly states, the fashionable costume of the day is represented. It is not our intention to examine the motives in detail; the important points are the general wish for fulness and weight in the clothing of the body, the development of broad lines, and accentuation of hanging and trailing effects, which gave stateliness to movement. The fifteenth century, on the contrary, emphasised agility. Short, tight-fitting sleeves which left the wrist free. No exuberant folds, but a dainty trimness. One or two slashes and ribbons on the under-sleeve, otherwise nothing but narrow hems and close seams. The Cinquecento demands heavy stuffs and a rustling fulness. It rejects a complicated cut and petty details. The flowered brocades disappear before the deep sweeping folds of drapery. Costume is determined by a system which looks to obtain great contrasts of surface, and only that is employed which produces a general effect, and does not require close in-

spection to be recognised. Botticelli's *Graces* have a network over their breasts: such archaic subtleties are as incomprehensible to the new generation as the conceits of fluttering ribbons, veils, and similar gauzy objects. Other ideas of contact prevail, and there is no longer the dainty touching with the tips of the fingers, but a firm grasp with the whole hand.

4

From this standpoint we must glance at architecture and its new form in the Cinquecento. This again, like clothing, is a projection of man and his sense of corporeal structure. An age shows what it wishes to be and where it looks for value and importance not less accurately in the rooms which it builds and in the forms of its ceilings and walls, than in the fashion of its figures and their movement. The Cinquecento had a peculiarly strong sense of the relation of man and architecture, and of the resonance of a beautiful interior. It could hardly conceive of any existence without an architectural setting and basis.

Architecture also becomes impressive and serious. It curbs the joyous liveliness of the early Renaissance and attunes it to a more sober measure. The various cheerful decorations, the wide-spanned arches and the slender columns disappear, and heavy forms, solemn proportions, and the most severe simplicity take their place. Taste demands spacious rooms and echoing footsteps; it cares only for great ceremonials and rejects trivial amusements, and these solemn effects seem incompatible with all but the strictest conformity to law.

Ghirlandajo gives us much useful information as to the internal decorations of Florentine houses at the end of the fifteenth century. The lying-in room in the *Birth of St. John* probably represents with tolerable accuracy a patrician house, with pilasters in the corners, a cornice running round, a coffered wooden ceiling with gilded rosettes, and coloured tapestry, hung unsymmetrically upon the wall. Then a medley of furniture, useful or ornamental, placed about without any system. The beautiful was considered to be beautiful in any place.

The Cinquecento room appears stiff and cold by comparison. The severe architecture of the exteriors seems to have affected the interiors. There are no elaborate effects, no picturesque corners. Everything in architecture conforms to the new style, not merely in form but in

decoration. All colour is abandoned. Such is the room in Andrea del Sarto's *Birth of the Virgin* of 1514.

Monochrome is adopted as more compatible with dignity of presentment. Reticent colour, the neutral, unobtrusive tone, is demanded in place of loquacious brightness. The nobleman, so Count Castiglione says, should usually dress in dark, unpretentious colours. The Lombards alone go about in bright, elaborately slashed dresses. Any one who attempted to do so in Central Italy would be thought mad.[1] Variegated carpets disappear as well as gaily-striped girdles and oriental shawls. The taste for them now seems childish.

All colour was therefore avoided in dignified architecture. It disappears entirely from façades, and is only very sparingly used in interiors. The idea that noble architecture should be colourless had extensive after-effects, and many ancient monuments suffered from it, so that we are obliged to reconstruct the picture of the Quattrocento from comparatively scanty remains. The architectural backgrounds of Gozzoli or Ghirlandajo are full of information on this subject, even if they cannot be taken literally in every detail. Ghirlandajo is almost insatiable in his variety of colours,—blue friezes, yellow panels on pilasters, chequered pavements,—yet Vasari praises him as a promoter of simplicity, because he abandoned the use of gold ornament in his pictures.[2]

The same remarks apply to sculpture. A prominent example of Quattrocentist polychromy, the tomb by Antonio Rossellino in S. Miniato, has already been mentioned (*supra*, page 73); the tomb of Marsuppini by Desiderio in S. Croce, which as we see it now is stripped of all its character, must have been another notable example. Traces of colour are found on careful examination, and in our age, when so much is restored, it would be a meritorious task to reclaim these degenerates, and to make them shine once more with their former brightness. Very little colour is needed to produce a coloured effect. The mere gilding of a few places is enough to prevent the white stone from appearing colourless, in strong contrast to the many-coloured world around. The relief of the *Madonna* by Antonio

[1] It was only a step further to adopt Spanish dress. The sympathy with the Spanish nature—"grave e riposato"—is frequently expressed in Castiglione's book. He thought the Spaniards far more akin to the Italians than the mercurial French.

[2] The use of gold was more firmly established among the Umbrians than the Florentines. It is interesting to mark its gradual disappearance in Raphael's works in the Vatican.

Rossellino in the Bargello is treated thus, as also the figure of St. John by Benedetto da Majano. A gleam of colour is given to the hair and the fur garment by a few strokes, without any heavy gilding. Gold blends naturally with bronze, and there are remarkably beautiful combinations of bronze and marble with gold, for instance, the tomb of Bishop Foscari in S. Maria del Popolo at Rome, where the bronze figure of the deceased lies on a marble cushion with gold decorations.

Michelangelo from the first abandoned colour, and monochrome was therefore at once adopted all along the line. Even terracottas, which are so dependent on the embellishment of painting, lost their colouring, as we find in the works of Begarelli.

I cannot endorse the often repeated assertion that the modern reluctance to colour sculpture comes from the wish to imitate antique statues. The rejection of colour was a settled matter before any archæological purist could have lighted upon this idea, and such radical changes of taste are not usually governed by historical considerations. The Renaissance accepted colour as an element of the antique, as long as it retained colour in its own works, and all antique monuments when represented in pictures were treated polychromatically. From the very moment that the desire for colour ceased, the antique also was deemed to have been white, but it cannot be said that it originated the disuse of colour.

5

Each generation sees in the world that which is congenial to itself. The fifteenth century was obviously bound to hold a standard of the beauty of the visible world different to that proper to the sixteenth, for it regarded it with different eyes. In Politian's *Giostra* we find in his description of the garden of Venus, a concise expression of the Quattrocentist sense of beauty. He speaks of the bright glades and the springs of clear water, he names the many beautiful colours, the flowers, he goes from one to the other and describes them in long enumeration, without any fear of wearying the reader (or listener). With what daintiness of feeling he tells of the little green meadow where

" Scherzando tra fior lascive aurette
Fan dolcemente tremolar l'erbette." [1]

[1] Wanton breezes sporting with the flowers make the tiny blades of grass quiver sweetly.

The flowery meadow was thus to the painter a world of individuals, whose little life and feelings he shared. It is recorded of Leonardo that he once painted a bunch of flowers in a vase with extraordinary skill.[1] I mention this one case as typical of many pictorial productions of the age. The reflections and sheen on jewels, cherries, and metal dishes were noted with a fresh delicacy of perception, derived from the pictures of the Dutch Quattrocentists. This peculiar *préciosité* of style induced painters to represent John the Baptist holding in his hand a glass crucifix with copper rings. Glittering foliage, bright flesh-tints and white cloudlets on an azure sky were favourite pictorial refinements, and every effort was made to secure the greatest brilliance of colour.

The sixteenth century knew nothing of these joys. The bright blending of beautiful colours had to give way to strong shadows and skilful effects of perspective. Leonardo makes merry over the painters who were unwilling to sacrifice beautiful colour-effects to modelling. He compares them to orators who use fine phrases without any meaning.[2]

Quivering blades of grass, and the reflections of a crystal are no longer subjects for Cinquecentist painters, who did not cultivate minuteness of vision. They only realised great actions and represented only the great phenomena of light. Nor was this all. Their interest in the world became more and more limited to the human figure. It has been already noted how the painters of altar-pieces and historical pictures concentrated their efforts on the special effect aimed at, and refused to justify the popular taste for detail. The altar-piece was formerly the spot where every beautiful object under heaven might find a place, and in pictorial narrative the artist worked not as a "historical-painter" merely, but also as a painter of architecture, landscape and *genre*. Such interests became incompatible. Even where there was no attempt at dramatic effect, or an impression of religious solemnity, in idyllic scenes and prosaic representations of secular and mythological subjects, the beauty of the figures swallows up almost every other consideration. To which of the great classic masters would one have entrusted Leonardo's vase of flowers? If Andrea del Sarto draws anything of the sort, it is dashed in perfunctorily, as if he feared to destroy

[1] Vasari III. 25. It was in a picture of the Virgin. Venturi quotes the passage in reference to the "tondo" (No. 433) of the Borghese Gallery, by Lorenzo di Credi.

[2] *Trattato della Pittura*. The strengthening of the effects of shadow both in architecture and sculpture must be considered as a step towards the disuse of colour.

Allegory, by Filippino Lippi.

the purity of the monumental style.[1] And yet he sometimes gives us a beautiful landscape. Raphael who, at any rate potentially, was perhaps the most versatile of them all from the picturesque point of view, produced little in this domain. The means were still everywhere to hand, but everything tended towards an exclusive style of figure-painting, which did not condescend to notice any subjects but figures. It is worthy of remark that a native of Upper Italy, Giovanni da Udine, was employed in Raphael's atelier on the smaller details in his pictures. Later, the Lombard Caravaggio caused a positive storm in Rome with a flower-vase; it was the sign of a new art.

If a Quattrocentist like Filippino paints *Music* (picture in Berlin), as a young woman, who is decking the swan of Apollo, while the wind makes her mantle, gay with the bright hues of the Quattrocento, flutter round her, the picture with its "putti" and animals, its water and foliage, has all the charm of a myth rendered by Böcklin. The sixteenth century would have selected only the sculpturesque motive. The general feeling for nature narrowed. There can be no doubt that the development of art was not thereby benefited. The High Renaissance stood in a restricted domain, and there was considerable danger that it would exhaust itself.

The tendency towards a sculpturesque style coincides in Italian art

[1] There was now a difference between monumental and non-monumental. Other considerations of style are clearly noticeable in the small "Cassone" pictures.

with an approximation to antique beauty. There is an inclination to assume that the wish to imitate was the effectual motive in both cases, as if the picturesque world had been abandoned in favour of antique statues. But one must not judge from the analogies of our historical century. If Italian art showed a new impulse at its apogee, it can only have been due to a development from within.

6

In summing up we must once more speak of the relation of Italian art to the antique. The popular idea is, that the fifteenth century had certainly studied the antique monuments, but that it forgot alien influences in the fervour of its own production, whereas the sixteenth century, less gifted with a strong originality, never escaped from the impression once received. This argument tacitly assumes that both centuries regarded the antique in the same light, but the assumption is not unassailable. If the Quattrocentist eye saw effects in nature other than those beheld by the Cinquecentist, it follows that, in presence of the antique, the same features of the surface of observation were not impressed upon the consciousness. Men only see that which they look for, and a long training, such as cannot be presupposed in an age artistically productive, is required to overcome this *naïveté* of vision, for the mere impression of objects on the retina is not sufficient. A more correct supposition is that, moved by a similar desire to assimilate the antique, the fifteenth and sixteenth centuries were bound to attain different results, because each understood the antique differently, *i.e.* sought its own image therein. But if the Cinquecento strikes us as more antique, the reason is that its own spirit was more akin to that of antiquity.

The relation between ancient and modern is most clearly seen in Architecture, where one cannot doubt the honest intention of the Quattrocentists to reintroduce the "good, old style," and where the new works are nevertheless so unlike the old. The attempts of the fifteenth century architects to comply with Roman formulæ almost give one the impression that the antique was only known to them from hearsay. They adopt the idea of the pillar, the arch, and the cornice, but their way of constructing and combining these features makes it hard to imagine that they had seen Roman ruins. Yet they had seen, admired, and studied them, and were

R

convinced that they were reproducing antique effects. When every detail of the *façade* of S. Marco in Rome, built in imitation of the arcades of the Colosseum, became different, *i.e.* Quattrocentist, in the all important matter of proportions, this result was not due to any deliberate deviation from the model, but to the idea that the building might be so constructed and still be antique. Architects borrowed the material part of the system of form, but remained quite independent in feeling. It is an instructive task to investigate some example, such as the antique triumphal arches, which were equally available for imitation in early and later styles, and to observe the attitude of the Renaissance, how it passed by the classical model of the Arch of Titus, and adopted archaic methods of expression, which had their analogies in the Augustan buildings at Rimini and farther away, until the hour came when artists had themselves become classical.[1] The same is true of antique figures. With the most unerring feeling, artists only adopted from these admired models such parts as they understood, *i.e.* what they themselves possessed, and it may certainly be said that the world of antique monuments, which contained the productions of a ripe and of an over-ripe art, far from determining the progress of the modern development of style, did not even conduce to a premature harvest of results. When the early Renaissance took an antique motive in hand, it never reproduced it without the most sweeping alterations. It treats the antique just as the Baroque or Rococo periods, so marked in style, would have done. In the sixteenth century art reached such a pinnacle that for a short time it was on a level with the antique. This was a distinctly individual development, and not the result of a deliberate study of the remains of antiquity. The broad stream of Italian art flowed on, and if there had been no antique figures the Cinquecento must have become what it actually became. Beauty of line came not from the *Apollo Belvedere*, nor classic repose from the *Niobides*.[2]

It takes a long time to discern the antique in the Quattrocento, but there can be no doubt that it is there. When Botticelli set to work on a mythological subject, he wished to create an antique impression. Strange

[1] Cf. *Repertorium für Kunstwissenschaft*, 1893 : "Antique Triumphal Arches, a study in the development of Roman Architecture, and its relation to the Renaissance." (Wölfflin.)

[2] The Florentine *Daughters of Niobe* were indeed unknown at the beginning of the sixteenth century.

as it may seem to us, in his *Birth of Venus* or his *Calumny of Apelles* he certainly did not intend to represent his subject otherwise than as an antique painter would have represented it, and his picture of *Spring* with the goddess of love in her scarlet gold-brocaded gown, with the dancing Graces and the Flora scattering flowers, was accounted a composition thoroughly in the spirit of the antique. The *Venus on the Shell* bears indeed but a faint likeness to her antique sister, and the group of Graces is far from antique in feeling, and yet no intentional wish to diverge from classic models need be assumed. Botticelli, after all, only did what his contemporaries and colleagues did in architecture, when they thought that they were erecting their arcades of slender columns and lofty spans and rich decorations in imitation of the antique.[1]

If a Winckelmann had then arisen to preach the quiet grandeur and the noble simplicity of antique art, no one would have understood such ideas. The early Quattrocento had approached this ideal far more nearly, but the earnest attempts of a Niccolò d'Arezzo, a Nanni di Banco, or even of a Donatello were not renewed. Men now looked for movement, and valued what was rich and decorative; the feeling for form had completely changed, yet no one thought that the antique had been abandoned. Was it not the antique which offered the chief models of movement, and of fluttering drapery, and did not the ancient monuments furnish an inexhaustible store of decoration for furniture, clothing and buildings?[2] Ancient buildings were thought to be the most appropriate background, and the enthusiasm for these monuments was so great that the Arch of Constantine, *e.g.* was repeatedly represented on frescoes in Rome, where the actual edifice was always before men's eyes, and sometimes more than once in the same picture. It was not indeed represented as it was, but as it ought to have been, brightly painted, and gorgeously tricked out. Wherever antique scenes were represented, there was an attempt to give the impression of a fantastic, almost fabulous, splendour. At the same time artists looked for mirthful, not for serious, subjects in the antiques.

[1] We have the antique treatment of a contemporary scene in Verrocchio's relief showing the death of a Tornabuoni (from the tomb in the Minerva at Rome, now in the Bargello). Rome always approached more closely to the antique than Florence, and marble seems almost to impose the necessity of classical conception.

[2] Filippino, according to Vasari, was the first to employ antique motives wholesale to ornament his pictures.

They liked to see nude forms with bright scarves lying on the grass, and to call them Venus and Mars. Nothing was statuesque or marble-like, for men still loved a gay variety of colours, luminous flesh-tints and flowery meadows.

There was as yet no appreciation of the antique *gravitas*. Men read the ancient poets with altered emphasis. The pathos of Virgil resounded in their ears without effect. Their perceptions were not yet ripe for the splendid passages which have impressed themselves on later generations, such as the words of the dying Dido "et magna mei sub terras ibit imago." We may say this when looking at the illustrations of ancient poems, which conceive the subject on lines so utterly opposed to all that we could expect. We see from the charming description in Vespasiano[1] of a humanist—Niccoli—dining how little was required to produce an antique impression. The table was covered with the whitest cloth. Costly cups and antique vases were placed on it, and he himself drank from a crystal goblet. "A vederlo in tavola," the narrator exclaimed enthusiastically, " cosi antico come era, era una gentilezza." The little picture is delicately archaic in conception, and accords with the Quattrocentist ideas of the antique, but how unimaginable such a conception would have been in the sixteenth century! Who would have called it "antique"? or who would have associated dining with antique themes? The new ideals of human dignity and human beauty brought art of itself into new relations with classical antiquity. The two tastes met, and it is an intelligible consequence that now for the first time the eye learnt to regard archæological accuracy in the reproduction of antique figures. The fantastic dresses disappear; Virgil is no longer the oriental wizard, but the Roman poet, and the gods of mythology resume their proper forms.

Men began to see the Antique as it really was. The childish conception of it was abandoned. But from this moment it presented a danger, and the contact with antiquity necessarily proved fatal to the weak after they had once tasted of the tree of knowledge.

Raphael's *Parnassus* as compared with Botticelli's *Spring*, is an instructive example of the new conception of an antique scene, and in the *School of Athens* we find the figure of an Apollo which looks like a

[1] Quoted by J. Burckhardt, *Kultur der Renaissance*, and recently in his *Beiträge* (*Die Sammler*).

genuine antique. We need not ask here whether the figure was copied from an antique gem or not.[1] The remarkable point is that the spectator is at once impelled to think of an antique. For the first time we have imitations of antique statues which have the right effect. The modern feeling for line and mass had been so developed that the distance between the centuries was bridged over. Not merely did the ideas of human beauty coincide, but a feeling for the dignity of antique drapery was revived, the germs of which had existed in the earlier Quattrocento. Men realised the dignity of the antique style, and the majesty of restrained gestures. The scenes from the *Æeneid* in Marc' Antonio's *Quos ego* engraving form an instructive contrast to the Quattrocentist illustrations. The age had developed a feeling for the sculpturesque, and the tendency to place the plastic motive first and foremost, disposed men to assimilate ancient art. Nevertheless, all the great masters remained original in their conceptions, for otherwise they would not have been great. The adoption of some isolated motives, and the inspiration given by some ancient model, prove nothing to the contrary. The antique may be called a factor in the development of the art of Michelangelo or Raphael, but it is only a secondary factor. There was greater danger of loss of originality in sculpture than in painting. Sansovino, at the very commencement of the century, had begun the magnificent tombs in S. Maria del Popolo on truly antique lines, and, compared with earlier works, such as Pollaiuolo's tombs in St. Peter's, his style seems to herald a neo-Roman art. Michelangelo, however, himself sufficed to prevent art from entering the blind alley of an obsolete antique classicism. So too, where Raphael is concerned, increasingly large scope was given to the antique, but the highest productions of his art were always independent of its influence.

It is a noteworthy fact that architects never countenanced an actual reproduction of old buildings. The Roman ruins must have spoken more forcibly than ever. Their simplicity was now understood, since the unruly desire for decoration had been curbed. Men appreciated their symmetry, for they had themselves adopted similar proportions, and the keener eye now desired exact measurements. Excavations were made, and Raphael himself was half an archæologist. One stage of development had been

[1] Von Pulsky (*Beiträge zu Raffaels Studium der Antique*, 1877) is no doubt right in referring it to the Medicean gem of *Marsyas and Apollo*.

passed, and different periods[1] in the antique were distinguished, yet in spite of this clearer insight the age did not lose itself, but remained "modern," and the blossom of archæological study produced the fruit of the Baroque period.

[1] Cf. also the so-called *Report of Raphael* on the Roman excavations (printed *inter alia* in Guhl, *Künstlerbriefe* I.), and the surprising criticism of Michelangelo on the architectural periods of the Pantheon, in which, so far as I can see, he forestalls the most modern research. (Vasari IV. 512. in the *Life of A. Sansovino*).

Venus.
Copy from Marc Antonio's engraving

III

THE NEW PICTORIAL FORM

In this last chapter we propose to discuss the new method of representing objects. We mean the way in which the given object is arranged as a picture for the eye, in which sense the term " pictorial form " may be applied to the whole domain of the visible arts. It is obvious that the new feeling for the human body and its movements, explained above, would react upon the pictorial form of the same, and that conceptions of repose, grandeur, and importance in pictorial reproductions would impose themselves independently of the special subject of representation. But this enumeration does not exhaust the elements of the new pictorial form ; others must be added which cannot be deduced from the previous definitions, and are independent of feeling, the results merely of a more thorough development of the visual faculty. These are the actual artistic principles : clear definition of the visible object, a simplified presentment on the one hand, and on the other the desire for increasingly suggestive complexities of view. The eye desires more, as its power of receptivity is stronger, but at the same time the picture gains in simplicity and clearness, in so far as the objects are made easier to the sight. Then there is a third element, viz. the power of seeing the parts collectively, the capacity to form a comprehensive conception of the various parts, which is connected with the desire for a composition in which each part of the whole is felt to be necessary in its place.

This theme must be treated either at great length or very briefly, *i.e.* in short sections. An intermediate course would probably weary the reader without instructing him. I have chosen the second alternative, since a short sketch is alone suitable to the size of this book. If the chapter therefore appears unimportant, the author may be allowed to remark that

it has not been written hurriedly, and that it is easier to collect running quicksilver than to grasp the various components which make up the idea of a rich and mature style. The novelty of my attempt may be considered as a partial excuse, if this portion of my book in particular should not prove easy reading.

I. REPOSE, SPACE, MASS AND SIZE

The pictures of an age have their distinct pulsation no less than the pictures of an individual master. Quite apart from the subject of the representation, the lines may run restlessly and hastily, or calmly and quietly, the space may be cramped, or spacious and convenient, the modelling may be small and jerky, or broad and coherent. From all that has been already said of the new idea of the Cinquecento as to the beauty of the body and its movements, a calmer tendency may be expected, in pictures more mass and space. New relations between space and contents are established, the pictures become more impressive, and both in outline and in relief the same spirit of repose and the same reticence are felt, which are the indispensable characteristics of the new ideas of the beautiful.

1

The contrast is obvious when a youthful work of Michelangelo's, the *Tondo of the Madonna with the Book*, is placed by the side of a similar circular relief by Antonio Rossellino, whom we may take to represent the old generation. (*Cf.* the reproductions on page 14 and page 50.) In the latter we see a sparkling variety, in the former a broad simplicity of treatment.

It is not merely a question of leaving out details, of a simplification of subject matter (as to which something has already been said) but of the treatment of surfaces generally. When Rossellino enlivens his background with the quivering lights and shadows of a rocky landscape, and fills the expanse of sky with crinkled clouds, it is only a continuation of the style in which the head and hands are modelled. Michelangelo sought broad, coherent surfaces in the human figure, and thus the question of how to treat the rest was spontaneously solved. The same taste prevails in painting as in sculpture. Here also pleasure is no longer felt in the fantastic, in innumerable petty inequalities of surface ; quiet, massive effects

of light and shade have become the *desiderata*. The sign that governs the movement is *legato*.

The change of style is shown perhaps still more clearly in the treatment of line. Quattrocentist drawing is somewhat hasty. There are many petty flourishes and embellishments, harsh junctures and violent interruptions. The sixteenth century introduces a calmer flow of line, bold strokes and rhythmic cadences. A new sympathy with line would seem to have awakened everywhere, and once more it is allowed to develop freely. Perugino began, and Raphael with his incomparable delicacy of feeling continued in the same path. But even the others, who were very different in temperament, recognised the beauty of the broad sweep of line, and avoided the petty, breathless complexity of the earlier manner. It was still possible for Botticelli to make the point of an elbow press against the edge of the picture (*Pietà*, Munich). But now each line has to reckon with other lines; they make mutual concessions, and the eye has become sensitive to the glaring intersections of the former style.

2

The universal desire for breadth necessarily entailed a new relation of the figures to the space in painting. It was felt that there was a want of space in the old pictures. The figures stood sharply on the front edge of the stage, and thus an impression of narrowness was produced, which was not dissipated even by the extensive colonnades and landscapes in the background. Even Leonardo's *Last Supper* shows a certain Quattrocentist awkwardness, owing to the manner in which the table is brought to the extreme front of the scene.[1] The normal relation of figures to space is best shown in the portraits. What an uncomfortable existence must have been passed in the small room in which Lorenzo di Credi placed his *Verrocchio* (Uffizi), compared with the wide breezy atmosphere of Cinquecentist portraits. The new generation required air and space to move in, and it obtained this primarily by increasing the length of the figure. The three-quarters length is an invention of the sixteenth century. But even where little of the figure was shown, painters were now able to give an

[1] Raphael Morghen disguised the fact in his engraving of the *Last Supper*, and in order not to offend modern taste, inserted that interval between the table and the edge of the picture to which we have become accustomed since the Cinquecento.

impression of space. How much at his ease Castiglione seems within the four enclosing lines of his frame !

Quattrocentist frescoes usually produce a contracted and cramped effect. Fra Angelico's frescoes in the Chapel of Nicholas V. in the Vatican have a compressed look, and in the chapel of the Palazzo Medici, where Gozzoli painted the *Procession of the Kings*, the spectator, in spite of all the splendour, cannot shake off a feeling of discomfort. Something of the same sort must be said even of Leonardo's *Last Supper*; we expect a frame or a border, which the picture has not and never can have had.

Raphael shows a characteristic development in the Stanze. If the spectator looks at one picture alone in the Camera della Segnatura he will not find fault with the relation between the picture and the wall; but if he looks at two pictures together, as they meet in the corners, he will immediately become conscious of the antiquated dryness of the conception of space. In the second room the juncture at the corners is different, and the pictures, owing to the space available, are on a smaller scale altogether.

3

No contradiction is involved, if, notwithstanding the wish for space, the figures within the frame increase in size.[1] They are intended to produce a more striking effect as a mass, conformably to the idea which identified solidity with beauty. Superfluous space was avoided, because it was known that the figures thus lost in power, and means were available to create the impression of breadth in the drawing, in spite of any imposed limits.

The tendency was towards compactness, weight, and solidity. More importance was attached to the horizontal line. Hence the outline of groups was lowered and the tall pyramid became the triangular group with a broad base. The composition of Raphael's *Madonnas* furnishes the best examples. In the same way we may instance the combination of two or three standing figures into a compact group. The older pictures, where they represent groups, seem thin and fragmentary, and generally slight and light compared with the massive compactness of the new style.

[1] The plastic figure in the niche underwent the same change.

4

Finally the inevitable consequence was a general increase in actual size. The figures grow as it were under the hands of the artists. It is notorious that Raphael continually enlarged the scale in the Stanze. Andrea del Sarto, in the Court of the Annunziata, surpassed himself in his picture of the *Birth of the Virgin*, and was immediately surpassed in turn by Pontormo. The pleasure afforded by the grandiose was so great that even the newly awakened idea of unity raised no protest. The same holds good of easel-pictures. The change may be noted in every gallery, for with the Cinquecento large canvases and large figures appear on the scenes. We shall have to speak again later of the way in which the single picture is brought into harmony with the architecture. It is no longer seen by itself, but together with the wall for which it is intended, and this point of view once accepted, painting would have been destined to increase in size, even if it had not advanced spontaneously in this direction.

The characteristics of style noted here are of an essentially material kind, and correspond to a definite expression of feeling. But now, as we have already said, elements of a formal nature are found, which cannot be developed from the spirit of the new generation. The calculation cannot be made with mathematical accuracy: simplification in the sense of obtaining repose encounters a simplification, which aims at the greatest possible lucidity in the picture, and the tendency to concentration and mass encounters a strongly developed will to give pictures an increasing wealth of presentment, that will which created compactly grouped pictures and first found access to the dimension of depth. On one side there is the intention to facilitate perception, on the other the determination to make the contents of the picture as full as possible.

We shall now classify the elements affected by the conception of simplification and lucidity.

II. SIMPLIFICATION AND LUCIDITY

1

Classical art goes back to the elementary directions of vertical and horizontal lines, and to the primitive aspects of pure full-face or profile. This admitted of completely new effects, for the simplest of these had

fallen into disuse in the Quattrocento. These primitive directions of line and primitive aspects had been assiduously set aside with the intention of producing movement at any cost. Even an artist so simple-minded as Perugino has, *e.g.* in his *Pietà* in the Pitti Palace, not a single pure profile, and nowhere a pure full-face. Now, when artists commanded the widest range of resources, a new value was all at once attached to primitive notions. Not indeed that there was any deliberate archaism, but artists recognised the effect to be won by a combination of simplicity and richness ; it gives an average and the whole picture gains in balance. Leonardo appeared as an innovator when he enframed the company in his *Last Supper* by two profiles in a pure vertical line. He could not have learnt that from Ghirlandajo.[1] Michelangelo from the very first upheld the value of simplicity, and among the pictures of Raphael's maturity there is hardly one in which the deliberate application of simplicity to secure a powerful and emphatic effect is not apparent. Who of the older generation would have ventured to depict the Swiss guards in the *Mass of Bolsena* in such a way, three vertical lines in close juxtaposition ! Yet this very simplicity works wonders here. Again, in his most sublime essay, the *Sistine Madonna*, he uses the pure vertical line with astounding effect, and we have the primitive element combined with the most consummate refinements of art. An architectonic scheme like those of Fra Bartolommeo would be unimaginable without this reversion to elementary methods of presentment.

If then we take a single figure, as for example, Michelangelo's recumbent Adam on the Sistine ceiling, which impresses us as so firm and secure, we shall be forced to say that this effect would not have been produced, if the torso had not been turned so as to present the full breadth of the chest to the spectator. The figure is impressive because the position, which to the eye is normal, was achieved under difficult conditions. The figure is thus, as it were, secured. It has a certain inevitability.

Another example of the effect of such a tectonic aspect—if we may use the expression—is the sitting and preaching St. John by Raphael (Tribuna). It would have been easy to give him a more pleasing (or more

[1] The portrait-heads in the Tornabuoni frescoes can hardly be instanced in this connection, for here it was not a question of formal intentions on the part of the artist, but of a definite social convention. This is evident from his other compositions.

pictorial) attitude but, as he sits there, with the full breadth of his breast towards us and his head erect, not only the mouth of the prophet speaks, but the whole form cries aloud to us from the picture. This effect could not have been obtained in any other fashion.

In their methods of illumination, again, Cinquecentists adopted simple schemes. We find heads, which seen *en face* are accurately divided by the line of the nose, *i.e.* one half is dark, the other light, and this method of distributing the light is compatible with the most perfect beauty. Michelangelo's *Delphica* and Andrea del Sarto's ideal youthful head are drawn in this way. In other cases there was often an attempt to preserve a symmetrical shading of the eyes when the light was thrown strongly on the face, another device which produces a very clear and restful effect. Examples are to be found in the St. John of Bartolommeo's *Pietà*, and in Leonardo's *John the Baptist* in the Louvre. This does not at all mean that this method of illumination was universal, for the axis of operation was not always so simple. But simplicity was understood, and its special value was realised.

Three Female Saints (fragment), by Sebastiano del Piombo.

In the early picture by Sebastiano in S. Crisostomo at Venice three female saints are seen standing together on the left. I must instance this group as a peculiarly striking example of the new method of distribution, and here I am not speaking of the bodies but only of the heads. The combination is apparently a very natural one. One profile, a three-quarters face (this the most prominent), and then a third inclined, less independent and less strongly illuminated : a single inclination contrasting with two vertical lines. If we go through the stock of Quattrocentist examples in which a somewhat similar arrangement is found, we shall soon be convinced that the simple motive was by no means the obvious

one. The feeling for it did not revive until the sixteenth century, and in the year 1510 in the immediate vicinity of Sebastiano, Carpaccio could still paint his *Presentation in the Temple* (Academy, Venice), in which three female heads are placed together, quite in the old style, almost equivalent in value, each differing slightly in inclination, yet with no marked variety of type, without definite standard or clear contrast.

2

The return to the elementary methods of presentment is not to be divorced from the invention of the composition of contrast. It is allowable to speak of invention, for a clear discernment of the truth that all values are relative, and that all size or direction of lines is effective only in reference to other sizes or directions was not to be found before the Classical Age. Now for the first time it was perceived that the vertical is necessary because it gives the standard by which all deviations from the perpendicular are recognised, and throughout the whole realm of visible objects up to the expression of human emotions by action the truth was manifested that the separate motive can only exercise its full effective force when combined with its antithesis. Objects surrounded by smaller objects seem large, whether they be separate limbs or whole figures; that which stands beside the complex gains an air of simplicity, that which is opposed to the violently agitated looks calm, etc.

The principle of effect by contrast was of the highest importance to the sixteenth century. All classical compositions are based on it, and it was a necessary consequence that each motive could only be admitted once in one picture. The effect of such marvels of art as the *Sistine Madonna*, rests on the completeness and the uniqueness of the contrasts. This picture, which might be supposed to be more free than any other from calculated effects, is simply filled with strong contrasts. In the St. Barbara, for example—to take one case only—it had evidently been decided that, as a parallel figure to the Sixtus, who is looking up, she must be looking down, before any special reason had been invented for a downward gaze. It is a characteristic of Raphael's pictures that the spectator, looking at the general effect, does not think of the details, while Andrea del Sarto, who is somewhat later, obtrudes his treatment of contrasts on us from the very first moment. The reason for this is, that with him, contrasts are mere formulæ without any special significance.

There is also an application of the principle in the psychological domain: a passion must not be represented side by side with a like passion, but should be contrasted with other emotions.

Fra Bartolommeo's *Pietà* is a model of psychical economy. Raphael introduces into the group round his *St. Cecilia*, where all the characters are under the influence of the heavenly music, the indifferent Magdalen, knowing that the intense rapture of the others will be more fully impressed upon the spectator by this means. The Quattrocento shows numerous examples of unsympathetic bystanders, but such considerations were unknown to it. It is unnecessary to say how completely compositions of contrast like the *Heliodorus* and the *Transfiguration* soared above the horizon of the older art.

3

The problem of contrasts is a problem of the increased intensity of pictorial effect. The whole sum of the efforts which were directed towards the simplification and elucidation of the presentment, had the same object in view. The processes then at work in architecture, the system of purification, and of exclusion of all details which did not help towards the whole, the selection of a few grand forms, the reinforcement of the sculptures, all find complete parallels in pictorial art.

Images were carefully selected. Great leading lines had to play a prominent part. The old way of considering details, of groping after isolated effects, and passing from one part of the picture to the other, is now abandoned. The composition must be effective as a whole and be clear even when viewed from a distance. Sixteenth century pictures are easily seen. Perception is facilitated, and the essentials are at once detected. There is a distinct scale of values, and the eye is led into definite paths. A reference to the composition of the *Heliodorus* will supply the place of examples. We can hardly imagine how many equally important and prominent details would have been forced on the spectator's view by a Quattrocentist painter working on so large a surface.

The style of the whole is also the style of each detail in that whole. The drapery of the sixteenth century is distinguished from that of the Quattrocento by great continuous lines, by the marked contrast between plain and ornamented parts, and by the visible outlines, beneath the drapery, of the body which ever remains the chief motive.

An appreciable part of the Quattrocento form-fantasy is found in its system of folds. Persons with little visual sensibility will pass by these fabrics unheeding, and will believe generally that such a minor detail was more or less spontaneous. But if once an attempt be made to copy some such piece of drapery, it will immediately command respect, these displacements of a lifeless material will be felt to bear the impress of style, that is, the expression of a definite purpose, and attention will readily be given to all the rippling and rustling and murmuring of the stuff. Every artist has his style. The most hasty is Botticelli, who with characteristic impetuosity dashes off long simple furrows, while Filippino and Pollaiuolo and Ghirlandajo linger lovingly over the construction of their nests of folds, so rich in form.[1]

The fifteenth century poured out its wealth with profusion over the whole body. If there are no folds, there is a slash, a slit, a puff or the pattern of the stuff to attract attention. It is thought impossible to let the eye rest idle anywhere, even for a moment.

We have already explained how the new interests of the sixteenth century affected drapery. It is sufficient for a comprehension of the new style to have seen the female figures in Leonardo's picture of *St Anne*, Michelangelo's *Madonna of the Tribuna* or Raphael's *Alba Madonna*. The

Prudence, by Pollaiuolo.

[1] The drapery of Ghirlandajo's *Madonna* in the Uffizi (with two archangels and two kneeling saints) is closely akin to the famous and often copied study of drapery by Leonardo in the Louvre (Müller-Walde, No. 18).

essential idea here is that the drapery shall not overload the plastic motive.[1]

The folds are to accentuate the body and not to intrude themselves on the eye as something independent. Even with Andrea del Sarto, who delighted to let his rustling stuffs gleam in picturesque folds, the drapery is never independent of the movement of the figure, whereas in the fifteenth century it repeatedly claims attention as a special motive.

If in drapery the forms could be arranged according to taste (and it is clearly comprehensible how a new taste aimed at substituting the few for the many, at emphatic and strongly accentuated lines), the fixed forms, such as head and body, were not less subject to the transforming spirit of the new style.

Fifteenth century heads have this common characteristic, that the glittering eye gives the chief accent. Contrasted with the light shadows, the dark pupil with its iris has such importance, that it is necessarily the first thing one sees in the head, and this indeed is perhaps the normal effect produced in nature. The sixteenth century suppresses this effect; it dims the lustre of the glance. The bony sub-structure is now called upon to speak the emphatic word. The shadows are deepened in order to give more energy to the form. As great compact masses, not small scattered particles, their function is to combine, arrange, and organise. What formerly fell apart as pure detail is now made to cohere. Simple lines and emphatic directions are required. The trivial disappears in the important. No details may be prominent. The principal forms must be conspicuous enough to secure the proper effect at all distances.

It is difficult to speak convincingly on such topics without adducing instances, and even demonstration will be useless, unless personal experience coincides with it. Instead of going into particulars we will let the question rest on a comparison of the two portraits by Perugino and Raphael, reproduced on page 123 and as frontispiece. The observer will be able to convince himself that Perugino, while minutely elaborating his work, uses shadows only in small quantities without emphasis, and that he employs them cautiously, as if they were a necessary evil. Raphael, on the contrary, shades boldly, not only to strengthen the relief, but more especially as a means of welding the presentment together in a few large forms. By these

[1] Leonardo, *Trattato della Pittura*: "Do not make your figures too rich in ornamentations, lest these should interfere with the form and position of the figures."

s

means the orbits of the eyes and the nose are included in one stroke, and the eye appears clear and simple by the side of the quiet masses of shadow which surround it. The angle between nose and eyes is always emphasised in the Cinquecento; it is of decisive importance for the physiognomy, a centre where many threads of expression meet.

The secret of the great style is to say much in few words.

We will not attempt to follow the new ideas to the point where they are faced by the problem of the whole body, nor even to render a detailed account of the simplified method of representing the body by the selection of essentials. It is not the growth of anatomical knowledge which decides the question here, but a habit of seeing the figure in its great outlines. The way in which the articulations of the body are understood, and the essential points of development noted, presupposes a feeling for organic structure which is independent of anatomical erudition.

The same development plays its part in architecture; we need take but one example of it here. The fifteenth century allowed the profile of an arched niche to be continued uniformly all round; now an abutment is required, *i.e.* the important point where the arch springs has to be emphasised. A precisely similar definition of the articulations of the body was insisted upon. A new manner of setting the neck on the torso appears. The parts are more distinctly differentiated, but at the same time the body as a whole acquires a more convincing unity. There was an effort made to grasp the important points of attachment; men learnt to understand what had been so long shown them in the antique. The ultimate result indeed was that corporeal structure became a purely mechanical exercise—for which, however, the great masters are not to be held responsible.

The question at issue now was not merely the representation of man in repose, but still more that of his emotions, his physical and spiritual functions. An interminable array of new problems arose in the domain of physical movement and of physiognomic expression. Standing, walking, lifting, carrying, running and flying—every physical action, in short, had to be elaborated in accordance with the new requirements, no less than the expression of the emotions. It seemed everywhere both possible and necessary to surpass the Quattrocento in clarity and in force of expression. Signorelli did most to prepare the way for representations of action in nude bodies; independently of the laboriously minute study of details which the Florentines made, he arrived more certainly at a comprehension

of what was impressive to the eye and essential to the conception. But with all his art he seems merely to offer hints and suggestions as compared with Michelangelo. It was Michelangelo who first discovered those aspects of the functions of the muscles, which compel the spectator to realise the incident. The effects he wins from his material are as novel as if no artist before him had ever worked upon it. The series of Slaves in the Sistine Chapel, now that the cartoon of the *Bathing Soldiers* is lost, must be termed the real " School of the World," the " Gradus ad Parnassum." It is only necessary to look at the drawing of the arms, to get an idea of the significance of the work. Whereas the Quattrocento sought out the most easily attainable ways of presentment, *e.g.* the profile view of the elbow, generation after generation continuing the scheme, one man suddenly broke down all barriers, and exhibited drawings of the joints which must have been an absolute revelation to the spectator. The mighty limbs of these Slaves, no longer uniformly shown in their full breadth, nor with a dull parallelism of contours, make an impression of life surpassing that of nature itself. The inward and outward sweep of the line, the expansion and contraction of the form, bring about this effect. We shall have to speak of foreshortening further on. Michelangelo is for all time the great teacher, who showed what the effective points of view are. To take a simple example in illustration, let us turn back to the figures of women carrying burdens by Ghirlandajo and Raphael (see the reproductions on p. 228 and p. 229). When we note the superiority of the lowered left arm holding a flagon in Raphael's picture to that in Ghirlandajo's, we shall have a standpoint from which to estimate the difference of draughtsmanship in the fifteenth and sixteenth centuries.[1]

As soon as the pictorial importance of the joints became evident, it was natural that artists should have desired to make them all visible, and hence arose that tendency to bare the arms and legs, which was not held in check even in the rendering of saintly figures. The sleeves of male saints were often thrown back, for the elbow-joint had to be seen. Michelangelo went further, and bared the arm of his Virgin up to the shoulder-joint (*Madonna of the Tribuna*). Although other painters do not follow him in this, yet the exposure of the junction of arm and shoulder is common in the case of angels. Beauty came to be identified with a clear definition

[1] It is immaterial in this connection that we have reproduced Raphael's figure, not from an original drawing, but from an old copy of the fresco.

Reclining Venus (fragment), by Piero di Cosimo.

of the joints. As a prominent instance of the defective knowledge of organic structure which was peculiar to the fifteenth century, we may cite the treatment of the loin-cloth in the figure of Christ or St. Sebastian. This piece of drapery is intolerable when it conceals the lines of transition between the torso and the extremities. Botticelli and Verrocchio do not seem to have felt any reluctance to mutilate the body in this way, but in the sixteenth century the loin-cloth is arranged in a manner which clearly expresses a comprehension of the structural idea and a wish to preserve the purity of presentment. It is not surprising that Perugino, with his architectonic cast of thought, should have soon arrived at a similar solution.

In order to end this discussion with a more weighty example, let us place side by side the Venus in Piero di Cosimo's *Venus and Mars*, in Berlin, and Titian's recumbent *Venus* in the Uffizi, where Titian must be the representative of the Cinquecento for Central Italy also, since no figure equally good for purposes of comparison can be found. We have then in both pictures a nude recumbent female figure. The reader will at first naturally wish to explain the difference of effect by the difference of the model. But if he further says that the articulated beauty of the sixteenth century, as we showed it above (p. 231) in Franciabigio's study, is being compared with the inarticulated product of the fifteenth century, and that a form after the style of the Cinquecento, where the firm outline is emphasised in contrast to the swelling fleshy parts, must necessarily be superior in clarity, we shall still feel that there are other vast differences in the manner of representing the figure. In the one case it is rendered in

Reclining Venus, by Titian.

a fragmentary and faulty fashion, in the other with the most consummate perspicuity. Even novices in the study of Italian art will be puzzled when they examine Piero's drawing of the right leg, a uniform line parallel to the frame of the picture. It is quite possible that the model presented this view, but why did the painter allow himself to be satisfied with it? Why does he show nothing of the conformation of the limb? He had no desire to do so. The leg is stretched out; it would not look different were it absolutely stiff; it is loaded and compressed from above, but it looks as if it were withered. It is against such distortions of physical development that the new style enters its protest. We must not say that Piero is merely an inferior draughtsman to Titian. The question is one of generic difference of style, and he who investigates the problem will be surprised at the extent of the analogies to be discovered in connection therewith. Dürer's earlier drawings might supply parallels to Piero's figures.

The body, bulging in the invariable Quattrocento style, leans over to one side. The attitude is far from pleasing, but we would allow the realist to gratify himself in this respect, if only he had not cut off the connection between the legs and the body. There is a complete absence of the continuity of outline which is required by the representation.

In the same way the left arm suddenly disappears at the shoulder, without any hint as to its form, until we discover a hand which must belong to it, though it has no visible connection with it. If we ask for any explanation of the functions, how the weight of the body on the right arm is suggested, the turn of the head, or the movement of the wrist, Piero tells us nothing. Titian not only exhibits the formation of the body with absolute clearness, leaving us in no uncertainty on any single point, but the action of each part is carefully yet adequately represented. We need not dwell on the harmony of line, how on the right side especially the contour flows downwards in an even rhythmic cadence. It may however be said generally that even Titian did not compose so admirably from the first. The simpler and earlier *Venus* with the dog in the Tribuna, may have the advantage of greater freshness, but it is not so mature a production.

What is true of the individual figure applies in a still higher degree to a combination of several figures. The Quattrocento made incredible demands on the eye. The spectator not only has the greatest difficulty in picking out individual faces from the closely-massed rows of heads, but is given fragmentary figures to look at, of which it is almost impossible to imagine the complete forms. There seemed no limit to what might be done in the way of audacious intersections and concealments. I may instance the intolerable segments of figures in Ghirlandajo's *Visitation* (Louvre) or Botticelli's *Adoration of the Kings* in the Uffizi, where the reader is invited to analyse the right half of the picture. Signorelli's frescoes at Orvieto, with their absolutely inextricable confusion of figures might be recommended to advanced students. On the other hand, how profound is the sense of satisfaction with which the eye dwells on those compositions of Raphael's which are richest in figures; I speak of his Roman works, for he is still indistinct in his *Entombment*.

The same impropriety is found in the use of architectural details. The portico in Ghirlandajo's fresco of the *Sacrifice of Joachim* is so designed that the pilasters with their capitals abut on the upper margin of the picture. Every one at the present time would say that he ought either to

have included the entablature or to have cut off the pilasters lower down. But it was the Cinquecentists who made this criticism inevitable. Perugino was superior to the others in this point also, yet archaisms of the kind are still found with him, as when he imagines that he can indicate the span of an arch by means of the small ends of a cornice projecting from the edge of the picture. The proportions of rooms in old Filippo Lippi's works are positively ludicrous. They are taken into account in the judgment passed on him in the first chapter of this book.

III. Enrichment

1

Among the achievements of the sixteenth century the first place must be awarded to the complete emancipation of physical movement. It is this quality which primarily determines the impression of richness in a Cinquecentist picture. The activity of body seems to be due to more lively organs, and the eye of the spectator is incited to increased activity.

Movement does not now mean simple progression. The Quattrocento shows many examples of running and springing, and yet a certain poverty and emptiness is inseparable from it all, inasmuch as a very limited use is made of the joints, and the possibilities of turnings and bendings in the greater and lesser articulation of the body were only partially exhausted. At this point the sixteenth century steps in with such a development of the body, such an enriched presentment even of the figure at rest that we recognise the inauguration of a new era. The figure at once becomes rich in directions, and what was previously regarded as a flat surface acquires depth, and becomes a complex form in which the third dimension plays its part.

It is a prevalent mistake among amateurs in art that everything is possible at all times, and that art, as soon as it has acquired some facility in expression, will at once be able to represent any movement. In reality art develops like a plant, which slowly puts forth leaf upon leaf, until at last it stands round and full and branching out on every side. This tranquil and regular growth is peculiar to all organic systems of art, but it can nowhere be observed so perfectly as in the antique and in Italian art.

Perseus (cast), by Benvenuto Cellini.

I repeat that we are not concerned here with movements which aim at some new purpose, or serve some new form of expression. We are merely discussing the more or less elaborate picture of a seated, standing, or leaning figure, where there is one main action, but where by contrasts in the turn of the upper and the lower part of the body, or of the head and the breast, by the raising of one foot, the extension of an arm, the thrusting forward of a shoulder, and such-like gestures, very varied contours of torso and limbs may be obtained. No sooner did these become general than certain rules for the application of motives of movement were formulated, and the system of diagonal correspondence, in which, for example, the bend of the left arm corresponds to that of the right leg and *vice versa*, is called "contraposition." But the term "contraposition" cannot be applied to the entire phenomenon.

It might now be thought desirable to draw up a scheme of the differentiation of the correlative parts, the arms and legs, shoulders and hips, and of the newly discovered possibilities of movement in the three dimensions. But the reader must not expect this here, and, as so much has already been said about plastic richness, he must be satisfied with a few selected examples.

The methods of the new style will be most clearly shown in the cases where the artist has to deal with the perfectly motionless form, as in the theme of the Crucified Christ, a figure,

which owing to the fixity of the extremities, does not seem susceptible of variation. Yet the art of the Cinquecento gave novelty even to this barren motive, by doing away with the symmetrical disposition of the legs, and placing one knee over the other, while by a general turn of the figure it produced a contrast of direction between the upper and lower parts of the body. This treatment has been already discussed in the case of Abertinelli (cf. p. 154). Michelangelo worked out this motive to its logical conclusion. And it may be remarked incidentally that he added the element of emotion. He created the figure of the Crucified Lord who is casting His eyes upwards, and whose mouth is opened to utter the cry of anguish.[1]

The motive of the bound figure presents richer possibilities. St. Sebastian fastened to the stake, or the Christ of the Flagellation, or even that series of Slaves fettered to pillars which Michelangelo proposed for the tomb of Julius. The influence of these very "Captives" on religious subjects can be clearly traced, and if Michelangelo had completed the full series for the tomb, little more would have been left to discover.

Giovannino, in the Berlin Museum.

When we approach the subject of the unsupported standing figure, vast prospects naturally open out before us. We will only ask what the

[1] Vasari (VII. 275) gives another interpretation: "Alzato la testa raccomanda lo spirito al padre." The composition is preserved only in copies. (Reproduction in Springer's *Raffael und Michelangelo*.) This is the origin of the Seicentist Crucified Christ.

St. Cosmo, by Montorsoli.

sixteenth century would have done with Donatello's bronze *David*? It has such affinity to the classical style in the line of movement, and the differentiation of the limbs is so effective that, apart from the treatment of form, it might well have been expected to satisfy even this later generation. The answer is given by the *Perseus* of Benvenuto Cellini, a late figure (1550) but relatively simply in composition, and therefore suitable for purposes of comparison. Here we see what was lacking in the *David*. Not only are the contrasts of the limbs accentuated, but the figure is no longer in one plane, it extends backwards and forwards. This change may be looked upon as an ominous one, portending the coming decay of plastic art, but I use the example because it is characteristic of the tendency.

Michelangelo is certainly richer, yet his composition is compact and solid. His endeavours to give his figures more depth have been sufficiently explained by the comparison of his *Apollo* with the panel-like *David*. The turn of the statue, from the feet upwards, gives life to the figure in all dimensions, and the outstretched arm is valuable not merely as a contrasting horizontal line, but possesses a space-value, since it marks a degree on the scale of the line of depth, and thus establishes a relation between back and front. The *Christ* of the Minerva is similarly conceived, and the *Giovannino* of Berlin (*vide* above, note on p. 53) comes into the same category, only Michelangelo would not have approved the breaking up of the mass here. Any one who analyses the

movement in this figure may profitably refer to Michelangelo's *Bacchus*. The primitive flatness and simplicity of the genuine youthful work of the artist will be seen to contrast clearly with the complicated movement in the late work of an imitator, and the difference, not of two individuals, but of two generations, will be brought home to the unprejudiced mind.[1]

The St. Cosmo from the Medicean sepulchral chapel may be quoted as an instance of a Cinquecentist seated figure. It was modelled by Michelangelo and executed by Montorsoli, and is a beautiful quiet figure, a kind of tranquillised Moses. There is nothing striking in the motive, and yet it formulates a problem which was inaccessible to the fifteenth century. Let us by way of comparison review the Quattrocentist seated figures in the Cathedral. Not one of these earlier masters has even attempted to differentiate the lower extremities by the elevation of one foot, to say nothing of the bending forward of the upper part of the body. The head here once more shows a new direction, and the arms, notwithstanding the tranquillity and unpretentiousness of the gesture, form a most effective contrast in the composition.

St. John the Baptist, by J. Sansovino.

[1] The elaborate motive of raising a cup to the mouth—a simpler rendering would have given the act of drinking—occurs contemporaneously in painting. Cf. Bugiardini's *Giovannino* in the Pinacothek of Bologna.

Sitting figures have the advantage that the form is compact as a mass, and therefore the differences in axis are vigorously contrasted. It is easier to make a sitting figure interesting than a standing figure, and it is not surprising that they are constantly recurring in the sixteenth century. The type of the seated youthful St. John almost completely ousted that of the standing figure, both in sculpture and painting. The late figure by J. Sansovino from the Frari in Venice (1556) is very exaggerated, but for that reason instructive, as it betrays the pains taken to secure an interesting presentment.

Madonna with eight Saints, by Andrea del Sarto.

The greatest possibilities of concentrated richness are presented by recumbent figures, in connection with which a mere mention of the *Day and Night* in the Medici Chapel must suffice. Even Titian could not resist their influence. After he had been in Florence, the full-length prostrate figure of the beautiful nude female, as it had been painted in Venice since Giorgione's times, seemed far too simple to him. He sought for stronger contrasts of direction in the limbs, and painted his *Danaë*, who, with half-uplifted body and the one knee raised, receives the golden rain in her lap. It is also especially instructive to notice how in the sequel—for this picture was thrice repeated in his atelier—the figure becomes more and more crouching and how the contrasts (even in the accompanying figure), are emphasised.[1]

[1] The order of the pictures can be exactly determined. The picture at Naples (1545) begins the series, as is well known, then come the Madrid and Petersburg pictures with

Madonna with Angels and six Saints, by Botticelli.

We have hitherto spoken more of plastic than of pictorial examples. Not that painting had taken a different course, for the two developments were absolutely parallel, but the problems of perspective at once obtrude themselves in sculpture, since here the same movement may have a richer or a poorer effect according to the point of view, and for a while we only had to deal with the increase of objective movement. But so soon as we wish to show this objective enrichment in a group of several figures, painting can no longer be left in the background. Sculpture, it is true, forms its groups too, but it soon reaches its natural limits, and has to leave the field to painting. The tangle of movement which Michelangelo shows us in the "tondo" of the *Madonna* of the Tribuna has no plastic analogies

considerable variations, and the *Danaë* at Vienna contains the last and most complete revision.

even in his works, and Sansovino's St. Anne in S. Agostino's at Rome (1512) appears very meagre by the side of Leonardo's composition.

It is surprising that, in spite of all the vivacity of the later Quattrocento, a crowd of persons, even with the most excitable painters—I have Filippino in my mind—never presents a rich appearance. There is much unrest on a small scale, but little movement on a large scale. There is a want of marked divergences of direction. Filippino can place five heads in close juxtaposition, all having practically the same inclination, and this, not in a procession but in a group of women, the eye-witnesses of a miraculous resuscitation (*Resuscitation of Drusiana*, S. Maria Novella). What a variety of axis was displayed on the other hand in the group of women in Raphael's *Heliodorus*—to mention but one example!

When Andrea del Sarto brings his two fair Florentines to visit the lying-in-room (Annunziata) he gives at once two totally distinct contrasts of direction, and the result is that with two figures he produces an impression of greater fulness than Ghirlandajo with a whole company.

Sarto, again, depicting saints grouped tranquilly together in a votive picture in which all the figures are standing (*Madonna delle Arpie*), achieves a richness of effect which a painter like Botticelli does not possess, even where he alternates the positions, and inserts a central seated figure, as in the Berlin *Madonna* with the two Johns. (See pp. 171 and 274.) It is not the greater or less amount of individual movement that determines the difference; Sarto wins his advantage from the one great motive of contrast, which consists in placing the side figures in sharp profile against the central full face figure.[1] But how greatly the richness of movement in the picture is increased when standing, kneeling and sitting figures are combined, and the distinctions of forward or backward, above and below, are introduced, as in Sarto's *Madonna* of 1524 (Pitti) or the *Madonna* of 1528 at Berlin, pictures which have their Quattrocentist counterpart in that great composition of the *Six Saints* by Botticelli, where the six vertical figures stand together almost completely uniform and similar.[2]

[1] We may quote Leonardo, *Trattato della Pittura*: "I repeat that direct contrasts should be placed near each other and commingled, for one intensifies the effect of another, and the more so the nearer they are," &c.

[2] Our reproduction shows the well-known picture with the omission of the upper fifth of it, which is an obvious addition of a later date. The figures thus have their original effect, for a hollow empty upper space is quite incompatible with the Quattrocentist requirements as to an equal filling of spaces.

If, finally, we think of the varied compositions in the Camera della Segnatura, all points of contact with the Quattrocento cease in the presence of this contrapuntal art. We recognise that the eye, which had obtained a new power of perception must have required ever richer complexities of aspect before finding a picture attractive.

2

If the sixteenth century brings with it a new wealth of directions, that change is connected with a general enlargement of space. The Quattrocento remained under the spell of the flat surface, it places its figures close together in the breadth of the picture, and its composition takes the form of stripes. In Ghirlandajo's picture of the lying-in room (see illustration on p. 226) the chief figures are all developed on one plane; the women with the child, the visitors, the maid, with the priest, all stand on one line parallel with the margin of the picture. In Andrea del Sarto's composition on the other hand (see illustration p. 159) there is nothing more of the sort. We have a series of curves, outward and inward movement; there is the impression that the space has become instinct with life. Now such antitheses, as compositions on flat surfaces and compositions in space must be understood " cum grano salis." Even the Quattrocentists made frequent attempts to secure depth. There are compositions of the *Adoration of the Kings* in which every effort is made to remove the figures from the foremost edge of the stage into the middle distance and background, but the spectator generally loses the clue which was intended to guide him into the depth of the picture, in other words, the picture is broken up into distinct sections. The significance of Raphael's great space compositions in the Stanze is best shown by Signorelli's frescoes at Orvieto, which the traveller usually sees just before his entry into Rome. Signorelli, whose masses of figures rise before us like a wall, and who is only able to show, so to say, the foreground on his vast surfaces, and Raphael, who from the first easily brings his wealth of figures out from the depth of the picture, seem to me to sum up the contrasts of the two ages.

We may go still further and say that all conception of form in the fifteenth century is superficial. Not merely does the composition fall into stripes, even the separate figures are conceived as silhouettes. These words are not to be understood in their literal sense, but there is a difference between the drawing of the early Renaissance and the High Renaissance

which cannot be stated in any other way. I must once more adduce the example of Ghirlandajo's *Birth of St. John*, and especially the figures of the seated women. Might it not be said here that the painter has flattened out his figures upon the surface? Contrast with this the group of servants in Sarto's *Birth of the Virgin*. Here the painter seeks for effect by bringing forward or thrusting back various portions of the composition; in other words, the efforts of the draughtsman are directed to effects of perspective, not to a superficial presentment. As another example take Botticelli's *Madonna with two Saints* (Berlin) and Andrea del Sarto's *Madonna delle Arpie*. Why is the *St. John the Evangelist* so much richer in effect in the latter? He certainly is far superior in movement, but the movement is so represented that a plastic idea is at once suggested to the spectator, who is impressed by the salience and resilience of the form. Apart from light and shade, the impression of space is a different one, because the vertical plane is interrupted, and the panel-like figure is replaced by a body with three dimensions, in which the axis of depth, namely the foreshortened aspect, is expressed on an extensive scale. Foreshortening had been employed before this, and the Quattrocentists had toiled at this problem from the first, but now the matter was so thoroughly settled once for all that a practically new conception may be said to have been formed. In the picture of Botticelli's referred to (see p. 274) there is once more a St. John, pointing with his finger, the typical gesture of the Baptist. The way in which the arm is laid flat on the surface, parallel to the spectator, is characteristic of the whole fifteenth century, and is found as often in the preaching as in the pointing St. John. But the new century had hardly dawned before attempts were being made on every side to get rid of this superficial style, and, within the limits of our illustrations a comparison of the preaching of St. John in the pictures of Ghirlandajo and Sarto will sufficiently demonstrate the fact. Foreshortening was reckoned the consummation of draughtsmanship in the sixteenth century. All pictures were judged by this standard. Albertinelli was at last so wearied of the everlasting talk about "scorzo," that he exchanged his easel for the tavern-bar, and a Venetian dilettante like Ludovico Dolce would have endorsed his view: "Foreshortening is only a matter for connoisseurs, why should one take so much trouble about it?"[1]

[1] Ludovico Dolce, *L'Aretino*.

This may have been the general view in Venice, and it may be allowed that Venetian painting certainly had means enough of gratifying the eye, and may have thought it superfluous to enquire into the attractions of Tuscan masters. But in the Romano-Florentine school the great masters all took up the problem of the third dimension.

Particular motives, such as the arms pointing out of the picture, or the drooping full-face seen in perspective, appear everywhere almost simultaneously, and it would not be uninteresting to enumerate instances. The matter does not however depend on individual "tours de force," and astounding "scorzi," the important point is the universal change in the projection of material objects on the flat surface, and the education of the eye to the representation of the three dimensions. Andrea del Sarto consistently attempted to modify the effect of the silhouette which attached the figure to the surface by perpetual intersections.

3

It is obvious that light and shade were destined to play a new part in the domain of this new art. The tactile effect, it would naturally be supposed, was to be more directly achieved by modelling than by foreshortening. As a matter of fact, efforts, both theoretical and practical, were made simultaneously in both directions even by Leonardo. What Vasari describes as his ideal as a youthful artist: "dar sommo relievo alle figure," remained so all his life. Leonardo began with dark grounds, which were intended to set off the figures, a very different matter from the plain black which had been previously employed as a foil. He intensified the depth of the shadow and expressly insisted on the point that in a picture deep shadows should appear by the side of high lights. (*Trattato della Pittura*.) Even an artist so essentially a draughtsman as Michelangelo underwent this phase of the development, and an increasing accentuation of the shadows can be clearly traced in the course of his work on the Sistine ceiling, while one after another of those who were more especially painters may be seen trying their hands at dark grounds and boldly salient lights. Raphael in his *Heliodorus* furnished an example, in comparison with which not merely his own *Disputa*, but also the frescoes of the earlier Florentines must have all seemed flat; and what Quattrocentist altar-piece would not have suffered by being hung near to a picture of

T

Madonna with the two SS. John, by Botticelli.

Fra Bartolommeo's, with its mighty plastic life? The tactile quality of his figures, and the convincing dignity of his niches with their great shadowy recesses, must have made an impression at that time which we can with difficulty realise at the present day.

The general heightening of the relief naturally involved a change in the frame of the picture. The flat Quattrocentist frame of pilasters with a light entablature is discarded, and in its place we get a kind of shrine with half or three-quarter pillars, and a massive roof. The fanciful decorative treatment of such objects is set aside in favour of a solemn impressive architecture to which a special chapter might be devoted.[1]

[1] I do not know to what models the gabled frames are to be referred, which were made some years ago for two well-known pictures in the Munich Pinacothek (Perugino and Filippino). They seem to me rather too ponderous and architectonic.

Light and shade were now not only employed in the service of modelling, but were very soon recognised as valuable aids to the enrichment of the representation. When Leonardo requires that a dark foil should be given to the bright side of the body and *vice versa*, he may have been thinking solely of effects by relief, but as a rule light and shade are employed on the analogy of plastic contraposition. Michelangelo himself yielded to the charm of partial shadow, and the later figures of the Slaves on the ceiling are a proof of this. There are cases in which the complete half of a body is immerged in shadow and this motive is almost enough to replace the plastic differentiation of the body. Franciabigio's *Venus* (see page 231) and the youthful St. John of Andrea del Sarto come into this category. If we turn from single figures and look at multiform compositions we shall see more clearly how indispensable these elements are for the richer art. What would Andrea del Sarto be without those patches of shadow which give a vibrating effect to his compositions, and how greatly does the architectonic Fra Bartolommeo depend upon the effect of picturesque masses of light and shade! Where these are wanting, as in the sketch of the St. Anne, the picture seems still to lack the breath of life. I will close this section with a quotation from Leonardo's *Trattato della Pittura*. In the works of one who paints for an uncritical public, he says incidentally, little movement, relief or foreshortening will be found. In other words, the artistic value of a picture, according to him, depends on the extent to which the author is able to solve the problems enumerated. Movement, foreshortening, and plastic effect are precisely the elements which we tried to explain in their significance for the new style, and thus if we do not continue the analysis further, Leonardo may be held responsible.

4. Unity and Inevitability

The idea of "Composition" was not new and had been discussed even in the fifteenth century, but in its strict sense of co-ordination of parts, to be seen as a whole, it is not found before the sixteenth century, and what was considered a composition before this appeared as a mere aggregation without any real form. The Cinquecento not only conceived a vaster scheme of cohesion, and understood the position of the part within the whole, whereas formerly one detail after another was regarded with close and separate attention; it developed a union of the parts, an inevitability

of arrangement, in comparison with which all Quattrocentist work has an incoherent and arbitrary effect.

The meaning of this may be made clear by a single example. Let the reader compare the composition of Leonardo's *Last Supper* and of Ghirlandajo's. In the former, one central figure, dominating and bringing all the component parts together; a company of men, to each of whom a definite rôle is assigned within the general movement of the picture; a building no stone of which could be removed without destroying the equilibrium of the whole. In the latter, a quantity of figures, closely packed together regardless of sequence or necessary numerical limitation. These might have been more or fewer, and if each one of them had been depicted in a different attitude, the look of the picture would not have been essentially changed.

Symmetrical grouping had always been observed in sacred pictures, and there are pictures of profane subjects, like Botticelli's *Spring*, which carry out the principle that there should be a central figure and that the two sides should be equally balanced. The sixteenth century, however, could not rest satisfied with this. The central figure was after all only one among the others, the whole was a combination of parts in which each had almost the same value. Instead of a chain of similar links, a structure was now required with a distinct system of super- and sub-ordination. Subordination took the place of co-ordination.

I will take one of the simplest instances, the sacred picture with three figures. In Botticelli's picture at Berlin (see illustration on p. 274) there are three persons close together, each an independent figure, and the three similar niches in the background emphasise the idea that the picture could be cut up into three parts. This idea never presents itself in connection with the classical version of the theme, as we see it in Andrea del Sarto's *Madonna* of 1517 (see illustration on p. 171). The secondary figures are still indeed limbs which would have a certain importance by themselves, but the commanding position of the central figure is evident and the connection seems insoluble. The transformation to the new style was more difficult in historical pictures than in these sacred pictures, for the basis of a central scheme had to be invented here. The later Quattrocentists made frequent attempts, and Ghirlandajo in the frescoes of S. Maria Novella shows himself one of the most assiduous in this direction. It is noticeable that he is no longer content with the mere fortuitous juxtaposition

of figures. In places at least he has devoted himself with all seriousness to architectonic composition.

Nevertheless Andrea surprises the spectator by his frescoes of the life of the Baptist in the Scalzo. Eager to avoid the incidental at any cost, and to obtain the impression of inevitability, he made most unpromising motives subject to the central scheme. His example was universally followed. The rules of arrangement forced their way into the wild and crowded scenes of the *Massacre of the Innocents* (Daniele da Volterra, Uffizi), and even stories like the *Calumny of Apelles*, which so evidently require an oblong field, are worked up round a central motive, to the detriment of their clarity. Franciabigio on a small scale (Pitti), and Girolami Genga on a large scale (Pesaro, Villa Imperiale) supply instances.[1]

This is not the place to describe in detail how far the rule was again relaxed, and how the laws of representation were modified to permit of a more vivid impression. The Vatican frescoes contain well-known examples of broken symmetry in the midst of a style which remains purely tectonic. It must however be emphatically said that no one could make proper use of this freedom who had not been accustomed to compose on the strictest system. The partial relaxation of form could only be effective on the basis of a firmly fixed idea of form.

The same holds good of the composition of the single group, in which, since Leonardo, an analogous striving after tectonic configurations can be traced. The *Madonna among the Rocks* may be contained in an equilateral triangle, and this geometrical property, which is at once visible to the spectator, differentiates the work marvellously from all other pictures of the time. Artists felt the benefit of a compact arrangement, where the group appears inevitable as a whole, though no single figure has suffered any loss of free movement. Perugino followed on the same lines with his *Pietà* of 1495, to which no analogy could have been found either with Filippino or Ghirlandajo. Raphael finally, in his Florentine *Madonna* pictures, developed into the subtlest of master-builders. But here again the change from regularity to apparent irregularity was irresistible. The equilateral

[1] This is a suitable occasion to mention a motive of perspective. The later Quattrocento attempted sometimes to produce an attractive effect by placing the vanishing point of the lines at the side, not outside the picture, but yet towards the edge. This is seen in Filippino's Corsini *Madonna* (see illustration, p. 216) and in Ghirlandajo's fresco of the *Visitation*. Such divagations offended classical feeling.

The Death of Peter Martyr, by Gentile Bellini (?).

triangle became a scalene triangle, and the system of symmetrical axes was shifted, but the kernel of the effect remained the same, and the impression of inevitability would be kept up even in an entirely non-tectonic group. Thus we are led up to the great composition of the free style.

We find with Raphael just as with Sarto a freely rhythmic composition combined with the tectonic scheme. In the court of the Annunziata the picture of the *Birth of the Virgin* comes next to the severe rendering of miraculous scenes, and in the tapestries we find an *Ananias* immediately beside the *Miraculous Draught of Fishes* or the *Calling of Peter*. These are not antiquated motives which are merely tolerated. This free style is distinct from the former irregularity, where one thing might just as well have been another. Some such emphatic expression is needed to accentuate the contrast. The fifteenth century can in fact show nothing which even approximately possesses that character of absolute rightness and inevitability which we find in the group of Raphael's *Miraculous Draught of Fishes*. The figures are not bound together by any architecture, and yet they form a perfectly compact structure. Similarly—although in a

somewhat less degree—in Sarto's *Birth of the Virgin* the figures are brought into one line, and the whole line has a convincingly harmonious inevitability. To make the case quite clear I venture to illustrate it by an instance from Venetian art as here the conditions are especially favourable for observation. I refer to *The Murder of Peter Martyr* in the National Gallery, London, as painted by a Quattrocentist,[1] and as, on the other hand, it was reduced to classical form by Titian in the burnt picture in the Church of S. Giovanni e Paolo.

The Quattrocentist spells out the elements of the story. There is a wood, and the persons attacked, namely, the saint and his companion; the

The Death of Peter Martyr, by Titian.

one flees this way, the other that. The one is stabbed to the right, the other to the left. Titian starts with the idea that two analogous scenes cannot be depicted in close proximity. The death of Peter is the chief motive, with which nothing must compete. He accordingly leaves the second murderer out, and treats the attendant friar only as a fugitive. At the same time he subordinates him to the main motive; he is included in

[1] The ascription of the picture to Giovanni Bellini now appears to be universally abandoned. Berenson attributes it to Gentile Bellini. (*Venetian Painters.* 1894.)

the same connected movement, and by continuing the direction intensifies the fury of the onslaught. As if he were a fragment bounding off from the main group at the shock, he hurls himself forward in the direction towards which the saint has fallen. Thus a distracting and inharmonious element has become an indispensable factor in the effect. If we use philosophic terms to describe the process, we may say that development here implies integration and differentiation. Each motive is only to appear once, the antiquated equivalence of the parts is to be replaced by absolute distinction, and at the same time the differentiated elements must combine into a whole, where no part could be omitted without the collapse of the whole structure. This system of classical art had been anticipated by L. B. Alberti, when in an often quoted passage he defined perfection as a condition in which the smallest part could not be changed without marring the beauty of the whole. Here we have a visible proof of what he puts forward as a theory.

St. Jerome, by Basaiti.

The treatment of the trees may teach us how in such a composition Titian employed all accessories to heighten the main effect. Whereas in the older picture the forest seemed a thing apart, Titian made the trees share in the movement; they take part in the action, and thus lend grandeur and spirit to the incident in a novel way.

When, in the seventeenth century, Domenichino, closely following Titian, retold the story in a well known picture now in the Gallery at Bologna, the feeling for all this artistic wisdom had become blunted.

It is unnecessary to state that the employment of a landscape-background harmonising with the action of the figures, was as familiar in Cinquecentist Rome as in Venice. The importance of the landscape in Raphael's *Miraculous Draught* has already been discussed. The next tapestry, the *Charge to Peter*, presents the same spectacle: the summit of the long line of hills exactly coincides with the cæsura of the group, and thus quietly yet emphatically helps to make the disciples appear a distinct group as contrasted with the figure of Christ (cf. the illustration on p. 115). But if I may again appeal to a Venetian example, Basaïti's *St. Jerome* (London), when compared with Titian's corresponding figure (in the Brera), may represent with all desirable clearness the different way in which the two ages understood the subject. In the former picture there is a landscape which is intended to have some meaning by itself, and into which the saint is inserted, without any sort of necessary connection. In the latter, the figure and the line of the mountain have been imagined together from the first inception: there is an abrupt wooded slope, which powerfully assists the upward action in the form of the recluse, and absolutely forces him heavenwards. The landscape is as well adapted to this particular figure as the other was inappropriate.

Similarly, the architectural backgrounds were no longer regarded as an arbitrary embellishment of the picture, on the principle of "the more the better," but the necessary fitness of such adjuncts was considered. There

St. Jerome, by Titian.

had always been a feeling that the dignity of human forms could be increased by architectural surroundings, but usually the buildings overwhelmed the figures. Ghirlandajo's gorgeous architecture was far too rich to set off his figures favourably, and where it was simply a question of a figure in a niche, it is astonishing to see how little the Quattrocentists attempted effective combinations. Filippo Lippi carried his principle of isolated treatment so far that his sitting saints in the Academy do not even correspond to the niches of the wall behind them, an exhibition of casual treatment which must have seemed intolerable to the Cinquecento. He evidently aimed at the charm of vivacity rather than at dignity. The *Risen Christ* in the Pitti Palace shows how Fra Bartolommeo was able to give his heroes grandeur in a very different way, by intersecting the top of the niche. It would be superfluous to refer to all the other examples of Cinquecentist employment of architecture, in cases where the architecture seems an imposing expression of the actual persons represented.

While dealing with the universal wish to correlate the parts of the whole composition, we meet with a point of classical taste which invites criticism of the earlier art in general, and carries us far beyond the domain of mere painting. Vasari records a characteristic incident: the architect of the anteroom to the sacristy of S. Spirito in Florence was blamed because the lines of the compartments of the vaulted roof did not coincide with the axis of the pillars.[1] This criticism might have been applied to a hundred other places. The deficiency of continuous lines, and the treatment of each part by itself without regard to the unity of the total effect, were among the most striking peculiarities of Quattrocentist art.

From the moment when architecture shook off the playful irresponsibility of youth and became mature, sedate, and stern, it took the command of all the other arts. The Cinquecento conceived everything "sub specie architecturæ." The plastic figures on tombs had their appropriate place assigned to them; they were enframed, enclosed, and pillowed. Nothing could be shifted or changed, even in thought. It is evident at once why each piece was there and not a little higher up or lower down. I may refer to the discussion of Rossellino and Sansovino on pp. 73, 74. Painting underwent a similar process. When as fresco-painting it came into relation

[1] Vasari IV. 513 (*Vita di A. Contucci*), where also the excuses made by the architect may be ead with interest.

with architecture, the latter always had the upper hand. Yet what marvellous liberties Filippino takes in the frescoes of S. Maria Novella! He extends the floor of his stage so that the figures stand partly in front of the line of the wall, and then are brought into a remarkable relation with the real architectural portions of the framework. This had also been done by Signorelli at Orvieto. Sculpture shows an analogous case in Verrocchio's St. Thomas group, where the action is not confined to the inside of the niche, but takes place partly outside. No Cinquecentist would have done this. With him it was an obvious assumption that painting must produce the illusion of a space in the depth of the wall, and that its enframement must suggest the entrance to its stage.[1]

Architecture, which had now become homogeneous, demanded a like unity in frescoes. Leonardo had held that it was not permissible to paint picture above picture as in the choir-paintings of Ghirlandajo, where we look as it were into the different storeys of a house all at once.[2] He would hardly have sanctioned the painting of two pictures close together on the wall of a choir or a chapel, while the path which Ghirlandajo struck out in the adjoining pictures of the *Visitation* and the *Rejection of Joachim's Sacrifice* would have seemed preposterous. He carried the scenery behind the dividing pilaster, and each picture has its own perspective, which is not even similar to that of the neighbouring composition.

The tendency to paint uniform surfaces uniformly became prevalent in the sixteenth century, but now a more advanced problem was taken up, the problem of harmonising the interior and the covering of the wall, so that the spaciously conceived picture seemed to have been created for the hall or chapel where it was, the one explaining the other. When this result is attained, there is a sort of melody of space, an impression of harmony, which must be included among the highest achievements attainable by pictorial art.

We have already said how little the fifteenth century understood unity of treatment in an interior, and how indifferent it was to the effect of each detail in its place. The observation may be extended to larger spaces,

[1] Though Masaccio had established very clear ideas on the subject, in the course of the century they had again become so confused that frescoes are found which meet in angles without any borders between them. It would be interesting to follow out connectedly the architectural treatment of frescoes.

[2] *Trattato della Pittura.*

such as public squares. We might instance the great equestrian figures of Colleoni and Gattemelata, and ask whether anyone at the present day would venture to erect them so entirely independently of the chief axis of the square or the church. Modern opinion is represented in Giovanni da Bologna's mounted princes at Florence, but in such a way that much still remains for us to learn. Finally, the homogeneous conception of space makes itself most widely felt in cases where architecture and landscape are included in one point of view. We might call to mind the grounds of villas and public gardens, the selection of wide prospects for points of view, &c. The Baroque period reckoned with these effects on a larger scale, but anyone who has looked from the high terrace of the magnificent and incomparably situated Villa Imperiale at Pesaro towards the hills over Urbino, where the whole country is subordinated to the castle, will have received an impression of the majestic ordination of the High Renaissance, which could hardly be surpassed by the most colossal achievements of later times.

There is a conception of the history of Art, which sees in Art merely a "translation of life" into pictorial language, and tries to make every style comprehensible as an expression of the prevalent spirit of the time. Would any one deny that this is a profitable way of looking at the question? Yet it only leads to a certain fixed point, one might almost say only as far as the point where art begins. Anyone who restricts himself to the subject-matter in works of art will be satisfied with it, but as soon as he wishes to estimate things by artistic standards, he is compelled to deal with formal elements which are in themselves inexpressive, and belong to a development of a purely optical kind.

Quattrocento and Cinquecento as terms for a style cannot be explained by material characteristics. The phenomenon has a double root, and points to a development of the artistic vision which is essentially independent of any particular feeling or particular ideal of beauty.

The imposing gestures of the Cinquecento, its dignified attitudes, and its spacious and powerful beauty characterise the spirit of the generation of that day. At the same time, everything that we have said as to the increased clarity of pictorial representation, and the desire of the cultured eye for richer and more suggestive aspects, until a multiplicity of effects can be visualised as a collected whole, and the details comprehended as

parts of an inevitable unity, constitute formal elements, which cannot be inferred from the spirit of the age.

The classical character of Cinquecentist art rests on these formal elements. We have to deal with recurring phases of development and continuous forms of art. The merits which placed Raphael at the head of the older generation were the same as those which made Ruysdael, under very different conditions, a classicist among the Dutch landscape painters.

By saying this we do not wish to advocate a formalistic view of art. Even the diamond requires light to make it sparkle.

Holy Family, by Bronzino.

INDEX OF PROPER NAMES

A.

Albertinelli, Mariotto (1474–1515): "The Annunciation," *ill.*, 155; "The Crucifixion," 154; "The Holy Family," *ill.*, 154; "Madonna with two kneeling Saints," *ill.*, 135-6; "The Visitation," 153-4.
Allegri, Antonio da Correggio (1494-1534), 16.
Amerighi, Michelangelo (1569-1609), 240.
Ammannati, Bartolommeo (1511-1592), "Neptune," 196.
Andrea del Sarto, *see* Sarto, Andrea del.
Angelico, Fra Giovanni (1387-1455), 250.
Antonio, Marc, 23, 34, 246, 142.

B.

Baroccio, Federigo (1528–1612): "Institution of the Lord's Supper," 34; "Madonna del Popolo," 150-1.
Bartolommeo, Fra (1475–1517): "The Annunciation," 155-6; "The Baptism of Christ," 203; "God Almighty," 136, 145-6; "The Last Judgment," 144-5; "Madonna," 149; "Madonna della Misericordia," 150-1; "Madonna with Saints," *ill.*, 149; "The Marriage of St. Catherine," 147-3; "Patron Saints of Florence," 147; "Pietà," *ill.*, 151-2, 253, 255; "The Risen Christ with Four Evangelists," *ill.*, 90, 143-4, 151, 282; "St. Sebastian," 143-4; "Virgin appearing to St. Bernard," *ill.*, 145, 217.
Basaiti, Marco (*c.*1503-*c.*1521), "St. Jerome," *ill.*, 281.
Bellini: Gentile (*c.*1426-1507), "The Death of Peter Martyr," *ill.*, 279; Giovanni (*c.*1428-1516), "The Transfiguration," *ill.*, 137.
Beltraffio, Giovanni Antonio (1467-1516): "La Belle Ferronière," 40; "Madonna with the Child," 40; "The Risen Lord," 40.

Benedetto da Majano: "Angel bearing Candelabrum," *ill.*, 15; "Madonna and Child," *ill.*, 50; "St. John," 227, 238.
Bigio, Francia (1482-1525): "Blessing of St. John," 1518, 168; "Portrait of a Young Man," *ill.*, 181; "Sposalizio" (Annunziata), 162; "Venus," *ill.*, 232, 275.
Bondone, Giotto di, *see* Giotto.
Botticelli, Sandro, *see* Filipepi.
Bronzino, Angelo (1502-1572): "An Allegory," 103; "Christ in Limbo." 196; "Holy Family," *ill.*, 285.
Bugiardini: "Betrothal of St. Catherine," 214; "Madonna del latte," 214.
Buonarroti, Michelangelo (1475-1564): "Apollo," *ill.*, 56, 266; "Bacchus," 1498, 53-4, 227, 267; "Bathing Soldiers," *ill.*, 56, 61, 78, 160; "The Battle of the Centaurs," 56; "Christ," *ill.*, 192, 266; "The Conversion of St. Paul," 194-5; "The Creation of Adam," 71; "The Creation of Eve," 62-3, 71; "Crouching Boy," *ill.*, 91; "Crucifixion of St. Peter," 194-5; "David," *ill.*, 53-6, 78; "The Drunkenness of Noah," 61, 71; "Dying Slaves," 72; "The Expulsion," 61-2; "The Fall," 61-2; "Figures of Slaves," *ill.*, 66; "The Flood," 61, 71; "Giovannino," 53, 266; "Giovanni delle Bande Neri," 190; "Holy Family," *ill.*, 52, 85, 221, 256, 259, 269-70; "Judith," 64; "The Last Judgment," 59, 185, 194; "Light and Darkness," 64; "Madonna," 269; "Madonna with a Book," 50, 248; "Madonna of Bruges," *ill.*, 48-50, 53, 191; "The Madonna of the Medici," *ill.*, 191; "The Madonna on the Steps," 51; "Pietà": Cathedral, Florence, 53, 193-4; St. Peter's, Rome, *ill.*, 47-9, 53, 76, 84, 206, 218; "The Prophets and Sibyls," *ill.*, 64-7; "The Sacrifice of Noah," 61, 71; "St. Matthew," 56, 76; Ceiling of the Sistine Chapel, 58-72, 252; "The Slaves," 67-71; "The Tomb of Julius II," 72-7; "The Tombs of the Medici," *ill.*, 185-190, 268; "Victory," 193; "Vittoria Colonna," *ill.*, 234.

INDEX OF PROPER NAMES

C.

Caravaggio, *see* Amerighi, Michelangelo.
Carpaccio, Vittore (c. 1450—after 1522), "The Presentation in the Temple," 254.
Carracci, L., "The Transfiguration," 141.
Cellini, Benvenuto, "Perseus," 1550, *ill.*, 231, 266.
Correggio, *see* Allegri, Antonio.
Cosimo, Piero di, *see* Piero di Cosimo.
Credi, Lorenzo di (1459-1537): "Venus," *ill.*, 212, 232; "Verrocchio," 249.

D.

Desiderio da Settignano (1428-1464): "Bust of a Florentine Girl," *ill.*, 35; "Tomb of Marsuppini," 209, 237.
Domenichino, *see* Zampieri, Domenico.
Donatello (1386-1466): Bronze door of San Lorenzo, Florence, 97; "David," *ill.*, 11, 12, 54, 224, 266; "Gattemelata," 13, 284; "Miracles of St. Anthony," 11; "St. John," 11.

F.

Fiesole, Mino da, *see* Mino da Fiesole.
Filipepi, Sandro (1446-1510) (Sandro Botticelli): "Adoration of the Kings," 19, 23, 262; "Allegory of Spring," *ill.*, 19, 244, 236, 276; "Birth of Venus," 243; "Calumny of Apelles," 243, 277; "Exodus of the Jews from Egypt," 209; "Madonna with Angels and Six Saints," *ill.*, 269; "Madonna with the two SS. John," *ill.*, 272, 276; "Pietà," 249; "The Rebellion of Korah," 210; "Venus on the Shell," 223, 243.
Francesca, Piero della (1415-1492), "The Annunciation," 206

G.

Ghirlandajo, Domenico del (1449-1490): "The Adoration of the Kings," 23, 271; "The Adoration of the Shepherds," 1485, 211; "Attendant carrying Fruit," *ill.*, 228; "Birth of St. John," *ill.*, 236, 272; "Birth of the Virgin," 21; Frescoes, 16, 21, 276; "The Last Supper," 1480, *ill.*, 29-34, 207, 276; "Madonna in Glory," 133-4; "The Marriage of the Virgin," 20-1; "The Preaching of John the Baptist," 163-165; "The Presentation of Mary in the Temple," 20, 221; "Rejection of Joachim's Sacrifice," 262, 283; "The Visitation": Louvre, 1491, 153, 219-220, 262; Santa Maria Novella, Florence, 283; "Zacharias in the Temple," 221.
Gianpietrino, "Abundantia," 45.
Giotto di Bondone (1266-1336): Frescoes, 8, 10; "Presentation of Mary in the Temple," 20.
Giovanni da Udine, 240.
Gozzoli, Benozzo (1420-1498): "The Drunkenness of Noah, 201; "Procession of the Kings," 250.
Guido, Tommaso, *see* Masaccio.

J.

Jacopo da Pontormo, *see* Pontormo, Jacopo da.

L.

Leonardo da Vinci, *see* Vinci.
Lippi, Filippino (1459-1504): "The Assumption," 20; "Madonna and Child with Angels," *ill.*, 216; "Music," 240; "The Resuscitation of Drusiana," 270; "The Triumph of St. Thomas," 94; "Virgin appearing to St. Bernard," 80, 145; "Virgin with Saints," 19-20.
Lippi, Fra Filippo (c. 1412-1469); "Coronation of the Virgin," 16; Frescoes, 15-6.
Luciani, Sebastiano, c. 1485-1547 (Sebastian del Piombo): "Birth of the Virgin," 160-1; "Christ Bearing the Cross," 141; "Dorothea," *ill.*, 128, 234; "The Flagellation," 141; "Pietà," 141; "The Resurrection of Lazarus," 141; "Three Female Saints," *ill.*, 253-4; "The Venetian Maiden," 128; "The Violin Player," *ill.*, 127, 176; "The Visitation," *ill.*, 141, 206,
Luini, Bernardino, c. 1475, "Susanna at the Bath," 45.

M.

Masaccio, Tommaso Guidi: "The Birth of the Virgin," 160; Frescoes, 9, 15.
Michelangelo, *see* Buonarroti.
Mino da Fiesole, 36.
Montorsoli, "St. Cosmo," *ill.*, 267.

P.

Pacchia, Girolamo del, b. 1477, "Scenes from the Life of the Virgin," 220.
Palma, Jacopo (Il Vecchio), 1480-1528, "St. Barbara," 254.

Perugino, *see* Vannucci.
Piero di Cosimo, 1462-1521 : " La Bella Simonetta," *ill.*, 233 ; " Venus and Mars," *ill.*, 260.
Piero dei Franceschi, *see* Francesca.
Pippi, Giulio (or de' Giannuzzi), 1492-1546, " The Stoning of Stephen," 105.
Pisano, Andrea : Baptistry Gates at Florence, 8.
Pisano, Giovanni, 7.
Pollaiuolo, Antonio, 1429-1498 : Engravings by, 57 ; " Prudence," *ill.*, 256.
Pontormo, Jacopo da, 1494-1557 : " The Visitation," 148, 161, 219-20.

R.

Raphael, *see* Sanzio, Raffaello.
Robbia, Luca della : " Angel bearing Candelabrum," *ill.*, 15 : " Philosophy," 96-7.
Romano, Giulio, *see* Pippi, Giulio.
Rosselli, Cosimo, " The Last Supper," 209-10.
Rossellino, Antonio : " Madonna " (relief). *ill.*, 14, 248 ; " Tomb of the Cardinal," *ill.*, 15, 237.
Rubens, Peter Paul (1577-1640) : " The Entombment," 198 ; " The Last Supper," 34 ; " Lion Hunt," 43.

S.

Sansovino, Andrea : " Baptism of Christ," *ill.*, 203 ; " Justitia," 169 ; " St. Anne," 1512 ; *ill.*, 270 ; Tombs in Santa Maria del Popolo, Rome, *ill.*, 74.
Sansovino, J., " St. John the Baptist," *ill.*, 268.
Sanzio, Raffaello (1483-1520), (Raphael): " The Battle of Constantine," 44 ; Cartoons at South Kensington, 1515-1516 : " The Blinding of Elymas," 118-9, 120 ; " The Charge to St. Peter," 114-5, 120, 278, 281 ; " The Death of Ananias," *ill.*, 116-8, 120, 278 ; " The Healing of the Lame Man," 115-6, 120 ; " The Miraculous Draught of Fishes," *ill.*, 111-14, 120, 278, 218 ; " The Sacrifice at Lystra," 119, 120 ; " St. Paul Preaching at Athens," 119, 120 ; " The Chastisement of Heliodorus," 104-6, 220-1, 255, 270, 273 ; " The Coronation of the Virgin " (Sketch for Tapestry), 204 ; " The Deliverance of Peter," 106-8 ; " The Disputa," 90-5, 99, 145, 158, 273 ; " The Entombment," *ill.*, 85, 197-8, 262 ; " The Five Saints," school of, 204 ; " Incendio del Borgo," 110, 221, 228 ; " Jurisprudence," 102-3 ; " The Last Supper," by school of, engraved by Marc Antonio, 34. Madonnas : " La Belle Jardinière," 87 ; " Bridgewater Madonna," 86 ; " Madonna del Baldacchino," 89 ; " Madonna del Cardellino," *ill.*, 87 ; "[Madonna della Casa Alba," *ill.*, 41-2, 87, 256 ; " Madonna della Casa Canigiani," 88 ; " Casa Tempi Madonna," 86, 206 ; " Madonna del divino Amore," 88-9 ; " Madonna with the Fish," 134-5 ; " Madonna di Foligno," *ill.*, 24, 132-133, 135, 217, 227-8 : " Madonna of Francis I.," 89, 206 ; " Madonna del Granduca," *ill.*, 86 ; " Madonna in the Meadow," 87 ; " Orleans Madonna," 86 ; " Madonna della Sediai," *ill.*, 86-7, 206 ; " Sistine Madonna," 29, 135-7, 146, 171, 217, 252, 254 ; " Marriage of the Virgin," 80-1 ; " The Mass of Bolsena," 108-10, 252 ; " The Meeting of Leo I. and Attila," 110 ; " Mount Parnassus," 99-102, 244. Portraits : " Beazzano and Navagero," 124 ; " Count Castiglione," 123-4 ; " Donna Velata," *ill.*, 128-9 ; " La Fornarina," 128, 234 ; " Inghirami," 122-4 ; " Julius II., 121-2 ; " Maddalena Doni," 39, 121, 128 ; " Portrait of a Cardinal," *ill.*, 124 ; " St. Catherine," 132 ; " St. Cecilia," 131-2, 173, 255 ; " St. John the Baptist," 176-7, 231, 252 ; " The School of Athens," 90-1, 96-9, 148, 158, 244-5 ; " Spasimo," 141 ; " The Story of Cupid and Psyche," 59, 223 ; " The Transfiguration," *ill.*, 137-40, 229, 255 ; " Women carrying Water," *ill.*, 229 ; " The Youthful St. John preaching," *ill.*, 224.
Sarto, Andrea del (1486-1531) : " Abraham's Sacrifice," 176 ; " The Announcement to Zacharias," 167-8 ; " The Annunciation," 1512 and 1528, *ill.*, 156, 163, 169-170, 170-1 ; " The Arrest," 166 ; " The Assumption," 167 ; " The Baptism of Christ," 1511, 163, 168 ; " The Baptism of the People," 165-6 ; " The Beheading," 166-7 ; " The Birth of the Virgin," *ill.*, 128, 158-162, 220, 225, 235, 237, 251 ; " The Disputa," *ill.*, 172-3 ; " The Last Supper," *ill.*, 34 ; " Madonna," 174, 270 ; " Madonna delle Arpie," *ill.*, 169, 171-4, 213, 227, 270, 272 ; " Madonna with two SS. John," *ill.*, 270 ; " The Madonna del Sacco," *ill.*, 175-6 ; " The Madonna with Eight Saints," 268 ; " The Madonna with Six Saints," *ill.*, 174 ; " The Naming," 108 ; " The Offering," 167 ; Portraits, *ill.*, 177-182 ; " The Preaching of John the

Baptist," *ill.*, 163-5; "The Procession of the Three Kings," 158, 178; "St. Agnes," 176; "St. John the Baptist," *ill.*, 176-9; "Salome dancing before Herod," 1522, *ill.*, 166; Scenes from the Life of San Filippo Benizzi, 158; "The Visitation," 168.

Sebastiano del Piombo, *see* Luciani.

Signorelli, Luca (c. 1441-1523): Frescoes at Orvieto, 217, 271.

Sodoma, "Scenes from the Life of the Virgin," 220.

Solario, Andrea da (c. 1460-after 1515), "The Beheading," 1507, 44.

T.

Tibaldi, P., "The Adoration of the Shepherds," *ill.*, 198.

Titian, *see* Vecellio, Tiziano.

U.

Udine, Giovanni da, *see* Giovanni.

V.

Vannucci, Pietro (Il Perugino or Pietro Perugino), (1446-1523): "Apollo and Marsyas," 39; "Christ delivering the Keys," 82, 114; "The Entombment," *ill.*, 82; "Pietà," 80, 83, 148, 252, 277; "Portrait of a Man," *ill.*, 124; "Virgin appearing to St. Bernard," 80, 145; "The Virgin with SS. Sebastian and John the Baptist," *ill.*, 79.

Vasari, "Venus," *ill.*, 196.

Vecellio, Tiziano (Titian) (1477-1576): "The Assumption," 140, 150; "La Bella," 131; "Danaë," 268; "The Entombment," 85; "The Murder of Peter Martyr," *ill.*, 279; "The Presentation," 194, 196; "St. Jerome," *ill.*, 281; "Venus," *ill.*, 260.

Venusti, Marcello, "The Annunciation," c. 1580, 206.

Verrocchio, Andrea del (1435-1488): "The Baptism of Christ," *ill.*, 22, 78, 202-4; "Christ and St. Thomas," 14; "Colleoni," 13, 42, 190, 229, 284; "David," *ill.*, 12, 54, 231; "Three Archangels," 227; "Tobias" (? Botticini), *ill.*, 227.

Vinci, Leonardo da (1452-1519): "The Adoration of the Magi," 23-4, 133; Angel in Verrocchio's "Baptism," 22, 25; "The Battle of Anghiari," 42-3; "John the Baptist," 253; "The Last Supper," *ill.*, 21, 29-34, 40, 99, 207, 218, 249, 250, 252, 276; "Leda," 44; "The Madonna of the Rocks," 22, 41-2; "The Madonna with St. Anne," 88; "Monna Lisa," *ill.*, 26, 35-40, 78, 124; "St. Anne with the Virgin and Infant Christ," *ill.*, 40, 256; "St. Jerome with the Lion," 23; "St. John," 44; "Study of a Girl's Head," *ill.*, 27, 36.

Volterra, Daniele da, "Massacre of the Innocents," 277.

Z.

Zampieri, Domenico (Domenichino), "The Deliverance of St. Peter," 107-8.

RICHARD CLAY AND SONS, LIMITED,
BREAD STREET HILL, E.C., AND
BUNGAY, SUFFOLK.

CPSIA information can be obtained
at www.ICGtesting.com
Printed in the USA
LVHW081655150821
695366LV00002B/63